D0775071

Shifting Memories

The Nazi Past in the New Germany

Klaus Neumann

Ann Arbor

THE UNIVERSITY OF MICHIGAN PRESS

Copyright © by the University of Michigan 2000
All rights reserved
Published in the United States of America by
The University of Michigan Press
Manufactured in the United States of America
⊗ Printed on acid-free paper

2003 2002 2001 2000 4 3 2 1

A CIP catalog record for this book is available from the British Library.

Library of Congress Cataloging-in-Publication Data

Neumann, Klaus, 1958–
 Shifting memories : the Nazi past in the new Germany / Klaus
Neumann.
 p. cm. — (Social history, popular culture, and politics in
Germany)
 Includes bibliographical references and index.
 ISBN 0-472-11147-7 (acid-free paper) — ISBN 0-472-08710-X (pbk. :
acid-free paper)
 1. Memorials—Germany. 2. Memory—Social aspects—Germany.
3. Memory—Political aspects—Germany. 4. Political culture—
Germany. 5. Germany—History—1933–1945—Historiography.
6. National socialism—Historiography. I. Title. II. Series.
DD20 .N48 2000
943.086'072—dc21 00-009466

For my parents, Ruth and Dietrich Neumann

Contents

Acknowledgments

Throughout the research that resulted in *Shifting Memories,* I relied on the generous support of numerous individuals and institutions. I owe the greatest debt to the many people in Germany who patiently told me about memorial practices in their towns and shared their own views on the Nazi past, or made their private archives available to me. I cannot possibly name all and instead shall mention a few who may stand for all those who contributed so generously to this project: Linde Apel, Gudrun and Jürgen Appel, Raimund Aymanns, Eva Freudenstein, Hans-Jürgen Hahn, Rudi Hechler, Bernd Heyl, Dorothee Lottmann-Kaeseler, R. W. L. E. Möller, Günther Schwarberg, Sabine Stein, Axel Ulrich, Rüdiger Wiese, and Elke Zacharias. *Shifting Memories* is not a book about survivor memories. It is, however, informed by the many long discussions I had with survivors. When singling out Shifra Mor, Georgia Peet-Taneva, and Felicja Zylberberg for a special thank-you, I am not intending to diminish the contribution made by others. I am indebted to the teachers who invited me to talk with their students about the Nazi past.

Archivists and librarians in Germany, Israel, and Australia assisted me in every possible way. *Hildesheimer Allgemeine Zeitung, Oranienburger Generalanzeiger,* the archives of Gedenkstätte Buchenwald, Schöning Verlag, Foto-Rudolph, Förderkreis Aktives Museum Deutsch-Jüdischer Geschichte in Wiesbaden, Heinrich Lessing, and Rudi Hechler generously donated some of the photographs used in this book.

I would not have been able to write *Shifting Memories* if I had not some time ago left Germany to live in Australia. But the book is also informed by my familiarity with places in Germany, most notably my hometown Hildesheim, and Wiesbaden. Most of the fieldwork on which this book is based was done on four research trips in 1994, 1996, 1997, and 1998, which were in large part funded by the Australian Research Council, whose assistance is hereby gratefully acknowledged. The disadvantage of writing about Germany from Australia could be partly offset by being able to rely on people in Germany, who hunted down printed and archival

material and did interviews for me. I was fortunate to find a particularly gifted researcher in Jan Patjens, whose recorded conversations with Burgwedel residents form much of the basis of the final chapter, and I would like to thank him and all other research assistants who provided me with material for this book.

I thank all those colleagues who responded to papers in which I presented preliminary results of my work, to Jennifer Balint, Anne Brennan, Greg Dening, Bill Gammage and John Milfull, who read parts of the manuscript, and to Hank Nelson for his detailed comments on a complete draft.

I thank Liz Suhay, Susan Whitlock, and the staff at the University of Michigan Press for their encouragement and guidance, and Geoff Eley for his faith in the project.

Last, but not least, *mille grazie* to Susanna Scarparo.

Introduction

On 26 September 1996, about one hundred people met for a public ceremony at Koppenplatz (Koppen Square) in the center of Berlin. They had come to witness the dedication of a memorial "for the contributions of Jews in Berlin." The small crowd listened to speeches by a local government representative from the borough of Mitte, and by Hermann Simon, the director of Centrum Judaicum, a Jewish community and research center a couple of blocks from Koppenplatz. Berlin's senior cantor, Estrongo Nachama, spoke the kaddish. Students from a nearby Jewish high school played music. The dedication ceremony was low-key: there were no unctuous words by prominent politicians, and no wreath-laying rituals.

The memorial was designed by the German artist Karl Biedermann. It is titled *Der verlassene Raum* (The deserted room). The wall-less "room" contains a bronze table and two chairs, one of them appearing to have been knocked over as if those sitting at the table had left in great haste. Chairs and table are affixed to a rectangular bronze base representing a parquet floor. Lines from the poem "O the chimneys" by Nelly Sachs, the German-Jewish writer who fled Berlin to Sweden in 1940, run like a border around that base. In Michael Roloff's translation, they read:

> O the habitations of death,
> Invitingly appointed
> For the host who used to be a guest —
> O you fingers
> Laying the threshold
> Like a knife between life and death —
>
> O you chimneys,
> O you fingers
> And Israel's body as smoke through the air![1]

The Koppenplatz memorial is one of thousands of publicly funded sculptures, installations, and plaques in memory of victims of Nazi Ger-

many that have been put up in Germany since the early 1980s. While being symptomatic of what Andreas Huyssen has described as the "memory boom" of the 1980s and 1990s,[2] the proliferation of public memories of the Nazi past—given material form in museums and monuments—is specific to Germany.

Memorials and Their Histories

The memory boom has sparked a boom in memorial criticism, that is, in critical readings of tangible manifestations of public memory. In *Shifting Memories,* I am little concerned with memorials as texts, however, and more interested in the contexts of public memories. Some of these contexts appear to be plainly visible. Somebody visiting Koppenplatz in the late 1990s, for example, could have been excused for thinking that the memorial had been put up to mark an old center of Jewish culture in Berlin. Koppenplatz is in the heart of what used to be the Spandauer Vorstadt. This part of town was referred to as Toleranzviertel, "Tolerance Quarter," and was the center of Berlin's thriving Jewish culture in the nineteenth and early twentieth centuries. Seeing the memorial in the context of the restoration of the New Synagogue in nearby Oranienburger Straße and the recent establishment of Jewish businesses in the area, it could also be understood as testimony to a revival of Jewish culture in what is now the borough of Mitte. The dedication ceremony may have conveyed a similar impression: it was a Jewish rather than a civic occasion. A growing and increasingly self-confident Jewish community appeared to be publicly acknowledging its predecessors, its history, and the rupture caused by the Shoah.

I am particularly concerned with discursive contexts that are not apparent to the passing visitor. Every memorial has its own history. Some of these histories are complex and contradictory. They often stretch over many years, but rarely leave easily discernible traces. In fact, these histories seem prone to a collective amnesia. Who still remembers the origins of *Der verlassene Raum* at Koppenplatz? In late 1988, the (East) Berlin local government invited entries for a competition to design a memorial "in honor of the contributions of Berlin's Jewish citizens, in memory of their persecution, and in honor of their resistance."[3] In the second half of the 1980s the government of the German Democratic Republic (GDR) was finally acknowledging the persecution of Jews between 1933 and 1945. The government's interest was due partly to expectations that a reappraisal of the Nazi past could lead to a reformulation of the relationship between the GDR and the United States of America. That the project was initiated by the government rather than by East Germany's Jewish community is confirmed by the fact that the memorial was initially to be located on the site of a former Jewish cemetery in Große Hamburger Straße.

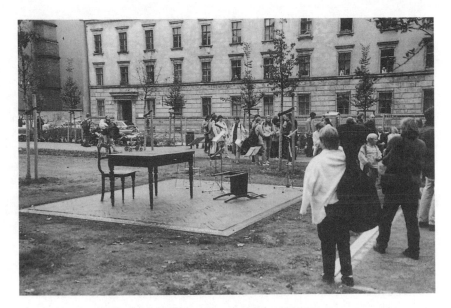

Fig. 1. Waiting for a dedication ceremony at Koppenplatz, Berlin, on 26 September 1996. The memorial *Der verlassene Raum* is by Karl Biedermann.

"To be forgotten means to have died for ever," wrote Biedermann and landscape architect Eva Butzmann in their submission. They suggested a memorial, designed by Biedermann, to be integrated into a small park, designed by Butzmann. Contrary to the government's expectations of this and similar initiatives, Biedermann and Butzmann did not mark the memorial as a conspicuous symbol of Jewishness that could be shown off to official visitors from the United States. The artists did not mention the term *Widerstand,* resistance, that was so crucial to East German public discourses about the Nazi past. Unlike so many East German memorial artists on previous occasions, Biedermann did not envisage an uplifting sculpture, depicting defiance and survival. "The pieces of old-fashioned furniture," Biedermann and Butzmann explained, "are to point to *irretrievable* losses that occurred because a large group of people, their way of life and their culture, are missing."[4]

By 31 May 1989, seventy-four individuals and collectives had submitted proposals and models. Biedermann and Butzmann were awarded the first prize, and the (East) Berlin local government decided to realize their project. From 16 October 1989, while people in Leipzig and other East German cities took to the streets to call for more democracy, the entries were publicly exhibited at East Berlin's Humboldt University. One news-

paper commented that Biedermann's was "the most poetic" of the proposals.[5] The media coverage and the public exhibition of entries other than those awarded prizes revealed how far East Germany's political culture had changed in the previous months.

Utilizing their newly granted freedom of speech, from March 1990 some of the people living around Koppenplatz objected to the projected memorial. A few argued that the square had nothing to do with Jewish history, others that the memorial was too small and would be easily overlooked.[6] These objections did not occasion a reversal of the 1989 decision to fund the sculpture but may have contributed to the reticence displayed by the authorities that dealt with the square's refurbishment after the reunification of Berlin. In 1994, Biedermann withdrew from the project when he discovered that revised plans provided for a dogs' toilet next to the memorial. That *Der verlassene Raum* was eventually put up in 1996 (and the dogs' toilet located elsewhere) was also due to interventions by local organizations and individuals that had long been committed to the memorialization of the Shoah.

The above brief account is a locally specific history. But a close look at the history of the Biedermann memorial could make it reflect, and thus could shed light on, broader developments. The following eleven chapters constitute such scrutiny of local histories. My examples are to illuminate key aspects of the memorialization of the Nazi past in Germany, even though they do not and cannot embrace the variety of "German" public memories.

Glancing at Memorials

I was early for an interview with the initiator of an impressive monument in memory of a Hildesheim synagogue that was destroyed in the 1938 Kristallnacht pogrom. Rather than wait in his office, I wandered around the small park in front of the building. I took in a large granite cube that I had never paid any attention to in the many years that I had lived in the town. Copper plates depicting various motifs, such as a woman or a soldier, were affixed to the sides of the cube. They carried three inscriptions: *Wir mahnen* (We remind you/admonish), *Memento,* and *Misericordia.* My interlocutor, when later asked about the memorial a few meters from his office, also admitted never having paid much notice to it and not knowing what it was about. "[M]onuments are so conspicuously inconspicuous," Robert Musil commented when contemplating similar experiences.

> There is nothing in this world as invisible as a monument. They are no doubt erected to be seen—indeed, to attract attention. But at the same time they are impregnated with something that repels attention,

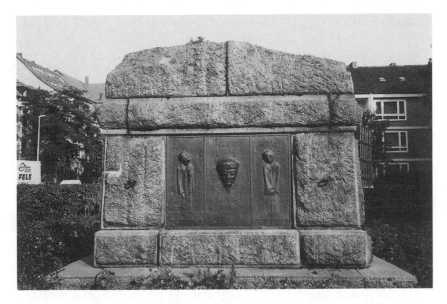

Fig. 2. Conspicuously inconspicuous: Karl von Dornick's *Mahnmal des stillen Gedenkens* (Memorial of quiet remembrance) of 1955, Hildesheim. (Photograph by D. Neumann.)

causing the glance to roll right off, like water droplets off an oilcloth, without even pausing for a moment.[7]

Some of the more recent artistic attempts at remembering the Nazi past in Germany do not appear to be "erected to be seen"—at least not as memorials. *Der Verlassene Raum,* after all, looks from afar like nothing more than a table and two chairs. From a distance, there are no signifiers that point to its function as a memorial. In Saarbrücken, artist Jochen Gerz and a group of students inscribed 2,146 cobblestones in front of the palace with the names of Jewish cemeteries in Germany. They then put the stones back with the inscribed side facing down. Those now crossing the open space in front of the palace cannot know which of the 8,000 stones used to pave the square have an inscription.[8]

Like Musil, I am intrigued by the often seemingly ineffectual nature of material manifestations of public memory. I am fascinated by attempts to challenge the "impregnation" of a monument by defacing it, and by responses to such challenges. Musil would have been amused to know that these days many German memorials are chemically impregnated to protect them against desecration. Gerz's Saarbrücken memorial, of course, appears to be defacement-proof.[9] "Down with fascism! Socialism

triumphs!" unknown graffiti artists spray-painted in May 1977 on a war memorial in front of the Celle palace. They were apparently protesting against a meeting in Celle of the state's National Democratic Party, a formation of the extreme right that was particularly successful in the late 1960s and early 1970s. "After staff of the Department of Civil Engineering had unsuccessfully tried to remove the writing," the local newspaper reported, "the memorial was covered by the national flag."[10] Delegates to the party meeting laid a wreath at the memorial, and later police removed the flag to unveil once more the graffiti.

Notwithstanding the aptness of Musil's observation, as public objects memorials occasionally make observers stumble, as it were. They can provoke thoughts related to their subject matter: people walking across the square in front of the Saarbrücken palace may, for example, contemplate the invisibility of Jewish cemeteries. Memorials can entice passers-by to remember. If a memorial is noticed, it is often the subject of contest, that is, of attempts to redefine its place in the public sphere (by, for instance, daubing it with paint, or draping a flag over it). Such interventions may then spark acts of recognition.[11] In the case of Celle's war memorial, readers of the 1977 newspaper article could have been provoked to remember how the legacy of the Nazi years had been officially dealt with in postwar Celle.

Shifting Memories is concerned with public memories, and with public controversies about instances of memorialization. It is concerned with discourses about the intended or visible public effects of memorials rather than with their actual effects on individuals. But while some memorials may attract more attention than others, it is important to keep in mind that there is no automatism involved. Whether or not in May 1977 Celle residents contemplated the possible meaning of the West German flag covering their war memorial is beyond the scope of this study, but it cannot be beyond my interest. Public memories become effective to the extent that people engage with their subject matter. In the narratives told in this book I am taking for granted that agency and responsibility for such engagements rest in the final instance with private individuals.

The Past in the Present

I am interested in one (intended) effect in particular, namely the extent to which memorials provoke communities to remember. To be more precise, I am interested in whether and how collectives and individuals publicly engage with or face the past. In his Paris exile, Walter Benjamin wrote an article about the collector Eduard Fuchs in which he postulated that the "work of the past" should not be regarded "as over and done with."[12] Max Horkheimer, the editor of the journal *Zeitschrift für Sozialforschung,*

where the Fuchs paper was to be published, reproached Benjamin for toying with an idealistic and theological concept. "Past injustice has occurred and is done with [*abgeschlossen*]," Horkheimer maintained;[13] if one denied such closure, then one would have to believe in the Last Judgment. Benjamin took Horkheimer's objections seriously. The "Theses on the Philosophy of History," drafted after the exchange with Horkheimer, read like a response to his rebuke. They reaffirm and elaborate Benjamin's previous statement about the rejection of closure.

The ninth thesis is a cryptic reading of a painting by Paul Klee that since 1921 had been in Benjamin's possession:

> A Klee painting named "Angelus Novus" shows an angel looking as though he is about to move away from something he is fixedly contemplating. His eyes are staring, his mouth is open, his wings are spread. This is how one pictures the angel of history. His face is turned towards the past. Where we perceive a chain of events, he sees one single catastrophe which keeps piling wreckage upon wreckage and hurls it in front of his feet. The angel would like to stay, awaken the dead, and make whole what has been smashed. But a storm is blowing from Paradise; it has got caught in his wings with such violence that the angel can no longer close them. The storm irresistibly propels him into the future to which his back is turned, while the pile of debris before him grows skyward. This storm is what we call progress.[14]

The angel of history is unable to redeem the past. He is trying to withstand the storm blowing from Paradise but is driven away from the past, toward the future. The angel of the painting is suspended in midair. He has no ground to stand on, which makes more hopeless his attempts to move close enough to the past to be able to intervene in it.

The angel's choice between turning his back to the past and turning his back an amply signposted future is akin to the choice between remembering and historicizing the past, that is: between recalling or conjuring the past in(to) the present, and turning it into one among other histories safely removed from that present. This is no easy choice. A strong argument could be made against remembering, or rather, against the debilitating effects of the compulsion to remember everything.[15] In fact, the assumption that individuals and societies need to remember is often accepted uncritically in debates about the memorialization of Nazi crimes in Germany. Those who admonish Germans today not to forget seem often to assume that what needs to be remembered is self-evident, as if a memory was like a specific text, with a beginning and an ending and a never-changing string of words. But a memory is never just there

already—as if only temporarily in storage. It needs to be invoked, conjured, made.

Different pasts require different choices. These choices are different for each individual. They are dependent on, as well as constitutive of, his or her identity. Today's Germans can choose to remember the Nazi past. In making their choice, they are guided and compelled by readings of the past and present that circulate in the public arena. They are rarely aware of the choices they make. But they are not merely variables in a sociological equation. In the last instance, they speak for themselves, however much they reproduce dominant discourses. So did, of course, the German voters in January 1933.

German public discourses about the Nazi past are often about whether or not, and how, *others* ought to remember. But in the last instance, the choice to remember is a moral decision that can only be made by each individual herself or himself. *Shifting Memories* is therefore not attempting to identify a *correct* approach to the past (as if there ever was one!). The book is nevertheless informed by my own inadequate attempts at making a choice. The historian cannot pretend to be Benjamin's angel, even though, for Benjamin at least, there may not have been any alternative to the angel's posture. But as a historian, I feel compelled to conjure the past in the present rather than divorce the past from the present, and to scrutinize the past in order to recognize the present and glimpse the future. This future—unlike the chimera beckoning on the horizon of Progress—does not reveal itself if one turns one's back to the past.

Key Words

In the introduction to a book he wrote in 1977, the social theorist Peter Brückner grappled with issues of terminology. How could he refer to the entity he was analyzing? As *Deutschland* (Germany)? *Westdeutschland* (West Germany)? *BRD* (FRG)? Or by its full name: *Bundesrepublik Deutschland* (Federal Republic of Germany)? His choice, he realized, would imply a particular political stance.[16] In the mid-1970s, the term *BRD,* for example, signaled dissidence, and was, as I was told in my last year of high school, strictly to be avoided in the final exams. Whereas Brückner's German readers could have been aware of the implications of his choice of terms, he would have needed to spell out those implications for an audience outside Germany. In the following, I try to convey something of the connotations that the key words in *Shifting Memories* have had for German audiences to allow my English-speaking readers to appreciate the implicit meaning of statements that I translated from the German language.

Merely by identifying the period from 1933 to 1945, Germans often

indicate how they approach that part of their nation's past. A preference of the term *Faschismus* (fascism) over *Nationalsozialimus* (National Socialism) or *Drittes Reich* (Third Reich) is likely to betray the speaker's allegiance to an analysis once favored in the GDR; in the old (that is, pre-1990) FRG, this preference suggested that the speaker belonged to the Left.[17] By referring to *Nazi Germany* and the *Nazi past* in the following, I also aim to distinguish my commentary from the German discourses that I write about.

In the 1950s, the horror committed in the name of Nazi Germany remained largely nameless.[18] It was not until the Auschwitz trial in the early 1960s that it acquired a widely accepted name, at least in the FRG: for nearly twenty years, Auschwitz became the most common metaphor for that horror. Then, Auschwitz was associated with the persecution of Jews. Only in the 1990s did Auschwitz become a word that also signifies the murder of Sinti and Roma. The term *Holocaust,* in use in the English-speaking world since the late 1950s, was made familiar in Germany through the television series of the same name that was broadcast in Germany in early 1979. The term *Shoah,* which appeared frequently in German public discourse in the 1990s, is similarly associated with Claude Lanzmann's film *Shoah.* When I use *Shoah* in the following, it is to refer specifically to the Jewish genocide; whereas I use the metaphor of "Auschwitz" to denote the totality of the Nazi crimes.

The Nazis classified their victims. In concentration camps, prisoners were made to wear differently colored triangles: red for political prisoners, pink for homosexuals, green for so-called professional criminals, and so on. These classifications were unproblematically reproduced in postwar writings. In the first three decades after Liberation, even survivors often did not pay attention to their origins.[19] When referring to the victims of Nazi Germany, it is, however, sometimes unavoidable to draw on these classifications—to point out, for example, that prisoners with black triangles (persecuted on account of being considered social deviants, *Asoziale,* by the Nazis) were ignored both in East German accounts, which privileged political prisoners, and in West German histories in which the generic victims were Jewish.[20]

The Nuremberg Laws made Jews of people who did themselves not identify as Jews or who were not recognized as such by Jewish communities. Inevitably, there are occasions in this book when the term Jews refers to those who were persecuted as Jews. So-called *Zigeuner* (Gypsies) were also persecuted on account of their "race." The term *Zigeuner* makes no distinction between the Sinti, who have lived in Germany for centuries, and the Roma, who were mainly from southeastern Europe. In Germany, members of these ethnic groups are now identifying either as Sinti or as Roma, and I follow this distinction.

When referring to victims, Germans use the word *Opfer*. This noun also means "sacrifice," and the overtones of the word's second meaning may be conjured even if the speaker ostensibly only uses *Opfer* in the sense of "victims." Until recently, Germans used *Opfer* (or *Verfolgte*, persecutees) also when referring to survivors. When referring to Nazi perpetrators, Germans usually employ the nonspecific term *Täter*, which could refer to a petty thief as much as to a murderer. But the authors of Nazi crimes are also frequently depersonalized by means of terms such as *nationalsozialistische Gewaltherrschaft* (National Socialist tyranny), or made to disappear through the speaker's use of the passive voice.

I use some terms in the German original, because they cannot be adequately translated. The most crucial of these is the noun *Vergangenheitsbewältigung*, "coming to terms with the past" or "mastering the past."[21] The notion of *Vergangenheitsbewältigung* presupposes a deficiency that can be overcome. It has often been invoked by Germans intent on pointing out such deficiencies in the approaches of others, or of their own nation, excluding themselves. West Germans most acutely felt the need to "master the past" between the second half of the 1940s and the second half of the 1980s. In the 1990s, *Vergangenheitsbewältigung* as a laborious chore was often contrasted with *Betroffenheit* as a spontaneous response. *Betroffenheit*, perhaps best rendered as "dismay" or "consternation," denotes an emotional reaction to the Nazi past that accepts guilt rather than responsibility—that stands in awe of rather than engages with the past, and that encourages a listening to the respondent's own heartbeat rather than to the voices of survivors.[22]

The term *Mahnmal* is a composite of the verb *mahnen*, "to admonish," "to warn," or "to remind," and the noun *Mal*, "sign" or "mark." In contrast to a *Denkmal*, which is to function merely as a reminder of a past, or an *Ehrenmal*, which honors somebody or something from the past, a *Mahnmal* is a critical statement about the past. It is to serve as an admonition—lest the past recur in the future. The term *Mahnmal* is a product of the twentieth century and has been used most often to designate memorials that are ostensibly warning present and future generations not to allow the horrors of the Nazi years to repeat themselves. All three terms reflect how particular memorials are, or are meant to be, publicly perceived, rather than any innate qualities.

Most Germans would refer to the Koppenplatz memorial as a *Mahnmal*. The copper-plated granite cube in Hildesheim that I mentioned earlier is to remember the dead of World War II and was also conceived as a *Mahnmal* when dedicated in 1955. Earlier, and at the same site, the block of granite on its own had served as the pedestal for a *Denkmal*, an equestrian statue of Emperor Wilhelm I. The statue was unceremoniously

melted down in World War II. The war memorial in front of the Celle palace, on the other hand, is considered an *Ehrenmal.*

The verb *gedenken* means "to commemorate" or "to remember." A *Gedenkstätte* is a kind of extended *Denkmal.* The term could refer to a larger landscaped complex with several different monuments. In most cases, a *Gedenkstätte* includes the display of information, or a museum. The term *Gedenkstätte* also refers to the institution administering a memorial complex. The most prominent *Gedenkstätten* in today's Germany are those at the sites of former concentration camps, such as Dachau or Buchenwald, and sites associated with resistance and/or persecution, such as the Plötzensee prison in Berlin, where many of those accused of conspiring to assassinate Hitler on 20 July 1944 were executed. Unlike other memorials in what once was the GDR, the memorial at the former site of the Ravensbrück Concentration Camp has retained its original name and is still referred to as *Mahn- und Gedenkstätte,* as a place and institution that is to act as a reminder as well as a site of memory. A *Dokumentationsstätte* or *Dokumentationszentrum,* finally, is a memorial museum that places great emphasis on educating visitors—often about aspects of the past that supposedly received little attention previously.

Hannah Arendt, among others, has drawn attention to the inertia of language, that is, to the fact that the past appears in language as a residue.[23] This inertia has been evident in postwar Germany, when a whole way of talking and conceptualizing reality—what Victor Klemperer in a remarkable 1947 study called *LTI, Lingua Tertii Imperii,* the language of the Third Reich—was preserved beyond its official use-by date.[24] Somebody using a term associated with Nazi ideology and practices, such as *Volksgemeinschaft* (national community), after 1945 did not thereby deliberately condone Nazi practices. But such unconscious usage in the 1950s is not only an indication of how little the speaker was prepared to reflect on the past that had produced this term, but also suggests that aspects of Nazi Germany survived well beyond 8 May 1945, and that traces of "Auschwitz" had a postwar afterlife.

Writing about Auschwitz

Many histories of "Auschwitz" are predicated on a space, inhabited by the writer and his or her audience, that lies beyond "Auschwitz"—even, or perhaps especially, when he/she denounces the impending recurrence of what he/she identifies as precursors or portents of "Auschwitz." I am trying not to take for granted that safe space, which has supposedly been excised and quarantined from the historian's subject matter—the comfort zone for the writer and the audience alike. But engaging with the issue of

"Auschwitz" in the context of postwar Germany, I am often unsettled by the pervasiveness of the traces of "Auschwitz" and wish not only for a different past, but also for the possibility of a different history.

I am addressing the issue of "Auschwitz" by writing about its memorialization in the present. The engagement with the past's presence in the present that I am attempting here is to constitute an act of remembering as much as a critique of memory. The former also requires that I present my own account of what has become the subject of public memorialization. I am therefore also writing about various concentration camps, about medical experiments involving Jewish children, about the 1938 Kristallnacht pogrom, and about the killing of prisoners in the last days of World War II.

The critique of memory is sometimes implicit rather than explicit: "I need say nothing. Only show."[25] *Shifting Memories* makes extensive use of quotations, here too paying homage to Walter Benjamin, who wrote in *One-Way Street:* "Quotations in my work are like wayside robbers who leap out armed and relieve the stroller of his conviction."[26] A radio feature by Regina Scheer about the Koppenplatz memorial quoted a woman living in the area:

> A friend of mine once came to visit. She said, "Hey, that is some nice table over there. I'll take it home." Well, she must have thought it was an old table that somebody left there. She came in the evening, so did not recognize it as a memorial.[27]

The woman's friend may not have remembered the deportation of Berlin's Jews, but Scheer probably recognized the past in the woman's reaction to the Koppenplatz memorial and quoted her to make the listeners draw connections and remember. Scheer did not comment on what the woman said. Scheer's audience may or may not have remembered that many non-Jewish citizens, while not directly involved in the murder of Jews, coveted their possessions. Both the quotations and the illustrations in *Shifting Memories* are likewise intended to engage the readers, and to entice them to engage with the past.

This book is not written with a handful of specialist readers in mind but rather for an English-speaking audience interested in contemporary Germany. It tells stories—for example, about a one-million-mark memorial project that was never realized, or about public reactions to the desecration of Jewish graves, or about the choice between naming a street after Snow White or after a victim of the Shoah—that in themselves function like quotations. These are to surprise the readers, capture their attention, and encourage them to comment. They are intended to be unpretentious. They are not intended to be atheoretical. But theory, too, does not always need to be spelled out.

Germany

The literature that analyzes, contextualizes, and critiques German public and social memories of the Nazi past is vast.[28] But nearly all of the relevant English-language scholarship is concerned with national discourses; localized case studies are mostly used to illustrate arguments dealing with the FRG or the GDR as a whole.[29] *Shifting Memories* does not attempt to provide a comprehensive overview of the way Germans have dealt with the Nazi past since 1945. Neither does the book focus on nationwide discussions such as the four debates about the statute of limitations between 1960 and 1979; the historians' controversy in the 1980s; the ruminations about a projected German "Holocaust Museum" and about a central memorial for the victims of the Shoah in Berlin (which are ongoing as I am writing this); the debates about the so-called *Wehrmachtsausstellung* depicting crimes committed by the German army between 1941 and 1944; or the discussions about the "dual" legacies of German fascism and East German Stalinism.

The narratives I tell in the following feature places in only five of the sixteen German states: Lower Saxony (Niedersachsen), Hamburg and Hessen in West Germany, and Brandenburg and Thüringen in East Germany, and for that reason alone my case studies can hardly be representative. I am discarding an analysis that assumes that memories in Germany could be subsumed under the label of "German memories," in favor of one that pays attention to their specificity. This is nevertheless a book about "German" approaches to the Nazi past—and here *German* is as loaded and problematic a term as *Jewish*,[30] depending on who uses it and where it is used—rather than, say, one about the perspectives of Jews in Germany, although the former could hardly be viewed in isolation from the latter.

The first three chapters are concerned with towns in central and southeastern Lower Saxony. Chapter 1 analyzes how Salzgitter's origins as a city to serve an iron- and steelworks established in the late 1930s were publicly remembered after 1945, and recounts how the local past and identity have been depicted in official discourses. It tells the history of a *Gedenkstätte* at Drütte, which opened in 1993 at the former site of a satellite of Neuengamme Concentration Camp inside the iron- and steelworks. The second chapter picks up the story of prisoners of Drütte who in April 1945 ended up in the town of Celle. The chapter explores the legacy of the so-called *Hasenjagd,* the hunting down and murder of these prisoners, by Celle residents. I discuss the pitiless narratives of residents of the district of Celle, who—in interviews recorded in the first few years after the war— gave their views on forced laborers and concentration camp prisoners. I also tell the history of a memorial, a *Mahnmal* for the victims of the *Hasenjagd* that was unveiled in 1992. Finally, I contrast the approach to the *Hasenjagd* with local attempts to remember the town's Jewish past.

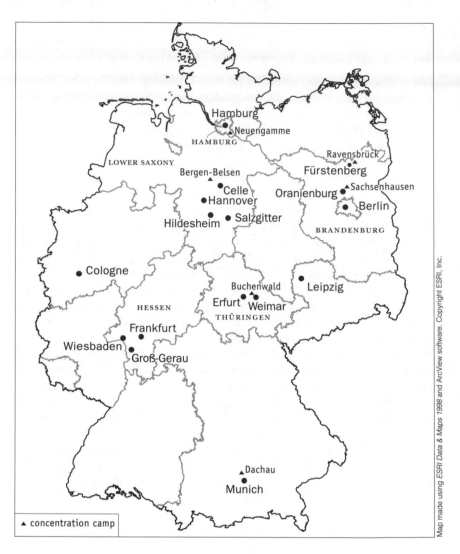

Fig. 3. Federal Republic of Germany

An investigation of efforts by the city of Hildesheim to commemorate the destruction of the local synagogue on the night of 10 November 1938 is central to chapter 3. I recount the genealogy of a memorial put up in 1988 at the former site of the synagogue. Hildesheim's rediscovery of the persecution of the local Jewish population coincided with the rebuilding of a famous half-timbered house that was destroyed in World War II. By juxtaposing an account of official *Vergangenheitsbewältigung* with one about the reconstruction of the town's architectural heritage, I suggest how much local discourses about the Nazi past are linked to other public discussions about the town's image. The fourth chapter puts the previous chapters into perspective by showing how the discourses of non-Jewish Germans can be dependent on what survivors say. Discussing the impact Jewish, Italian, and Sinti survivors had in postwar Hildesheim, I expand the story begun in the previous chapter. I also introduce a fourth West German town, Wiesbaden, the first German city that funded a monument to commemorate the Sinti genocide.

The fifth chapter shifts the focus to antifascist German discourses. I analyze tenets of official GDR antifascism and the way the persecution of Jews featured in public discourse in East Germany both before and after 1989. After providing a brief historical overview of public remembrance in East Germany, I discuss two case studies: the desecration of Jewish graves in Salzgitter in 1957, and the 1992 arson attack on the so-called Jewish barracks of the Sachsenhausen concentration camp memorial in East Germany.

Chapters 6 and 7 continue to explore the contours of antifascist remembrance. The sixth chapter is an account of the various forms in which the murder of twenty Jewish children in Hamburg has been memorialized, and asks how the biography of one of the murderers has featured in these memorializations. In chapter 7, I investigate the posthumous reputation—in the GDR, the old FRG, and the new Germany—of a German Communist imprisoned in Buchenwald and credited with having saved the lives of Jewish children.

The legacies of two concentration camps in East Germany are the subject of chapters 8 and 9. Chapter 8 is particularly concerned with the relationship between Weimar and Buchenwald, and with the way the two places have been perceived as opposite poles of German history. In chapter 9, I trace the history of the so-called supermarket scandal that resulted from the post-Reunification aspirations of Fürstenberg residents to go shopping at a site that once belonged to Ravensbrück Concentration Camp.

The tenth chapter is concerned with public discourses about the Nazi past in the city of Wiesbaden and, in particular, with a 1986 decision by the local city council to erect a memorial in honor of all victims of Nazi rule

"and particularly in honor of those who resisted." I explore the context of the decision and of the failure to implement it. I contrast the council's decision with more specific forms of remembrance, paying particular attention to how the destruction of one of Wiesbaden's synagogues in 1938 has been memorialized. Finally, I present an alternative to the council's projected all-encompassing memorial, which the architect Heinrich Lessing and I proposed in 1998.

The final chapter adds to the history told in chapter 6. It looks at the naming of streets in a Hamburg suburb after the murdered Jewish children and pays particular attention to how individual residents living in these streets relate to this form of memorialization. The chapter emphasizes the role individual memories play in shaping public memories, and argues that in the last instance the issue of remembering the Nazi past in Germany is one of individual responsibility.

The stories told in *Shifting Memories* intersect. But they do not easily slot into an overarching narrative. Individual chapters could be read on their own, in tandem (chapters 1 and 2, 3 and 4, 6 and 7, 8 and 9), or in conjunction with the readings suggested in the select bibliography. The selection of case studies was guided by my intention to tell intersecting stories and to perform a mixture of narratives—those in chapters 6 and 10 being more personal than others, for example—and to present a variety of cases. The book features the chic and affluent capital city of Wiesbaden and the desperately poor country town of Fürstenberg; the comparatively new industrial city of Salzgitter and Celle, venerable center of a large rural district; the reputedly liberal Hamburg, Weimar with its reputation of a cosmopolitan past, and the parochial Hildesheim. I do not contrast more with less appropriate ways of remembering "Auschwitz." Neither do I identify a clear pattern. While it makes sense to contrast the old FRG with the GDR, it is less fruitful to compare Catholic with Protestant areas, or cities with rural settings. The reluctance of Protestant and SPD-governed Hamburg to acknowledge its Nazi past was hardly less pronounced than the unwillingness of Catholic and deeply conservative Dachau to take note of the local concentration camp.[31]

The cases depicted in this book feature different periods in postwar Germany. But nearly all of them reach into the 1990s. This is also a book about the new Germany and about its Nazi and postwar legacies. With Reunification, Germany—or rather, German understandings of Germany (in the past and present)—changed. Many Germans now expected to have finally done away with what they considered to have been a forty-five-year-long provisional and irregular state of affairs. They expected that their country ought now to be recognized as just any other; that they were entitled to openly display patriotic, if not nationalistic sentiments; and that they could now comprehensively acknowledge and tell the German past as the nation's history without having to feel embarrassed.

The Germany of the 1990s appeared to be as removed from the old FRG where once the Nazi years were hardly mentioned and former Nazis could become cabinet ministers, as from the GDR where once the Shoah was considered of only peripheral interest. In the late 1990s, school curricula emphasized the importance of the Nazi period for an understanding of present-day Germany and prescribed an extensive engagement with that past. History museums, be they national, regional, or local, were more likely than not to deal extensively with the Nazi years. Dozens of monographs documented the persecution of Jews in particular towns or regions. Most large cities and many small towns now had conspicuous memorials commemorating the victims of Nazi Germany.[32] (These changes did of course not come overnight: a more inclusive understanding of Nazi crimes in the GDR, as well as a keen interest in "Auschwitz" in the wake of the screening of the television series *Holocaust* and a host of new commemorative sites and practices in the old FRG, preceded the flurry of memorial activities in the 1990s.)

The new Germany, many of its citizens claimed in the 1990s, had reached maturity. According to such an interpretation of the postwar period, the silence about the genocide of Sinti and Roma, to give but one example, could be brushed aside as part of the nation's teething troubles. When recounting the histories of local memorials in the eleven chapters that follow, I try to show that instances of postwar remembrance cannot be accommodated in a linear narrative of growing up. And if the issue is not whether or not a history is made of the past but to what extent the past is allowed to intrude into the present, then the ubiquity of memorials as such does not prove anything. There may be structural affinities between the indifference documented by this book's cover image (which shows a "spring excursion" of Weimar residents to Buchenwald five days after Liberation), and the *Betroffenheit* of the 1990s, evidenced by a myriad of memorial projects (and by the well-meaning chatter accompanying their realization).

The key word of late 1990s Germany was *Normalität,* normality. Many Germans were hoping that with Reunification *Normalität*—which had been conjured throughout the 1980s, at least in West Germany[33]— had finally "arrived." They used the verb that otherwise describes the arrival of seasons, *Einzug halten,* as if only a prolonged period of irregular weather had delayed what was coming naturally. That the arrival of *Normalität*—even if taken to be something only in the eye of the (German) beholder—did not happen smoothly, was seemingly the result of an altogether unnatural phenomenon: a past that was some fifty years removed from the present had not faded—as if the irretrievability of the losses to which Biedermann and Butzmann referred in their submission stood in the way of declaring the past to be "over and done with."

CHAPTER 1

Salzgitter: A City Coming of Age

Most of the images in the coffee-table book published in 1992 by the city of Salzgitter are predictable. Photographic essays by young West German photographer Andreas Baier are on topics such as "The City and the Landscape," "Civic Festivities," "Industry and Labor," and "Sport and Leisure." The first of ten essays, however, has few if any equivalents in similar books published about other West German cities. Titled "Kranzniederlegung" (Laying of Wreaths), it depicts the unveiling of a memorial commemorating the suffering of prisoners at Watenstedt/Leinde, one of three local satellites of Neuengamme Concentration Camp. Most of the people in the black-and-white photographs are elderly men and women; two carry flags. The largest of nine images shows an old man taking a picture of a memorial plaque. He could be a survivor of the camp. His entire attention is focused, through the lens of his camera, on the memorial—and, presumably, on the experiences that it commemorates.

The photographs are not captioned. The book opens with a substantial introduction, in German, English, and French, by the West German novelist Wolfgang Bittner, and ten short statements signaling the themes of the photographic essays. The paragraph introducing "Kranzniederlegung" reads, in the English version:

Acknowledging the History of the City

Salzgitter acknowledge [*sic*] itself to be a city founded by National Socialism. The pictures of the dedication of the memorial tablet to the inmates and victims [*sic*] of the former Drütte-Leinde [*sic*] concentration camp, a branch of Neuengamme concentration camp, is [*sic*] only one indication of that fact. Further sobering reminders are the memorial cemeteries of Jammertal and Westerholz, where some 4000 dead slave labourers are buried.[1]

Reichswerke "Hermann Göring"

Salzgitter's foundations were laid in 1937 when the German government decided to underwrite the construction of an iron- and steelworks to utilize the very substantial local iron ore deposits.[2] Previously there had been few systematic and sustained attempts to exploit the Salzgitter ore, which cannot be easily processed because of its high level of silicic acid.[3] A strong interest in the Salzgitter deposits in the mid-nineteenth century, which saw the establishment of new mines and of several smelters, was short-lived, not least because the German iron- and steelworks in the Ruhr Valley could draw on cheaper and superior ore once Lorraine had fallen to Germany after the Franco-Prussian War of 1870–71. Nazi Germany's striving for autarky, coupled with the invention of a new method of smelting acidic ore in the early 1930s, led to a reassessment of the Salzgitter option.

The driving force behind the large-scale exploitation of the Salzgitter ore, and the establishment of a steelworks near the deposits, was Paul Pleiger, a businessman and adviser of Hermann Göring. With Göring's backing, and against the expressed wishes of the leaders of the steel industry in the Ruhr Valley (who preferred to use ore imported from Sweden), Pleiger set up a corporation, Reichswerke "Hermann Göring," with himself as its managing director and Göring as its chairman, in July 1937.[4] The state held the majority of shares. As its trademark the company chose a ring held by a square block sitting on a rectangular base. The logo made an unmistakable reference to Göring's coat of arms: a stylized fist holding the "Gö" ring.

By early 1938 the construction of the Salzgitter steelworks was well advanced. What had been a comparatively affluent rural area with twenty thousand people living in some thirty villages was transformed into a huge industrial site. Farmers living on the land that was taken up by the plant were expropriated and resettled—some as far as West Prussia. New roads, railways, and a canal were built. Workers from all over Germany were recruited to work for the Reichswerke. In October 1939, the Reichswerke commenced the production of pig iron in one of the new blast furnaces designed to exploit acidic ore. In August 1940, the Salzgitter plant produced its first steel. In March 1940, the Reichswerke began with the construction of a large metalworking factory, Stahlwerke Braunschweig, near the steelworks. It soon became one of the largest German arms producers. By mid-1941, Stahlwerke Braunschweig employed about ten thousand workers.[5]

In 1937 there were still about 900,000 registered unemployed in Germany. By November 1938, the number of unemployed had dropped to 152,430; by then the German economy already required an additional one

million workers.[6] The scarcity of labor became even more acute during the war because large numbers of men were withdrawn from the domestic labor market while the demand for labor increased as the German army required more and more arms. The construction of the Reichswerke steelworks and the building of houses for its workers in Salzgitter were given high priority; but even before the war, the number of Germans who could be recruited or conscripted to work in Salzgitter was insufficient to satisfy the needs of the Reichswerke. Before September 1939, workers were also recruited in Austria, Italy, the Netherlands, and, to a lesser extent, other European countries. During World War II, the Reichswerke employed large numbers of workers from countries occupied by the German army.

Up to about forty-seven thousand non-Germans at a time worked in the Salzgitter area, nearly all of them in the mines, iron- and steelworks and metalworking plants that belonged to the Reichswerke, or in the building industry.[7] Between 1940 and 1945, non-Germans made up the majority of the Reichswerke's workforce. The extent to which they were *forced* to labor for the German armament effort, and their living conditions, varied greatly. On one end of the spectrum were the Italians who were in Salzgitter before September 1943: they were volunteers and earned often significantly more than they could have earned at home.[8] On the other end were so-called *Ostarbeiter,* laborers from the Soviet Union who had often been arrested in raids and then deported to Germany. Their pay and rations were well below those of workers from Western Europe. They were not allowed to return home on leave once they were in Germany. They were isolated from the local population, and their camps were enclosed by barbed-wire fences.[9]

Through the influx of workers, the population of the Salzgitter area grew from about twenty thousand in 1937 more than fivefold within five years. On 1 April 1942, the city of Watenstedt-Salzgitter was founded. It comprised the town of Bad Salzgitter (a small spa that had been established around a former salt mine in the fourteenth century and was renamed Salzgitter-Bad), the new settlements around the steelworks, and surrounding villages. After securing access to Swedish iron ore following the occupation of Norway, and to the ore deposits and steelworks in Lorraine after the surrender of France, Germany was no longer dependent on the Salzgitter deposits. It has been argued that it would have been more productive for the German war effort if the labor and amount of steel required to build the steelworks in Salzgitter had been used for the production of arms.[10] Nevertheless, the construction of the steelworks and of the new city continued, albeit not at the pace envisaged in 1937. By the end of the war, twelve of the thirty-two projected blast furnaces were operating, and another four were under construction. With a nominal capital of 2.4 billion marks, about half a million workers, and subsidiaries all over

Europe, the parent company of the Salzgitter plants was by 1944 the largest corporation in Germany, and possibly in the world.[11]

In Salzgitter, the Reichswerke's agenda extended far beyond the production of iron and steel. The company provided its workers with food, housing, and health services and took over functions otherwise performed by the state, thereby becoming a model for Nazi economic and social policy.[12] The Reichswerke's plans for a new city, however, were not realized until after the war. Between 1937 and 1945, the company was not able to build nearly enough houses to accommodate its German employees, let alone others.[13] Some seventy camps housed the majority of the workforce. All non-Germans working for the Reichswerke, be they in Salzgitter voluntarily or against their will, were accommodated in camps; nearly all these camps were equipped with standard barracks.

The Gestapo ran its own camp, Lager 21. Lager 21 was an instrument to discipline the Reichswerke's workers without withdrawing them from the company's workforce. It was designated an *Arbeitserziehungslager,* that is, a camp for men and women who were supposedly unwilling to work. Its inmates included Germans who incurred the wrath of local Nazi dignitaries, Jews who had escaped deportation, and German women who had befriended prisoners of war.[14] Most of the guards were provided by the Reichswerke's security service; the Gestapo also recruited local women to guard the female prisoners. Lager 21 had up to about eighteen hundred inmates at a time; most were imprisoned for periods of between three and eight weeks.

The Reichswerke drew also on the labor of prisoners who were held in three satellites of Neuengamme Concentration Camp (which was some 160 kilometers to the north of Salzgitter, on the southern outskirts of Hamburg): these included a camp in Salzgitter-Bad with mainly Russian, Italian, Greek, and Jewish Polish women (from about September 1944); a camp at Watenstedt/Leinde for women and men (from May 1944); and a camp at Drütte in the grounds of the steelworks.[15] Probably up to about sixty-five hundred prisoners were living in these three camps at any one time.

The Drütte satellite was established on 18 October 1942 to provide labor for the production of antiaircraft ammunition.[16] The Reichswerke leased the prisoners from the SS at a daily rate of six marks per skilled worker, and four marks per unskilled worker. Drütte's first fifty prisoners, whose job it was to build facilities for a larger number of prisoners, came from Buchenwald Concentration Camp; all other inmates came from or via Neuengamme. Drütte had a population of up to three thousand men. The largest contingent comprised men from the Soviet Union, followed by groups of French, Dutch, German, and Czech nationals. The prisoners at Drütte included Jews, most of whom came from Poland.

On 7 April 1945, the prisoners of the three Neuengamme satellites

were moved by train toward destinations in northern Germany (see chap. 2). The inmates of Lager 21 were marched to nearby Helmstedt, where their guards released them. On 10 and 11 April, Salzgitter was liberated by the American army.

Ausländerfriedhöfe, Kriegsgräberstätten, Ehrenfriedhöfe

In the first few years after the establishment of the Reichswerke, many of the non-Germans who died while working for the company, including prisoners of Drütte Concentration Camp and Lager 21, were buried at Westerholz, a newly opened cemetery north of the village of Hallendorf.[17] By mid-1943, the Westerholz cemetery could take no more bodies, and the Reichswerke provided, on a temporary basis, a piece of land south of the village of Engelnstedt, which already carried the fitting name Jammertal ("valley of sorrows"). From July 1943, all those who died—and that often really meant: were murdered—at Lager 21 or in one of the concentration camps, as well as other non-Germans, were buried at Jammertal. Altogether about 670 men died in Drütte, more than 500 men and women lost their lives in the camps in Watenstedt/Leinde and Salzgitter-Bad, and at least 932 prisoners did not survive Lager 21. The victims' names, nationalities, and alleged causes of death are comparatively well documented. Most of the dead were buried by a private funeral director—the company's detailed records survived the war and were later used to establish the number of people buried as well as the location of individual graves.

Soon after the liberation of Salzgitter, the local German authorities closed the Jammertal cemetery. There were some changes to its occupation, however. The French, for example, were repatriated; most of the Dutch were reburied at a cemetery in Hannover. Non-Germans who between 1938 and 1945 had been laid to rest in smaller church-owned cemeteries in Salzgitter were after 1945 reburied at Jammertal, which was generally referred to as *Ausländerfriedhof* (cemetery for foreigners). In 1998, there were 2,974 graves at Jammertal and 857 at Westerholz.

At Jammertal, several memorials commemorate the victims of Nazi Germany.[18] In September 1946, Polish, Yugoslav, and Russian liaison officers attached to the British occupying forces put up a five-meter-high obelisk in memory of all those buried at the cemetery. In May 1948, the Jewish community of nearby Braunschweig erected a memorial to commemorate the 185 Jewish victims buried at Jammertal. In October 1949, French survivors unveiled a memorial for their compatriots. Separate memorials commemorate Polish victims and the dead from the Soviet Union, who made up about a third of those who died in the Salzgitter camps.

In the first twenty-five years after the war, the city of Salzgitter was

solely responsible for the maintenance of the two cemeteries. In the early 1970s, the Volksbund Deutsche Kriegsgräberfürsorge, which since 1919 has looked after the graves of the German war dead in Germany and abroad, assumed responsibility for Jammertal and Westerholz and organized work camps with young people from various European countries to maintain the cemeteries. A 1996 map of Salzgitter still referred to the Jammertal and Westerholz cemeteries as *Kriegsgräberstätten* ("war cemeteries"),[19] whereas in the 1990s the official designation was *Ehrenfriedhöfe* ("cemeteries of honor"). In 1975, the Volksbund, the city of Salzgitter, and the company that superseded the Reichswerke jointly funded a new memorial at Jammertal. Its inscription lists the countries of origin of those buried at Jammertal and proclaims: "On this cemetery rest 2,970 victims of war and terror 1939–1945." A similar memorial was erected at Westerholz, which always attracted less public attention.

The Vereinigung der Verfolgten des Naziregimes (VVN), the Association of Persecutees of the Nazi Regime, took an early interest in the Jammertal cemetery. Established in 1947, the VVN grew out of local committees of former prisoners of the Nazis that had been set up all over Germany within weeks of Liberation.[20] Like these committees, the VVN lobbied the authorities to provide pensions and social services to survivors and represented them in their claims for restitution. The organization also pursued more overtly political aims: it demanded that the Nazi perpetrators be held responsible for their deeds and removed from the public service, and vowed to educate Germans about the crimes committed in the name of Nazi Germany. Initially the VVN represented Germans regardless of their political affiliation. As the VVN was foremost an organization of former political prisoners, and as members of the Communist Party, KPD, were overrepresented among German political prisoners, a comparatively large proportion of the VVN membership comprised Communists. However, their numerical strength was initially not reflected in the composition of the VVN leadership.[21]

With the Cold War setting in, Social Democrats and Christian Democrats set up rival organizations, claiming that the VVN was turning a blind eye to human rights violations in the Soviet zone and uncritically supported the stance taken by the East German Communist leadership. In May 1948, the executive of the Social Democratic Party (SPD) decreed that members of the VVN could not at the same time be members of the SPD. The rationale for this decision, namely that the VVN was dominated by Communists, became a self-fulfilling prophecy. Over the next few years, the VVN indeed became an organization that comprised and was directed mainly by members or sympathizers of the KPD. This process took, however, some time: in 1950 in Lower Saxony, for instance, only twelve of the forty members of the VVN executive were members of the KPD, and nine

others still belonged to the Social Democratic Party.[22] In some West German states the VVN was temporarily banned: in Lower Saxony, a 1951 order to disband the organization was eventually successfully challenged in the courts in 1956.

For the VVN, Jammertal was a symbolically potent site. Initially, the association was not much concerned with the specific histories of that site in particular, or of Salzgitter in general. One of the first events organized by the VVN in Salzgitter was a commemorative ceremony to honor the victims of Nazi Germany. The commemoration focused on two prominent politicians who had been killed in Buchenwald, the Communist Ernst Thälmann, and the Social Democrat Rudolf Breitscheid, rather than on those who died at Drütte or in Lager 21.[23] From the late 1940s, the VVN organized commemorative ceremonies at Jammertal. Its regional office in Hannover usually provided speakers. Sometimes, former concentration camp prisoners addressed the audience, but none of these speakers had been imprisoned in Salzgitter.

Heinz Mannel was born into a working-class family in Bottrop in the heart of the Ruhr Valley.[24] When the Nazis came to power, he was eighteen and had been unemployed for some time. Identifying as a Free Thinker, he joined a group of Socialist and Communist youths who printed and distributed anti-Nazi leaflets. In 1935, he and others from his group were arrested. In 1936, he was sentenced to six years in prison but was soon moved to Esterwege Concentration Camp. From there he was transferred to Fuhlsbüttel Prison in Hamburg. In 1940, Heinz Mannel was released and sent to Salzgitter, where his father was working for the Reichswerke. Because the company was in great need of skilled workers, its workforce included comparatively many political opponents of the Nazis, who found it difficult to gain employment elsewhere in Germany.[25] Soon after his arrival in Salzgitter, however, Heinz Mannel was drafted into Strafbatallion (punishment battalion) 999. After his release from a British POW camp in 1947, he returned to Salzgitter and joined the KPD. He was also one of the founders of the VVN in Lower Saxony. After prolonged periods of unemployment and various short-term jobs, Heinz Mannel found work at the steelworks, succinctly referred to as *die Hütte* (the smelter) by most people in Salzgitter.

Heinz Mannel met his future wife Lotte, who is twelve years his younger, immediately after his return to Salzgitter. Her father had been recruited to work for the Reichswerke, and the family had moved from the Ruhr Valley to Salzgitter-Bad in 1939. Lotte and Heinz Mannel married in 1948. She, too, became politically active on the Left. In 1952, Lotte Mannel and other women demonstrated against price increases for milk. The demonstration was not authorized by the police, and some of its participants were arrested and subsequently prosecuted. Being considered the

women's ringleader, Lotte Mannel was sentenced to ten months in prison. After Lotte and Heinz's children had grown up, Lotte worked for ten years as a bus driver for Salzgitter's public transport corporation.

When I met Lotte and Heinz Mannel in 1997, they did not remember the 1950s and 1960s fondly. Being Communists, they were marginalized. They regularly attended the ceremony organized by the VVN at Jammertal on 11 April, the anniversary of Salzgitter's liberation. After the Social Democrats left the VVN, only a few true believers joined the Mannels. "Sometimes," Lotte Mannel recalled, "we were outnumbered by members of the political police who were sent to spy on us."

Heroic Battles

While in the early 1950s the KPD was a negligible force in Salzgitter, left-wing unionists were powerful. They owed this position not least to Allied policies. Even though the Reichswerke complex had several times been the target of Allied bombing during the war, damage to the plants had been slight. When the Americans occupied the company's Salzgitter offices on 11 April 1945, they ordered that the blast furnaces be shut down. Mines and workshops continued to operate, but the production of pig iron and steel was halted for several years. Over the next six years, the Reichswerke plants in Salzgitter were subject to restitution, dismantling and demilitarization.[26] Restitution meant that machinery the Germans had confiscated elsewhere in Europe was returned to its rightful owners. Dismantling (which began in 1947) meant that components of the steelworks were shipped to Britain and other countries, such as Greece and Yugoslavia, whose inhabitants had suffered at the hands of the Germans during World War II. From April 1949, the remaining furnaces operated again, but the dismantling continued. Vociferous protests by the company, its workforce, and the city of Watenstedt-Salzgitter were to no avail.

The dismantling of the Reichswerke plants had a devastating effect on the town that had been set up to serve the iron- and steelworks. The economic situation in Salzgitter was already bleak because of the large number of German refugees moving to camps vacated by the Reichswerke's former workers. On 31 January 1950, the unemployment rate reached 30.4 percent. Widespread discontent with the established political parties, which either did not oppose the dismantling, or only opposed it in West Germany, resulted in a record protest vote for the far-right Deutsche Reichspartei, which won 23.6 percent of the local vote in the first federal elections on 14 August 1949 (compared to 1.8 percent nationwide).[27] The British military government and later the West German government were, however, more concerned about the prospect of left-wing radicalism. In 1947 the British actually considered resettling unemployed Salzgitter

residents elsewhere to counter what they perceived to be a Communist threat.[28]

Demilitarization effectively meant the demolition of plants that had initially been earmarked for dismantling but could not be shipped. The demilitarization of the steelworks in Salzgitter commenced in February 1950. On 2 March, Reichswerke workers prevented the demolition of one of the coking plants. As German police did not intervene, either on that or on a similar occasion four days later, British troops occupied the steelworks. The situation was tense, and a violent confrontation between British soldiers and Reichswerke workers was narrowly averted. The workers emerged as victors from this standoff, which pitted soldiers in tanks against unarmed steelworkers. The Reichswerke plants in Salzgitter, or what was left of them, were saved, even though dismantling continued for another year, and Salzgitter's economic situation (which led to the declaration of a state of emergency in June 1950) did not substantially improve until a couple of years later.[29]

The saving of the Reichswerke in 1950 provided the material for a local foundational history that was not immediately tainted by National Socialism. "The aura that Salzgitter had lacked emerged from the struggle for the Reichswerke; the struggle against the dismantling also demonstrated the uniqueness of the town," the historian Wolfgang Benz observed.[30] What made a history of this struggle particularly suitable is the fact that in 1950 Salzgitter's residents fought a lonely (and in its retelling: heroic) battle: the support received by the Reichswerke workers and the local branch of the IG Metall metalworkers' union from the German Trade Union Congress, Deutscher Gewerkschaftsbund (DGB), was as lukewarm as that initially rendered to the city by the Adenauer government.

The history of Allied dismantling was suitable in yet another respect. It could be used to recast Salzgitter from being a city where massive crimes had been perpetrated against concentration camp prisoners and non-German workers, to one that had suffered and whose residents could now identify as victims. At a city council meeting on 6 March 1950, at the height of the conflict, Wilhelm Höck, the Christian Democratic mayor of Watenstedt-Salzgitter, said:

> I may say that what is happening with Watenstedt-Salzgitter, is in the last instance worse than the worst National Socialism with its theory of the scorched earth. Whoever does not want to believe this may go to Stahlwerke Braunschweig and see how every square meter has been ploughed up and made for ever infertile and useless.[31]

The most obvious hero of the antidismantling campaign was Erich Söchtig (1905–1980), since 1946 chairman of the *Betriebsrat,* the council

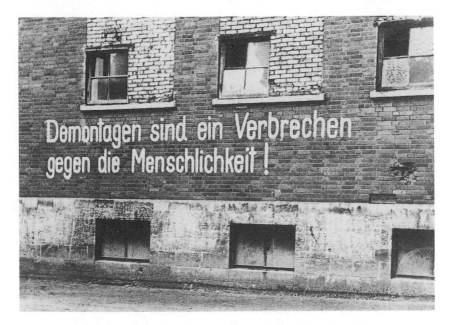

Fig. 4. "Dismantling is a crime against humanity": graffito in Salzgitter, March 1950. (Photograph courtesy of Stadtarchiv Salzgitter.)

representing the Reichswerke workers vis-à-vis the management. He was a former member of the KPD, which he left in 1948 to join the syndicalist Arbeiterpolitik (Arpo) tiokrot. The Arpo saw itself in the tradition of the Kommunistische Partei Opposition (KPO), an anti-Stalinist offshoot of the KPD in the Weimar Republic.[32] Like many other trade unionists in Salzgitter who followed him from the KPD to the Arpo, Söchtig had become increasingly frustrated with the stance of the KPD, which half-heartedly opposed the dismantling in the French, British, and American zones but supported the Potsdam Agreement and the dismantling in the zone administered by the Soviet Union. The Arpo's popularity soared when it led the Reichswerke workers to defy the British authorities.

The issue of dismantling aside, Söchtig and his Arpo colleagues were primarily concerned with bargaining for better working conditions and securing a greater role for workers in the company's decision-making processes. They were less interested in politics that were not directly related to the workplace, and they did not seek to be represented on Salzgitter's city council. Salzgitter's left-wing unionists were, however, committed to commemorating the victims of the Reichswerke. Their commitment was probably made easier by the fact that their own local history

did not reach back to the 1930s.[33] When the Jammertal cemetery was desecrated in April 1957 (see chap. 5), the IG Metall staged a rally at Jammertal that was attended by thousands of young unionists. When in December 1960 the director of the Salzgitter Housing Trust, Gerhard Wiegand, suggested building a *Gedenkstätte* for German refugees and the German dead of World War II at Jammertal, "thereby removing its character as a ghetto cemetery and symbol of an unmastered past [*unbewältigte Vergangenheit*]," the trade unions successfully mobilized public opinion against the proposal.[34]

The "Good Old German Pioneering Spirit"

The vast majority of those working for the Reichswerke from 1937 to 1945 had been non-Germans. After 11 April 1945, the non-German survivors of the various camps in Salzgitter who did not immediately return home became DPs, displaced persons. In fall 1945, the British military administration counted more than thirty-seven thousand DPs, most of them from Poland, in Salzgitter alone.[35] They included foreigners who had worked and/or been imprisoned elsewhere but were now accommodated in the Salzgitter camps. Thousands of DPs remained in Salzgitter for several more years because they could not, or did not want to, be repatriated. In early 1948 there were still some thirteen thousand DPs in Salzgitter. In the following two years, most were resettled in Western Europe and overseas, so that the last DP camp in Salzgitter could be disbanded in mid-1950. But the camps originally built to house those brought to Salzgitter to work for the Reichswerke were to leave a more lasting legacy and influence the composition of Salzgitter's postwar population. As the DPs were repatriated or resettled, the camps were taken over by refugees from eastern Germany. Most of them came from Upper Silesia, which after the war had become part of Poland. German refugees had been resettled in Salzgitter from 1944, but their number increased dramatically only toward the end of 1945. By the end of 1946, there were more refugees than DPs in Salzgitter. On 13 September 1950, 44,422 of a population of 100,667 Salzgitter residents were German refugees. Refugees were housed in barracks well into the 1950s; in 1955, 6.1 percent of Salzgitter's population was still accommodated in camps.[36]

In the 1950s and 1960s, Salzgitter finally became the new city that Hermann Göring had envisaged. Barracks gave way to blocks of flats. Toward the end of the 1950s, Salzgitter-Lebenstedt, located in the geographical center of the new city and close to the steelworks, emerged as the focus of what until then had been an amorphous conglomeration of industrial plants, villages, makeshift settlements, and the small town of Salzgitter-Bad. The city of Salzgitter, as it was called from 1951, covered a

much larger area than other German cities with a comparable population, and still included numerous villages. Most of the "villagers," however, worked for the steelworks or in other industries, including a Volkswagen plant, that were set up in postwar Salzgitter. From 1963, the Salzgitter AG recruited workers in Turkey, who were housed in camps that were structurally similar to those built for, for example, Dutch and Italian contract workers in the late 1930s.

When Salzgitter celebrated its tenth anniversary in 1952, the city was perceived to be recovering from the postwar crisis. By then, the federal government had approved a package of relief measures for the city. Salzgitter's mayor, Wilhelm Höck, and the *Oberstadtdirektor* (the head of the city's administration), Kurt Seibt, were satisfied that thereby the most immediate threat posed by the demilitarization of the Reichswerke, political radicalism, had been averted. In his contribution to a brochure published by the city to mark the anniversary, Höck noted that "the subversive efforts of certain elements, for whom the demilitarization measures in Salzgitter seemed to provide a particularly fertile ground for their propaganda, did not affect our young people."[37]

Höck did not mention the suffering of the forced laborers and inmates of concentration camps who had built Salzgitter and the Reichswerke plants. Seibt referred to the forced laborers only in the context of what he saw to be one of Salzgitter's postwar scourges, namely the "many thousands of foreigners who were conscripted to work more or less involuntarily for the Reichswerke during the war [and who subsequently] swamped the area."[38] The *Oberstadtdirektor* concluded his brief assessment of Salzgitter's ten-year past by invoking the "pioneering spirit" of the city's residents—not without making a reference to the pioneering of 1942: "Forgoing many a convenience that other 'cities' are able to offer, and with a truly genuine pioneering spirit, all responsible forces are working toward securing the future of this city for the benefit of its citizens, of the state, and of the great *Volksgemeinschaft* [national community] whose ultimate goals are peace and freedom."[39] No longer anticipating the *Endsieg* (ultimate victory) but striving for an *Endziel* (ultimate goal), the *Volksgemeinschaft* of 1952 appeared to have more than just a name in common with that of 1942. The mentioning of "responsible forces" implied that there were also "irresponsible elements"—"certain elements," Höck called them; *Gemeinschaftsfremde* (community aliens), they probably would have been termed seven years earlier—who presumably did not fit into the "great *Volksgemeinschaft*." Those to be excluded from the *Volksgemeinschaft* in 1952 included members of the Communist Party, as they did in 1942. In 1952, as well as in 1942, criteria for exclusion from the *Volksgemeinschaft* were based on how those who claimed to represent the *Volksgemeinschaft* perceived the threat to their project from within the nation.

On the occasions of the city's twentieth and twenty-fifth anniversaries, Salzgitter's political leaders continued to praise the pioneering spirit of its residents. The introduction to a brochure published by the city in 1967 reflects the sentiments that officially prevailed at that time:

> The young city of Salzgitter celebrates its twenty-fifth birthday. In the light of the centuries-old tradition of venerable cities it may appear presumptuous to observe such a jubilee. But for Salzgitter, other standards apply. The history of the city has been unique from its first day until today; it has been without precedence in the past and is setting the trend for the future . . . People who lost their home and all their worldly possessions flocked to this city from all parts of the former German Reich. With admirable energy and under many sacrifices, they turned a simple human settlement into a livable city. The people of this young city of Salzgitter are distinguished by their vigor and optimism. They have retained some of the good old German pioneering spirit, without which the founding of a city such as this one would not have been possible. The sharing and shaping of their destiny has brought them together as a community that is willing to complete the building of this modern city in spite of all apparent difficulties.[40]

This brochure contained only an oblique and misleading reference to the slave labor that had been so crucial in Salzgitter's early years: "A second big task that the Reichswerke had to undertake was to accommodate the workers who flocked to Salzgitter from all parts of the Reich as well as from abroad."[41]

In publications to mark the twenty-fifth and thirtieth anniversaries, Erich Söchtig and his successor as chairman of the *Betriebsrat,* Erich Sewald, emphasized the role the workers had played in saving Salzgitter in 1950; but they too failed to mention the contribution and suffering of German and non-German forced laborers between 1939 and 1945.[42] They did not raise another delicate issue, namely that of congruities between their employer and the Reichswerke. The Reichswerke were liquidated in 1953; the state became the sole owner of their successor, AG für Bergbau- und Hüttenbetrieb (from 1961: Salzgitter AG; from 1970: Peine + Salzgitter AG). Söchtig condoned attempts by the new management to establish a personal continuity between the Reichswerke and the state-owned company; Paul Rheinländer (1903–1979), who had been one of the seven Reichswerke directors between 1937 and 1945, was appointed chairman of the board and remained with the company until 1972.[43] Only in the 1980s did Peine + Salzgitter AG (P+S) drop the Reichswerke logo and part with the most conspicuous symbol of such continuity, the "Gö" ring.

A Declaration of Love for Salzgitter

It was not until Salzgitter's fortieth anniversary in 1982 that a sizable number of its citizens began to view the past of their city in a profoundly different way. A renewed interest in the Jammertal and Westerholz cemeteries was a first indication of how public memories of Salzgitter's early years were changing. On Volkstrauertag (Remembrance Day) in 1981, Salzgitter's churches organized a ceremony at Jammertal, which both the mayor, Rudolf Rückert, and the influential head of Salzgitter's administration, Oberstadtdirektor Hendrik Gröttrup, attended. On the same day, a Christian youth group organized a more informal commemoration at Westerholz.[44]

From 25 February to 6 April 1982, two local institutions of adult education, the Protestant Evangelische Erwachsenenbildung and the municipal *Volkshochschule,* offered a series of six public lectures and a panel discussion that dealt with different aspects of the topic "Salzgitter in the National Socialist Period."[45] The series demonstrated that this subject had until then not received much attention in Salzgitter: the first three lectures were by speakers whose knowledge of Salzgitter's history was incidental— all three were acknowledged authorities on the history of neighboring Braunschweig under Nazi rule. Unlike Salzgitter, Braunschweig has had a substantial student population and in the 1970s had a small but lively left-wing and alternative lifestyle culture. As in many other West German cities at that time and unlike in Salzgitter, in Braunschweig a *Stadtzeitung* reported local news, including items about the local Nazi past, that were not published by the usually cautious and conservative daily press.

In West Germany in the late 1970s and early 1980s, emerging public discourses about the local aspects of the Nazi years could draw on the work of individuals who, often for many years, collected documents, interviewed eyewitnesses, and wrote local histories that focused on the Nazi period. In the case of Salzgitter, it was a lab technician at the steelworks, Gerd Wysocki, who in the 1970s began to research the history of the Reichswerke. His work was supported by the IG Metall's local branch. By early 1982, Wysocki knew more than anybody in Salzgitter about the use of forced labor by the Reichswerke and taught a course offered in early March 1982 by Salzgitter's *Volkshochschule* to accompany the lecture series. In April 1982, he published a first result of his research: *Zwangsarbeit im Stahlkonzern,* a monograph about the Reichswerke in the Nazi period, was the first substantial text about Salzgitter's pre-1945 past. Wysocki became the obvious point of contact for Salzgitter residents intent on unearthing and publicizing the history of Salzgitter before 1945.

The *Volkshochschule* lecture series was well attended, generated enor-

mous local interest, and was reported in detail in the local daily paper, the *Salzgitter-Zeitung*. The city organized another series of events dedicated to exploring the history of Salzgitter. Salzgitter's governing politicians and administrators, led by the *Oberstadtdirektor* and supported by the editors of the influential *Salzgitter-Zeitung*, agreed that the history of the city needed to be explored but felt that the *Volkshochschule* initiative went too far. On 6 May 1982, the city held a reception to mark the anniversary and invited Matthias Riedel, professor of economic history at the University of Hannover and recognized authority on the Reichswerke, to give a lecture on the early history of Salzgitter.[46] Riedel reappraised the role of Paul Pleiger, who had set up the Reichswerke, and in 1949 had been sentenced to fifteen years imprisonment in one of the Nuremberg trials. Pleiger was released from prison in 1951 and thereupon resumed possession of his engineering works in Sprockhövel.[47] Riedel's attempted rehabilitation of the convicted war criminal led the *Salzgitter-Zeitung* to suggest its own version of *Vergangenheitsbewältigung:*

> Those dispassionately presented facts showed that Salzgitter, the steelworks and the city, would not exist if it had not been for Paul Pleiger. Although Mayor Rudolf Rückert pointed out in his welcoming address for the reception that it was about time to acknowledge the city's history in order to come to terms with it, the time does not yet seem to be ripe for an official recognition of this man's contribution, for neither he nor a member of his family was invited to the reception.[48]

On 2 April 1982, the city organized a panel discussion about Salzgitter's history, which was obviously intended to balance the *Volkshochschule* lectures. Under the heading, "A Declaration of Love for Salzgitter," the *Salzgitter-Zeitung* reported that the participants, most of them retired politicians or senior administrators, did not shy away from the issue of the slave labor camps: "[The panelists] unanimously agreed that people had known about the terrible injustices but had not been in a position to do anything about them."[49] Wilhelm Höck, mayor from 1948 to 1952, was more specific about these "terrible injustices":

> I was shattered by one experience in particular. Once young Jewish women, pretty girls, arrived from the Ravenshausen [*sic*] camp. They had to manufacture hand grenades and bazookas . . . from 6:00 A.M. until 6:00 P.M. When the Allies were approaching, these women and girls were the first who were taken away by the SS. They lived in a camp . . . where those gravel piles are today. That was indeed a sad experience. But I would like to point out that we were proud not to

have let down the [troops fighting at the] front; here in Salzgitter, we did our job [*haben wir unser Muß und Soll erfüllt*].

When the panel's chair drew Höck's attention to the possibility that the death of four thousand people may not have been unrelated to such a fulfillment of one's duty, the former mayor replied: "One feels guilty, but in spite of these pangs of conscience I am retrospectively happy that we summoned the energy to establish and create from scratch a city such as Salzgitter."[50]

Arbeitskreis Stadtgeschichte

The 1982 *Volkshochschule* lecture series raised awareness about Salzgitter's Nazi past. Acting as a catalyst and focus for residents who were interested in a critical reassessment of local history but had not been sufficiently motivated to initiate such a reassessment, the series led to the formation of an association committed to continue the work begun with the lectures. The Arbeitskreis Stadtgeschichte was set up by a small number of Salzgitter residents, among them Gerd Wysocki, to promote "an international[ist] ethos," "tolerance in all areas of culture," and "the idea of international understanding," and to build and maintain "memorials for the victims of *NS-Gewaltherrschaft* [National Socialist tyranny], particularly the prisoners of concentration camps."[51] The Arbeitskreis Stadtgeschichte took up concerns and propagated an antifascism first articulated by committees of former prisoners of the Nazis in 1945 and 1946, and then by the VVN from 1947. Heinz and Lotte Mannel, who joined the Arbeitskreis shortly after its inception, had unexpectedly found allies in people of a different generation and different political beliefs: members of the Arbeitskreis included Social Democrats and Greens, as well as people not aligned with any political party.

On 6 May 1982, the day that the city held its official reception to mark Salzgitter's birthday, the Arbeitskreis organized a commemorative ceremony at Westerholz. The leaflet advertising the event explained: "In the year of the city's anniversary we want to commemorate the victims of the fascist terror by planting flowers, laying a wreath, and reflecting on the approach to our history."[52] In choosing Westerholz rather than Jammertal for its first public appearance, the Arbeitskreis signaled that it was primarily concerned with the largely forgotten past of Salzgitter and did not intend merely to continue the work begun by either the VVN or the trade unions.

The Arbeitskreis was not content to leave it at laying wreaths at cemeteries, and demanded to honor the prisoners of Neuengamme's local satellites where they had suffered. In 1982, the idea to commemorate the vic-

tims of Nazi Germany at so-called authentic sites, sites of persecution, was comparatively new. The most prominent "authentic site" in Lower Saxony was the area of the former concentration camp Bergen-Belsen.[53] Its authenticity could no longer be attested by material relics such as barracks; the camp had been razed. Part of the area had been turned into a large parklike cemetery. Various monuments erected to commemorate those who had lost their lives at Bergen-Belsen were integrated into this cemetery. Only one conspicuous *Mahnmal* in Lower Saxony commemorated the victims of Nazi Germany outside a cemetery. In Göttingen, a city with a very large student population in the state's south, a memorial marked the burning of Göttingen's synagogue in 1938. It had been commissioned by the city in time for the thirty-fifth anniversary of the Kristallnacht pogroms in 1973.

In 1982, no visible traces remained of Lager 21 and the satellite camps at Salzgitter-Bad and Watenstedt/Leinde. The barracks were gone, and the sites of the three camps would have been hardly recognizable to survivors. The prisoners of the Drütte satellite camp had not been housed in barracks but in rooms created under an overpass on the site of the former Reichswerke steelworks. In 1982, these rooms were still in use by the Reichswerke's successor. In 1983, the Arbeitskreis, the local branch of the metalworkers' union, and the *Betriebsrat* of the steelworks demanded that the site of the former camp at Drütte be used to house a memorial museum. At that time, the notion of a memorial museum was even less tested in West Germany than that of a *Mahnmal* outside of a cemetery. In Lower Saxony, the only such museum was at Bergen-Belsen. In Moringen, for example, only a memorial stone on the local cemetery served as a reminder of the concentration camp.[54]

In early 1985, the *Betriebsrat* won the management's approval to organize a commemorative ceremony at the site of the former camp in Salzgitter-Drütte and on 11 April 1985 unveiled a memorial plaque proclaiming, "On the occasion of the fortieth anniversary of the day of liberation in Salzgitter we remember at this site the murdered and the survivors from the satellite camp of Neuengamme." Following this ceremony, members of the Arbeitskreis and of the *Betriebsrat* formed the nucleus of a Komitee Dokumentationsstätte Drütte, whose sole purpose was to lobby for the establishment of a memorial museum under the overpass. Proponents of such a memorial repeatedly stressed the positive impact that the site's aura had on the effect of commemorative practices. In a discussion with the steelworks management, Komitee member Christoph Großmann recalled the ceremony on 11 April 1985 at Drütte and compared it to commemorations he had attended at Jammertal. Standing where Drütte's prisoners had assembled for the twice-daily parades, he "knew that a memor-

ial would only make sense at that site," right in the steelworks. Another Komitee member added: "Everyone who took part in the commemoration [on 11 April 1985] could sense that, and I believe the *Betroffenheit* had never before been as great."[55]

In its first public statement, the Komitee emphasized the didactic role that a memorial museum could play:

> But we also demand that we not just commemorate the victims but also that we remember how the National Socialist *Gewaltherrschaft* came about in the first place, and what kind of lessons we can draw from this part of our history. This appears to be particularly urgent when we consider the lack of a perspective, which results from mass unemployment affecting more and more people in our country, the resurgence of racist and authoritarian tendencies, and the increasing formation of neofascist groups.[56]

The motivation of Arbeitskreis and *Betriebsrat* to set up a memorial has also to be seen in the context of their allegiance to a particular explanation of German fascism, one emphasizing the role German corporations played in Hitler's rise to power, and the benefits German industry gained from the concentration camp system. The remains of the satellite camp under the overpass needed to be preserved and made accessible to the public, members of the Arbeitskreis argued repeatedly, because "nowhere else does the close link between industry and National Socialism become so apparent as in the iron- and steelworks at Salzgitter."[57]

The company vehemently rejected this interpretation of the past. In a discussion with members of the Komitee in 1986, P+S manager Kurt Stähler said that "Salzgitter isn't a good example of the connection between industry and National Socialism" because the decision to establish the Reichswerke had been political. He also implicitly rejected suggestions that the company's capital was created on the basis of slave labor and reiterated postwar Salzgitter's dominant foundational history, namely that "the plant was set up after the war through significant endeavor by its employees."[58]

Between 1983 and 1992, two camps opposed each other in Salzgitter. There were the advocates of a memorial museum at Drütte. They included the local trade unions, the Green members of the city council, the *Betriebsrat,* many local church leaders, and the members of Arbeitskreis and Komitee Dokumentationsstätte Drütte. Their main opponent was the management of the local steelworks. The company categorically rejected the idea of a memorial in the grounds of the steelworks. They argued that the overpass would eventually be in the way of an extension of the plant

and would then have to be demolished, and that anyway for safety reasons public access to the site of the former camp was impossible. The city administration and the majority of the city council supported the idea of a memorial but sympathized with the company (which was, after all, Salzgitter's largest employer and landlord and most significant taxpayer). The company offered to fund a memorial at Jammertal or some other site well away from the plant, but the *Betriebsrat* and Arbeitskreis did not budge. Until 1989, the company was state-owned, and so the supporters of an on-site memorial carried the fight to the state and federal parliaments in Hannover and Bonn, and to the European Parliament in Strassbourg.

By 1992, the positions of Arbeitskreis and steelworks management appeared to be as inflexible as they had been in 1983, despite a blow to the company's position when in 1988 the curator of monuments in Lower Saxony placed a heritage order on the section of the overpass under which the prisoners had been accommodated. By 1992, many local supporters of the idea to establish a memorial museum felt that the stubbornness of Arbeitskreis and *Betriebsrat* was counterproductive and that a compromise should be reached. It thus came as a surprise when in 1992 the management of the steelworks, which three years earlier had been bought by the Preussag Corporation, informed the *Betriebsrat* that it agreed to the establishment of a memorial museum under the overpass. In 1993, the Gedenk- und Dokumentationsstätte KZ Drütte opened.

The campaign for the establishment of a memorial at the site of the former Drütte satellite camp was by no means an all-German affair. Since the late 1940s, French Neuengamme survivors have regularly visited Salzgitter on *pelerinages,* pilgrimages, that led to Neuengamme itself and to other sites where Neuengamme prisoners had suffered. When visiting Salzgitter, participants of such *pelerinages* laid wreaths at Jammertal. Visits by survivors were frequent enough to make one newspaper in 1961 invoke the "many visitors from Germany and abroad" when commenting on Wiegand's proposal for a war memorial at Jammertal. Some time in the 1970s, Pierre Restoueix and a fellow survivor persuaded the steelworks' security guards to let them look for traces of the Drütte camp and for the first time visited the site of their suffering under the overpass. In 1985, the *Betriebsrat* invited Restoueix to address those attending the ceremony on 11 April. Since then, speeches by survivors have been a regular feature of commemorations at Drütte. Survivors supported the demands for a memorial museum at Drütte.[59] In 1992, on the occasion of Salzgitter's fiftieth anniversary, the Arbeitskreis Stadtgeschichte invited former concentration camp prisoners and forced laborers to Salzgitter. One hundred sixty-seven men and women, most of them from France, Belgium, and Poland, visited the site of their suffering. In 1995, the Arbeitskreis organized a second meeting of survivors in Salzgitter.[60]

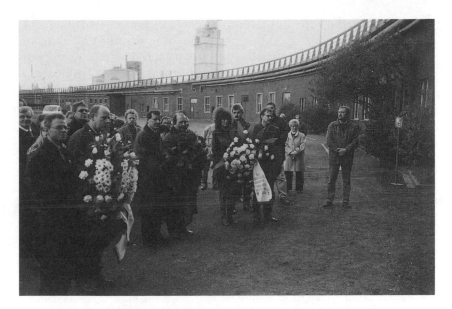

Fig. 5. Representatives of, *left to right,* the steelworks management, the City of Salzgitter, and the *Betriebsrat* laying wreaths on 11 April 1998 at the Drütte memorial. The rooms that were used to house concentration camp prisoners are under the overpass in the background.

Masters of the Past?

Before the granting of permission for a memorial museum at Drütte, both the company and the city tried to convince the public that they were as interested in *Vergangenheitsbewältigung* as was the Arbeitskreis. In fact, between 1982 and 1992, Salzgitter appeared to provide a stage upon which various actors vied for the honor of being the most convincing masters of the past, and each was provoking the other to match their own efforts. In September 1985, the *Betriebsrat* invited the management of the steelworks to participate in cleaning up and beautifying the area around the memorial plaque under the overpass.[61] The management prohibited the exercise and in turn invited the *Betriebsrat* to do some maintenance work at Jammertal. On Volkstrauertag in 1985, members of the *Betriebsrat,* local IG Metall representatives, and steelworks managers could be seen together weeding at Jammertal. In a press release, the *Betriebsrat* was at pains to assure Salzgitter's public that by joining P+S managers they did not compromise their position, namely that the management had to let them establish a *Gedenkstätte* under the overpass.

Soon after the fortieth anniversary, Hendrik Gröttrup and other lead-
ing politicians and administrators in Salzgitter felt that the city needed to
take a proactive role in confronting its early past. In 1985, Gröttrup com-
missioned one of West Germany's leading historians of twentieth-century
Germany, Wolfgang Benz, to edit a book that dealt comprehensively with
Salzgitter's history in time for the city's fiftieth anniversary in 1992. The
result, *Salzgitter: Geschichte und Gegenwart einer deutschen Stadt,* is an
eight-hundred-page tome that in thirty-two contributions covers nearly
every conceivable aspect of Salzgitter's past. Nearly two hundred pages
are devoted to exploring the history of Salzgitter under Nazi rule.[62]

Salzgitter: Eine deutsche Geschichte, the 1992 coffee-table book men-
tioned at the beginning of this chapter, was another project devised by
Gröttrup and his administration to mark the fiftieth anniversary. Its for-
mat was deliberately different from similar books published previously.
After initial hesitations, the editorial committee supervising the book's
production approved of the photographer's idea to open the book with
pictures of the dedication ceremony at Leinde.[63] This approval indicates
the extent to which the official understanding of Salzgitter's Nazi past had
changed since 1982.

The most significant work commissioned by the city of Salzgitter for
the fiftieth anniversary was not completed in time. In 1985, Gröttrup
talked to the Braunschweig artist Jürgen Weber about the possibility of a
sculpture that represented Salzgitter's history. Weber, one of the most
renowned realist sculptors in postwar Germany, had previously created a
portal for the council chambers in Göttingen, which depicted the history
of that city. Gröttrup had something similar in mind, but Weber insisted
on an unambiguously antifascist monument.[64] Both its site and its actual
form were hotly contested in Salzgitter. Weber suggested a marble and
bronze column, representing five different chapters of Salzgitter's history:
"forced labor," "industrial landscape," "expulsion and flight" (that is, the
issue of German refugees from former eastern Germany), "dismantling,"
and "reconstruction." On top of the column was to be the figure of a
founder. The most controversial part of the projected sculpture was a
relief that showed SS men with dogs hunting down young men in a forest
to send them as forced laborers to Germany. The opponents of this relief
objected because they feared that the uniforms could be mistaken for Ger-
man army uniforms. Weber then proposed an alternative that showed
forced laborers arriving in Salzgitter, but it was so unconvincing that even
the opponents of what became known as the "Jagdszene" (hunting scene)
eventually consented to its realization.

While people in Salzgitter debated the merits of Weber's sculpture,
there was no public mention that the city council had once before com-
missioned a memorial "for the victims of fascism." In 1948, the council

approved a design by a local artist, a student of Arno Breker, which showed a female figure holding her head in her hands. The memorial was to be located at the top of Lichtenberg Mountain.[65] While this project was never realized, the mountain now features a very different memorial, a large cross in memory of German prisoners of war.

Although Weber's sculpture was only completed in 1995, the anniversary celebrations in 1992 were markedly different from those in 1982. Salzgitter now publicly identified as a city conceived and born in Nazi Germany, whose growth was linked to the labor of concentration camp prisoners, POWs, *Ostarbeiter,* and others. The celebrations were different also, and perhaps most importantly, because of the large number of survivors visiting the city in 1992.

With the exception of the late 1930s and early 1940s, Salzgitter has never been a boomtown. But in the 1990s, the city's economic situation was particularly precarious. In 1997 the unemployment rate averaged 17 percent. The empty shell of a former department store in the center of Lebenstedt bespoke the link between such figures and the city's economic state in general. In 1997–98, Salzgitter's citizens rallied once more behind their steelworks, when Preussag AG announced that it was going to sell the plants to an Austrian corporation. Fearing mass redundancies, the *Betriebsrat* and the city council successfully lobbied the state government to buy the steelworks. In mid-1998 the again state-owned company was floated on the stock exchange. But despite the parallels between the early 1950s and the late 1990s, the moment when Salzgitter was saved from demilitarization—Salzgitter's "second, its true birthday!"[66]—was no longer as important as it had been in the 1970s and 1980s. That was only partly because in 1990 some seven thousand people worked for the iron- and steelworks, as opposed to seventeen thousand twenty years earlier. The foundational history of the workers saving the town had functioned as a screen that obscured Salzgitter's earlier past. It established demilitarization as point zero, when Salzgitter was nearly annihilated but fought back bravely. In this story, there was no space for victims other than the city's German residents. In the late 1990s, such a screen appeared no longer warranted.

The silence observed by Salzgitter's civic leaders until 1982 became untenable due to the loud and insistent talking of a small group of locals who were committed to publicizing Salzgitter's origins. Over the years, this talking has been institutionalized and ritualized. In the late 1990s, local secondary school students were more likely than not to learn and ask questions about Drütte and Lager 21. In 1997, Salzgitter's conservative mayor said that he routinely takes visitors to the Weber sculpture. Every year on 11 April, in a ceremony organized by the *Betriebsrat* of the steelworks, some two hundred locals meet at the Drütte *Gedenkstätte* to honor

the dead and listen to survivors. As people in Salzgitter keep talking about the origins of their city, it is unlikely that the Weber monument or the Drütte memorial will become "conspicuously inconspicuous." A lot of issues are of course glossed over in this talking. The 1950s and the marginalization of people like the Mannels, for example, do not feature in public discourse in Salzgitter. But in comparison to the talking about the Nazi past elsewhere in Germany, the talking in Salzgitter has been comparatively noisy, as the next chapter will show.

CHAPTER 2

A *Hasenjagd* in Celle

Beginning in mid-1944, when the Red Army was advancing into Poland, the SS tried to evacuate concentration camps ahead of the approaching Allied forces. On 25 March 1945, the SS moved 817 prisoners from the Büssing camp in Braunschweig, another satellite of Neuengamme Concentration Camp, to Watenstedt/Leinde, which was still relatively safe from the advancing American army. On 7 April, with American forces approaching, the inmates of the camp at Watenstedt/Leinde, including the new arrivals from Braunschweig, were also evacuated. About 3,100 prisoners were put on cattle cars and taken in two separate trains to Ravensbrück Concentration Camp north of Berlin, where they arrived on 14 or 15 April. Many of them did not survive that one-week journey. When Ravensbrück, too, was evacuated, some of the survivors from Watenstedt/Leinde were taken to the Malchow satellite camp, where they were liberated by the Red Army on 2 May. Another group was marched to Wöbbelin, where they were liberated by the Americans.[1]

Also on 7 April 1945, the prisoners from the Drütte and Salzgitter-Bad satellite camps were made to board a freight train that was supposed to deliver them to Bergen-Belsen, about ninety kilometers north of Salzgitter.[2] They possibly joined prisoners from Holzen, a satellite camp of Buchenwald, whose train had stopped in Salzgitter on its way to Bergen-Belsen. On 8 April the train, carrying approximately four thousand prisoners, was redirected to a freight terminal in Celle, a town some twenty kilometers southeast of Bergen-Belsen, and parked next to a train carrying ammunition. At about six in the evening, three American bomber squadrons with a total of 132 B-26 Marauders attacked Celle's rail facilities. Both trains were hit; about half the prisoners were killed. Most of the survivors tried to flee both the scene of destruction and their guards, who fired at escapees. Most of them headed west, toward a small wood, the Neustädter Holz.

Members of the SS, SA, police, and army combined to recapture or kill the escapees. Jointly they engaged in what became known in postwar

41

Celle as the "Celler Hasenjagd," the "Celle hare hunt," the hunting down of the survivors of the air raid. In 1989, Wilhelm Sommer, a local resident who had been thirteen in 1945, remembered that he saw "men in gray-blue striped pants and jackets . . . bounding across the field like hares." Members of SS and SA were shooting at them, Sommer recalled, "and then—as if it was a hare hunt—groups of seven or eight, sometimes single ones, and sometimes a whole bunch of them, tore out of . . . those hedges."[3]

Historian Mijndert Bertram found that not everyone who took part in rounding up escapees acted under orders:

> That was particularly true for civilians who individually or in small groups went hunting for prisoners, and some of whom, according to subsequent testimonies, boasted about the number of people they had killed. It could not be ascertained, however, whether the firemen, who came from the Wietzenbruch airfield and were armed with handguns and who also shot at the fugitives without any hesitation, had or had not been ordered to do so.[4]

The *Hasenjagd* extended until 10 April. Some prisoners were able to evade their hunters until the arrival of Allied troops on 12 April.

About eleven hundred recaptured prisoners, men and women, were concentrated at a sports field near the Neustädter Holz. Thirty of them were summarily executed as looters. SS men marched some five hundred of the prisoners to Bergen-Belsen; those who collapsed on the march were shot on the spot. The survivors were liberated on 15 April by British troops. The remainder, comprising men and women who appeared too weak to walk to Bergen-Belsen, were imprisoned in the grounds of the Heidekaserne infantry barracks and there left to their own devices. On 12 April, the Fifteenth Scottish Division occupied Celle and discovered the impromptu camp at Heidekaserne. For the British soldiers, this was the first encounter with such a large group of concentration camp prisoners. The division's chronicler later wrote:

> In Celle the 15th Scottish Division came upon a small but truly horrible concentration camp, a Belsen in microcosm, in which there were a few hundred dead and dying. The citizens of Celle expressed a bland ignorance of the horrors that had been going on in their midst. Colonial F. M. Richardson . . . however, took appropriate steps to bring the truth home to them. He saw to it not only that the citizens of Celle themselves removed the corpses, but also that they provided medical attention, linen, and supplies for those victims who had survived.[5]

KZ-Leute

In June 1946, Hanna Fueß (1886–1972), a Celle writer who had published two novels, written about local folklore, and for many years worked for the local daily newspaper, *Cellesche Zeitung,* was commissioned by the Celle Kreisbauernschaft (District Farmers' Association) to compile a chronicle of life in the *Landkreis* (district) of Celle (which excluded the town of Celle itself) in the war and immediate postwar years.[6] She recorded some 350 eyewitness accounts for the chronicle, most of them in 1947 and 1948. A collection was published in 1991, nineteen years after Fueß's death.[7] The accounts are a unique source about life and dominant discourses in rural Lower Saxony immediately after the war. Most of Fueß's informants were longtime residents of the district; many of them were members of the old elites. Fueß's interviewees did not include DPs, who in 1946 comprised a substantial proportion of the population of the district. Refugees from former eastern Germany who settled in the district after the war are underrepresented in Fueß's collection.

Fueß's informants often betray their ideological allegiance to the Nazi regime. Such allegiance is hardly surprising. The Nazi Party, NSDAP, had enjoyed comparatively strong support in the district of Celle since 1929, even though after 1933 the predominantly rural population of the district had viewed with skepticism aspects of state intervention that had a negative economic impact on farmers.[8] Those of Fueß's informants critical of the Nazi regime were mostly unhappy about the NSDAP's anti-clerical stance. Fueß herself had supported the Hitler regime and had continued to publish during the Nazi years. Her interviewees would have found it easy to be frank because Fueß was obviously a sympathetic listener, and because she promised not to publish an account while its narrator was still alive.

The accounts collected by Fueß are remarkable for the self-pity displayed by their authors. According to them, the end of the war heralded a period of tribulations for the Germans living around Celle. "The war was of course over, but the worst was now to come, and we all copped our share," a farmer from Altencelle complained (*UZ,* 144). For others the end of World War II by no means coincided with the end of the war they experienced: "Here the war only began when it had come to an end," a Catholic priest from Unterlüß said (*UZ,* 248). The "war" meant clashes between Allied and German troops, which affected the civilian population; the influx of refugees from eastern Germany; in some cases, the evacuation of houses or entire villages that were required by the Allies; and, most importantly, encounters with former prisoners of Bergen-Belsen, former forced laborers, and ex-prisoners of war.

During the war, up to three thousand forced laborers worked in Celle; up to fourteen thousand non-German laborers, including prisoners of war, were deployed in the surrounding district. When the British liberated Bergen-Belsen, they counted some sixty thousand survivors, more than one-fifth of whom died within the next couple of months. Thus town and district of Celle had their share of DPs after April 1945: on 1 June 1945, Celle, with a population of less than forty thousand in 1939, accommodated about twenty-three thousand non-Germans, most of them DPs, as well as forty-eight thousand Germans.[9]

In most of the accounts recorded by Hanna Fueß, the interactions with liberated non-German prisoners and forced laborers are described as if they did not warrant a prehistory. None of the narrators accepted any responsibility for what happened to POWs, Jews, Polish forced laborers, and others who were held captive in the district before April 1945. One can presume that knowledge of the existence of Bergen-Belsen Concentration Camp could not be denied, if only because of its proximity and its sheer size (the number of prisoners liberated by the British exceeded the entire prewar population of the Celle district), but hardly any of Fueß's informants admitted to knowing about conditions at the camp.

In postwar Germany, community leaders not only spoke for themselves but also vouched for their fellow citizens (as happened most famously in Weimar; see chap. 8). Ernst von Briesen, a judge from Bergen (the village closest to the camp), maintained: "Actually hardly anybody in Bergen knew anything about the existence of this camp. I could swear to that any time" (*UZ,* 290). A similar assertion can be found in the memoirs of Wilhelm Brese, a prominent local Christian Democrat and long-serving member of the federal parliament.[10]

Walter Redeker, a pharmacist from Winsen, was appalled by what he saw when he visited the camp several weeks after it had been liberated (rather than by the conditions before its liberation, which could have been easily deduced from information available in May 1945):

> The situation in Belsen resembled a painting by Breughel. The women relieved themselves in the nude, everything had broken away from morality and order. If Belsen had not been overcrowded, such conditions could never have occurred. It was well laid out with greens and good sanitary facilities. (*UZ,* 76)

While some interviewees saw Bergen-Belsen as a blot on the name of Germany,[11] no account evidences any genuine empathy with Bergen-Belsen's prisoners, the *KZ-Leute* (people from the concentration camp), as Fueß's informants often referred to them. "They should not have been set free just like that," two women from Dageförde thought.[12] Before becom-

ing a refugee and settling in Winsen, Oskar Stillmark had owned an estate in Wartheland, a part of Poland that the Germans subjected to what would now be called ethnic cleansing. Describing the impression a group of prisoners on their way to Bergen-Belsen made on him, Stillmark cleared himself and all other Germans of any responsibility, and qualified the suffering of the concentration camp prisoners by moving in his narrative suddenly from Bergen-Belsen to Winsen:

> Three days before the arrival [of the British army], the *KZ-Leute,* most of them from the Ruhr Valley, came through, accompanied by a few guards. They gave the impression of being very weak; for the past five days, they had only received half a loaf of bread and a small tin of meat. They did not give the impression that they were political prisoners but that they were criminals. In this manner, Belsen became totally overcrowded. The dying only started after the arrival of the English. The prisoners from Auschwitz had arrived with typhoid and had also given it to the SS guards. The supply of food had stopped. The camp management had to requisition [food] from the farmers. Then the English occupying forces arrived, and the lard and the corned beef in the starved stomachs really caused mass casualties, however well intentioned it was. Our men from Winsen were ordered to bury the dead after the arrival [of the British]. When Winsen was captured, it suffered a lot. Fourteen to fifteen houses were destroyed. In Winsen, Alfred Eicke and a Red Cross nurse were killed by low-flying aircraft. (*UZ,* 84)

Käthe Lontzek, a Red Cross nurse from Belsen, was interviewed in 1960. By then her memory of Bergen-Belsen had become a caricature, which emphasized three points. First, the concentration camp was a good place to be before February 1945 ("we envied the inmates, who were not bothered when there was an air-raid warning; their camp was brightly lit and shone into our darkness"). Second, the situation in the camp became unbearable after February 1945 because Auschwitz prisoners were evacuated to Bergen-Belsen; the commandant, Josef Kramer (who was hanged as a war criminal in December 1945) should not have been held responsible for the conditions then because they were the result of external circumstances (such as the "bombardment of trains delivering food [to the camp] by low-flying [Allied] aircraft"). Third, the British were responsible for the death of liberated prisoners after 15 April 1945 because they provided them with unsuitable food. Lontzek in fact surmised that the British did so because they were interested in shooting footage of dying prisoners![13] More than fifty years after the liberation of Bergen-Belsen, inhabitants of Bergen and neighboring villages who are prepared to name the nightmar-

ish scenes they inevitably witnessed, at least after the camp's liberation, were still the exception.[14]

In the immediate postwar period, Germans generally regarded Eastern European DPs disdainfully, if not as a threat. In Salzgitter, for example, the British commandant noted in 1946 that the local German population believed all DPs were bad.[15] What makes the accounts of Fueß's informants so remarkable is the openness and unanimity with which they rejected the victims of Nazi Germany. A farmer from Bollersen appeared to rue the assistance he rendered starving ex-prisoners: "First the people from the concentration camp were that run-down, when they came. They were given milk and food and recovered so quickly that after eight days they began to pillage and loot!" (*UZ*, 333)

Without exception, Fueß's interviewees saw those who were liberated at Bergen-Belsen as a scourge who looted and threatened the German population of the Celle district. "The *KZ-Leute* caused us a lot of trouble. The shops were looted; it became more and more extreme," a business man from Winsen said (*UZ*, 81). Käte Wente, an evacuee from Hannover, claimed: "The *KZ-Leute* stole my children's bread, butter, and jam off the table, tore down the flyscreen from the cupboard and took everything: eggs and cranberries, including the glass jars" (*UZ*, 150). Accounts of instances of looting are remarkable for the amount of detail about the items that were taken:

> The victors' first job consisted in putting up the *KZ-Leute* from the concentration camp in the army barracks. As my farm was directly opposite the barrack square, everything flooded onto my farmyard. In three nights, I was burgled and the *KZ-Leute,* together with the Russians and the Poles, stole nineteen pigs, eighteen head of cattle, two sheep, all geese, ducks and turkeys as well as one hundred chickens, by smashing the doors and windows (usual stock of cattle and horses: twenty-eight head). (*UZ*, 306)

A former teacher from Bostel who had lost his job because of his NSDAP membership provided Hanna Fueß with a list of stolen goods that included "three pairs of underpants, three pairs of long johns . . . six forks, five table spoons," as if such stocktaking could help him reaffirm the order that was disrupted in April 1945.[16]

Fueß's informants presented themselves, not Jews or POWs, as victims. Farmer Rudolf Habermann from Bergen, in the most openly anti-Semitic account in the published collection, at first seemed to acknowledge the plight of the prisoners at Bergen-Belsen, although he used terms more appropriate for animals than for human beings: "the poor creatures . . .

had perished and were lying about in the thousands when the occupation troops arrived." But, according to Habermann, there was worse:

> What happened during this time, is about the most terrible thing since the Thirty Years War. In the thousands the concentration camp prisoners and Polish and Russian prisoners of war, Italians and Frenchmen, poured into our peaceful village, pillaging and looting whatever goods they could find. (*UZ*, 299)

There is no doubt that survivors from Bergen-Belsen and former forced laborers and prisoners of war looted, and that initially the British occupiers, many of whom were deeply shocked by what they had seen in Bergen-Belsen, did little to stop them.[17] Similar observations could be made about Salzgitter, and, for that matter, all other parts of Germany that were initially occupied by American and British forces, during the first few weeks under Allied rule. In Celle, as in Salzgitter, the British occupiers soon took control of the situation. There is no evidence that the number of crimes committed by DPs, either in the Celle area or in other parts of Germany, was proportionally higher than that attributable to the local German population.[18] The fact that according to West Germans' perception then and collective memory since, there was a disproportionately high incidence of capital crimes and looting by DPs in the first three postwar years, suggests that by talking about lawless DPs Germans have avoided admitting the high number of crimes committed by Germans in the immediate postwar years. Fueß's informants largely glossed over this latter issue, which must have posed a major problem, particularly in closely knit rural communities. The only one of Fueß's informants to say that locals were responsible for many of the crimes attributed to *KZ-Leute* and Polish forced laborers had a Communist brother-in-law who had been imprisoned in Mauthausen Concentration Camp.[19] There is no evidence either of survivors from Bergen-Belsen attempting to take revenge for their suffering by terrorizing the local German population; the only Germans who—in Bergen-Belsen and in other liberated camps—were pursued in revenge by survivors were former guards and *Kapos,* that is, prisoners whom the SS had put in charge of fellow prisoners.[20]

The "peaceful" villagers, while emphasizing their suffering at the hands of *KZ-Leute* and others, did not portray themselves as *passive* victims. Several of the accounts mention the activities of vigilantes. In one the term *Hasenjagd* appears again: "When there was looting, the entire village gave help. Somebody from the trombone ensemble had a bugle. He had to play it when there was trouble. Then we all took off with cudgels; often it was a veritable *Hasenjagd.*"[21]

Although several accounts mention the train from Salzgitter, none refers to the events of 8–10 April that became known in Celle as the *Hasen-jagd.* Anna Rehwinkel, a farmer from Westercelle, described how she gave bread and coffee to prisoners who had sought refuge in her garden. She chided an army officer for suggesting that the escapees should be shot rather than cared for: "I said: 'Get off it! I don't want to know anything about this business; it won't happen on my farm!'" (*UZ,* 181–82) That "it," namely the killing of the runaway prisoners, then happened else-where, did not seem to bother Rehwinkel much.

Leaseholder Ferdinand Knoop from Hambühren reported:

> Unfortunately, on Sunday, 8 April, a train with *KZ-Leuten,* which had been parked at the Celle railway station, was bombed. Now the *KZ-Leute* in their zebra dresses ran around in the Neustädter Holz. We then picked up a few; many were actually willing to be taken pris-oner, because they did not know anyway where they should turn. We then sent them with scattered Wehrmacht soldiers to Bergen-Belsen. (*UZ,* 96)

Like many accounts collected by Fueß, Knoop's recollections are as reveal-ing for what their author did not say as for what he did say. What was involved in "picking up" *(auffangen)* the escapees? What happened to those who were not willing to be taken captives? Why would Wehrmacht soldiers have been in a position to take recaptured prisoners to Bergen-Belsen?

As in Habermann's account, the *KZ-Leute* are only momentarily accorded the status of victims, before being rendered victimizers, the vic-tims' role having been usurped by the Germans. Knoop's story continues: "The ringleaders from the *KZ* train took lodgings with the foreign work-ers from our Hambühren Muna [munitions factory]. Together they then went out pillaging . . . These hordes just took everything they wanted" (*UZ,* 97).

For Fueß's informants, the liberation of the various groups of non-German prisoners marked the beginning of a general state of disorder. There is no mention in the accounts of either the systematic disorder of the preceding twelve years, or of the widespread lawlessness triggered first by the bombing raid of 8 April, when "ordinary Germans" took it upon them-selves to hunt down escapees, and then by the arrival of the British, when large numbers of Germans looted businesses and private houses in Celle.[22]

Hannah Arendt, visiting Germany at about the time when Hanna Fueß collected most of the testimonies, offered what could be read as a succinct and apt comment on the attitudes of Fueß's interviewees. "This apparent heartlessness," the author of *The Origins of Totalitarianism* wrote in 1950 about postwar Germany, "is only the most conspicuous out-

ward symptom of a deep-rooted, stubborn, and at times vicious refusal to face and come to terms with what really happened . . . Such an escape from reality is also, of course, an escape from responsibility."[23]

Hanna Fueß, Hermann Löns, and Accounts of Pillaging and Looting

The events of 8–10 April 1945 were not unique to Celle. Elsewhere in Germany, trains with prisoners were bombed and escaping survivors shot dead by their guards. A train with prisoners from Bremen, also on its way to Bergen-Belsen, was bombed when parked at the Wintermoor railway station on 11 or 12 April 1945; fleeing prisoners were killed by the SS guards accompanying the transport.[24] On 10 April 1945, the train station at Lüneburg, a town not far from Celle, was bombed and a train with concentration camp prisoners hit. The local newspaper, *Lüneburger Landeszeitung,* appealed to the civilian population to help apprehend the prisoners and kill those who resisted.[25] At the same time in nearby Soltau, civilians, among them members of the Hitler Youth, hunted down and executed escaped concentration camp prisoners.[26] Even the term *Hasenjagd* was used in similar circumstances elsewhere: local residents from near Mauthausen Concentration Camp in Austria said they were on a *Hasenjagd* when hunting down 495 Soviet prisoners who in February 1945 took part in a mass breakout.[27] What is unique, however, is the way the "apparent heartlessness" of inhabitants of the town and district of Celle was prefigured in a book published in 1910.

By the time of her involvement with the Celle Kreisbauernschaft, Hanna Fueß had already gained considerable prominence. This was not so much because of her work for the *Cellesche Zeitung* but because of her relationship with Hermann Löns. Löns (1866–1914) was one of the most popular German writers in the first half of the twentieth century. He published several novels and collections of poems, which mythologized the people, flora, and fauna of rural Lower Saxony, and, in particular, of the Lüneburg Heath. From 1902, Löns stayed for prolonged periods in Celle, initially because his second wife Lisa, née Hausmann, was from there. Soon, however, his romantic attachment to Hanna Fueß, who was his wife's cousin and living in Celle, provided an even better reason to visit the town for many weeks at a time. Löns' association with Celle is reflected in his writings. Even before living there, he had written a feature for a Hannover newspaper about the town.[28] He continued to publish articles about Celle and wrote poems and lyrics featuring it.

Löns's third novel, *Der Wehrwolf,* published in 1910, has been hailed as the most significant testimony to his association with Celle. Hanna Fueß claimed in 1927 that Celle was "the golden thread in the fabric of his

life's work. [This thread] shines most brightly in *Der Wehrwolf.*"[29] The novel was apparently inspired by a visit to remnants of a prehistoric rampart near Altencelle, a village a few kilometers from Celle. It is set in the Celle district in the time of the Thirty Years War (1618–48). Small bands of soldiers roam the area, terrorizing the local population. The novel's main protagonist is a peasant named Harm Wulf who, after his family is killed by marauding soldiers, organizes his neighbors into a militia who pursue the soldiers and their female companions mercilessly and sentence to death by hanging any captives they take. The peasants call themselves *Wehrwölfe.* Although Löns insisted that the word only referred to the fact that the peasants put up a fight *(sich wehren),* the connotations with the term *Werwölfe,* werewolves, were hardly unintentional: in the novel, Wulf and his companions turn into veritable wolves who feel compelled to kill and enjoy doing so.[30]

In *Der Wehrwolf,* killing marauding soldiers is justified on three levels. First, Löns, or rather his vigilante protagonists, suggest that as the soldiers rape and murder, they need to be punished accordingly.[31] The villagers' view is supported by the state (represented by the local duke, who lives in Celle), and by the church. "He who fights evil does not act contrary to the Lord's commandment" (HL, 134), a priest assures Harm Wulf, whose front door sports the motto "Help yourself, and God shall help you" (HL, 74). Second, the soldiers are classed as nonhuman on account of their behavior. They are repeatedly referred to as vermin (HL, 112, 119, 186); in one instance killing them is likened to killing lice between one's fingernails (HL, 123). The "Gypsy" women who accompany the soldiers are considered subhuman by the villagers (HL, 28–29). The third reason is only alluded to: the soldiers are considered foreign intruders who need to be expelled by the country's rightful inhabitants.

Since he died in 1914, Löns can hardly be accused of being a Nazi, but the far right lapped up his writings. Löns's poems and novels—*Der Wehrwolf* in particular—lent themselves to illustrating the *Blut und Boden* ideology that claimed that autochthony was a basis for political stability. Those who did not recognize the congruities between sentiments articulated in *Der Wehrwolf* and elements of National Socialist ideology could have let these congruities be pointed out to them by Hanna Fueß as early as August 1933.[32] The Nazis encouraged the memorialization of Löns's life and death and the celebration of his work. In January 1945, Celle's local newspaper began serializing *Der Wehrwolf.*[33] Toward the end of the war, NSDAP leaders called upon Germans to become *Wehrwölfe/Werwölfe* and continue to fight as partisans behind enemy lines.[34] The last newspaper to be published in Hildesheim before the town was taken by the Americans, for example, contained an appeal titled "Prove Yourself as Lower Saxonians" and alluded to Löns's novel:

The enemies have left us in no doubt about the seriousness of the situation and about the compulsion to hold our own lest we perish. The *Werwölfe*'s [*sic*] motto is valid for us, too: He who does not bite today, will be bitten.[35]

Löns's writings did not need to be promoted by the Nazi state in order to be read. Well before the NSDAP gained any influence, *Der Wehrwolf* and similar bestsellers furnished elements of the collective imagery to which Hitler and Goebbels appealed so successfully in the 1930s.[36] By 1923, *Der Wehrwolf*'s print-run had reached 460,000 copies, and by the end of World War II, the novel had become one of the most widely read books in Germany.[37] It is likely that for many of the descendants of those who featured so prominently in *Der Wehrwolf,* the peasants of the Lüneburg Heath, the popularity of Löns's novels was second only to that of the Bible. Incidentally, in April 1945, the Lüneburg Heath was considered "the worst region for [*Werwolf*] activities."[38]

The extent to which Löns was inspired by Celle and by Hanna Fueß has long been subject to controversy.[39] In 1920, Fueß adopted a nom de plume to publish a much-read autobiographical novel about her relationship with Löns, in which she attempted to highlight her role in the writing of *Der Wehrwolf.*[40] More relevant here, and I believe easier to ascertain, is the extent to which *Der Wehrwolf* provided a blueprint for the stories that Fueß's interviewees told of their postwar experiences. The *KZ-Leute* took the place of the marauding soldiers. Like them, they were seen as a scourge. The "reign of terror" claimed by many of Fueß's interviewees is reminiscent of that which Löns's *Wehrwölfe* opposed.[41] Like the marauding soldiers, the *KZ-Leute* were sometimes said to look like criminals.[42] And while the British occupation troops ensured that the *KZ-Leute* were not hunted down in the same way as the seventeenth-century marauders, the language of the accounts collected by Fueß suggests that their authors identified with Harm Wulf.

The *Wehrwölfe* take pleasure in killing the soldiers. They describe their activities as both work (HL, 118, 124) and fun (HL, 162, 170)—as much fun as the hunts described by the hunting enthusiast, Löns, elsewhere in his writings.[43] Similarly, Fueß's informants provided gleeful descriptions of instances where they successfully fought back, or outfoxed *KZ-Leute* who were searching their houses for valuables and food. Even the reference to a *Hasenjagd* seems to come from *Der Wehrwolf.* Löns describes how Wulf and his men hunt down sixty men and forty women who have been identified as intruders:

The females screamed, and then shots rang out everywhere, and Wulf and Thedel leaped from one juniper tree to the next, fired, reloaded,

leaped forward and waited until one of that bunch came closer, aimed carefully, and when the shot rang out, he did a cartwheel. Regardless of whether they wore trousers or skirts, they were riddled with bullets like hares that have been encircled by hunters. (HL, 142)[44]

In two other instances in *Der Wehrwolf,* the pursuit and killing of marauding soldiers is compared to a hare hunt (HL, 30, 66).[45]

By using terms such as *Hasenjagd* to describe the killing of soldiers, by reverting to dialect when quoting the *Wehrwölfe*'s war cry, "Slah doot, all doot!" [Kill them, all of them!] (HL, 180), and by obscuring violence through the use of euphemisms and proverbs such as "Boiling water is the best means of driving wasps out of the garden" (HL, 91), Löns made the actions of the *Wehrwölfe* appear acceptable. Löns, or rather, his bloodthirsty peasants, refused to acknowledge the extent of the violence directed against the marauders. The postwar inhabitants of the district and town of Celle eventually refused to talk publicly about the events of April 1945.

The "Tragedy and Shame That Have Befallen Us"

The town of Celle suffered only one fatal air raid before 8 April 1945—a woman and a child died when bombs fell on 26 January 1942.[46] But its citizens were aware of their comparatively good fortune: the fire that raged through Hamburg after massive bombing raids in July 1943 was visible from Celle, more than one hundred kilometers south. Subsequently, some four thousand homeless people from Hamburg were evacuated to Celle.[47]

The raid of 8 April 1945 probably resulted in about eight hundred dead among Celle's population and the only substantial war-related damage to the town.[48] The mayor of Celle, the general of the troops detailed to defend the town, and a group of socialist opponents of the Nazis successfully conspired to prevent the local Nazi leadership from organizing the defense of Celle and thus its destruction. The town was spared any major shelling before being occupied by Allied troops.

The non-Jewish German residents of the district and town of Celle had not only been comparatively little affected by the war, they had also benefited from German rearmament efforts. From 1933 to 1939, Celle enjoyed an unprecedented economic boom that was largely due to the dramatic increase in the number of soldiers garrisoned there (from three hundred in 1933 to three thousand in 1939), and to the expansion of a local silk-spinning mill. The mill had been assigned a crucial role in the government's strategy to become independent from imports: in 1932 it had fifteen employees and produced mainly panty hose; during the war it produced parachutes and employed more than three thousand workers.[49]

Rather than thinking of themselves as victimizers, people in and

around Celle soon remembered April 1945 as a time when they had become victims—first targeted by Allied bombers, and then harassed by former forced laborers and by prisoners liberated at Bergen-Belsen. But Bergen-Belsen, which supposedly had been so invisible before 15 April 1945, cast a shadow over Celle and the surrounding area in the months following the camp's liberation. People in Celle felt that they were made responsible for crimes in which they had no part—which had been committed by "a few brutal nut-cases," to quote Wilhelm Brese.[50] The local Germans, or rather their leaders, were concerned about Celle's reputation. Only three days after the liberation of Bergen-Belsen, an appeal in the local newspaper asked Celle residents to donate clothes, towels, and blankets for survivors of the camp. This and several other such collections that followed were ordered by the military government but organized by Germans. One of these Germans, journalist Eduard Genz, toured Celle in a car equipped with a loudspeaker: "You have heard about the tragedy [*Unglück*] and shame that have befallen us because of the discovery of a concentration camp in our heathlands. We are not to blame for the tragedy. [But] we all have to bear the shame."[51]

Celle's citizens were asked to give freely in order to erase the blot on the name of Germany—and more particularly on the name of Celle.[52] To erase the latter—which they might have perceived more acutely from May 1946 when the second Belsen trial began in Celle—and to appease the British authorities, in August 1946 Celle's politicians supported plans by former political prisoners to erect a memorial for the concentration camp prisoners who had been killed during and immediately following the raid of 8 April 1945.[53]

This memorial was to be located at Waldfriedhof, the municipal cemetery, where victims of the raid who had been dumped in bomb craters at the freight terminal had already been reburied. But there were many other makeshift graves. In August 1946, a committee representing former prisoners of the Nazis, together with the heads of the town and district administrations, called on the local population to identify sites where victims of the raid and subsequent *Hasenjagd* lay buried. More than a year after the events of April 1945, the murders could still be named, even though the reference to the murderers was oblique:

Appeal!
Who knows of the graves of former *KZ* prisoners in the town and district of Celle?
Relatives are still looking for one million *KZ* inmates.

During an air raid on 8 April 1945, a cargo train with *KZ* inmates at the Celle freight terminal was also badly hit. Reputedly more than

4000 prisoners were in that train. Only about 500 of them arrived in Bergen-Belsen. What happened to the others? Undoubtedly, many of them were torn to pieces by the exploding bombs; others, however, who escaped this hell and tried to get themselves to safety in houses and gardens were killed there. At Neustädter Holz and in the wider area shootings took place for days afterwards. . . .

It is certain that other *KZ* prisoners are buried at Neustädter Holz and along the road to Bergen-Belsen. The entire population is called upon to find these unfortunate victims of a system of madness in the woods [and] shrubbery and on roadsides, to identify them if possible and give them a dignified [*würdige*] resting place at the Celle Wald-friedhof. Relatives of the *KZ* prisoners have every right to ask where their sons, brothers, or fathers are. We must do everything we can to give them an answer. It is everybody's duty to assist in solving these last crimes.[54]

The vagueness of the first paragraph contrasts sharply with the certainty of the second. "Solving these last crimes" did not seem to require the identification of the killers. Nor did the circumstances appear to require further investigation: the figure for the number of prisoners who were killed—after all far more than the total number of civilians killed in Celle during the entire war—was quoted as if based on mere hearsay. In fact, the authors of this text seemed ignorant of the victims' identity: they wrongly assumed that the train carried only male prisoners. The location and identification of the victims appeared warranted primarily because the authorities in Celle received enquiries from the relatives of some of those "unfortunate victims."[55]

By March 1947, more than three hundred bodies had been exhumed and reburied at Waldfriedhof. Unlike in April and May 1945, when Celle's citizens had been obliged to assist the British authorities in caring for the survivors at the Heidekaserne barracks, this time the actual work was performed by inmates of the local prison. The municipal administration covered the expenses but expected to be reimbursed by the regional government because "the work that has been delegated to the [municipal authorities] is really a concern of society at large."[56] In several irritated letters, Oberstadtdirektor Krohn, for whom the *Hasenjagd* was soon to become unmentionable, reminded the regional government of the outstanding item, totaling 52,518.62 marks.[57]

In late 1947, with the reburial of *Hasenjagd* victims completed, the local committee of former prisoners organized a public subscription for the projected memorial at the Waldfriedhof cemetery.[58] The town and district of Celle pledged a total of twenty-five thousand marks. The town's contribution of ten thousand marks was clearly marked as a donation,

indicating that the city council no longer felt responsible for the project (which was, incidentally, pursued by a committee that two years earlier had been appointed by Celle's mayor).[59] An architect was commissioned to realize a design by Hannover artist Ludwig Vierthaler.

The events of 8–10 April were once more recalled between December 1947 and May 1948 during the Celle massacre trial.[60] According to the prosecution, between two hundred and three hundred prisoners were killed in the *Hasenjagd*. Of fourteen men charged with their murder, a British military court acquitted seven, imposed the death penalty on three, and sentenced the remainder to between four and ten years in prison. One death sentence was quashed in August 1948 by a British court of appeal; the other two convicted men had their death sentences commuted to long prison terms. All those convicted were released long before they had served their full terms; the last two were released in February 1952, barely four years after they had first been charged. The Celle massacre trial dealt only with the shootings of escapees in Celle; no charges were brought against anyone for killing prisoners on their way to Bergen-Belsen, or neglecting prisoners held at the Heidekaserne barracks.

By the end of 1948, the *Hasenjagd* had vanished from public memory. *KZ-Leute* were remembered as a scourge associated with the *Zusammenbruch,* the collapse of Nazi Germany. By then, Celle residents had identified a new scourge, the so-called *Veronikas,* German women who followed the Allied military personnel who were airlifting supplies to Berlin from airfields near Celle.[61] Vierthaler's memorial at Waldfriedhof was never completed, as the funds proved to be insufficient. Letters by the commissioned architect, asking the municipal administration to pay for his expenses constitute the last mention of the project.[62] The graves at Waldfriedhof were marked by three large wooden crosses and by a plaque referring to the site as "resting-place for victims of the Second World War."

Ewiggestrige

Celle's population grew from 37,830 inhabitants in 1939 to some 75,000 in the 1990s. This increase was due to the incorporation of neighboring villages such as Altencelle rather than to growth of the town itself. Celle is still a large country town. The Celle area is best described as a rural district that includes a sizable town, rather than as a town with a rural hinterland. Celle's inhabitants have seen themselves not so much as townsfolk but as urban *Heidjers,* people of the heathlands that make up much of central Lower Saxony. The closest city, the capital city of Hannover, has always seemed a long way away, even though today Celle is within commuting range.

Unlike Salzgitter, Celle can claim a long history. From 1924 Celle pro-

moted itself as "die alte Herzogstadt in der Heide," the ancient ducal town on Lüneburg Heath. In the mid-1920s, when Celle's population stagnated at around twenty-five thousand and its status and the confidence of its citizenry seemed to have reached a low, this epithet was to conjure a glorious but distant past (with the death of Duke Georg Wilhelm in 1705, Celle ceased to be seat of the rulers of the duchy of Lüneburg).[63] An English-language tourist brochure, published in around 1930, in fact suggested that Celle "exhale[d] a charm sui generis" because it had been "left in the lurch" by "the receding tide of prosperity."[64] In brochures put out by the municipal Department of Tourism in the 1930s and early 1940s, Hermann Löns's association with Celle was also emphasized as one of the town's attractions. A brochure published during World War II featured pictures of the Löns Gallery in the local museum and of the Lönsweg in Neustädter Holz.[65] After the war, while references to Löns were omitted from the brochures, Celle's identification as the "ancient ducal town" was retained until the early 1970s, when the Department of Tourism began to emphasize both the town's half-timbered houses and its location on Lüneburg Heath.

Until at least the late 1980s, Celle tried to present itself foremost as tangible evidence of a distant past. In this romantic town, residents claimed the license to remain wedded to the past rather than face the changed circumstances of the present: there was seemingly no need to forget or remember the Nazi years—as if they were yet to happen. Between the late 1940s and the early 1980s, the town largely sealed itself off from public debates about issues of remembrance and forgetting—not by rejecting them but by pretending that they could not even be imagined. An inward-looking Celle was comfortable with Löns and his lyrical waxing about landscape and country folk. "Celle: die romantische Fachwerkstadt" (Celle: romantic town of half-timbered houses) the sign at Celle's railway station reads. The half-timbered houses in Celle's town center would of course be less remarkable had not most other historic town centers in northern Germany gone up in flames during World War II.

In postwar West Germany, well into the 1960s and 1970s, the ruling elites in the district and town of Celle were reputed to be harboring sentiments such as those expressed by Fueß's informants in the immediate postwar years. Celle was considered a town of *Ewiggestrige,* of people who preferred to live in the (Nazi) past. The town's reputation as a stronghold of *Ewiggestrige* was due not to any good results for neofascist parties, but to the extent to which mainstream conservatives in Celle condoned or reiterated neofascist sentiments. In a way, Celle's postwar civic leaders continued an older tradition: during the Weimar Republic, anti-Semitism and jingoism were prominent in Celle, although with the exception of the elections of July 1932 local NSDAP results were below the national average.[66]

Celle's reputation may have had to do with the fact that compara-

tively many of Celle's residents belong to the legal profession, the section of the ruling elites least affected by denazification. Since the early eighteenth century, Celle has accommodated one of Germany's courts of appeal *(Oberlandesgericht);* several of its postwar judges were dispensing "justice" before 1945. This is not to say that between 1933 and 1945, the majority of Celle's judges and prosecutors were committed Nazis. But neither were most of them committed republicans (before 1933), antifascists (from 1933) or democrats (from 1945). A British report from the late 1940s referred to the first postwar president of the court of appeal, Freiherr von Hodenberg, as a "reactionary and an autocrat," and noted: "He was certainly never a Nazi, but he typifies that species of anti-Nazi who hat [*sic*] little understanding of democracy . . . Critics of the [Lower Saxony] judiciary have him in mind when they allude to the 'Spirit of Celle.'"[67] The ease with which Celle's legal establishment accommodated the Nazi years and evaded any accounting for their own actions between 1933 and 1945 was particularly evident in a publication to mark the 250th anniversary of the court of appeal in 1961. Loudly, Celle's postwar judges and prosecutors proclaimed their clear conscience.[68]

For the overwhelming majority of Celle's citizens, by the end of the massacre trial the events of April 1945 had apparently been sufficiently dealt with. Those events became part of history, albeit a history hidden from public view. The *Hasenjagd* was not mentioned in the relevant chapter of a history of Celle first published in 1959 and republished in a revised edition in 1992. The chapter begins with a reference to the aerial barrage of 8 April:

> The town of Celle was granted the favor of emerging unscathed from the war, at least as far as the old town center was concerned. On 8 April 1945, four days before English [*sic*] troops entered Celle, English [*sic*] planes attacked the area around the railway station, and in addition to some residential buildings the municipal gasworks was particularly badly damaged.

The author, former *Oberstadtdirektor* Helmut Krohn, then dealt in some detail with what he considered the only other war-related casualty suffered by Celle, the detonation of a bridge across the river Aller, which also damaged several nearby houses.

> The new bridge . . . was completed in 1951. The damaged gasworks was . . . largely repaired before the monetary reform [of 1948]. With the healing of these war wounds the town regained at least outwardly its old peaceful image, and after the monetary reform the owners of the old houses lovingly repainted the timber and, in particular, the

carved inscriptions. Thus the late medieval townscape shone anew and attracted many visitors from Germany and abroad.[69]

"Seven Hundred Years Young"

Between the late 1940s and the early 1980s, the events of April 1945 were talked about only on the quiet. A first indication that this was to change came in November 1980. As in most other West German towns since the early 1950s, in Celle Volkstrauertag (Remembrance Day) has provided the most significant regular occasion for public commemorations. In most West German communities, the civic Volkstrauertag ritual has been enacted at the local cemetery or indoors, in the town hall or council chambers. In Celle, however, this ritual has been celebrated in the open in the heart of the town, against the backdrop of a war memorial in form of a kneeling soldier, in front of the Celle palace. Would it have been difficult to have Volkstrauertag commemorations exclusively for the German war dead at Waldfriedhof, a place where so many non-German prisoners of war and *KZ-Leute* were buried? In 1980, the Protestant priest delivering the speech at the war memorial questioned the exclusive nature of the ritual in Celle and asked his audience also to think of those killed because of their religious or political conviction or because of their "race," and of the non-German war dead, including the Russians. His speech was a passionate plea for peace in the world and included some passages that could be understood as criticism of the West German army, the Bundeswehr.[70]

The 1980 Volkstrauertag was also a first in that it led to a public debate about postwar public remembrance on the pages of the conservative local newspaper, *Cellesche Zeitung* (which had once employed Hanna Fueß). In 1976, the paper's long-serving arch-conservative editor-in-chief had left. From then, the paper occasionally published critical letters to the editor. It did so in late November 1980, with two letter writers, both of them Lutheran pastors, supporting their colleague's comments.[71]

Neither letter referred to the events of April 1945. The *Hasenjagd* was first mentioned again publicly in a book published in 1982, whose authors were highly critical of the apparent longevity of Celle's Nazi past.[72] On 17 June 1983, at the Waldfriedhof cemetery, the dead of April 1945 were commemorated publicly in a ceremony organized by a loose alliance of leftists associated with the trade union movement. That year a class of grade nine students in the suburb of Groß Hehlen came across a reference to the events of April 1945 when researching the beginning of Nazi rule in Celle. The students interviewed Wilhelm Sommer and circulated a report of their research, including a transcript of the interview.[73]

The year 1983 was crucial for *Vergangenheitsbewältigung* in Celle. It was the last occasion when Celle's conservative civic leaders seemed to be

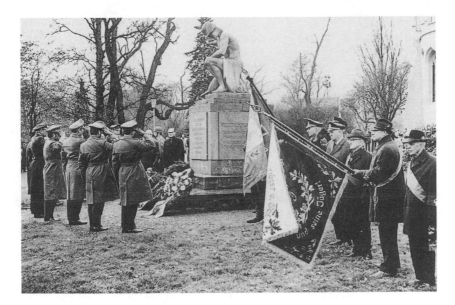

Fig. 6. Volkstrauertag ceremony in about 1966 at the war memorial in front of
the palace in Celle. The text fragment on the flag says, "and its hunters!" (Photo-
graph courtesy of Stadtarchiv Celle.)

oblivious to being branded *Ewiggestrige.* After the war, Celle provided a
popular venue for meetings of organizations of the far right. In 1983, the
Stahlhelm, a veterans' organization aligned with the extreme right, held its
annual meeting in Celle. With the backing of the majority of the city coun-
cil, Celle's mayor, Helmuth Hörstmann, himself a former member of the
SS, accepted an invitation to deliver a welcoming address to the meeting.
The meeting, and its condoning by the council, galvanized the opposition
against what the British observer had once termed the "Spirit of Celle."
The coalition of Lutheran pastors, left-wing Social Democrats, Commu-
nists, and environmentalists was a miniature replica of the West German
peace movement of the early 1980s. The campaign against the Stahlhelm
meeting was partly successful; it became politically impossible for Hörst-
mann to deliver his speech:

> In this town, we never before experienced such a stirring up of hatred,
> intolerance, and threats as we did in the past weeks and days . . . In
> Celle, you are in a soldiers' town . . . The preservation and recognition
> of military virtues, and love and loyalty for our country, are in accor-
> dance with the views of people in this area.[74]

In 1985, Celle residents again commemorated the victims of the *Hasenjagd* in a ceremony at the cemetery.[75] On the occasion of the fortieth anniversary of the bombing raid, the *Cellesche Zeitung* published an account of the killings.[76] The first sign that Celle's establishment was prepared to face aspects of the local Nazi past came with the publication of a festschrift to mark the 275th anniversary of the court of appeal in 1986.[77]

From the mid-1980s, with Celle's seven-hundredth anniversary approaching, its administrative and political leaders tried to change its retrogressive image and present Celle as a modern town. "Celle—700 Years Young" was the slogan chosen for the anniversary celebrations in 1992. In order to appear young, Celle had to shed its image of being a leftover from Nazi Germany. So it, too, had to acknowledge its Nazi past. The most embarrassing episode from that past concerned the *Hasenjagd.* Those honoring the dead of April 1945 at the cemetery had already demanded a new memorial for the victims. In 1985, a majority of the city council supported a proposal put forward by the Social Democrats, to put up a memorial plaque at the freight terminal. The council also commissioned the historian Mijndert Bertram to research the events of April 1945.

Influenced by Bertram's findings, and because Deutsche Bundesbahn (German Federal Railways) declined to allow the council to put up a plaque at the freight terminal, the council's Standing Committee for Cultural Affairs opted for a site in the so-called Triftanlagen, halfway between the town center and the railway station.[78] Following a proposal by the Greens, the council decided to hold an open competition for a more conspicuous monument to commemorate the victims of April 1945.[79]

When agreeing to a memorial in Triftanlagen, the majority of the city council had more than Celle's reputation in mind. Their acquiescence took the pressure off the war memorial in front of the palace, which was being repeatedly daubed with paint (see introduction). Celle's dissidents had on various occasions demanded its removal.[80] On the eve of the 1987 Volkstrauertag, its right arm and left hand were broken off.[81] The violation made the authorities offer a DM 10,000 reward for information leading to the identification of the culprit(s).

At the time of the competition for the Triftanlagen memorial, the kneeling warrior in front of the palace had been repaired, and a plaque added: "For the dead and victims of the wars, of *Gewaltherrschaft,* of expulsion, of terror, and of political persecution." Of 281 models submitted for the competition, the judges chose that of Johnny Lucius.[82] The Lucius memorial consists of a beech tree that is enclosed by a square horizontal frame of steel, set in a square bed of gravel. The terms of the competition had stipulated that a lengthy prescribed text about the events that occurred between 8 and 10 April 1945, be integrated into the memorial.[83] Lucius used raised letters to write the text on one side of the steel frame:

On 8 April 1945, four days before the occupation by Allied troops, Celle was the target of a large-scale air raid. A train parked at a siding at the freight terminal, which was to take 4000 men, women, and youths from several satellites of Neuengamme Concentration Camp to Bergen-Belsen, was hit. When the prisoners who had escaped the bombs tried to get to safety, members of the NSDAP and its organizations, of the army, of the police, and of the Volkssturm [home guard] hunted them down in the town and in the nearby Neustädter Holz and caused a bloodbath among them. About 500 of the survivors were marched by the SS to Bergen-Belsen.

The wording was contested in the city council and criticized by many of the artists who attended a colloquium convened by the municipal administration in July 1990, because it did not mention the involvement of civilians that had been established by Mijndert Bertram.[84] Whereas Jürgen Weber's *Jagdszene* upset some of Salzgitter's aldermen because it depicted German uniforms (see chap. 1), the representation of the *Hasenjagd* upset left-wing aldermen in Celle because it depicted only uniforms.

The memorial was unveiled on 7 April 1992. Celle's mayor, the chief rabbi of Lower Saxony, the local head of the Lutheran Church, and a Polish survivor made speeches. The latter, Marian Gnyp, had found out about the dedication ceremony by accident; Celle's mayor had rejected a proposal by the VVN to invite other survivors.[85] A picture accompanying a newspaper article reporting the ceremony depicts about thirty onlookers.[86]

In the context of the park, Lucius's memorial is inconspicuous. Children mistake it for a sandbox. As the steel frame and the bed of gravel are slightly raised, anybody walking on the path closest to the memorial could fail to see the text that is part of it. Not one of the students of a school situated two hundred meters from the memorial, when asked in 1995 by German writer, Peter Schneider, knew about it.[87] There are no such problems with another monument in the same park, for the dead of World War I: its purpose and its message are unmistakable. Unlike other designs, which tried to address and challenge the war memorial's presence, Johnny Lucius's design appears to be deliberately deferential, as if to respect the seniority of the earlier monument. Lucius's was one of the least offensive models submitted in 1990. In the first six years after its erection, the municipal administration organized a ceremony at the memorial to commemorate the anniversary of the killings only once, in 1995. The Lucius memorial was, however, on several occasions in the 1990s used by Celle's left-wing activists as a starting point for rallies against neo-Nazis.

After the war, Salzgitter took in many refugees from what used to be eastern Germany. They cultivated their own customs, but were also

Fig. 7. Johnny Lucius's memorial for the victims of the *Hasenjagd* in Celle

interested in Salzgitter's early history. The town and district of Celle also accommodated a disproportionately large number of German refugees.[88] However, by the time the first refugees arrived in Salzgitter, the local population was already outnumbered by migrants who had moved to the area since 1937, whereas in Celle, refugees from eastern Germany faced a self-confident and comparatively homogenous indigenous majority and were expected to assimilate. In Salzgitter, most refugees were accommodated in camps, whereas in Celle they were mainly billeted with local residents. In Celle, as in many other places in West Germany, refugees from eastern Germany were barely tolerated and, for a long time after the end of the war, tended to be put in their place. They did not gain nearly as much say in running the town as did people from Silesia in Salzgitter (which in post-war West Germany was the exception rather than the rule).[89] By the 1980s the overwhelming majority of the newcomers to Salzgitter and their children and grandchildren no longer identified with towns and villages they

or their parents and grandparents had left, but rather with the town they were living in. Their interest in the history of Salzgitter contributed to the unearthing of Salzgitter's early years. In Celle, whose postwar leaders have largely belonged to the town's traditional elites, any official moves to uncover the local Nazi past were met with much more circumspection than in Salzgitter.

When Salzgitter celebrated its fiftieth anniversary, the city presented itself as having come of age. An acknowledgment of its Nazi origins was presented as evidence of the city's maturity. This acknowledgment was provoked by a coalition of trade unionists, Greens, and others who considered themselves part of the Left. At times they numbered not more than two dozen, but from 1982 they have represented the views of a very sizable section of Salzgitter's population. They had the backing of the powerful local branch of the IG Metall and were often supported by the city council. By 1992 the views expressed by Salzgitter's former mayor in a panel discussion in 1982, namely that he was proud to have done his job during the Nazi years, would no longer have been supported by a majority in Salzgitter. Indeed, many of Salzgitter's citizens would then have pointed out that such a sense of duty had to be seen in the context of the exploitation of slave labor by the Reichswerke.

Salzgitter's acknowledgment of its Nazi origins can be partly explained in terms of the search of its citizens for a local identity. It was shaped by the interventions of survivors. Celle's engagement with the Nazi past was likewise provoked by oppositional forces. But their agenda was appropriated by the town's establishment. Celle's acknowledgment of the *Hasenjagd* became tantamount to closing what Mijndert Bertram in a book published to celebrate the seven hundredth anniversary termed "the darkest chapter in the town's history"[90] and was crucial for the town's corporate identity vis-à-vis the outside world. In the narrative that effected this acknowledgment, survivors did not feature. A brochure available from the town's Department of Tourism in 1997 proclaimed, "We in Celle are more than the town of half-timbered houses!"[91] In order to present their town as "700 years young," Celle even disowned Hermann Löns.[92] In 1994, the town honored Arno Schmidt (1914–1979)—whose avant-garde writings could not be more antithetical to Löns's—by naming the square in front of the Celle Public Library after him. (There are, however, still a Lönsweg, a Lönspark, a Hermann-Löns-Straße—and a Hanna-Fueß-Straße!—in Celle.)

Jews in Celle

In 1996 a group of Slovenian women who had been imprisoned in the Salzgitter-Bad satellite camp visited Salzgitter. They had survived working

for the Reichswerke, they had survived the bombing of the train that was supposed to deliver them to Bergen-Belsen, and they had survived the ensuing *Hasenjagd* in Celle. They wanted to visit the town, and the Arbeitskreis Stadtgeschichte in Salzgitter got in touch with the municipal authorities in Celle to ask whether the mayor or the *Oberstadtdirektor* would receive the women. Celle's *Oberstadtdirektor* granted the request. In his welcoming address, he recounted Celle's long German-Jewish history. Afterward the women were invited for a meal at an old people's home owned by the town. The manager of the home proudly confided to a German accompanying the women from Salzgitter that her staff had been in touch with somebody from the Jewish community in nearby Hannover to find out about the requirements of kosher cooking. The Slovenians, upon hearing about the kosher food they were enjoying courtesy of the town of Celle, chuckled. They had been political prisoners; some of them had been suspected by the Germans of aiding partisans. None of them was Jewish.[93] In his account of the *Hasenjagd,* Mijndert Bertram does not say that the prisoners were Jewish. Maybe the 1987 Celle dictionary of the local artist and radical amateur historian R. W. L. E. Möller was the source: there, the *Hasenjagd* is mentioned under the entry "Jews."[94] But Möller too does not say that the prisoners were Jewish, and his dictionary did not appear to be favorite reading for Celle's conservative local politicians. In fact, his decision to feature the account of the *Hasenjagd* under the entry "Jews" may have been as much a subconscious lapse as that performed by the *Oberstadtdirektor.*

In Celle, official *Vergangenheitsbewältigung* has become synonymous with a highly selective embracing of Celle's Jewish history. When I began researching the history of the memorial in Triftanlagen, I contacted the head of the Department of Cultural Affairs in Celle. I told her that I was interested in how Celle had publicly remembered the dead of April 1945. She immediately referred me to the director of the municipal archives who, she said, was very knowledgeable about Celle's Jewish past and could give me background information regarding a small exhibition about Jewish life in the town, which had been set up in Celle's restored synagogue. The latter featured prominently in brochures put out by Celle's Department of Tourism. They did not mention Lucius's memorial.[95]

The synagogue survived the Germany-wide Kristallnacht pogrom of 9 and 10 November 1938. Plans to demolish it in 1941 were not implemented,[96] and so it could be used again after the war when a new Jewish community constituted itself in Celle. By the 1960s the synagogue was abandoned, as most of the Jews who settled in Celle after 1945 had left Germany. In 1969 the city council acquired the synagogue from the Association of Jewish Congregations in Lower Saxony in order to pull it down, but at the last minute decided to restore it. In 1974 the synagogue was reopened as a museum.

To mark the occasion, the town of Celle published a festschrift. Jür-
gen Ricklefs, director of the municipal archives and official guardian of
the town's history, contributed a twenty-page article about the history of
the Jewish congregation in Celle. He mentioned the period from 1933 to
1945 in one short paragraph:

> In 1933, sixty-two Jewish *Mitbürger* [fellow citizens] lived in the town,
> which then had 28,029 inhabitants. Little is known about the fate of
> those Jewish *Mitbürger*. About 40 percent emigrated during the Third
> Reich, while about 50 percent moved elsewhere in the German Reich.
> Of three former Jewish *Mitbürger* it has become known that they
> passed away [*verstorben sind*] in a concentration camp. After the war,
> one citizen moved back to Celle from abroad.[97]

Considering Ricklefs was an archivist and an historian, his was a curious
choice of words. He reported hearsay rather than the results of meticulous
historical research: "little is known," he wrote, rather than "little could be
found out"—as if he feared to uncover a past that reached into his present.

While in 1974, Celle's official history did not include any specific
detail about what happened to the town's Jewish community, it included a
reference to an apparently well-known "fact": the Festschrift's foreword,
jointly signed by the mayor and the *Oberstadtdirektor,* opens by saying
that the Celle synagogue was saved "because of the thoughtful and coura-
geous stance of the then chief of the municipal fire brigade, Gustav
Krohne."[98] This version of events can be traced back to Krohne himself.
Yet far from having been intent on rescuing the synagogue, Krohne had
actually handed out the axes that were used to destroy its furniture. As the
synagogue was deemed too close to other historic half-timbered houses in
Celle's town center, it would have been dangerous to set fire to it. In fact,
an order by the chief of the security police, Reinhard Heydrich, instructed
the police to prevent the destruction of non-Jewish property and the
endangering of non-Jewish lives.[99]

In the 1990s a Jewish cemetery was the only other tangible evidence of
a Jewish community in Celle. Here both discontinuities and continuities
were most apparent. While the cemetery had not been used for a long time,
it was still being abused: "No Jewish cemetery in all of Lower Saxony has
been vandalized as often as the one Am Berge in Celle," said a 1986 article
in a local newspaper quoted by the author of a memorial book about the
Jewish community in Celle, who continued: "In March 1992, we, too,
detected further desecrations. Nearby residents told us that they had never
noticed the vandalism outside their windows."[100]

While the synagogue was restored in the early 1970s, the remains of
the *mikwe* (the ritual bath) of 1945, the Jewish mortuary of 1910, and the

house for the cemetery's caretaker of 1741 were unceremoniously demolished.[101] The mortuary was damaged, but it was by no means derelict. Maybe that explains why the authorities were in a hurry to create a fait accompli: a handwritten memorandum in the Celle municipal archives reveals that on 8 April (!) 1974 the *Oberstadtdirektor* instructed the relevant department to demolish the two buildings at the cemetery, because, as he put it: "These buildings are not to be regarded as historical monuments." Another note records the accomplishment of the task on that very same day.[102]

By the time Celle celebrated its seven hundredth anniversary, the town's Jewish past could safely become part of its history. In 1992 the author of the above-mentioned memorial book wrote that his search for people who witnessed the Jewish congregation in Celle before 1933 was unsuccessful.[103] By then, no personal continuities existed between the pre-Shoah Jewish past in Celle, and the present. The "young" Celle did acknowledge significant aspects of its Jewish history. In 1996, one of Ricklef's successors, Brigitte Streich, edited a collection of essays about Celle's Jewish history: four of the ten biographical sketches are about Jews who were killed during the Holocaust.[104] Earlier, Mijndert Bertram, the author of the commissioned booklet on the *Hasenjagd,* which had been published "in anticipation of the seven-hundred-year jubilee of the town of Celle,"[105] was asked to write a history of Celle that reached from World War I to the present. The first volume, covering the period 1914–45, was also published in time for the anniversary in 1992. In his comprehensive account of that period, Bertram did not shy away from tackling Celle's Nazi past. His summary of the "fate of those Jewish *Mitbürger*" contrasts sharply with Ricklef's earlier account:

> Of seventy-one persons of the Jewish faith who had lived in Celle on 30 January 1933, three died in the mid-1930s of natural causes; at least eleven fell victim to the National Socialist machinery of murder; thirty-four are known to have fled their persecutors' sphere of influence; and of twenty-three nothing certain is known. Such a statement does not say anything about, for example, the fact that the merchant Viktor Roberg escaped to America but died there in 1942 of the effects of his imprisonment in a concentration camp, from which he never recovered. The physical and psychological harm suffered by the survivors can be guessed at but can never be represented by naked figures.[106]

But while Bertram's text is very specific about the victims—he named sixteen of the Jews who still lived in Celle in September 1939—he did not name the local perpetrators.

The Jewish history that was being publicly told in Celle in the late 1990s was by and large the history of Celle's dead Jews. It did not contain references to the several hundred Jewish survivors who made Celle their temporary home after the end of the war.[107] In 1998, the Celle authorities granted Jews from Hannover the right occasionally to use the synagogue, but they did not invite Jews from the former Soviet Union to settle in Celle, because, as Stadtdirektor Christian Burchard explained to me, Celle's capacity had been exhausted by refugees from Bosnia.[108] Such an invitation would have enabled the handful of Jews who belonged to the newly reestablished Jewish congregation of Celle to marshal the number necessary to celebrate the Sabbath in Celle.

Like many other towns in Germany, Celle invited its former Jewish citizens to visit the town. Unlike many other towns in Germany, Celle discontinued the visiting program in 1989 because the authorities argued that whoever wanted to come and was entitled to an invitation had done so. One of those invited in the mid-1980s was Rosa Kameinskiy. She had spent the last years of the war in hiding; neither her Jewish father nor her Gentile mother survived the Shoah. In August 1945 she returned to Celle. A few months later she responded to a call put out by the local authorities to lodge claims for restitution. In a letter to the mayor of Celle, she wrote:

I am the daughter of the businessman Julius Wexeler. My father owned a clothes store in 14 Hehlentorstrasse. After the *Machtübernahme* [the installation of the NSDAP-led government in 1933], this shop was systematically boycotted. On 12 September 1944, my parents were imprisoned by the Gestapo. My father ended up in Sachsenhausen, my mother in Ravensbrück Concentration Camp.[109]

Rosa Kameinskiy kept reminding Celle's postwar authorities that the Jewish genocide was not something that had only happened to anonymous victims in Bergen-Belsen. On several occasions she approached the city council to help her establish a business. Her first application in March 1946 for a loan of five thousand marks was rejected because the aldermen did not consider it *angebracht* (appropriate) to help her in that way.[110] When she approached the council for the third time a couple of months later, the aldermen "affirmed that Ms. Kameinskiy is to be helped but that loans can only be granted if they are matched by securities" and decided to offer her a part-time job with the municipal administration.[111] Apparently Ms. Kameinskiy persisted in her attempts to set up a business in Celle. In November 1947, at about the same time as the *Hasenjagd* was last talked about publicly until the events were remembered again some thirty-five years later, the aldermen heard her case for the last time. No, they advised her, she could not be allocated a place to store tree stumps, as there was no

appropriate place available in Celle.[112] She eventually left Germany to settle in the United States.

When Rosa Kameinskiy was invited to return to Celle in 1985, the murder of her parents could be safely historicized. Not only that: in 1985, the lack of empathy shown by the council nearly forty years earlier had been conveniently forgotten. When the memorial to commemorate the events of April 1945 was unveiled in 1992, these events had been written up and become history. As had happened in Salzgitter with the memorial "for the victims of fascism," it was forgotten that there had been an earlier decision to erect a memorial for the *Hasenjagd* victims that was not implemented. Even those who from the early 1980s again made public the killings of 8–10 April 1945 could not imagine that these events had been widely talked and written about in Celle in the first two years after the end of the war. It was similarly forgotten that in 1946 the council nearly ordered the war memorial in Triftanlagen, which now appears to dwarf Lucius's work, to be demolished.[113] And the fact that one of the murderers, sentenced to death by the British and released from prison in 1952, was again regarded as a respectable citizen and not long after his release officially commended for his contribution to boxing, went unmentioned, too.

CHAPTER 3

Postwar Reconstruction in Hildesheim

Typical or unique buildings can be symbolic of a town's character. The buildings that could have stood for Salzgitter in the late 1990s included a smelter, one of the bland administrative buildings erected in the 1950s or 1960s, and the defunct department store in Lebenstedt. Salzgitter, notwithstanding the numerous villages that are part of the city, is an industrial town. And notwithstanding high unemployment and declining employment opportunities at the iron- and steelworks, at the Volkswagen plant, and in other factories, Salzgitter is still a blue-collar workers' town. By contrast, Celle is a lawyers' town. An ensemble of its most representative buildings would include one of the many half-timbered houses in the town center, a prison, and a courthouse.

Hildesheim is about thirty kilometers west of Salzgitter and sixty kilometers south of Celle. If a steelworker represents Salzgitter and a lawyer stands for Celle, then Hildesheim's representative would have to be a Catholic priest or a Lutheran pastor. Its symbolic buildings would have to include one of its many churches, as well as an example of the functional architecture of the 1950s and 1960s that is as prevalent in the center of Hildesheim as it is in Lebenstedt. As in Celle, these markers of Hildesheim's identity should also include a half-timbered house, albeit one that was rebuilt after the war.

Local discourses about *Vergangenheitsbewältigung* can be understood in the context of national discourses. The demands to commemorate the suffering of prisoners in Drütte, put forward on Salzgitter's fortieth anniversary, arose in the context of left-wing unionism and of the peace movement in West Germany. The decision by Celle's local parliament in 1946 to fund a memorial for the victims of the air raid and *Hasenjagd* of April 1945 was taken within the framework provided by the British occupiers. It was driven by widespread German anxieties specific to the first two postwar years. Local discourses about the Nazi past may also be seen

in the context of other, seemingly unrelated, local debates. In the course of this chapter, I recount the history—or what James Young has called the "biography"[1]—of a memorial in Hildesheim and place this biography in the context of other instances in which the local Nazi past has been publicly remembered. I also tell an incidental history that features a famous half-timbered building in Hildesheim.

"Destroyed by Sacrilegious Hands the 9th of November 1938"

With just over one hundred thousand inhabitants, Hildesheim is slightly smaller than Salzgitter but, unlike Salzgitter, considered a regional center of cultural and political significance. Established in the eighth century, Hildesheim was historically more important than Celle. Writing around the turn of the last century, Hermann Löns called it a "distinguished old lady who does not have to hide her past."[2] From the ninth century, Hildesheim was the seat of a bishop, who for most of its history was also the town's sovereign.

For several hundred years, Hildesheim also had a substantial Jewish population. In fact, the town's Jewish community was one of the oldest in northern Germany. But next to the town's world-famous churches—such as the Romanesque Michaeliskirche or the cathedral with its eleventh-century bronze columns and doors—Hildesheim's last synagogue hardly stood out. It was built in 1849 in the Lappenberg neighborhood, which lies in the part of Hildesheim known as Neustadt (New Town). Unlike the synagogue in Celle, the synagogue in Hildesheim did not survive the Kristallnacht pogrom in November 1938. In Hildesheim, the leader of the local SS contingent received instructions late on 9 November 1938 to arrange for the destruction of the synagogue within an hour.[3] A group of about ten SS men then forced the synagogue's caretaker to hand over the keys, and set fire to the building in the early hours of 10 November. The fire brigade belatedly fought the blaze—as in Celle, not least because of concerns that it would spread to adjoining buildings. By the time the fire was under control, the synagogue had been reduced to smoldering ruins. That same night, SA and/or SS men smashed the windows of businesses owned by Jews and looted their contents. They also arrested at least seventy Jewish men and took them to the police headquarters. Later police and SS led the prisoners, who had to remove their suspenders and shoelaces, through the center of the town, past the burned-out synagogue, to the local prison. From there, some of these men were sent to Buchenwald.[4]

The deportation of Jewish men to concentration camps in November 1938 was a temporary measure intended to make them and their families leave Germany. Once the war began, the Jews remaining in Hildesheim were trapped. Many of them were made to move to so-called *Judenhäuser,*

Fig. 8. Hildesheim's synagogue at Lappenberg (postcard). (Photograph courtesy of Stadtarchiv Hildesheim, Best. 952, Nr. 154/2/1.)

that is, houses exclusively occupied by Jews. In the early 1940s, Hildesheim's Jews were deported to ghettos and concentration camps such as Warsaw (on 1 March 1942), Trawniki near Lublin (on 31 March 1942), and Theresienstadt (on 23 July 1942). At least 165 of more than 500 Jews who had lived in Hildesheim in 1933 were murdered by the Nazis. Under the heading "Order Returns to Lappenberg," Hildesheim's daily newspaper reported on 14 June 1940:

> The site of the fire at Lappenberg is now being entirely cleared. The rubble and rocks have been taken away for future road works; larger chunks of concrete are for the time being stored at the municipal public works yards . . . Residents are hoping that the cleared site will be covered by a park or paving to prevent the formation of dust.[5]

Five years after Lappenberg residents worried about the level of dust generated on the site of the former synagogue, Hildesheim's citizens had become used to rubble and dust in their streets. Most of Hildesheim was in ruins as a result of massive air-strikes, most notably those of February and March 1945. It took a while until the lack of flowerbeds at Lappenberg was again seen as a problem. Eventually, the open space created when the remains of the synagogue were removed was made into a small park and

planted with trees. For forty years, a memorial stone at Lappenberg served as the only reminder of the Kristallnacht pogrom. It is 1.65 meters high and of rectangular shape with a metal plaque carrying an inscription. Having grown up in Hildesheim, I remember this stone from my childhood. I did not understand, or even imagine, it in the context of a local German-Jewish history. The church steeples of Hildesheim seemed to be too imposing to allow for anything but a fleeting and marginal Jewish episode in my town. Thus the memorial appeared as a reference to events that had happened elsewhere. I was not the only one who could not—or would not—imagine Jewish life in Hildesheim: of forty-six guidebooks on Hildesheim that were published between 1949 and 1992, nearly half mention the burning down of the synagogue in 1938, but only two refer to aspects of Jewish life in Hildesheim other than those immediately related to the 1938 pogrom.[6]

The decision to fund the memorial was made at a council meeting on 14 March 1947. According to the minutes, "Council voted unanimously to provide 3,600 marks in the next budget for a memorial stone at the site of the synagogue . . . A motion by Alderman Hanne to involve the public by way of a subscription was defeated to one vote."[7] Although the amount of money that was actually spent on the memorial was more than twice the sum allocated by the council, the design provided by Hildesheim's Department of Town Planning in July 1947 was only partially realized. The department had proposed a paved triangle with a base twenty meters long and sides thirty-two meters long, and a monument more than two meters high in its center.[8] The monument that was realized in 1948 is significantly smaller and is not part of a larger structure. It was, however, not only the first publicly funded memorial after the end of the war, but also one of only a handful of such memorials in Hildesheim. The great majority of statues had shared the fate of that of Emperor Wilhelm I (see introduction) and been melted down toward the end of the war, with many of them never replaced. The Lappenberg memorial has an inscription in Hebrew, German, and English. The English version reads: "This was the place of the synagogue destroyed by sacrilegious hands the 9th of November 1938." Neither naming the owners of those hands nor mentioning the wider context of the 1938 pogrom, the council had chosen a conventional solution.[9]

The proposal by SPD alderman Louis Hanne was rejected because his colleagues did not think that a public subscription would yield the funds required for the monument. They were right to be skeptical about the enthusiasm for such a memorial among Hildesheim's citizens. A newspaper report about the dedication ceremony on 22 February 1948 noted a "good turnout of representatives of the churches, political parties, and trade unions but the nearly total absence of the population of

Hildesheim."[10] Judging from the invitation distributed by the Jewish congregation of Hildesheim, the unveiling was foremost a Jewish affair. Most of the speakers were Jewish representatives. Confirmed participants included delegates from seven newly established Jewish congregations in northern Germany.[11]

For the next thirty years, this ceremony was to be the last public event in Hildesheim that was exclusively devoted to the victims of Nazi Germany and attended by high-ranking representatives of the city. The commemoration that followed the unveiling of the memorial at Lappenberg, in September 1948, was already marred by a row over the correct approach to Stalinist repression. One speaker used the occasion, which had been designed to honor the Nazis' victims, to talk about five men who had been sentenced to forced labor for taking part in an illegal protest in Soviet-occupied East Berlin, whereupon some of the audience left the room.[12]

The dedication of the Lappenberg memorial marked the end of a period of less than three years in which an antifascist consensus ensured that the crimes of Nazi Germany were named—however hesitantly—and many of its victims honored. In all zones, civic leaders had publicly demonstrated this consensus during elaborate commemorations. In Celle, one such event took place in September 1946, when representatives of the municipal and district authorities, of the churches, and of SPD and KPD attended a public ceremony in a local cinema that included the performance of Haydn and Beethoven quartets.[13] On the same day in Hildesheim, civic leaders laid wreaths at the local cemetery to honor Jewish and non-German victims of Nazi rule.[14] A year later, Hildesheim's Jewish community put up a headstone at the Jewish cemetery for several Jewish concentration camp prisoners who had been killed in Hildesheim. Hildesheim's *Oberstadtdirektor* attended the dedication ceremony and gave a promise that the city would protect, and care for, the graves.[15]

Between 1948 and 1977, the local newspapers commemorated the burning of the Hildesheim synagogue only on one occasion: in 1963, the smaller of the two daily papers, which tended to support the Social Democrats, carried an article to remind its readers of the twenty-fifth anniversary of the Kristallnacht.[16] The events of 10 November 1938 were, however, also mentioned in media reports about the judicial consequences of the pogrom. Soon after the city council's decision to fund a memorial, the former leader of the local SS was sentenced to three months in prison for his involvement in the pogrom. One of the policemen who had marched Hildesheim's Jews through the town's center on the day following the burning down of the synagogue was tried in 1948, and again in 1950, and sentenced to six months in jail. He did not have to serve this sentence as a result of one of the first laws passed by the newly constituted parliament of the Federal Republic of Germany, the Amnesty Law of 1949.[17] Like other similar trials

that were considered to be of local relevance—because the offenses had happened in Hildesheim, because the trial took place there, or because the defender was a local resident—those involving the policeman were reported in some detail in the local newspapers.

Between 1945 and 1977, there were other instances when the Nazi period was brought to public attention in Hildesheim. In 1961 and 1963, the city council decided to name twenty streets in a new suburb after opponents of the Nazis. The men and women who were thus honored included Catholic and Protestant priests, Social Democrats, and people linked to the failed coup of 20 July 1944.[18] They did not include any Communists. Nor did they include any local opponents of the Nazis. In Hildesheim, the *Viertel* comprised by those twenty streets soon became known as Genickschußviertel, a *Genickschuß* being a bullet in the neck.

In 1966, the city of Hildesheim made a prominent survivor an honorary citizen: Sir Hans Adolf Krebs (1900–1981), who was born and grew up in Hildesheim. According to the Nazi criteria, he was Jewish. He once claimed that "Hitler made me become a Jew"; his father had strongly believed in assimilation and had denied him any Jewish religious teaching.[19] In 1933, Krebs was dismissed from his job at the Freiburg University Hospital. He emigrated to England in June 1933, a month before the university's new rector, Martin Heidegger, terminated his appointment as a lecturer.[20] In 1953, Krebs was awarded the Nobel Prize for medicine and physiology. He could be made an honorary citizen of his native Hildesheim, however, only after it had been established that he had reapplied for German citizenship after 1945. In the 1960s, it was apparently inconceivable to honor a *foreign* opponent or victim of the Nazis—the streets in the Genickschußviertel were likewise named after Germans only.

In 1978, the city council named another street after Oskar Schindler, who had been declared a Righteous among the Nations by Israel's Yad Vashem Authority, and was later to be immortalized through Thomas Kenneally's novel, *Schindler's Ark,* and Steven Spielberg's film, *Schindler's List.* Unlike the men and women whose names previously featured in the Genickschußviertel, Schindler, who had died in 1974, could be linked to Hildesheim, where he had lived for several years after he had returned to Germany from South America.

Hildesheim had waited longer than most other towns in Germany before honoring opponents of the Nazis through street names. The city council refrained from once more renaming all streets that had been renamed between 1933 and 1945. Hildesheim's most central square, the former Paradeplatz, was renamed Paul-von-Hindenburg-Platz during the Nazi years, and in 1998 was still called after the former German president (1925–34). Maybe the council's reluctance to rename scores of streets in the second half of the 1940s was due to the aldermen's wariness about the

Fig. 9. Hildesheim's mayor, Martin Boyken, *left,* awarding the city's honorary citizenship to Sir Hans Adolf Krebs, 1966. (Photograph by A. Hartmann, courtesy of *Hildesheimer Allgemeine Zeitung.*)

longevity of the antifascist sentiment. Some street names allocated in postwar West Germany did in fact not survive beyond the early 1950s. In nearby Peine, for instance, the Sedanstraße and the Hindenburgstraße were renamed in 1949 after two opponents of Hitler, one of them Nobel laureate Carl von Ossietzky. In 1953, Peine's local parliament caused much irritation when it decided that the streets should revert to their old names.[21]

Hotel Rose

When the new synagogue was built in the mid–nineteenth century in the Neustadt, most of the houses in this part of Hildesheim dated from the sixteenth and seventeenth centuries; the Neustadt was "new" in relation to the older town center. The half-timbered houses in the Neustadt were considered not nearly as attractive as those in the older part of the town, which gave Hildesheim the reputation of being the "Nuremberg of the North." Before 1945, Hildesheim's fame was more than a match for Celle's. When the latter called itself the "Nuremberg of Eastern Hannover" in 1936, it was on account of its allegiance to the National Socialist cause rather than because of its half-timbered houses.[22] The gem among Hildesheim's secular buildings was the Knochenhaueramtshaus, a seven-story half-timbered house facing the town square. It had been completed in 1529 and was initially owned and occupied by the butchers guild. In 1884 a fire destroyed its upper stories. The city council did not hesitate to allocate the sizable sum of thirty thousand marks for its restoration.

Like most of the "old" Hildesheim, the Knochenhaueramtshaus, held to be the most beautiful half-timbered building in Germany, if not in the world, fell victim to an Allied bombing raid on 22 March 1945, only two weeks before Hildesheim was occupied by the American army. A pile of ash was all that remained of the famous building. The raid, by Canadian and British bomber squadrons, resulted in the most severe damage sustained by Hildesheim during the war.[23] It cost more than one thousand lives, or about 60 percent of all casualties from Allied air raids on Hildesheim. Of the town's fifteen hundred half-timbered houses, thirteen hundred were destroyed. The raid of 22 March was aimed at the city center; the pilots were not given any specific targets of strategic importance but instead instructed to drop their loads around the spire of the Andreaskirche, the most conspicuous of Hildesheim's churches.

Very soon after the war, various groups of citizens began campaigning for the reconstruction of the Knochenhaueramtshaus.[24] The city council was not openly opposed to such a plan, but with 70 percent of Hildesheim destroyed or damaged, there were more pressing needs on its agenda. While the majority of aldermen never explicitly ruled out a reconstruction of the Knochenhaueramtshaus, in 1951 the council voted in favor of an enlargement of the town square, partly to provide additional parking. This decision, which was also approved by a majority of voters in a referendum in 1953, presumed that Hildesheim's erstwhile symbol would not be rebuilt, at least not on its original site.

Ten years after the referendum, a seven-story hotel was erected where once the Knochenhaueramtshaus had stood. The design, by Hannover architect Dieter Oesterlen, signaled that Hildesheim preferred to celebrate

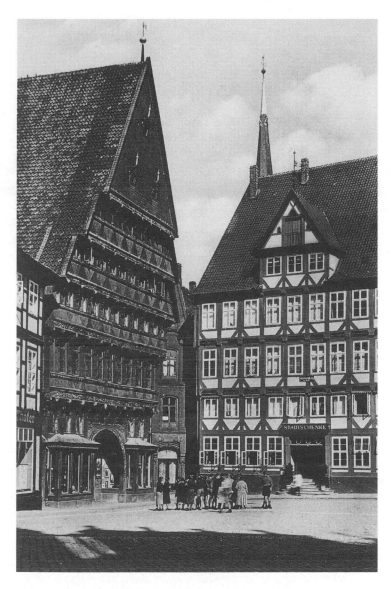

Fig. 10. Knochenhaueramtshaus, c. 1930 (postcard). (Photograph courtesy of
Stadtarchiv Hildesheim, Best. 952, Nr. 57/10.)

Fig. 11. Hildesheim's market square in 1946. A pile of rubble was all that remained of the Knochenhaueramtshaus. (Photograph courtesy of Stadtarchiv Hildesheim, Best. 951, Nr. 473.)

the *Wirtschaftswunder* rather than cry over the losses of the war. The hotel was named Rose, after a famous rosebush that climbs the wall of the cathedral's apse. According to local legend, the rose is more than one thousand years old, having been sighted in the ninth century by the Carolingian king Ludwig the Pious, who ordered a chapel to be built next to it. The bush burned in a bombing raid but miraculously started to bud in 1946 and was blooming the following year. Its recovery was said to signal that Hildesheim, too, was about to blossom again.[25] The rosebush became a symbol for Hildesheim's recovery and testified to the organic links between the city's venerable past and its postwar present.

Eighteen years after the bombing raid, Hildesheim's new town square was finally complete. While most of the old secular buildings in the center of Hildesheim were gone for good, its main churches—also heavily damaged during the war—had by then nearly all been restored to their former glory. The restored cathedral and Michaeliskirche, the latter having been nearly completely destroyed, were both consecrated in 1960. In 1965, the last of Hildesheim's major churches, the Andreaskirche, which had initially been earmarked for demolition, followed.[26] Now, samples of bland postwar architecture, such as Hotel Rose, contrasted sharply with the imposing symbols of the Catholic and Protestant presence.

Fig. 12. Hotel Rose, with the spire of the Andreaskirche in the background, 1986. (Photograph by Goetzen, courtesy of Stadtarchiv Hildesheim, Best. 951, Nr. 2345/3.)

Demands for the reconstruction of the Knochenhaueramtshaus were subdued, particularly after the 1953 referendum, but they never ceased. The Knochenhaueramtshaus was a symbol for Hildesheim's perceived status as a distinguished old lady. Little did it matter that its upper stories, at least, dated from the late nineteenth rather than from the early sixteenth century. The collective nostalgia of Hildesheim's citizens focused on the building. It represented a time when Hildesheim had stood its ground in relation to neighboring Hannover. It was tangible proof of Hildesheim's seniority and of Hannover's status as a parvenu that in the wake of the

Napoleonic wars had usurped the political power that rightfully belonged to the "distinguished old lady."

In 1970, with the twenty-fifth anniversary of Hildesheim's destruction approaching, a group of fifteen local citizens, most of them journalists, commenced a new campaign for the reconstruction of the building that had once contributed so prominently to Hildesheim's fame. This time both the city's administration and the majority of the city council favored the idea, which also had considerable popular support. Significantly, the initiative predated what were to become national phenomena from about 1973, namely the rediscovery of historical town centers and a renewed interest in architectural preservation that was paralleled by emerging environmentalist concerns. It was not until 1980, for example, that Celle's Department of Tourism decided to switch the focus of their brochures from the town's location on Lüneburg Heath to its half-timbered houses.[27] In 1970, all parties concerned agreed, however, that for obvious reasons the Knochenhaueramtshaus could not be rebuilt on its former site.

Thirteen years later, the city council debated the reconstruction of the facade of another historical building facing the old town square, the Wedekindhaus. As it became apparent that this project was feasible, not least because Hildesheim's citizens demonstrated their support by donating more than six hundred thousand marks for it, the reconstruction of the entire former square suddenly appeared to be an option. One of those speaking out in favor of the reconstruction of the Wedekind facade, which was eventually approved by the conservative majority on the council, was the city treasurer, Hermann Siemer. On 2 March 1983 he said: "The Wedekind facade has more to offer than if the funds went into social projects. Building the Wedekind facade is in fact a measure of social policy. You have to see these things in economic terms."[28]

A *Judendenkmal*

While Hildesheim's old town center was nearly completely wiped out in the Allied bombing raid of 22 March 1945, much of the Neustadt, including the immediate neighborhood of the synagogue, was spared. The site of the former synagogue, on the so-called Lappenberginsel, was a block of triangular shape flanked by two narrow streets with small half-timbered houses on two sides and a large redbrick building from the late nineteenth century at the third. In the first twenty-five years after the war, little attention was paid to the old houses that date from the sixteenth century. Many of them were run down and lacked basic sanitation. They were often inhabited by the poor and old. At one stage it looked like some of these houses would be pulled down in order to widen the existing streets and provide room for new houses. But from the 1970s, the area around Lappenberg was slowly gen-

trified. Public opinion demanded that what was left of the old Hildesheim be saved. The city council was under some pressure to redevelop the Lappenberg neighborhood while at the same time preserving the buildings dating from Hildesheim's early-modern past. In the 1970s, however, neither the foundations of the synagogue nor the memorial featured in public debates about what to do with the Lappenberg.[29]

Only since 1978 have ceremonies at the site of the former synagogue marked the anniversaries of the pogrom of 9 November 1938. On 9 November 1978, Hildesheim's mayor and its *Oberstadtdirektor* laid a wreath at the memorial at Lappenberg. Once again a newspaper report noted critically that not many citizens joined the city's representatives.[30] This was perhaps not surprising, as the newspaper had not advertised the ceremony. Many of Hildesheim's citizens did, however, attend another event that same evening (which had been advertised):[31] an ecumenical church service in which texts were read in memory of Hildesheim's murdered Jews. For the fortieth anniversary of the pogrom, the only remaining local daily paper also published a detailed account of the events of 9 and 10 November 1938 in Hildesheim. The article, which ran over several pages, was adopted from an essay written by a local high school student.[32]

But the attention given to the anniversary of the 1938 pogrom did not rival that devoted to 22 March, the anniversary of the town's destruction. Every year, the church bells were rung to mark the time when the bombers dropped their loads on Hildesheim. Nor did the commemoration on 9 November 1978 attract as much attention as Volkstrauertag later that same month, when more local residents wanted to attend the civic commemoration in the town hall than could be accommodated. In fact, the first conspicuous observance of 9 November occurred in a year when more local residents took part in the public commemorations on 22 March and on Volkstrauertag than had done so for many years previously. Incidentally, the 1978 Volkstrauertag rituals were more inclusive in Hildesheim than in Celle and included the laying of a wreath at Lappenberg.

A couple of months later, the persecution of Jews became a major talking point in Hildesheim and everywhere else in West Germany, when the NBC miniseries *Holocaust* was broadcast on West German television (see chap. 6). But while the fate of the Weiss family captivated Hildesheim viewers, there is no indication that the outpouring of emotions extended to the locally specific aspects of the Holocaust. According to what Frank Stern called the "geography of genocide,"[33] the murder of Jews was something that happened "in the East." This latter point was also emphasized in the public discourses that accompanied Hildesheim's last Nazi trial. The defendant, Leopold Puradt, was an ethnic German from Poland who had moved to Hildesheim after the war. He was charged with murdering Jews while working as an auxiliary policeman in his native Losice. After a

widely reported court case lasting from 1979 to 1981, Puradt was acquitted of the murder charge. He was not cleared of the accusation of having killed Jews; however, a conviction on the lesser charge of manslaughter was not possible because that offense came under the statute of limitations. The Puradt trial reminded Hildesheim's citizens of local dimensions of debates about a national *Vergangenheitsbewältigung,* particularly in relation to the statute of limitations for murders committed under Nazi rule (see chap. 6). It did not occasion public reflections on connections between local and nonlocal histories of the Nazi past.

The commemoration of the forty-fifth anniversary of the Kristallnacht pogrom was again attended by the mayor of Hildesheim and other representatives of the city.[34] In the year 1983 much was publicly said about the Nazi past, including some of its local aspects, in Hildesheim. For the fiftieth anniversary of the so-called *Machtergreifung* (seizure of power) in 1933, the local daily newspaper published a four-page pullout.[35] The paper asked its readers to send in personal reminiscences about the Nazi years. One of those responding was Sigurd Prinz, whose father had been the lessee of the Stadthalle, a former church used for concerts and other functions. In 1945, Prinz recalled, his father had been ordered to accommodate some five hundred concentration camp prisoners who had been sent to Hildesheim to help clear the rubble after heavy bombardments on 22 February 1945.[36] The prisoners were probably mainly Hungarian Jews who had been transferred from Auschwitz via Groß-Rosen to Bergen-Belsen. When Hildesheim was bombed again on 22 March, the Stadthalle was hit and many of the prisoners were killed. The article reporting Prinz's information remained inconsequential until many years later; in 1983 Hildesheim's citizens were not yet ready for local aspects of the Shoah other than Kristallnacht.

The idea of commissioning a larger memorial was probably born the following year. The old memorial was now considered too small. The chairman of the city council's Standing Committee for Town Planning and Construction described it as "a pathetic and pitiful stone."[37] And, as early as 1984, some local politicians were apparently concerned about the need *adequately* to commemorate the fiftieth anniversary of the pogrom. After all, nearby Göttingen had long had a sizable memorial (see chap. 1).

Funding for the new monument was provided by the Weinhagen Foundation, a trust belonging to the city of Hildesheim.[38] The board of directors and board of trustees of the foundation were largely identical with Hildesheim's most senior public servants and key members of the city council. The city treasurer was one of two ex-officio managing directors of the trust. Treasurer Hermann Siemer, then in his early forties, had studied philosophy and theology before embarking on a career as a public servant. He became the driving force behind the new monument. Siemer conceived

of it as one of three memorials to be funded by the foundation, the others being monuments to commemorate the Protestant reformer Bugenhagen and the Catholic bishop Godehard.

The foundation's board of trustees wanted a representative and conspicuous monument at Lappenberg that could be easily "read" by passersby. Unlike Celle's authorities, the Weinhagen Foundation did not risk the imponderables of an open competition. Instead it approached four artists who had worked in Hildesheim before. Of the designs submitted to the foundation, the board of trustees chose that of Elmar Hillebrand, an artist and professor at the College of Arts in Cologne, who proposed a cube with motifs from biblical history. Hillebrand then agreed to involve the three artists whose designs had been rejected. The four of them drew lots and each created one side of the cube, with Hillebrand also providing the overall design.

Hillebrand and fellow artists Theo Heiermann, Jochen Pechau, and Karl Matthäus Winter, created a cube of red marble, 2 by 2 by 2.3 meters, that sits on a bronze base. A bronze model of the temple of Jerusalem, carried by four lions, tops the cube. Including that model, which was also designed by Hillebrand, and the base, the monument reaches a height of about 3.5 meters. Each side of the cube has a theme: the Jews as the Chosen People; Jewish Law; Jewish cult; and persecution. A series of motifs in bronze or marble bas-relief illuminate each theme. For the side that depicts the theme of persecution, these motifs include the imprisonment of the Jews by Nebuchadnezzar in Babylon, the conquest of Jerusalem by the Romans, the burning of Hildesheim's synagogue on the night of 9 November 1938, the deportation of Jews from the Warsaw ghetto, and the killing of a Jewish mother and her child by a member of the SS. The last three bas-reliefs are based on well-known photographs. The image of the burning synagogue has a smaller inset that shows Hildesheim on fire as a result of the Allied bombing raid of 22 March 1945. To accommodate several different motifs as well as texts, a Star of David divides each side into thirteen segments. A low wall marks some of the foundations of the synagogue.

The memorial cube alone cost DM 700,000; the total costs of the memorial amounted to DM 1.1 million.[39] According to Hermann Siemer, the memorial was funded by the Weinhagen Foundation rather than directly through the city's budget because it might have been difficult to gain the support of the majority of the city council for the project. Hildesheim's politicians were not enthusiastically in favor of a new memorial, Siemer explained to me, but neither were they openly against the proposal, because

> people do not like to say things that can be interpreted as anti-Semitic. Now if you propose to build a *Judendenkmal* [memorial

for/of Jews], then the local politician won't say, "I'm against it." Because then he would be shown in a bad light. Therefore he needs to resist cautiously.[40]

The—overall comparatively modest—public dissent regarding the memorial was most pronounced when the foundations of the synagogue were excavated in November 1987 and dissipated in the couple of months before the unveiling of the monument. After reviewing the results of the excavation, the chief curator of monuments in Lower Saxony struck a chord with some local residents when he asked: "Why should there be a memorial here—after all the whole area is already a memorial?"[41] Those responsible for the commissioning of the memorial were anxious to obtain a public consensus among Hildesheim's citizens before the artists embarked on the actual construction of the monument. As would later also happen with the Weber sculpture in Salzgitter, a life-size model of the cube was exhibited at the designated site in March 1987, partly to alleviate concerns that the memorial would be too imposing.[42] Once completed, the cube was encased in a large wooden box for fear that right-wing extremists would damage it before its official unveiling.[43] As with similar memorials in other German cities, the discussion about its form was influenced by anticipation of its defacement.

The memorial was officially handed over to the city of Hildesheim and its citizens in a ceremony on 9 November 1988. There were speeches by the mayor, by Hermann Siemer (representing the Weinhagen Foundation), by two Jewish survivors who were then living in the United States, by a non-Jewish writer who described his witnessing the pogrom in two other German cities, and by a representative of the Ecumenical Judeo-Christian Association, a group of Hildesheim Christians who have been particularly interested in the Jewish origins of Christianity. This time, the dedication ceremony was well attended.[44]

Whereas the controversies about whether or not this particular memorial should be built had either not been carried out in public, or had been rather subdued, the ceremony on 9 November 1988 was followed by a heated and public debate. This was due to a passage in Siemer's speech:

Auschwitz begins or can begin everywhere, where children are mistreated or just neglected. Auschwitz begins in those laboratories where experiments are made with human embryos, allegedly in the name of progress. And Auschwitz also begins here, may God have mercy on us, where we have come to an agreement that no human being has the unconditional right to birth and life. Auschwitz didn't first begin with Auschwitz, and Auschwitz need not end there. Auschwitz begins in our hearts.[45]

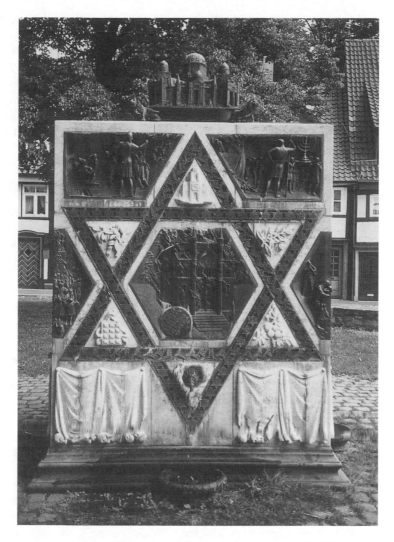

Fig. 13. Motifs depicting the persecution of Jews on a memorial by Hillebrand,
Heiermann, Pechau, and Winter at Lappenberg, Hildesheim

Siemer had made an unmistakable reference to the Federal Republic's
abortion laws, which permit abortions up to the third month of preg-
nancy under certain, closely defined conditions. The debate about these
laws, which were reformed between 1972 and 1976, has divided Ger-
mans for decades. Conservative politicians and the leaders of the
Catholic Church in Germany had vehemently opposed the liberalization

of the old, more restrictive, laws that was pushed through by the major-
ity of the SPD.[46]

Siemer was not the only one who promoted a memorialization of the
victims of Nazi Germany while at the same time pursuing an agenda that
was informed by his own political interests. In Hildesheim, the public
memories promoted by the city's political leaders have been entangled
with those championed by the Catholic and Lutheran churches. Unlike in
Celle, but not as successfully as in Salzgitter, the official memorialization
of the local Nazi past has been loudly contested on various fronts. As in
other cities in West Germany, the local branch of the VVN was research-
ing locally specific aspects of the Nazi past long before anyone else.

The first publication that provided a detailed account of the Nazi past
in Hildesheim was Hans Teich's *Hildesheim und seine Antifaschisten*
(Hildesheim and its antifascists), which was published posthumously by the
VVN's Hildesheim branch in 1979.[47] Like Gerd Wysocki in Salzgitter,
Teich was doing the research for his book largely by himself: "These manu-
scripts are the result of a two-year solo effort," he wrote in 1975, six months
before his death.[48] Teich was a prominent Communist and trade unionist.
Before 1933 he was one of the leaders of the KPD in Lower Saxony and edi-
tor of a Communist newspaper. Originally from Dresden, he had moved to
Hildesheim in 1940 when he found employment with the Trillke-Werke, a
metalworking company, for which he continued to work after 1945. During
the Nazi period, Teich was active in the antifascist resistance. He was
arrested repeatedly and harassed by the Gestapo. After the war, he helped
set up the IG Metall in Lower Saxony, became chairman of the Trillke-
Werke's *Betriebsrat* and represented the KPD in the first state parliament.

The cover of Teich's book is symptomatic of its content: a drawing
depicts three men meeting against the backdrop of the burning synagogue
at Lappenberg. Their dress signifies their working-class background.
Under his arm, one of them holds copies of the journal *Ran,* which was
produced and distributed by local Social Democrats and Communists
between June and August 1933. None are talking, as if the men could only
communicate by unwaveringly looking into each other's eyes and firmly
shaking each other's hands. Their demeanor conveys a strong sense of
determination, and awareness of the dangers of their meeting. The perse-
cution of Jews is indeed merely part of the wider context in Teich's book:
its protagonists are Communists, Social Democrats, and trade unionists.
Nearly all of them are men. Teich wrote about the suffering of non-Ger-
man forced laborers in Hildesheim. But he did not mention the systematic
murder of Sinti and Roma, the persecution of gay men and those classed
as social deviants, and the local aspects of the Nazis' euthanasia program.

For the VVN, the honoring of the Nazis' political opponents often

went hand in hand with exposing the West German elites for either discrediting antifascists or for not distancing themselves from old or new Nazis. Teich's book, for example, lists twelve judges and prosecutors who worked in Hildesheim after 1945 although they had distinguished careers as judges or prosecutors under Nazi rule. From the late 1970s, the question of whether or not, or how, Hildesheim needed to distance itself from the Nazi period was the subject of heated public debate. In 1978, shortly before the city council decided to hold a commemorative ceremony at Lappenberg, the aldermen debated the implications of a decision their predecessors had taken unanimously on 3 April 1933. On that date the council had awarded honorary citizenship to Adolf Hitler.[49] The decision had never been revoked.

When the council debated this matter in 1978, 1982, and 1983, discussions were complicated by two issues. The first concerned a legal technicality: while Hitler was undoubtedly an honorary citizen from 1933 until 1945, his citizenship might have ended with his death. The majority of aldermen claimed that they could not strip him of an honor that he had already lost. The second issue had to do with other recipients of the highest award that can be bestowed by the council. In April 1933, Paul von Hindenburg had also been made an honorary citizen. The Christian Democrats were not prepared to condemn the man who in January 1933 had appointed Adolf Hitler to lead the German government. In 1983, Gerold Klemke, the mayor and a Christian Democrat, argued: "The eighty-five-year-old's inadequacies, his weakness, his resignation, and his yielding to the pressure from powerful political forces, possibly due to senility . . . cannot be equated with criminality."[50] A formal reappraisal of Hindenburg's role by the council would have also necessitated the renaming of the square that the Nazis had named after him.

The other deceased honorary citizen, whose achievements became the subject of much controversy from 1978, was Ernst Ehrlicher, who had served as mayor of Hildesheim from 1909 until 1937, and then again from April 1945 until October 1945. Like fellow Freemason Ernst Meyer, mayor of Celle from 1924 to 1945, Ehrlicher had compromised himself in order to retain his job after the Nazis assumed power. As early as March 1933, he had called upon Hildesheim's citizens to cooperate with the new regime, reasoning that "what alone matters is the destination pointed out by Hitler, and not the road leading to that destination."[51] Ehrlicher's role between 1933 and 1937 was vehemently defended by Hildesheim's conservative establishment. By speaking up for Ehrlicher in 1978, Hildesheim's conservatives were also defending the local politicians who had decided to honor him in 1950. In a letter to a local newspaper, the former director of Hildesheim's municipal archives, Helmut von Jan, wrote:

Now that some fools reproach Ehrlicher for harmless political state-
ments after March 1933, it has to be remembered that the Hitler of
1933 was not identical with the Hitler of 1938–1945, because he still
preached peace with all nations, genuine *Volksgemeinschaft,* and
equal rights for Germany. *Then, one could, and indeed had to, fully
agree with this stance!*[52]

The notion of *Volksgemeinschaft,* also invoked by Salzgitter's *Ober-
stadtdirektor* in 1952, continued to have its attractions—even for Germans
like Jan who could otherwise not be suspected of being closet Nazis. One
former resident of Hildesheim who would not have agreed with Hitler's
ideas of *Volksgemeinschaft* in 1933 was of course Hans Adolf Krebs, who
left Germany that same year. When the city of Hildesheim made him an
honorary citizen in 1966, the local newspaper reported: "Professor Krebs
was delighted to learn that Dr. Ehrlicher, whom he remembers well as a
mayor from his youth, is among the men who after the war were made
honorary citizens by the city of Hildesheim."[53] Krebs's reported comment
would have been perceived as an expression of his desire to return to the
fold from which he was expelled in 1933.

When Krebs died in 1981, the city placed an advertisement in the
local paper that was signed by the mayor and the *Oberstadtdirektor:* "The
deceased grew up in our old city, to which he remained attached through-
out his life, even though the *Gewaltherrschaft* drove him out of Germany
in 1934 [*sic*]."[54] In 1948, an earlier generation of Hildesheim's political
leaders did not identify with the "sacrilegious hands" that set fire to the
synagogue. In 1981, the representatives of the city of Hildesheim did not
see themselves as in any way connected to the *Gewaltherrschaft* that made
Krebs leave his native Germany. The text of the advertisement suggests
that the *Gewaltherrschaft* was somehow external to "our old city."

"The Joy of the People of Hildesheim"

The erection of the new memorial for the Hildesheim synagogue in 1988
became an integral part of the redevelopment of the Lappenberg. The old
houses were renovated. The local newspaper suggested that one of them
had a particular *Leidensgeschichte* (tale of woe), thereby articulating what
had been one of the underlying assumptions of local public discourse
since the late 1970s, namely that public policy needed to be guided by a
sense of empathy with Hildesheim's half-timbered houses.[55] The redbrick
buildings were demolished and replaced by a row of two-story houses
that were said to fit better into the sixteenth-century streetscape. Plans for
a widening of the existing streets were shelved; in fact, the Lappenberg
became a cul-de-sac.

Notwithstanding the attention and funds devoted to the Lappenberg and to other parts of the Neustadt, in the late 1990s these neighborhoods were no longer considered the most obvious showcases of the old Hildesheim. In 1984, the city reacquired the block of land formerly occupied by the Knochenhaueramtshaus. Three years later, the hotel built in 1963 was demolished, and the foundations were laid for the new Knochenhaueramtshaus. The rebuilding of Hildesheim's most famous half-timbered house was reported in detail in the local media. In 1989, a restaurant opened its doors in the new building. On 22 March 1990, the forty-fifth anniversary of the destruction of the town, a new local history museum opened in the reconstructed Knochenhaueramtshaus. About 40 percent of the total costs of this and of the building next door, the former offices of the bakers guild, were raised by Hildesheim's citizens and businesses.

In Hildesheim, as in other German cities, the enormous energies that went into reconstructing historic buildings, particularly from the early 1980s onward, are testimony to a collective desire. The Knochenhaueramtshaus, the reconstructed Römerbergzeile in Frankfurt, and other similar projects appear to proclaim that the Nazi years and World War II did not really happen. The physical re-creation of pre-Nazi Germany is to deny a loss and make the past unhappen. The impossibility of this project was succinctly stated by Hildesheim's famous son, Hans Adolf Krebs. Shortly before his death in 1981, he wrote about his departure from Germany in 1933: "I was never to see again the town I knew and loved as a child for it was to be completely destroyed by bombs on 22 March 1945."[56]

Although Krebs gratefully accepted the honorary citizenship offered to him, he never reclaimed Hildesheim. But Hildesheim reclaimed him. An exhibition in 1990, one of the first in the newly reconstructed Knochenhaueramtshaus, celebrated his ninetieth birthday. It was accompanied by a small book that contained translated extracts from Krebs's memoirs and quoted him misleadingly in the title: "Meine Liebe zu Hildesheim hat nie aufgehört" [I have never lost my love for Hildesheim].[57] "I have never lost my love for it although my enforced emigration greatly strained my emotional attachment and disrupted my physical connection with it for sixteen years," Krebs had written about his former hometown in his memoirs. "Much as I had loved Hildesheim, my early liking for England and its people had quickly deepened to the point of feeling it to be my real home."[58] The reclaiming of Jewish émigrés, and the insistence that they had remained loyal to Germany, were not peculiar to Krebs and Hildesheim. In 1965, Nelly Sachs was awarded the prestigious Peace Prize of the German Booksellers' Association in Frankfurt. She was then hailed in Germany as a poet of reconciliation. FRG president Heinrich Lübke thanked her, a woman who had been most reluctant even to visit Germany, for having remained "faithful to her homeland."[59]

**Fig. 14. Hildesheim's market square with Knochenhaueramtshaus in 1999.
(Photograph by D. Neumann.)**

At the beginning of the 1990s, Hildesheim had finally recovered from the effects of war and Nazi rule—or so many of its civic leaders suggested. The redevelopment of the market square and of the Lappenberg, including the building of the memorial, were projects that had the support of Hildesheim's citizens. Hildesheim's citizens have been proud to have undone the symbolically most important damage inflicted in the bombing raid of 22 March 1945 by rebuilding the Knochenhaueramtshaus. They have also been proud of the new memorial at Lappenberg that has effectively replaced the synagogue. In the conclusion of a book about Hildesheim's destruction and reconstruction, the influential local journalist Menno Aden found in 1994 that

> Hildesheim in 1994–95 is a new town on an old ground. The ash did not cover the memory of a history of more than one thousand years, nor the will to live for tomorrow. It is a town that in these months and days remembers the events of half a century ago with sadness, with a sense of outrage, but also with shame. Yet it is also one that looks ahead soberly to the next millennium, knowing full well that new challenges are to be met.[60]

Publicly displayed shame, as in the Lappenberg memorial, in fact made it possible for Hildesheim's leaders to draw attention to the town's victimization during World War II. In 1991, the mayor and the *Oberstadtdirektor* joined the mayor of Pforzheim in lodging a protest with the British embassy against the erection of a memorial for Marshall Harris in London.[61] In Hildesheim, as elsewhere in Germany, Harris has been held responsible for the destruction of German towns.

In the immediate postwar years, memorial services for those murdered by Germans regularly preceded commemorative ceremonies for the German war dead; in Hildesheim, the first official commemorations for the victims of the Allied bombing raid on 22 March 1945 took place only in 1950.[62] More recently, it seemed as if the people of Hildesheim needed to make a conclusive statement about the events of 10 November 1938 before they could memorialize the town's destruction by Allied bombers: six years after the erection of the new memorial at Lappenberg, a memorial plaque dedicated to the "victims of war and terror" was unveiled at the market square. It commemorates the raid of 22 March 1945 and "is meant to express the joy of the people of Hildesheim about the reconstruction of the historic market square."[63] The first memorial in Hildesheim explicitly to commemorate the victims of the Allied bombing raid of March 1945, however, was the monument at Lappenberg: the burning city—by then long *judenrein*—is depicted on the side of the cube dedicated to the theme of persecution. Only the Lappenberg memorial of 1948—which was retained—and its veiled reference to the arsonists may now remind local residents of victimizers other than Marshall Harris.

The conspicuous observance of the fiftieth anniversary of the Kristallnacht pogrom paved the way not only for the reconstruction of the Knochenhaueramtshaus but also for the extensive commemorations on the fiftieth anniversary of the town's destruction. They could have served as the final chord of the official history of Hildesheim under Nazi rule. They did not, because of the persistence of some local citizens who continued to probe the local Nazi past, and, even more so, because of the questions asked by Jews and other survivors.

CHAPTER 4

Survivors

Former forced laborers and concentration camp prisoners visiting Salzgitter in 1992 and 1995 had a big impact on how the establishment of the city of Watenstedt-Salzgitter in 1942 and Liberation in 1945 were publicly commemorated and remembered in the 1990s. For Salzgitter residents involved in the campaign for a memorial at Drütte, meeting a survivor was often a formative experience. Such an encounter could easily change the nature of their political activism: what once was the outcome of abstract analysis and of strategic considerations became the matter of a personal commitment. Regardless of whether or not this commitment was ever articulated, it was made to another person rather than to a cause. When Hildesheim's mayor, in his speech on 9 November 1988 at Lappenberg, suggested that the events of 1938 were almost part of the present, he did so with reference to two survivors attending the dedication ceremony.[1] The presence or absence of survivors—and the ways in which their absence or presence have been noted, ignored, or imagined—has shaped German public memories. This chapter explores in some detail several instances in the FRG, in which Jews, former forced laborers, and German Sinti have played a role in the public memorialization of the Nazi past.

Jews

In the immediate postwar years, Jewish survivors in West Germany took it upon themselves to organize commemorations for victims of the Shoah. Similarly, former political prisoners took the initiative to commemorate and memorialize their own and their comrades' suffering. Both groups insisted that their persecution under Nazi rule be publicly acknowledged. Until about 1948, they had enough clout to be able to stage commemorative ceremonies that were endorsed by local and state parliaments, as well as church and civic leaders, regardless of their respective party allegiances.

Throughout the 1950s and 1960s, the Jews murdered by Nazi Germany were publicly remembered usually only in towns with a sizable Jew-

ish presence. In places such as Hildesheim and Celle, where the post-Shoah Jewish congregations folded in the early 1950s because their members left Germany, the town's elected or appointed non-Jewish representatives belatedly assumed responsibility for publicly remembering their former Jewish *Mitbürger* in the 1970s. While local parliaments and municipal administrations rediscovered locally specific legacies of the Shoah (in Celle, in the early 1970s with the decision to restore the synagogue as a museum; in Hildesheim, in 1978 with the decision to observe the fortieth anniversary of the Kristallnacht pogrom), Christian groups often claimed to speak on behalf of the (missing) Jews. In Hildesheim, the Ecumenical Judeo-Christian Association played a major role in commemorative events in the 1980s and 1990s; in Celle, from 1980 an Association for Christian-Jewish Cooperation likewise influenced the way the local Jewish past was publicly remembered and commemorated. While both groups (and other similar groups in West Germany) were made up of adherents of different Christian denominations, they did not usually include Jews.

That in Hildesheim the initiative to commemorate the Jewish victims of Nazi Germany was eventually taken by the descendants of the victimizers rather than by survivors or the descendants of victims was nowhere more apparent than in the planning and designing of the second Kristallnacht memorial at Lappenberg. The (non-Jewish) artists who designed the memorial cube admittedly sought the advice of the Jewish scholar Pinchas Lapide, who has been well known in Germany for his writings about Christianity's Jewish heritage.[2] Yet "there was no Jew among those who designed or realized the monument, nor among those who had the idea to build the monument," Hermann Siemer conceded.

> My efforts to get the Jews in Germany interested more or less failed. I rang the chairman of the Central Council [of Jews] . . . but I could not deduce any real interest from this conversation. This is something I regretted because it dampens your spirits a bit. You think, if there was any interest at all, then those who suffered, or whose parents or brothers and sisters suffered, would support [such a project].[3]

Siemer's stance was symptomatic of that of many other non-Jewish Germans who were comfortable with commemorating the Jewish victims of Nazi Germany as if on behalf of (invisible) Jewish survivors but puzzled and slighted when their initiatives were not endorsed by Jews.

Since 1988, the Kristallnacht pogrom has been annually commemorated in Hildesheim at the new memorial. Until 1997, these commemorations were organized by the city of Hildesheim in conjunction with the Ecumenical Judeo-Christian Association. Their format was informed by Catholic and Lutheran liturgies; the ceremonies included the singing of

hymns, the recitation of Christian prayers, and performances by a trombone ensemble. Between 1989 and 1996, the mayor of Hildesheim and his deputy each made speeches at four Kristallnacht commemorations. In 1993, 1994, and 1995, the chairman of the Association of Jewish Congregations in Lower Saxony also spoke. These public rituals regularly incorporated contributions from high school students. They proved far more intent on listening to the past than the politicians and church representatives, who preferred to talk about the present and the lessons supposedly offered by the past. Between 1993 and 1997, the Ecumenical Judeo-Christian Association organized ceremonies also on the occasion of Yom Hashoah, the date chosen by the state of Israel to commemorate the victims of the Shoah. Until 1997, no local Jews actively participated in either of these ceremonies.

The peculiarly Christian appearance of the memorial and of the commemorative ceremonies conducted at the site until 1997 reflected the successful eradication of a Jewish presence in Hildesheim in the early 1940s. After the war, some Jewish survivors moved to Hildesheim. As in other West German towns, many of them were Eastern European Jews who settled temporarily in Germany. Their number steadily declined. According to a newspaper report, in 1957 there were still nine Jewish families in the town of Hildesheim;[4] by 1988, there was probably only one local resident who identified as a Jew.

There were others whose "Jewishness" was discussed on the quiet. They included a politician prominently involved in the decision about the Lappenberg memorial, Lore Auerbach. On the quiet, Auerbach was referred to as *Halbjüdin* in Hildesheim. The term reproduces Nazi racialist criteria and means that the person in question has one Jewish and one non-Jewish parent. Auerbach's parents emigrated to England and returned to Germany after the war. She did not grow up as a Jew and does not identify as one. Similar references are made to many Germans who do not identify as Jews (and are often not Jews according to Jewish orthodox definitions) but would have been classified as such under the Nuremberg Laws of 1935.

The case of Salzgitter provides another example. The Preussag management's change of heart in 1992, when it allowed the *Betriebsrat* to set up a memorial museum at Drütte, has puzzled observers. Why did the same managers who previously fought the project tooth and nail suddenly relent and make concessions that were unexpectedly generous? Nearly everybody I talked to in Salzgitter, including members of the Arbeitskreis Stadtgeschichte, drew my attention to the chair of the board of directors, Ernst Pieper (1928–1995), who was generally believed to have been behind the 1992 decision. Pieper, I learned, was "apparently Jewish" or "reputedly of Jewish ancestry" or had a "relevant family history." And had he

not also been one of the supporters of a *Mahnmal* in Hannover that lists the names of all Jews deported from that city? Nobody, however, explicitly said that Pieper changed his mind because he was Jewish. Whether or not he was, and whether or not he was responsible for the 1992 decision, is beside the point. What matters is the veiled reference, as if Jews were no longer supposed to exist and as if somebody's Jewishness automatically entailed complex obligations (toward six million dead Jews) that could not be spelled out.

Germans like myself, who were growing up in places where the post-war establishment of a Jewish community had been but temporary, were not presented with many opportunities to meet Jews. In fact, in the 1970s and 1980s, young Germans from towns such as Hildesheim were more likely to encounter people who identified publicly as Jews outside of Germany than in Germany itself. Young Germans worked as volunteers in kibbutzim and visited Israel as tourists or on exchange programs. One such German-Israeli exchange was set up between a school in Haifa and Robert-Bosch-Gesamtschule, a state school in Hildesheim. The young people from Hildesheim, when visiting Israel, could not escape their roles as descendants of the perpetrators, regardless of their parents' or grandparents' actual involvement in the Shoah, and the young Israelis, when visiting Hildesheim, were seen as the descendants of the victims. But unlike their German peers, who resisted being perceived as the heirs of the victimizers and for whom the distancing from earlier generations was an important component of their identity, the Israeli exchange students took on the responsibility of being the rightful heirs of the victims.[5]

A group of young Israelis visited Hildesheim for the first time in 1981. The German students and their teacher, Hans-Jürgen Hahn, took them on a tour of Hildesheim's Jewish sites. At that time, the only tangible evidence of a German-Jewish past were the memorial at Lappenberg and two cemeteries.[6] The newer one adjoins Hildesheim's main municipal cemetery, Nordfriedhof. The Israelis were shocked to realize that the Jewish graves had not been tended to for a long time and that the mortuary had fallen into disrepair. Their German counterparts, confronted by the outrage of their guests, were ashamed and vowed to look after the cemetery and renovate its mortuary. Over the next few years, a group of students from Robert-Bosch-Gesamtschule, their ages ranging from thirteen to nineteen, cleaned up the cemetery and, after raising a substantial amount of money and securing funding from the city of Hildesheim and the Weinhagen Foundation, restored the mortuary.[7] They used it as their meeting room and called themselves Arbeitsgemeinschaft (AG) Jüdische Kapelle, Jewish Chapel Association. Later they changed their name to AG Beth Shalom.

As the group was made up of secondary school students, its composition changed regularly; only the teacher, Hans-Jürgen Hahn, guaranteed

personal continuity. Although the students joining the group in the 1990s otherwise knew little of their predecessors in the early 1980s, the group's foundational moment, when the scandalized Israelis shamed their German counterparts into tidying up the cemetery, has played a crucial role in the group's identity.

When I met with the Hildesheim students in 1997 at the mortuary, we arrived to find a smashed window. They were upset but did not seem to be particularly surprised. Since 1981, the students of the AG Beth Shalom had identified themselves as guardians for the cemetery and publicly conveyed their sense of identification. Ironically, their activities have indirectly led to a series of desecrations. Until 1981, the cemetery's existence had slipped from public consciousness. Soon after the students drew attention to it in order to raise funds for the restoration of the mortuary, it became the target of neo-Nazis. In 1988, for example, the local chairman of the far-right Freie Arbeiterpartei, together with three accomplices, hung half a pig's head over the door of the mortuary.[8] The local newspaper registered ten desecrations between 1984 and 1994 alone,[9] but according to Hans-Jürgen Hahn, there had been more.

The students actively remembered Hildesheim's Jews by weeding the cemetery and renovating the Jewish mortuary. At the mortuary they understood, their teacher wrote, "that the evil and incomplete past around them has faces, names, and addresses."[10] Their active interest in the Jewish past made them look beyond the burning of the synagogue in November 1938. They rediscovered the history of the five hundred concentration camp prisoners at the Stadthalle, which had already been made public in 1983. The questions they asked about the prisoners' fate proved more consequential than the 1983 newspaper article and led to commemorative ceremonies involving Hildesheim's mayor in 1995 and 1996.

The students and their teacher also corresponded with former Jewish residents of Hildesheim, many of whom have visited the town since 1986 as part of a visiting program organized and funded by the city. Unlike the equivalent scheme in Celle, Hildesheim's program was in 1998 still in operation. Since former Jewish residents have regularly visited Hildesheim, the history of Hildesheim's prewar Jewish community could no longer be easily mediated by non-Jews. On the occasion of their visits, these official guests of the city have been interviewed by the local media, and they have talked publicly about their experiences. Like the Israeli exchange students, these survivors could expect answers to any questions they might have about the local Nazi past, about individual perpetrators, and about the way that past was dealt with after 1945, and thus had an impact on how the past could be narrated.

In 1978, when the city organized the first commemorative ceremony in thirty years at the Lappenberg memorial, the history of Hildesheim's

Jews was still the domain of Helmut von Jan, director of the municipal archives from 1964 to 1975 (and staunch defender of Ernst Ehrlicher; see chap. 3). On 9 November 1978, Jan gave a talk at the local *Volks-hochschule* about the history of Hildesheim's Jewish community.[11] Hildesheim's municipal archives hold a file with a five-page manuscript by Jan that is titled "Regarding the History of the Hildesheim Jews." His text mentions the persecution of the local Jewry under Nazi rule only in passing: "The number of local Jews rose from 337 in 1803 to 601 in 1910. In 1933, there were still 515 Jews here. Of those, about a third were killed, and two-thirds died 'in time' or could emigrate. Quiet greetings to them!"[12]

The same file contains a four-page letter that an eighty-nine-year-old former resident of Hildesheim, Hugo Goldberg, wrote to Jan in 1971.[13] The letter is accompanied by a thirty-seven-page appendix, in which Goldberg lists the names of many Jews formerly resident in Hildesheim, recounts what happened to them after 1933, and provides addresses of survivors. While Jan used some of the information supplied by Goldberg when writing about Hildesheim's Jewish past, he restricted access to Goldberg's letter, including its appendix. Few people in Hildesheim knew of its existence; those who did were prevented from reading it in the archives. It was not until seventeen years after receiving the letter that Jan published an annotated version of Goldberg's text.[14]

Since early 1997, the members of the AG Beth Shalom have known that they may have to vacate the Jewish mortuary, which had become something like a clubhouse for them. Since the mid-1990s, Jews started to move back to Hildesheim. Now there is again a sizable Jewish community in the town. Most are Jewish immigrants from the Ukraine and Russia. They came after the last GDR government invited Jews from the Soviet Union to settle in Germany (see chap. 5).

Peter Hirschfeld was the first chairman of the Jewish congregation that was founded in February 1997 in Hildesheim. In an interview on the day after the 1997 Yom Hashoah commemoration at Lappenberg that had, probably for the last time, been organized by the Ecumenical Judeo-Christian Association, Hirschfeld said:

> I think it is appropriate to keep alive [the memory of] what has happened . . . If the Jews are not in a position to organize that themselves, then it's okay for the city or the churches to take over this task . . . Now that a [Jewish] congregation has been set up, we have to approach this in a fundamentally different way . . . For example, there are lists of the Hildesheim Jews who perished in the concentration camps. So we might say: "Okay, dear church, please write placards with the victims' names, and carry them through town." And then we meet on [Yom Hashoah] with these placards at the memorial. So the

church is given an assignment to demonstrate in a tangible way: "We are standing here on behalf of those who were murdered." Or we could put the leaders of the city or the church in prisoners' clothes and let them say: "We are standing here on behalf of the Jews whom we murdered."[15]

Beginning with the Kristallnacht commemoration of November 1997, Hildesheim's fledgling Jewish congregation took responsibility for publicly and ritually remembering the Shoah. While Hirschfeld's views were considered radical and were not necessarily shared by others in the Jewish community, the nature of the public ceremonies at Lappenberg became different from when they had been organized by the city of Hildesheim and the misnamed Judeo-Christian Association: civic leaders and the Christians from the association were now guests rather than hosts.

Although nearly all members of the Jewish congregation moved to Hildesheim several decades after the end of the war, and none was originally from there, Hildesheim's Jews have credibly claimed to be the heirs of those Jews who lived in the town before emigrating or being deported. For the new congregation, the local Jewish past provided markers of identity. Its members having come from different parts of the former Soviet Union and from other parts of Germany, the observance of Yom Hashoah at Lappenberg served as an affirmation of a common ancestry.[16] They have seen themselves in the tradition of the Jews whose synagogue was destroyed in 1938. For them, as for Hildesheim's non-Jewish citizens, the temporary Jewish community that was established after 1945 did not seem to warrant attention.

Members of Hildesheim's new Jewish community have been critical of the new Kristallnacht memorial's Christian imagery and of its location. Unlike the older memorial of 1948, that of 1988 marks the location of the destroyed synagogue. The cube effectively squats on the very site where ideally a new synagogue would be built. In 1998, however, the Jewish congregation did not number more than fifty adults, and the erection of a synagogue seemed to be one of their least urgent concerns.

Italians

The memorial cube at Lappenberg presents the events of 10 November 1938, when members of the SS burned down the synagogue, in relation to those of 22 March 1945, when Allied bombers destroyed the Knochen-haueramtshaus and killed about one thousand civilians in Hildesheim. From the late 1940s to the early 1990s, the burning synagogue alone signified the local fallout of Nazi rule in Hildesheim. Hans-Jürgen Hahn and his students drew attention to other aspects. The fate of the prisoners

Fig. 15. The leaders of Hildesheim's Jewish congregation, *left to right:* Peter
Hirschfeld, Channah von Eickstedt, and Roman Platkov, in front of the 1948
memorial at Lappenberg, February 1997. (Photograph by Weiterer, courtesy of
Hildesheimer Allgemeine Zeitung.)

accommodated at the Stadthalle represents one of two skeletons in
Hildesheim's closet that were kept well secured until the 1990s. Another
concerns the fate of forced laborers and prisoners of war in Hildesheim.[17]
Up to ten thousand non-Germans at a time were forced to labor in
Hildesheim toward the end of the war. Many of them worked for one of
Hildesheim's metalworking companies: Trillke-Werke, which later
became Bosch and Blaupunkt, and Vereinigtes Deutsches Metallwerk
(VDM), which later became part of Senking. They included large numbers
of civilians and prisoners of war from the Soviet Union and forced labor-
ers from Poland, Italy, and about a dozen other European countries. Most
of the Italians had been taken prisoner in September 1943, after the
Badoglio government had signed an armistice with the Allies.[18]

After Hildesheim had been bombed on 22 March 1945, many of its German residents as well as forced laborers looted food depots. The Gestapo carried out its threat to summarily execute looters and hanged dozens of alleged culprits on the market square in the days following the aerial barrage. At the same time, the Gestapo also killed probably more than one hundred men and women clandestinely in a building next to the central cemetery.[19] Many of those executed were Italians who had been accused of taking part in looting a food depot near the central railway station; the "looting," however, apparently had been condoned by police, as the depot was on fire and the food bound to be destroyed unless taken out of the building by members of a five-hundred-strong contingent of Italian prisoners that happened to be in the vicinity.

In 1948, the Italian Red Cross contacted the authorities in Hildesheim to confirm the existence of a mass grave with some 135 Italians at Hildesheim's central cemetery.[20] The authorities exhumed the bodies of 191 men and 17 women. The women and 135 of the men were naked; the clothing of some of the others indicated that they had been prisoners of a concentration camp. None of the bodies could be identified; nor could their nationality be established. The grave probably included the men executed at the market square. The bodies were reburied where they had been found, and the municipal authorities later arranged for the erection of a tombstone.

In 1950–53, the former head of Hildesheim's Gestapo, Heinrich Huck, was tried in Hannover. He was initially sentenced to five years in prison, but successfully appealed and was acquitted in 1953 because it could not be proven that he had done more than just follow orders. The mass grave at the central cemetery and the hangings on the market square featured prominently in the Huck trials. For more than twenty-five years, these court cases provided the last occasions when the murders of March 1945 were publicly mentioned in Hildesheim. A survey of Hildesheim's war dead, published in 1958 by the city's statistical office, lists 4,071 dead: 2,831 soldiers and 1,240 civilians who died as a result of aerial bombardments. The latter include 103 foreigners.[21] By 1958, the 208 men and women buried in the mass grave were already officially forgotten.

Hans Teich's 1979 book *Hildesheim und seine Antifaschisten* contains the first published German account of the executions since 1951. Teich's book, "dedicated to Hildesheim's victims of the resistance against the fascist Hitler regime," contextualized the public hangings as "attempts to intimidate those parts of the population that were inclined to revolt [against the Nazis]."[22] Not many people in Hildesheim took notice of Teich's work. The executions were not mentioned in the detailed accounts of the destruction of Hildesheim published in the local daily newspaper, *Hildesheimer Allgemeine Zeitung,* in March 1980. The next reference

Fig. 16. Tombstone for 208 nameless victims of Nazi rule at the "foreigners' section" of Hildesheim's main municipal cemetery. The back carries a Latin inscription: "In memory of those who in the war years 1939–1945 gave their lives for the Fatherland and for their faith. Good Jesus, sweet Lord, liberate their souls from the punishments of Hell and grant them eternal bliss."

appeared in a book about the air raid of 22 March 1945 that was published in 1985. Under the heading, "An Eyewitness Reports," the book reproduced a drawing of four men hanging from the scaffold on Hildesheim's market square, without, however, identifying the artist or the source of the extensive caption.[23] Although this book was widely read in Hildesheim, there was no conspicuous public acknowledgment of the hangings. Menno Aden, in his book about the destruction and rebuilding of Hildesheim (see chap. 3) published in 1994, also mentioned the hangings.[24]

While Hahn and his students were no doubt prompted to research the history of the Jewish prisoners in Stadthalle as a result of their extensive contacts with Israeli students and Jewish survivors visiting Hildesheim, the German students were the ones asking the questions and publicizing the answers. In the case of the Italians who were executed in late March 1945, the skeletons were dragged into the open, as it were, by Italian survivors.

Italians who worked in Hildesheim during the war held regular reunions after Liberation. On such occasions, they remembered their murdered fellow prisoners. In Italy, the fate of forced laborers and prisoners of war in Germany has for a long time attracted public interest. The first

published Italian account of the executions appeared at least thirteen years before Teich's book. In Italy, there has been a ready market for authors who recounted their own experiences in Germany or wrote about the experiences of others.[25] Ricciotti Lazzero belongs to the latter category. He interviewed Italians who had worked in Hildesheim during the war, and in 1994 attempted to follow up some of their stories in Hildesheim itself.[26] The owner of a secondhand bookshop, whom he approached as he was hoping to find publications in German that mentioned the hanging, put him on to a local VVN stalwart. Lazzero wrote to her (in Italian), asking her to provide him with more information. The recipient of the letter was at that time enrolled in an Italian language course at the local *Volkshochschule* and took the letter to her Italian teacher, Leonardo Civale. Civale was taken aback by what he read: he had been living in Hildesheim for six years and was married to a local but had never heard of the hangings. He realized that long-term Hildesheim residents knew, but did not talk, about them. The hangings of March 1945 were Hildesheim's equivalent of the Celle *Hasenjagd.*

Civale took it upon himself to research the events. He traveled to Italy to meet survivors and arranged for them to visit Hildesheim in time for the fiftieth anniversary of the mass executions. Having been briefed by Civale about the impending arrival of nineteen survivors from Italy, Hildesheim's mayor, Kurt Machens, officially invited the group. Machens is a Christian Democrat and thus belongs to the conservative side of politics. Unlike Celle's political leaders, however, Machens was not much interested in symbolic statements that could be seen to put the past at rest. He took a personal interest in the Italians' stories and spent much of the three days that they were in Hildesheim with his guests. He later wrote a foreword for Lazzero's book.[27]

The opportunity afforded to the Italian men to tell their stories, and, more importantly still, the willingness of some local residents to listen to their stories and be touched by them, made possible a public engagement with the Nazi past that was different from the *Vergangenheitsbewältigung* hitherto practiced in Hildesheim. In the 1980s, influential non-Jewish citizens orchestrated the memorialization of the Kristallnacht in Hildesheim in a way that accorded the Jews who were invited for the unveiling of the cube at Lappenberg in 1988 but a supporting role. Seven years later, in relation to the hangings of March 1945, Hildesheim's citizens were less able to control the way the past was historicized and memorialized, and often felt compelled to react to the memories that Italian survivors shared with them. That is, the nature of the commemorations in 1995, and of public discourses about the executions in the late 1990s, was profoundly influenced by the circulation of survivor testimonies. The Italians visiting Hildesheim extended a hand to its citizens—but they did so with the

understanding that those taking the hand were willing to let themselves be confronted by a history told by survivors.

The accounts of the hangings that were published in Hildesheim between 1979 and 1994 are German histories in more than one sense. None of them drew on Italian testimonies or referred to Italian-language publications mentioning the hangings. Italians and other forced laborers appear only as nameless victims. But since 1995 the stories of survivors have become like stumbling blocks. Ignoring them does not make them disappear.

The recognized leader of the Italians who visited Hildesheim in 1995 is Angelo Digiuni, who had worked at the VDM plant. His memories are quoted in Lazzero's book (which by 1998 had not been published in Germany):

That day I saw a cloud of airplanes, and I walked away to a ploughed field, putting my hands on my ears because of the deafening crashing of the bombs. My camp, Kommando 6001, which was five hundred meters away, was destroyed. There were fires in the city for three days; the sun was darkened . . . We ended up among the groups whose job it was to clean up the rubble and to remove the dead bodies. They forced us to work until eleven or half past eleven; then they led us (divided into units) to the market square to assist in the hangings. The square was small because it was covered by rubble. They made us line up in a horseshoe formation to allow us to see clearly. The [condemned men] went to the scaffold in groups of four. Once the first four were dead, the following four were forced to take them off, place themselves in the others' place, put the slipknot to their necks and wait to be pushed off the stool they stood on. The first time I lowered my head so as not to look. A Gestapo officer put his gun under my chin and forced me to raise my head telling me: "Schau! Schau!" "Look! Look!" A friend of mine, infantry corporal Luigi Todesco, from Poiana in the province of Vicenza, brought back home a piece of the cord that was used for the hanging. Together with him and with others I went to the cemetery, where another massacre had taken place. We took the guardian of the cemetery and made him talk. He claimed to know nothing, but when he understood that if he didn't speak he would be in trouble, he confessed. There was a house, on the right of the cemetery's entrance: with a stick we forced open the door and found ourselves in front of a series of cells, about one meter by one meter. In those holes they had crammed, after taking their clothes off, the Italians, the Russians, and the Poles destined to be hanged. Twelve people in each cell, almost suffocating, the killers pushed the doors shut. Naked, they were then passed on to the hangmen. In a

large room next to the cells there was a pile of shoes, gray-green uniforms, mess-tins, hats, and clogs that was half a meter high. With my friend from Vicenza I spent three days going through all of that stuff to find some names.[28]

Texts like this one, once inserted into discourses of public remembrance in Germany, unsettle the all too comfortable assertions of a universal brotherhood of victims, and of a past removed from the present. They are unsettling because they are being told by eyewitnesses, rather than because they could provoke reflections about the complicity of their audience. Those living in Hildesheim in the 1990s did not feel responsible for what happened at the market square and near the cemetery in March 1945. Such a rejection of responsibility may, however, be more complicated in relation to another aspect of Digiuni's story. After being told about the mass grave by the cemetery's caretaker, Digiuni and some of his friends erected a memorial "dedicated to all the Italians and a cross for the hanged. The monument does not exist anymore; the Germans knocked it down."[29] In 1969, the Italian government funded another memorial, which is still standing and bears the inscription "Ai caduti italiani" (For the fallen Italian soldiers).

In response to the Italians' visit in 1995, a group of local residents became interested in the history of forced labor in Hildesheim. They call themselves *Geschichtswerkstatt* (history workshop), a term associated with nonacademic projects exploring everyday life in Nazi Germany. In 1998, the *Geschichtswerkstatt,* in close collaboration with Italian survivors, organized an exhibition about Italian forced labor in Hildesheim in the foyer of the town hall. While the exhibition used the voices of survivors, it also made their experiences part of a German history. The *Geschichtswerkstatt* demanded that an additional memorial plaque be put up at the cemetery to alert visitors to the mass grave. Will this memorial—like the 1988 memorial at Lappenberg—be one of Germans again speaking on behalf of victims and survivors?

Sinti

That non-Jewish Germans in Hildesheim had mourned the Jewish victims of their parents and grandparents as if on behalf of survivors and their descendants was perhaps understandable in one respect: in the late 1970s and throughout the 1980s, there was no visible Jewish presence in Hildesheim. At the same time the presence of another group of people who had been persecuted by the Nazis on account of their "race" was well known and much talked about: after the war, Hildesheim has had a comparatively large Sinti community. Some of them were survivors who had

been deported to Auschwitz in March 1943 and returned after the war. In 1981, the local newspaper reported figures published by Lower Saxony's Ministry of Social Services under the heading "Stadt ist Zigeunermetropole," suggesting that Hildesheim was the state's "Gypsy capital."[30] According to the figures, 111 of the state's 420 Sinti families were then living in Hildesheim.

Until 1960, Hildesheim's Sinti community lived in caravans and shacks at the edge of the town.[31] The sanitary conditions in the Sinti camp were appalling: there were up to two hundred people for a single source of water. The Sinti were constantly harassed by the authorities; in the 1950s, there were raids by the police and representatives of the municipal authorities nearly once every month. On several occasions the Sinti were threatened with eviction. The situation improved slightly when in 1960 the municipal administration allocated them a new site at Lademühle, also at the edge of the town, where they had access to electricity and running water. This site was already demarcated by a rubbish dump, a train line, and a river. The authorities further enclosed it with a fence, thereby underscoring that they wished to keep the Sinti out of the actual town. In 1964 the Sinti were told to move to Münchewiese, another site at the edge of town, which they initially had to share with non-Sinti homeless families. Over the next twenty years, the living conditions in the Sinti settlement improved but very slowly. Occasionally, they were made public by social workers, and also occasionally, the authorities made halfhearted attempts to improve them. It was not until 1995 that the thirty-five Sinti families who had chosen to remain at Münchewiese could move into appropriate housing.

In 1960, social scientist Lucassen Jochimsen did some research into the Sinti of Hildesheim. In the tradition of a sociology concerned with producing knowledge about marginalized sections of society, she did not reveal the purpose of her stay at Lademühle to the people living there. Her approach was the more questionable, as the Department of Social Services made available to her files on individual families, unbeknownst to those families. The published results of her work are nevertheless valuable—not because of what she says about Sinti but because of what she says about non-Sinti. Jochimsen also interviewed two hundred non-Sinti residents of Hildesheim about their attitudes toward the Sinti at Lademühle. Asked which people they would not like to see living in Lower Saxony, only ten out of two hundred respondents declined to answer that question because they did not object to any particular ethnically or racially defined group. "Gypsies" were named by 115 of the respondents, followed by fifty-four nominations for "Negroes" and fifty-three for Italians. Jews came sixth on this list with thirty-eight nominations.[32]

Since at least the fifteenth century, anti-Tziganism (that is, hatred of

"Gypsies") had been as pronounced in Germany as anti-Semitism.[33] From the nineteenth century, with the emancipation and assimilation of Jews, anti-Tziganism became the more virulent of the two. In Wilhelminian Germany and in the Weimar Republic, the state guaranteed the perpetuation of anti-Tziganism by enacting policies directed specifically against Sinti and Roma. Nazi policies drew on and elaborated earlier anti-Tziganist decrees and legislation. At the same time, Nazi propaganda amplified traditional anti-Tziganism.

After 1945, anti-Tziganist state policy and anti-Tziganist popular sentiment continued in Germany, as the following examples from Celle illustrate. In September 1946, Celle's council debated what to do about the *Zigeunerplage* (Gypsy plague) in town; presumably at least some of the Sinti and Roma whom the council wanted to expel were survivors liberated at Bergen-Belsen.[34] In 1947, one of Hanna Fueß's interviewees, in what is one of the most heartless accounts in her collection, recalled how he dealt with poachers:

> First there were Gypsies. Once eight of them [*acht Stück*] were fishing at the ponds. I took them to task. "Poor Gypsy also needs protein, has starved in the *KZ*." "No, I can't tolerate that; all my money has gone into [stocking the pond]." The Gypsy then turned on me, when I wanted to take away his fishing pole. I hooked him under the chin, and he fell down immediately, and fell so that his head went underwater. The others now became really angry, but I kicked them in the stomach and got away.[35]

Jochimsen's research suggests that in 1960, people in Hildesheim were either not aware of or did not want to admit the fact that in Nazi Germany Sinti had been persecuted on account of their "race," and that many of them had been murdered in Auschwitz. In 1981, Werner Stehr, deputy head of the municipal Department of Social Services, was quoted in Hildesheim's local newspaper under the headline "Sie entwickeln manchmal viel Phantasie" [They are sometimes highly imaginative]. Stehr cited two cases of Sinti mothers giving reasons for not sending their children to school. One mother said that she did not own a washing machine and therefore the child did not have any clean clothes to wear. The other explained that her house was damp and the child's clothes did not dry. These two examples of Sinti "imagination" and "inventiveness" were followed by what in the context of the newspaper article could only be read as a third example: "Two young girls, when visiting the Department of Social Services about an application for welfare benefits, brought along a pictorial book about concentration camps. Blond and blue-eyed Werner Stehr, when talking to the Gypsies, was called a 'Nazi.' "[36] Regardless of

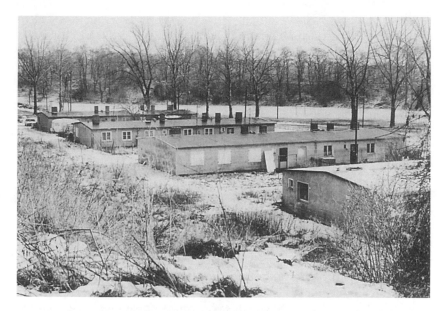

Fig. 17. Sinti settlement at Münchewiese, Hildesheim, 1981. (Photograph by Noelke, courtesy of *Hildesheimer Allgemeine Zeitung*.)

whether or not Stehr himself was aware of the Sinti genocide, the journalist obviously presumed that for his or her readers any drawing of a connection between concentration camps and the postwar situation of Sinti und Roma in the Federal Republic would be ludicrous.

In postwar West Germany, it was widely acknowledged that Jews had been murdered on account of their "race," and that this criteria was born of an ideology that the majority of West Germans then had learned to recognize as evil. Sinti, on the other hand, were often thought to have been persecuted on account of supposedly very real cultural and hereditary traits that continued to be ascribed to them after 1945. Both before and after 1945, "Gypsies" were often considered irredeemable *Asoziale,* antisocial elements, nomads who made a living from petty theft and fraud. In concentration camps, Sinti and Roma were often made to wear a black triangle, marking them as *Asoziale* rather than as members of a group persecuted because of its "race." This categorization was taken at face value after 1945 and resurfaced in approaches to Sinti demands for restitution, even when "Gypsies" were recognized as victims of Nazi racialist policies: in Hessen, for instance, Sinti and Roma in 1946 and 1947 forfeited any restitution entitlements if they had no permanent residence or job.[37]

In Hildesheim, there has been no attempt so far to erect a memorial to

the Sinti victims of Nazi Germany. In fact, nearly everyone I talked to about the memorialization of the local Nazi past was surprised when I tried to bring the conversation round to the Münchewiese settlement. The first sizable memorial to commemorate the suffering of Sinti under the Nazis was unveiled in December 1992 in Wiesbaden, capital of the West German state of Hessen. Unlike Hildesheim, Wiesbaden has not had a particularly large Sinti community after the war.

In 1991, Adam Strauß wrote to the mayor of Wiesbaden, the Social Democrat Achim Exner, on behalf of an organization representing Hessen's Sinti and Roma:

> We aim for reconciliation and understanding between our minority and the majority of the population, for the acknowledgment of the genocide of Sinti and Roma, and the overcoming of the consequences of the Holocaust. Five Hundred Thousand Sinti and Roma were murdered by the National Socialists in Auschwitz and in other death factories. For decades the surviving German Sinti and Roma were cheated by the government for their just material compensation . . . Dear Mr. Exner, on 8 March 1943, for example, over one hundred Sinti were deported from Wiesbaden to the internment camp at Frankfurt-Riederwald. Half of these Wiesbaden Sinti did not survive the Nazis' program of annihilation. The Hessen branch expects you and the capital city of Wiesbaden to take on the remembrance and reappraisal of the genocide of Sinti and Roma. The installation of a memorial plaque and a reception for survivors of the Holocaust and [representatives of] the Hessen branch by you would constitute a moral acknowledgment of the suffering and a symbol against the old and new racism in the Federal Republic. We assume that you will agree with our request and will invite us soon for a meeting.[38]

Exner was willing to oblige. But few of those whose voices carried weight in Wiesbaden were as receptive as the mayor. Gottfried von Kiesow, then chief curator of monuments in Hessen and a Liberal Democratic Party alderman on the Wiesbaden City Council, was not only concerned about the memorial's potential defacement but reportedly also argued that a separate memorial would exacerbate the isolation of Sinti and Roma in German society.[39]

Two letters to the editor, which appeared in one of Wiesbaden's daily newspapers, summarize the principal arguments brought forward against the Sinti memorial. The first writer asked:

> Wouldn't people prefer it . . . if the city erected a *Mahnmal* to commemorate the sufferings of [ethnic Germans] expelled from the terri-

tories now occupied by Poland. . . ? Why not also have a *Mahnmal* for the prisoners of war who had to live under inhuman conditions in Russian and French captivity and—I was a prisoner of war of the Russians myself—who perished in their thousands in those camps?[40]

The second writer pursued a very different (but equally popular) line of argument:

> The city wants to erect a *Mahnmal* that is to commemorate only the Sinti and Roma, of those persecuted by the Nazis. This one-sided approach constitutes a clear discrimination against the Jewish community . . . With all due respect to the Sinti and Roma victims, the deported Jews were the numerically and, more importantly, the historically and culturally far more significant group of victims of persecution from Wiesbaden . . . Considering how critically the international, and, particularly, the American, print media follow and report events that concern the German relationship to the Jewish fellow citizens and the German approach to the Nazi murder of Jews, the planned project gives rise to the greatest alarm . . . I am therefore asking [the mayor of Wiesbaden]: Do everything you can to make sure that no rash action unneccessarily put strain on our relationship with the Jewish fellow citizens and grievously harm the German reputation abroad![41]

The two writers listed the three single most pervasive arguments that were then made in the FRG on how to commemorate publicly the victims of Nazi Germany. By claiming that Germans were victims, too, the first writer echoed a sentiment articulated throughout the history of the Federal Republic by conservative politicians. The demand to privilege Jewish victims of Nazi Germany did not so much reflect a particular empathy on the part of the victimizers and their descendants with Jews, but the continuation of pre-1945 attitudes toward other groups persecuted by the Nazis, namely Communists, Sinti and Roma, and gay men. Finally, even those Germans who would rather put up memorials to German victims than to victims of Nazi Germany have often been guided in their actions by their anticipation of how others, particularly in Western Europe and the United States, might perceive these actions. Like much of the West German discussion about a memorialization of the Nazi past, the two letters are devoid of any consideration of a collective's moral responsibility for the past, and of the past's presence in the present.

Achim Exner's receptiveness encouraged Strauß to increase his demands and ask for a monument rather than merely a memorial plaque. As the mayor was supported by his own party (which in 1992 commanded

a majority in Council), the city of Wiesbaden eventually undertook to fund a memorial commemorating the deportation of Wiesbaden's Sinti to Auschwitz. The city offered a site in Bahnhofstraße, about half-way between the synagogue in Friedrichstraße, where Wiesbaden's Sinti had to await their deportation, and the railway station, from where they were sent via Frankfurt to Auschwitz on 8 March 1943. A masonry workshop owned by and employing Sinti designed and created the memorial. "Of course these men were craftsmen not artists," local art administrators and politicians hastened to tell me. None of my interlocutors mentioned the names of the Sinti artists, Josef Reinhar and Eugen Reinhardt.

Reinhar and Reinhardt's sculpture is a victims' memorial: memorials such as this one are always for a specific group of victims, such as Sinti and Roma, Jews, gay men, or German deserters. The first such memorials were put up in 1945 and 1946 by camp survivors. Hardly any of them are still standing. While many of them may have been temporary, others, including the memorial put up by Angelo Digiuni and his friends on Hildesheim's central cemetery, were demolished in the late 1940s or in the 1950s. By putting up such memorials, survivors and the victims' descendants mourned their dead. In doing this in a public space, they seemed to say aloud to the perpetrators and their descendants: "We have survived." For Sinti and Roma and for gay men, the erection of memorials and, more generally, the memorialization of the persecution of those groups in Nazi Germany have played important roles in their struggle for civil rights in postwar Germany. While from the late 1970s many Germans no longer objected to the commemoration of Nazi Germany's victims, either through ceremonies or through a monument, they were less comfortable with memorial practices that were controlled by survivors or their heirs, and felt uneasy about testimonies that were not mediated by local historians such as Helmut von Jan in Hildesheim and Jürgen Ricklefs in Celle.

In 1996–98, I did not come across any public opposition to the Sinti memorial in Wiesbaden. But as with those concerning Ernst Pieper's role in the establishment of Drütte, there were interpretations that were offered on the quiet, as it were. Frequently, opponents of the memorial alleged that Wiesbaden's mayor had given in to moral blackmail. This reading of events suggested that the memorial may not have been built if it had not been for Exner's weakness, but that his reaction was merely evidence of the potential of present-day Germans to become victims of Jews and "Gypsies" who "milked past injustice" for all it was worth. According to a second explanation, Exner could be persuaded because of his acquaintance with a local Sinto, Sylvester Lampert, who, unlike most of his family, survived Auschwitz, Natzweiler, and Dachau, and for many years after the war played the violin in Wiesbaden bars—as if Lampert had had a corrupting influence on Exner that made the mayor put Sinti interests over

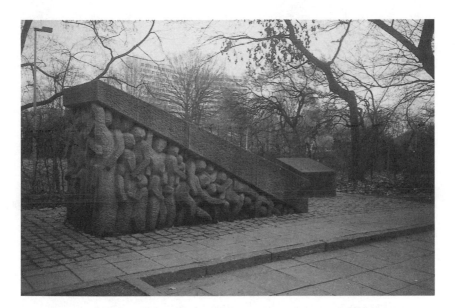

Fig. 18. Sinti memorial by Josef Reinhar and Eugen Reinhardt, Wiesbaden.
(Photograph by U. Müller-Reuss.)

"German." A third commonly heard reaction consisted of comments about the memorial itself and was couched in terms that at first glance appeared to blame the Wiesbaden authorities for an unsatisfactory solution; the memorial was variously said to be deliberately hidden from view, to have replaced a dog's toilet, or to have been put up without proper foundations.

Those supporting the memorial in Wiesbaden proudly pointed out that it was the first such *Mahnmal* in Germany. In their view, far from grievously harming Germany's reputation, the memorial actually enhanced the reputation of Wiesbaden. Similarly, in the 1990s, civic leaders in Salzgitter proudly pointed to the Weber sculpture in Lebenstedt, and in Hildesheim they emphasized the exemplary nature of the city's invitation to Italians in 1995.

No memorial could relieve Germans of their responsibility to listen to the voices of those who were silenced between 1933 and 1945 (and, in most cases, well beyond the formal end of Nazi rule). In the late 1990s, it in fact often appeared as if the chorus of Germans demanding a memorial *for and on behalf of* the victims of Nazi Germany could be the most effective means of drowning these voices. Perhaps an attentive listening would also allow the people of Wiesbaden to *recognize* the Sinti memorial as some-

thing other than an alibi funded by the city, supposedly built where dogs had been encouraged to shit, banished to obscurity, and upheld as evidence of Wiesbaden's progressive stance.

As in the case of Italian survivors visiting Hildesheim, survivor testimonies of Wiesbaden's Sinti potentially disrupt a "German" interpretation of the past. The organization representing Sinti and Roma in Hessen successfully demanded that the city of Wiesbaden fund another memorial: *Wiesbaden—Auschwitz,* a book published in 1997 about the persecution of the local Sinti community. Like other similar accounts of Sinti and Roma persecution, *Wiesbaden—Auschwitz* is providing survivors with an opportunity to speak. Sylvester Lampert, on the quiet held responsible for Achim Exner's support for the Sinti memorial, is one of the survivors quoted in the book:

> One day, police came to the bakery to arrest me at my workplace. They took me . . . to the Jewish synagogue in Friedrichstrasse. My brother was there; he happened to be on leave, being a soldier with the *Wehrmacht* . . . We stayed overnight, and the next morning, we went to the railway station in Wiesbaden, and from there by train to Frankfurt . . . It took us three days to reach Auschwitz. At the Wiesbaden station, my brother Alfons said, already out of some sort of premonition: "Wiesbaden, we will never meet again." I'll never forget that.[42]

CHAPTER 5

Antifascism and
Anti-Anti-Semitism

The Buchenwald memorial built in the late 1950s on and around the site of a former Bismarck monument is the most conspicuous of many monuments in the former German Democratic Republic that glorify the struggle and suffering of the Nazis' left-wing political opponents.[1] The visitor enters through a massive stone gate to descend past seven large stone reliefs depicting life and death in the camp to the first of three mass graves. The graves, circular hollows that are enclosed by stone walls, are linked by a road with eighteen pylons, each crowned by a sacrificial bowl and dedicated to a nation whose citizens were prominently represented among Buchenwald's prisoners.[2] There is no pylon for Israel. From the third mass grave, stairs lead to a square with a sculpture by Fritz Cremer. It represents a group of eleven prisoners, ten men and a boy, one of them carrying a gun, another waving a flag. A bell tower rises behind the sculpture.

In the new Germany, the Buchenwald memorial has come to symbolize an East German antifascism that ignored the Shoah and unduly focused on left-wing political resistance. A 1993 memorial by Tine Steen and Klaus Schlosser at the site of the former concentration camp in Buchenwald, which commemorates the suffering of the camp's Jewish prisoners, has been taken to be a West German corrective. Such symbolism presumes a static view of the postwar past. In this chapter, I provide a brief history of the role accorded to Jewish victims and survivors in East German public memories, and recount the public reactions to two cases of anti-Semitism, one of them in the old Federal Republic, and the other in the united Germany. My aim here is both to highlight the complexity of official approaches to Jewish survivors in both Germanies, and to detect the legacies of West and East German antifascisms and anti-anti-Semitisms in the new Germany.

113

Fig. 19. Buchenwald, 13 April 1997, celebrating the anniversary of liberation in front of the Cremer memorial (at the lectern: Emil Carlebach and Rosa Deutsch)

"Victims of Fascism" and "Cosmopolitans"

Between 1945 and 1948, the approach to Jewish survivors was contested among members of the three groups from which the political leadership of postwar East Germany recruited itself: Communists and Socialists who had been imprisoned in Nazi Germany; Communist Party cadres who had spent most of the Nazi years in exile in the Soviet Union; and Communists who had emigrated to Western countries such as the United States, Mexico, and Britain.[3]

Members of the first group had been isolated from the twists and turns of the Communist Party's doctrine during their years of imprisonment. They experienced Nazi repression as directed foremost against them and often saw Jewish fellow prisoners as hapless victims who became targets of the Nazis only after the suppression of the KPD, SPD, and trade unions. The Moscow group led by Ulbricht argued that the persecution of Jews had not been the result of an anti-Semitic ideology but the by-product of the Nazis' attempt to destroy the organizations of the working class, and of fights between different factions of the capitalist class. Like members of the first group, the former Moscow emigrants believed that German fascism was distinguished by its anti-Communism rather than by its

anti-Semitism; but more so than members of the first group, whose experiences in prisons and concentration camps had made them more rather than less dogmatic, Ulbricht and his followers were prepared to make tactical compromises. Members of the third and smallest group had had ample opportunities to interact with non-Communist Jewish refugees in Western countries, were more inclined to emphasize Nazi racist ideology and policies, and became convinced of the necessity to consider restitution, once the war was over.

One of the bodies outside the Communist Party that influenced the approach to different groups of victims and survivors in East Germany was set up by former prisoners of the Nazis in early June 1945 in Berlin: the Hauptausschuß für die Opfer des Faschismus (OdF)—the central committee for the victims of fascism—saw its main role in securing the provision of social services for former prisoners; it was affiliated to the Department of Social Welfare in the Berlin municipal administration. In 1945, the Hauptausschuss OdF was dominated by Communists who had remained in Germany. Their views were represented in an article about the first full meeting of the Hauptausschuss OdF, which was published on 3 July 1945 in the Communist Party newspaper, *Deutsche Volkszeitung:*

> Millions of people are victims of fascism. They include all those who lost their homes, their houses, their property. The men who had to become soldiers and were deployed in Hitler's battalions are victims of fascism, as are all those who gave their lives for Hitler's criminal war. The Jews who were persecuted and fell victim to the fascist racial mania, the Jehovah's Witnesses and *"Arbeitsvertragssünder"* [that is, people who did not honor their work contracts] are victims of fascism. But we cannot extend the term *victims of fascism* in this manner. They all have suffered hardship, but they have not fought. These people have to be supported by the providers of general welfare.[4]

This statement reflects an understanding of the Nazi past that remained pervasive in both German states. At least until the 1980s, in dominant public discourse in the GDR and in the FRG, a narrowly defined and therefore numerically small group of perpetrators was distinguished from the millions who followed Hitler and who were seen as victims rather than victimizers. But while distinctions between those who fought against the Nazis, and those who "merely" suffered on account of belonging to a group of people identified by racialist criteria were short-lived in the Western zones,[5] they became a crucial aspect of state policy in the Soviet zone, and later the GDR.

However, for the time being, the interpretation expounded by the Hauptausschuß OdF in July 1945 did not remain valid for long in East

Germany either. By late September 1945, the organization had accepted that Jews, too, were "victims of fascism." The first ceremony in Berlin to commemorate the Kristallnacht pogrom was further evidence of the KPD's taking a new approach to the persecution of Jews. In a speech as part of the commemorations on 12 November 1945, which were organized by the Hauptausschuss OdF, the leader of Berlin's KPD, Ottomar Geschke, recalled the Nazi terror against Communists, Social Democrats, trade unionists, and Jews and reminded his listeners that 160,000 Berlin Jews had been deported, most of them never to return.[6]

East Berlin's Kristallnacht commemoration in 1946 was again organized by the Hauptausschuss OdF, and Geschke, then chairman of the Hauptausschuss as well as local government minister for social affairs, once more gave the main speech. But while in 1945, a choir had sung "Brüder zur Sonne, zur Freiheit," the hymn of the German labor movement, the same choir now presented the *ha-Tikwa,* the hymn of the Zionist movement. By November 1946, the Nuremberg trials had provided ample evidence of the extent of the Jewish genocide. At the same time, antifascists had become worried about the longevity of German anti-Semitism: in 1946, in all parts of Germany, Jewish cemeteries had again been desecrated. In his speech, Geschke warned against anti-Semitism and Nazism. He also demanded the restitution of Jewish properties, thus supporting a position that was being put forward by Jewish members of the KPD (and of its successor from 1946, the Socialist Unity Party, SED) as well as by non-Jewish Communists such as Paul Merker, who had been in exile in the West.

During the 1947 and 1948 Kristallnacht commemorations in East Berlin, the issue of restitution was raised again. How much the interpretation of the persecution of Jews was contested among different factions of the ruling SED became most apparent in November 1948. On 10 November, the SED's daily newspaper, *Neues Deutschland,* published an extract from a two-volume analysis of German fascism by Paul Merker that had come out in Mexico City in 1944 and 1945. Merker observed: "The racism of the Nazis did not only serve to distract the betrayed masses, but was at the same time a means of shoring up the rulers, of corrupting the lower- and middle-ranking officials of the Nazi Party, and of ideologically preparing the war of conquest."[7] Merker's assessment contrasted sharply with that of Walter Bartel, who had been imprisoned in Buchenwald from 1939 to 1945 and there had played a prominent role both in the clandestine prisoners' organization and in the KPD. On the occasion of the central 1948 Kristallnacht commemoration in East Berlin, which was this time convened by the VVN, Bartel claimed that 9 November 1938 had to be seen in the context of 9 November 1918, in other words: that the pogrom resulted from the failure to eliminate the power of

the generals and of capitalists such as Thyssen and Krupp at the end of World War I.

Merker's influence reached its height in 1948. The book from which the *Neues Deutschland* article was taken, *Deutschland—Sein oder Nicht Sein?* was never published in the German Democratic Republic.[8] A regulation concerning the legal status of those persecuted under the Nazi regime was not issued by the Soviet authorities until a few days before the founding of the German Democratic Republic: "It precluded restitution for property taken by the Nazis, and made no provisions for returning stolen property to the Jewish communities."[9]

The failure of the East German government to acknowledge the Shoah (and to acknowledge its responsibility vis-à-vis Jewish survivors), and the fact that Merker and other émigrés who returned from the West, as well as prominent members of the SED who identified as Jewish, lost their influence, was largely due to external factors. One concerned the newly established state of Israel. The Soviet Union had supported the establishment of Israel and had in fact been the first country formally to recognize it. On 12 June 1948, a statement released by the SED's central secretariat, and authored by Paul Merker, agreed with the stance taken by the senior sister party in Moscow:

> Mighty interests of Anglo-American imperialism clash in the battle for Palestine . . . The Jewish working people are fighting for their homeland . . . The struggle of the Jewish workers in Palestine is a progressive struggle. It is directed not against the Arab working masses, but against their oppressors. It is supported by the Soviet Union and by all of progressive humanity.[10]

And at a rally to support Palestine, which was organized by the VVN on 21 June 1948 in Berlin, Walter Bartel demanded that the alliance between those persecuted for political reasons and those persecuted for racial reasons, which had been formed under Hitler, "has to prove itself anew in the defense of the young Jewish state against the warmongers."[11] But when the Soviet Union changed sides at the end of 1948, the Communist leadership of East Germany again followed suit.

A *Pravda* article by Ilya Ehrenburg in late 1948 was one of the first indications that the leaders of the Soviet Union were withdrawing their support for Israel.[12] Ehrenburg not only attacked the Jewish state, but also Zionism and the transnational ties of Jews. In the Soviet Union, such ties were soon regarded as evidence of "cosmopolitanism" and deemed a threat. The state-sponsored anticosmopolitan purges in the Soviet Union and most other Eastern bloc countries were directed mainly at Jews. In November 1952, fourteen leading Communists, eleven of whom were Jew-

ish, were publicly tried in Prague. They were charged with supporting Trotskyism, Titoism, and Zionism, and with being implicated in a worldwide Jewish conspiracy. This so-called Slansky trial concluded with death sentences for eleven of the defendants.

The SED was soon conducting its own campaign against cosmopolitanism and Social Democratism. In 1950 the party began screening all its members; this review resulted in the expulsion of about 150,000 full and probationary members. While the SED's anticosmopolitan purge was not explicitly directed against Jews, the anticosmopolitan rhetoric alluded to anti-Semitic tropes with which Germans were only too familiar.[13] The anti-Semitic campaign that accompanied the Slansky trial led to an exodus of Jews from East Germany. By the time the anticosmopolitan purges were halted immediately following the death of Stalin in March 1953, about a fifth, and possibly more, of East Germany's Jewish population had fled the country.[14] They included the leaders of all eight Jewish congregations in the GDR. Although many of those vilified during those purges were later rehabilitated, the authorities and the SED continued to regard Jews in East Germany with suspicion and disciplined party members if, for example, they were thought to support the state of Israel, or if they chose to identify as Jews in Germany rather than as Germans who adhered to the Jewish faith.

Communists who had supported Jewish claims for restitution and who had wanted to modify the explanation of the Shoah offered by the Moscow émigrés also fell victim to the cosmopolitan purges. Paul Merker was supposedly implicated in the crimes with which Slansky and others were charged in Prague. Shortly after the execution of Slansky, Merker was arrested. He was one of the key targets in a text published in December 1952 under the imprimatur of the SED's central committee, "Lessons of the Trial against the Slansky Conspiracy Center." Its author, Hermann Matern, claimed that there was "no further doubt that Merker is a subject of the U.S. financial oligarchy who called for indemnification for Jewish property only to facilitate the penetration of U.S. finance capital into Germany," and more generally regurgitated tenets of Nazi ideology in order to link Merker, U.S. imperialism, Zionism, and Jews.[15] Merker was eventually rehabilitated in 1956, but he never again resumed a prominent position in either the SED or the GDR government.

The East German VVN was another victim of the anti-Semitic campaign. In the early 1950s, a large proportion—and, in Berlin, most—of its members were Jewish. Thus when the anticosmopolitan purges began, the VVN became the only organization in East Germany that Jews could use to press their claims for restitution and recognition as "victims of fascism." In 1953, the VVN was disbanded in the GDR and replaced by a handpicked and largely non-Jewish Committee of Antifascist Resistance Fighters.[16]

The East German State and the Shoah, 1955–90

Between 1950 and 1954, there were no official Kristallnacht commemorations in the GDR.[17] In 1955, the Jewish congregation in East Berlin organized a ceremony that was attended by government and party representatives. The following year, the SED organized a public meeting in Berlin to mark the eighteenth anniversary of the 1938 pogrom. The party's renewed interest in the persecution of Jews has to be seen in the context of the German-German rivalry. Between 1955 and the early 1970s, the GDR's leaders used the Kristallnacht commemorations to draw attention to the prominence of former Nazis and war criminals, as well as to anti-Semitism, in the FRG.[18]

Attempts to invoke the Shoah in order to indict the ruling elites of the Bonn republic intensified after the capture of Eichmann by the Israeli secret service. The SED leadership was hoping to use the publicity surrounding his trial to draw attention to the connection between Eichmann and the most senior member of Adenauer's staff, Hans Globke. Globke had written commentaries on the Nuremberg Laws, and in 1953 been appointed director of the Federal Chancellor's Office. He kept this position until 1963 despite the controversial publicity surrounding his past.[19] Albert Norden, who coordinated the SED's campaign against the old Nazis among the elites of the Bonn republic, in 1960 called Globke the "Eichmann of Bonn." In 1961, Globke was tried in absentia in East Berlin.

While thousands of Jews from Eastern Europe who had become stranded in Germany as DPs settled after the war in the western zones, East Germany's Jewish communities were made up of émigrés and other survivors who returned to their former homes, and Jews who had been spared deportation as partners in so-called privileged marriages. The Jewish population in East Germany was always small and shrunk further in the early 1950s following the anticosmopolitan purges. Furthermore, in the 1950s, the few remaining East German Jews kept a low profile and did not take any initiatives that would have brought them in conflict with the policies pursued by the SED. In Kristallnacht commemorations, Jewish representatives appeared as extras in scenes scripted by the SED. But the state-sponsored commemorative rituals of the second half of the 1950s did not require more than a token Jewish input. From 1953, Jewish congregations were, however, generously supported by the state, which paid for the renovation of synagogues and other expenditures that could not be borne by the small membership. "Jews in the GDR," Robin Ostow wrote, "became a 'protected species.'"[20]

From the early 1960s, Jewish congregations in the GDR insisted on their own interpretations of the Nazi past, without, however, openly contradicting that advanced by the SED. In Berlin, Leipzig, and Dresden,

they dedicated memorials for those who had perished in the Shoah. Jewish representatives, while publicly maintaining that there was no anti-Semitism in the GDR, repeatedly drew the attention of the authorities to anti-Semitic incidents in East Germany. Although the government pursued an unambiguous anti-Israeli line, Jewish organizations in the GDR consistently refused to denounce the state of Israel. From the 1970s, they also demanded that East German school textbooks pay more attention to the persecution of Jews.

In the German Democratic Republic, public memories of the Holocaust slowly changed at about the same time as they underwent such significant transformation in the other Germany. In East Germany, it was the Lutheran churches who first publicly propagated a new approach. In anticipation of the fortieth anniversary of the Kristallnacht pogroms, working parties in the churches researched and published the history of the Shoah and the role of the churches in Nazi Germany. In 1981, East Germany's Protestant bishops repudiated the equation of Zionism and racism that had been proclaimed by the United Nations General Assembly six years earlier. In 1985, East German dissidents publicly called for a revising of the antifascist orthodoxy and for an acknowledgment of the suffering of Jews.

From about the mid-1980s, the official party line also changed. This was partly because of the government's attempts to establish or extend economic ties with the West, and in particular with the United States. "International Jewish organizations," Ostow observed, "were perceived in the GDR as channels of communication and potential mobilizers of local Jewish support in western countries for trade with the East"[21]—and, it should be added, to procure an invitation for Honecker to visit the White House. It is likely that the GDR leadership took a lesson from the Jackson-Vanik Amendment of 1974, when the United States had offered the Soviet Union favorable trading conditions in return for the granting of exit visas for Jews who wished to emigrate.[22] In June 1987, Erich Honecker invited the president of the Jewish Claims Conference to Berlin to discuss the issue of restitution. In November of that year, during a visit to East Berlin, U.S. deputy secretary of state John Whitehead was assured that the GDR acknowledged the fact that it, too, was a successor of Nazi Germany. In June 1988, Honecker met the chairman of the Zentralrat der Juden in Deutschland (Central Council of Jews in Germany), Heinz Galinski. The following day, the East German papers published Galinski's recommendation that "the media of the GDR be more balanced."[23] The East German state's overtures to the country's Jewish population culminated in the commemoration of the fiftieth anniversary of the Kristallnacht pogrom in the GDR parliament, Volkskammer, which was convened for a special sitting on 8 November 1988. These overtures also

included a host of unspectacular initiatives such as that for the Koppen-platz memorial in Berlin-Mitte (see introduction).

In the end, the SED did not live long enough to reap the benefits of its concessions to Jews. But the dynamic created by the tactical maneuvering of the SED leadership between 1987 and 1989 continued to have an effect after the SED had all but gone. On 8 February 1990, GDR prime minister Hans Modrow officially declared his country's willingness to enter into negotiations about restitution with Jewish organizations and the state of Israel. In April 1990, the first democratically elected Volkskammer passed a resolution that acknowledged the responsibility of all Germans for the crimes committed by Nazi Germany and asked Jewish survivors for forgiveness. As if to demonstrate its commitment, three months later the Volkskammer invited Jews from the Soviet Union to settle in the GDR. After Reunification, the German authorities rephrased this open invitation and restricted the migration of Jews from the former Soviet Union to Germany; nevertheless, the significant increase in the number of Jews living in Germany after 1990—the size of the Jewish population more than doubled within five years—is one of the few lasting legacies of the last GDR parliament.[24]

The most ambitious and most visible revisionist project promoted by the SED concerned the restoration of the New Synagogue in Oranien-burger Straße in the heart of Berlin. The restoration of what used to be Berlin's largest synagogue began with a state occasion. When the foundation stone for the New Synagogue was laid on 11 November 1988, "many flags of the GDR and the capital city decorated the central site of memory in Oranienburger Straße," as one East German newspaper reported.[25] The ꜱꜰᴅ'ꜱ ɢᴇɴᴇʀᴀl ꜱᴇᴄʀᴇᴛᴀʀʏ ᴇʀɪᴄh ʜᴏɴᴇᴄᴋᴇʀ ᴀɴᴅ ꜱᴇᴠᴇʀᴀl ᴍɪɴɪꜱᴛᴇʀꜱ ᴀɴᴅ ᴍᴇᴍbers of the party's politburo attended the ceremony. A young Jew gave Honecker a bunch of flowers "as a token of gratefully experienced security and equality."[26]

The New Synagogue had been consecrated in 1866.[27] The magnificent building, which could accommodate more than thirty-two hundred worshipers, then embodied the comparative affluence and self-confidence of Berlin's twenty-eight-thousand-strong Jewish community. It also reflected a striving for assimilation: like Christian churches, the New Synagogue was equipped with an organ. It was the third-biggest organ in Berlin and the biggest in a synagogue worldwide.[28] On the night of 9 November 1938, members of the SA set fire to the synagogue, but the policeman in charge of the local precinct chased the arsonists away and ensured that the fire brigade put out the flames. The synagogue was renovated and used in its original capacity again briefly from early 1939. The last service was held on 30 March 1940. Thereafter the building served as a warehouse for the Reichswehr's Uniform Store. On 22 November 1943 the building was

badly damaged in a British air raid. For more than ten years after the war, the ruin was left as it was. In 1958, the East German authorities demolished the nave of the building, possibly because it threatened to collapse.

The idea of restoring the synagogue did not come from the SED. Prominent members of East Berlin's Jewish community were already talking about rebuilding in 1984.[29] Since the early 1980s, East German Jews became increasingly interested in Jewish culture and in the history of their communities.[30] While this interest on its own would not have been sufficient to bring about a change of direction in the way Jewish culture and history were regarded by the East German authorities, it contributed significantly to the change.

The new New Synagogue was consecrated in 1991 and opened four years later—but not to serve as a synagogue. The nave was not rebuilt. The restored front part of the building partly functions as a museum and partly houses the Centrum Judaicum, a Jewish community and research center. The official opening in 1995 was attended by the leaders of the new Germany, Chancellor Helmut Kohl and President Roman Herzog. It was perhaps the only occasion when Kohl and Herzog celebrated the fruition of a work once begun by Erich Honecker. From afar, the New Synagogue now appears as magnificent as it was described before its destruction. The golden dome-shaped roof, crowned by a Magen David, again became a landmark in the center of Berlin, and the New Synagogue became the most conspicuous reminder of a German-Jewish culture in the past, and symbol for a Jewish presence in the new Germany.

Arabs, Balts, Communists, and Irresponsible Elements

At East German Kristallnacht commemorations, speakers representing the SED or the state regularly pointed their fingers at anti-Semitism in West Germany. Anti-Semitic incidents in the Bonn republic were cited as evidence of fascist tendencies. The period of state-sanctioned anti-Semitism in the first half of the 1950s was conveniently omitted from East German public consciousness. In the GDR, too, Jewish cemeteries were violated, but these violations never became as visible as those in the other Germany. In the following, I recount the public reactions to one desecration in West Germany, an almost forgotten precursor to the loud anti-anti-Semitic public discourse triggered by the desecration of a synagogue in Cologne in 1959.[31]

The Jammertal cemetery in Salzgitter was a symbolically potent site not only for German antifascists. On the night of 19 April 1957, seventy-eight Jewish graves at Jammertal were violated, the Jewish memorial was overturned, and an effigy was hung from the French memorial with a sign that read "Deutschland erwache, Israel verrecke" [Germany, awaken!

Israel, drop dead!]. While being a first for Salzgitter, and coming well before the wave of anti-Semitic desecrations in 1959–60, this incident was but one of many violations of graves with an unmistakably anti-Semitic intent in postwar Germany.[32] It nevertheless attracted some attention beyond Salzgitter, even beyond Germany.[33] The local authorities immediately put a reward of five hundred marks for information leading to the apprehension of the perpetrator(s) and arranged for the memorial to be repaired; a few days later, the federal minister for the interior, Gerhard Schröder, increased the reward by ten thousand marks. The minister for foreign affairs, Heinrich von Brentano—rather than Schröder or Konrad Adenauer—was the most senior politician to publicly condemn the act. No sentence would be too harsh, Brentano said. Such an irresponsible act was likely to shatter the hard-won trust gained by Germany abroad.[34] No federal politician visited Jammertal.

West German politicians would have been annoyed about the propagandistic leverage such "irresponsible acts" provided to the SED.[35] But more so, they were concerned because of the response the desecration provoked outside Germany. This concern was shared by the national and local media. "The damage done to Germany's reputation in the world, which had been restored with much difficulty, and also to the conscience of anybody concerned about overcoming the horrors of the past, is immeasurable," an editorial in the local *Salzgitter-Zeitung* noted on 24 April.[36] That same day, the Salzgitter City Council passed a resolution condemning the desecration:

> Council unanimously condemns this act in the strongest possible terms, knowing that in doing so it represents the views of all decent inhabitants of the city and of the entire Federal Republic. After the war, the council and the city administration, together with many other institutions, tried to compensate for the harm that irresponsible elements had done to the city and to the whole nation, as well as to other countries. Even today, twelve years after the end of the ill-fated war, thousands of inhabitants of this city, and millions of people outside its boundaries, suffer from the losses of this past as expellees and refugees, victims of war or victims of the National Socialist rule of terror [*Terrorherrschaft*]. Everywhere crosses are an indictment of a system that [was] also responsible for the dead of the Jammertal *Ehrenfriedhof*. Whoever disturbs the peace of the dead and lays hands on their memorial puts himself outside the community of his nation and of his town, whose citizens, through decency, diligence [*Fleiß*], and their renewed commitment to a peaceful community of nations, have slowly regained the reputation that was lost over the years.[37]

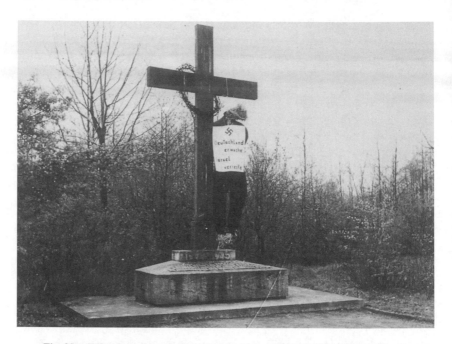

Fig. 20. Effigy hung from the French memorial at Jammertal, April 1957. The sign reads "Deutschland erwache, Israel verrecke." (Photograph courtesy of Niedersächsisches Hauptstaatsarchiv.)

The council's resolution is a remarkable statement about crimes, victims, and perpetrators. During the unmentionable period that is associated with the "ill-fated war," harm was not done to Jews, Sinti, and Roma, or others murdered in the name of Nazi Germany, but to Salzgitter, the German nation, and "other countries." Then "irresponsible elements" had tarnished the good name of Germany. Now, that name was again in danger of being sullied. Such an assault on the nation's reputation cried for drastic action: the perpetrator had to be excluded from the *Gemeinschaft des Volkes* (community of the nation)—from what Salzgitter's *Oberstadt-direktor* had in 1952 called more succinctly *Volksgemeinschaft* (national community).

The search for the perpetrators was initially carried out by the local police's special branch. As the public response to the desecration became more vociferous, the minister of the interior gave responsibility to the Federal Police, who formed a special task force of eleven detectives to work on the case. The leads followed by the police were in themselves indicative of the context in which anti-Semitic violence was seen in the second half of the 1950s. The police screened seventy-seven Arabs living in Salzgitter and

Braunschweig, who were prime suspects because of the tensions between Israel and its Arab neighbors. They carried out checks on 144 Latvians, Lithuanians, and Estonians because they were considered to be traditional anti-Semites, and because earlier in 1957 a prominent and popular member of the Baltic community in Salzgitter had been arrested on account of his involvement in the murder of Jews when he had been police commissioner in Memel. The largest group of suspects screened by the police were 536 visitors from the GDR, many of them in the Salzgitter area to take part in sporting events. But the police eventually excluded the possibility that the cemetery had been desecrated by an East German agent provocateur and concluded that the perpetrator was most likely a right-wing extremist.[38]

The investigation by the Federal Police task force did not yield any results and was closed within about a month. A final report filed by the detective in charge offered an explanation for this failure. The task force had exhibited the effigy and the sign that were found at Jammertal, in Salzgitter and neighboring towns, hoping that somebody would come forward and identify the suit worn by the effigy. These exhibitions occasioned only three tips; the report comments on the "very inadequate cooperation of members of the public": "While they largely condemn the crime as such, they do not want to contribute to solving it." The report cites several examples of people who refused to assist the task force with its work because they were afraid of the consequences, and continues: "Besides, some informants let it be known that they do not want to be associated with solving 'political' crimes, for 'you never know what's yet to come!'"[39]

The crime was solved by Lower Saxony's Verfassungsschutz, an intelligence service responsible for keeping political extremists under surveillance. The Verfassungsschutz soon suspected Günter Sonnemann, an electrician from Wolfenbüttel, a town about fifteen kilometers from Salzgitter. Sonnemann, born in 1930, was a supporter of the Sozialistische Reichspartei, a neofascist party that was formed in 1949 and banned by the High Court in 1952 as an NSDAP successor organization. But it was not until March 1961 that the Verfassungsschutz passed on the evidence collected on Sonnemann and his accomplices. The latter included a Syrian journalist who had left Germany in May 1957, and for whom Sonnemann had taken pictures of the effigy. When the intelligence service informed the Prosecutor's Office, it did so because it was convinced that Sonnemann was about to detonate the memorial at the former site of the Bergen-Belsen concentration camp and to assassinate the chief prosecutor of Hessen, Fritz Bauer, who was prominent in prosecuting war criminals.[40]

In March 1962, the Federal Court, in its first dealing with a projected rather than committed crime, convicted Sonnemann of damaging the Jewish memorial, of desecrating the cemetery, and of setting up a criminal

organization with the aim of carrying out bomb attacks. As demanded by the prosecution, the court sentenced him to six years' imprisonment; two accomplices received lighter prison sentences. Justifying the length of Sonnemann's sentence, the judges again referred to the harm done to Germany's reputation:

> Although there is no more National Socialism in Germany, but rather, at the most, a few people who are incorrigible, crimes with a National Socialist background, when committed on *German* soil, are judged according to a particularly strict standard. The crime [at Jammertal] was therefore highly suited to harm severely the German reputation in the world, and the defendants were aware of that. The desecration of the cemetery is thus evidence of a particularly base cast of mind on the one hand, and of political irresponsibility on the other.[41]

Sonnemann's attention may have been drawn to Jammertal because in early April 1957, the IG Metall metalworkers union, possibly in conjunction with the management of the steelworks, decided to take responsibility for the cemetery.[42] The IG Metall planned to fund a new memorial at Jammertal and possibly made this idea public two weeks before the desecration of the cemetery, during an IG Metall–sponsored local screening of Alain Resnais's *Night and Fog*.[43]

The union went beyond merely decrying the desecration. On 26 April, IG Metall delegates laid a wreath a Jammertal. Four days later, on the eve of Labor Day, thousands of young trade unionists rallied at the cemetery in protest against the desecration. The demonstration was anything but spontaneous: the union could confidently predict the number of participants several days before the rally.[44] The young unionists carrying torches and flags were addressed by Maria Meyer-Sevenich, a prominent Social Democrat and member of the state parliament: "You, whose shoulders carry the responsibility of future generations, are called upon to renew and heal a society marked by symptoms of a grave illness." Meyer-Sevenich also tried to put the desecration into perspective: "I am aware that the German nation in its overwhelming majority does not approve of the disgraceful deed done here."[45]

One week after the desecration of the graves at Jammertal, a newspaper from neighboring Braunschweig applauded the unions for organizing rallies and laying wreaths at the cemetery. But after the unions had publicly made their point, the newspaper commented, "we should let *Ruhe* [peace and quiet] come to Jammertal for ever."[46] The *Ruhe* envisaged by the newspaper entailed not just the kind of peace appropriate for a cemetery, but also a silence in relation to the past associated with Jammertal. As was discussed in chapter 1, peace did return to Jammertal—which

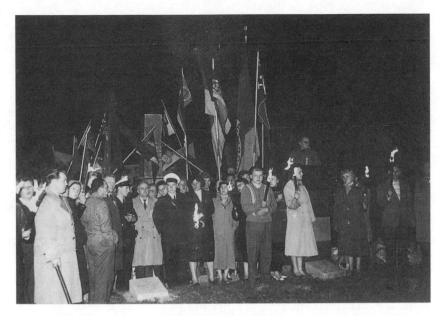

Fig. 21. Maria Meyer-Sevenich speaking at an IG Metall rally at Jammertal on 30 April 1957 against the backdrop of the repaired Jewish memorial. (Photograph courtesy of Arbeitskreis Stadtgeschichte Salzgitter e.V.)

remained the responsibility of the local authorities—and to Salzgitter, but not "for ever." The IG Metall initiative to erect a memorial at the cemetery came to naught and was as much forgotten as similar projects planned in the second half of the 1940s in Celle and other West German towns.

The Jewish Barracks

In the second half of the 1990s, visitors to Berlin's New Synagogue were possibly as much impressed by the armored personnel carrier parked in front of it as by the restored interior of the building itself. Neither the Centrum Judaicum nor the Zentralrat (which resides in the adjoining building) had demanded that the German state provide such conspicuous protection; they both had their own security arrangements: a private security service provided personnel who searched, and screened the bags of, visitors. Since at least the early 1990s, German authorities had been greatly worried about the possible desecration of *Mahnmale* and assault on symbols of the Jewish presence in Germany. Considering the extent of racist violence in the new Germany, their fear seemed justified. Yet the armored personnel carrier was not simply guarding the synagogue in Oranienburger Straße

lest harm be done to it or its staff and visitors. By protecting, or credibly appearing to protect, Jewish Germans and their institutions, the police were protecting the German reputation abroad. In the same way, the authorities in Hildesheim have been anxious about the vulnerability of the Kristallnacht cube at Lappenberg because Hildesheim's reputation would be severely damaged if the memorial were desecrated. Sometimes the German reputation has been invoked to mask other issues: one of the correspondents who objected to the Sinti memorial in Wiesbaden (see chap. 4) did so because he was afraid that it would send the wrong message to an audience outside Germany.

The public relations debacle of 1985, when Chancellor Helmut Kohl invited President Ronald Reagan to join him in visiting the Bitburg war cemetery and thus the graves of members of the SS, made West Germany's political leaders appreciate the enormous symbolic importance of sites such as those of former concentration camps to an audience outside of Germany, particularly in neighboring countries, the United States, and Israel. They slowly became accustomed to foreign dignitaries requesting visits to concentration camp memorials or other *Gedenkstätten,* while in Germany on official business. When visiting Germany in mid-September 1992, the Israeli prime minister Yitzhak Rabin requested to be taken to the former site of Sachsenhausen Concentration Camp in Oranienburg, just north of Berlin. On his way to Oranienburg, his convoy made a stop at Putlitz-Brücke (Putlitz Bridge), where Rabin visited a memorial to commemorate the deportation of Jews from a nearby freight terminal. The *Mahnmal,* one of the most frequently desecrated memorials in Berlin, had only a couple of weeks earlier been the target of a bomb attack.[47] After arriving at the concentration camp memorial, Rabin said: "I call upon you Germans: do not delay in fighting against neo-Nazism here in Germany and in other countries."[48] In Sachsenhausen, Rabin and his entourage were particularly interested in another memorial commemorating the persecution of Jews, the so-called Jewish barracks.

The Nazis had conceived Sachsenhausen as a model concentration camp.[49] When built in 1936, the camp was structured symmetrically in order to facilitate the most effective surveillance of its prisoners. The barracks were arranged in four concentric rings around the semicircular area where the prisoners had to line up for the twice-daily roll calls. The barracks were aligned toward a watchtower above the camp gate that was situated in the center of the semicircle's baseline. This baseline separated the triangular area of the actual camp from the buildings occupied by the SS. The symmetrical design was partly abandoned in 1938, when an additional eighteen barracks were built in the so-called new or small camp, an area that was added to the original triangle. With the completion of the new camp in 1938, Sachsenhausen had a total of sixty-eight barracks to accom-

Fig. 22. Police guarding the entrance to the New Synagogue, Oranienburger Straße, Berlin, 1997

modate prisoners. Like the barracks housing the non-German Reichs-werke laborers at Salzgitter, they were standard RAD barracks, which had been developed in 1934 for the compulsory Reichsarbeitsdienst (RAD) labor service, and were assembled from prefabricated parts. Following the Kristallnacht pogrom in November 1938, at least two of the barracks in the new camp, Barrack 38 and Barrack 39, housed Jewish prisoners. The Jews imprisoned in Sachsenhausen after the pogrom included, among many others, nearly all men and male youth from Celle's Jewish community.[50] Most of these prisoners were released in December 1938. In 1942, Barrack 38 and Barrack 39 again housed Jewish prisoners. At that stage, a total of 450 Jews were imprisoned in Sachsenhausen.

Soon after Sachsenhausen's prisoners were liberated by Soviet and Polish troops, the Soviet Ministry of the Interior took over the concentration camp to detain Germans suspected of being Nazis or enemies of the new regime. The internment camp was disbanded in early 1950. In the following seven years, most of the remains of the concentration camp fell into disrepair or disappeared as a result of neglect and theft.[51] In 1956, when plans to establish a memorial at Sachsenhausen began to take shape, four of the original barracks in the new camp were still standing, but they were derelict. The team designing the memorial opted to reconstruct two barracks in the area of the new camp from parts that were salvaged when all

remaining original barracks were demolished. Located where Barrack 38 and Barrack 39 had been, these reconstructed barracks were to demonstrate the living conditions in Sachsenhausen.

One of the key components of the Sachsenhausen memorial was the International Museum, where countries whose nationals had been prominently represented among the concentration camp's prisoners were assigned space. Jewish prisoners were not represented as Jews but as nationals of Poland, Hungary, Germany, or other countries. In his speech at the dedication of the Sachsenhausen memorial, Walter Ulbricht did not mention Jews, but referred to individual German political prisoners (Communists, Social Democrats, and liberals), "Soviet citizens," and nationals of ten other countries.[52] Jewish survivors protested about Israel having been left out. The protests were consequential, as they coincided with the GDR's attempts to draw a connection between Eichmann and Globke. In time for the opening of the memorial, a permanent exhibition about the "resistance and suffering of the Jewish people" was installed in a wing of Barrack 38.[53] While the International Museum was closed in August 1991, the exhibition in Barrack 38 survived the reorganization of the memorial in the wake of Reunification.

Ten days after Rabin's visit, in the early hours of 26 September, the two reconstructed barracks went up in flames. One wing of Barrack 38 was gutted; its other wing and Barrack 39 were badly damaged. In the German media, politicians of all parties represented in federal parliament and the Zentralrat loudly deplored what not until three days after the fire was confirmed to have been an arson attack. Brandenburg's state premier, Manfred Stolpe, warned against a "relapse into the darkest German past" and predicted that Germany would be "on its way to Auschwitz" if xenophobic violence and racism escalated any further.[54] The burning of the Jewish barracks elicited an anguished reaction in Israel and was noted with some concern in the American and Western European media. The concern abroad was in turn noted carefully in Germany. On 29 September, Klaus Kinkel, a leading Liberal Democrat and a senior member of the Kohl government, visited Sachsenhausen. Like Brentano, the federal minister who condemned the desecration of the Jammertal graves in April 1957, before him, Kinkel was in charge of foreign affairs. Increasingly, he had to deal "with many concerned inquiries from abroad," Kinkel explained in Sachsenhausen.[55] Kinkel's visit was followed only hours later by that of SPD chairman Björn Engholm and fellow Social Democrat, Manfred Stolpe. On both occasions, the politicians were accompanied by Ignatz Bubis, newly appointed chairman of the Zentralrat, who through his presence legitimized the demonstration of concern and suggested that the arson attack on the barracks had to be interpreted as an attack on Jews in Germany.

Fig. 23. German Minister for Foreign Affairs Klaus Kinkel and entourage in front of the remains of the Jewish barracks in Sachsenhausen, 29 September 1992. Kinkel is the person with glasses in the center of the photograph; Ignatz Bubis is to the right. (Photograph by F. Liebke, courtesy of *Oranienburger Generalanzeiger*.)

Kinkel did not visit Sachsenhausen to demonstrate his own *Betrof-fenheit.* Nobody was suggesting that he sympathized with the arsonists. Rather, he felt compelled to vouch for his non-Jewish *Mitburger.* Such a demonstration of faith was most effective at the scene of the crime. "This Germany is not xenophobic," he proclaimed in front of running cameras, many of them, he must have been hoping, recording his words for non-German television stations. His assurance was strangely reminiscent of German community leaders who after the defeat of Nazi Germany claimed that the majority of Germans had not actively supported the regime (see chap. 8). Kinkel also *sounded* like Maria Meyer-Sevenich, but unlike hers, his vouching for German innocence was directed at an audience beyond Germany. Kinkel also addressed his fellow Germans: "A few misguided people," he warned, must not be allowed to destabilize German democracy.[56]

When Kinkel inspected the ruins of the Jewish barracks, the background of the arson attack had not been established. The police had set up a special task force but had not been able to trace the arsonists. Nor had anybody claimed responsibility for the attack. Only Ignatz Bubis conceived of it as directed against Jews in particular. Everybody else assumed

that the arsonists were right-wing extremists, and that the attack on the barracks could be regarded as a symbolic expression of xenophobia and racism. These assumptions were only partly made with the specific target in mind. After all, if it was indeed a politically motivated act by right-wing extremists, then it could have been directed against the Sachsenhausen memorial in general. The arsonists could have considered the memorial a potent symbol of East German antifascism. That they burned down the Jewish barracks rather than the other museums could have had to do with the fact that the barracks were close to the memorial's perimeter and that they, unlike the brick buildings accommodating other exhibitions, would burn easily.

Those who assumed that the arson attack was the work of racists saw it in the context of a series of seemingly related incidents. Since the late 1980s, and increasingly so since early 1990, there had been a spate of politically motivated violent attacks on foreigners in Germany.[57] In 1992 alone, seventeen persons died as a result of such attacks. In August 1992, hundreds of Germans rioted in front of a hostel in Rostock and set fire to the building, threatening the lives of 115 Vietnamese refugees and a camera crew. The rioters were loudly applauded by scores of Rostock residents watching the spectacle. While similar riots were restricted to East German towns, arson attacks and other acts of physical violence against refugees and migrant workers were happening in all German states. In September 1992, there were 536 reported arson attacks against refugee hostels or foreigners' private homes.

Neither Kinkel nor any other senior member of the Kohl government had made an appearance in either Rostock or Hoyerswerda, where the first such riots took place in September 1991. Kohl and his ministers found it more difficult to express their solidarity with Turkish migrant workers or Vietnamese refugees than with Jews—and this really meant with dead Jews, for in 1992 Bubis and other Jewish representatives tended to be perceived as guardians of the graves of six million victims of the Shoah rather than as spokespersons of Jews living in Germany. The government had not condoned the violence of Rostock and Hoyerswerda. But prominent conservative politicians had empathized with the rioters, who supposedly were the victims of economic restructuring and merely misguided in their choice of means to vent their legitimate frustration.

The arson attack was generally seen as being part of the wave of xenophobic violence. Yet in 1992, anti-Semitism was not expressed by physical attacks on Jews in Germany but rather attacks "on the concrete representation of the memory of the past."[58] Germans who confused an attack on the memory of dead Jews with an attack on Jews in contemporary Germany, did not notice the presence of a living Jewish culture in Germany; according to their interpretation, Jews in Germany were essentially dead

Jews, and Germany was *judenrein.* Kinkel and his colleagues, however, did not react so strongly because they equated the Jewish barracks with contemporary Jewish life in Germany, but because the arson attack made the riots against refugees appear in a new light. They were less concerned that the fire in Sachsenhausen could be seen in the context of the wave of xenophobic violence but rather feared that the riots and murders of refugees and migrants could be seen in the context of Sachsenhausen. The Rostock riots had once again raised the issue of German responsibilities. "A few hundred citizens could have chased away the arsonists," Wolfgang Pohrt succinctly reminded anyone who mistook rallies against xenophobia for expressions of practical solidarity with foreigners, rather than as manifestations of German anxieties.[59] The past came to haunt the present. The arson attack could serve to give credence to the argument that Auschwitz needed to be invoked in the face of Rostock and Hoyerswerda.

Neither the desecration of the cemetery in Salzgitter nor the 1992 arson attack in Sachsenhausen appear to have been big news in the U.S., British, French, and Australian print media; the *New York Times* of 21 April 1957, for example, reported the desecration of the Jewish cemetery in Salzgitter in a thirteen-line note on page 45. In 1992, German concerns with reactions outside Germany were often reported more prominently than the arson attack itself.[60] But in order to understand sensitivities outside Germany, or rather, German perceptions of non-German sensitivities, it is worth looking for more than just articles about anti-Semitism. In April 1957, Western European newspapers were concerned about the BHE (Bund der Heimatvertriebenen und Entrechteten), a party representing German expellees that had a lot of popular support and demanded the return of former German territories and about the antisemitic sentiment in West Germany.[61] In mid-September 1992, newspapers outside Germany reported in detail plans by German industry to celebrate the fiftieth anniversary of the launching of the first V2 missile, and the government's reluctance to distance itself unequivocally from such celebrations.[62]

With journalists writing for the *Jerusalem Post* or the *New York Times,* Kinkel, Engholm, and other political leaders claimed to represent Germans. But their strategic reactions comprised only one segment of the public response to the Sachsenhausen arson attack. There were other, quite different public reactions. A comment in a Berlin newspaper, written on the day of the fire, echoed some of the sentiments of the 1957 resolution by Salzgitter's city council. The writer deplored the fire while at the same time noting that there were also German victims, both in the concentration camp and in the internment camp:

It is indicative of an extremely high degree of brutalization and intellectual blindness when anti-Semitism chooses Sachsenhausen as a

parade ground for its hatred. For in Sachsenhausen not only Jews suffered. Here, democrats, Communists, antifascists, National Socialists, and some who were prisoners by pure chance were mal-treated and murdered. The tragedy of Sachsenhausen does not wear any particular political or racial colors.[63]

Unlike in Salzgitter in 1957, in 1992 survivors spoke out and visited the scene of the fire. Unlike in 1957, there were public demonstrations of spontaneous outrage by "ordinary" Germans: Oranienburg residents vis-ited the memorial on the morning after the fire to put flowers at the gate of the memorial. On 30 September, five hundred high students from schools in the (West) Berlin borough of Reinickendorf rallied at Sachsenhausen.

In 1992, many organizations and individuals who publicly decried the arson attack declared themselves innocent and identified a sizable propor-tion of the population who supposedly were complicit with the arsonists. Meyer-Sevenich had called upon the young unionists to heal a sick nation. In 1992, many of those articulating their concern assumed that the nation could be divided into the sick and the healthy, with themselves having a clean bill of health. The sick, said the healthy, need to be punished severely. Such a distinction between the sick and the healthy, the guilty and the innocent, was no longer aimed at excluding irresponsible elements from the national community (except, when talking to a *New York Times* correspondent); in 1992, the "innocent" took the pariah status of neo-Nazi hooligans for granted. What was different between 1957 and 1992 was the collective sense of righteousness that pervaded so much of the public response to anti-Semitism in the 1990s. A sacrilege such as that committed in Sachsenhausen allowed even those to be self-righteous who felt for the rioters in Rostock.

It was not just flagrant anti-Semitism that proved so convenient in the new Germany. Concentration camp memorials had become sacred sites. Whenever they were violated, self-declared "decent" Germans felt com-pelled to assert their clear conscience. In 1991, "decent" Germans had been appalled by the building of a supermarket on a site that once belonged to the Ravensbrück Concentration Camp (see chap. 9). When some two years after the Sachsenhausen arson attack, twenty-two drunken skinheads went on the rampage in Buchenwald, the nation's good citizens again came out in force to parade their clear conscience and con-demn the incident as a "disgrace to our nation."[64]

As a phenomenon, such self-righteousness is not unique to Germany. What is specific to Germany is the phenomenon's complex genealogy. It grew out of German antifascism—out of claims such as those made by Walter Ulbricht in 1961 at Sachsenhausen. Survivors, he said,

have heard frequently in the past few years of the demands for revenge and of the atomic armaments of the West German government. They asked with justice: will the German people never learn the lesson of two world wars? We, the citizens of the German Democratic Republic, can answer with clear consciences: we have learnt the lesson, we have paid reparations to the extent that this was at all possible. We have conquered that evil militarist and reactionary spirit that influenced the German past so fatefully, by tearing out nazism and militarism by the roots.[65]

Following the attacks on Sachsenhausen in 1992 and Buchenwald in 1994, a small minority of antifascists continued to believe that the Left had "learnt the lesson." But their self-righteous declarations were easily drowned out by those who held antifascists responsible for having neglected the persecution of Jews and for breeding neo-Nazis. Those who had not learned their lesson were now thought to be more likely to be living in East than in West Germany. It was as if those who for forty years had been told that they had not been able to make a clean break with the past had in 1990 been handed an opportunity to turn around and scold their former accusers for not having themselves learned the appropriate lessons.

When the outrage over the arson attack had subsided, two questions remained: Who were the arsonists? What was to be done with the ruins of the Jewish barracks? In spite of boasting by the police in the days following the fire that they were closing in on the culprits, the first question remained unresolved for several months. As had been the case in Salzgitter thirty-five years earlier, the police proved incompetent. Although it was highly likely that the attack had been carried out by a larger group of people, only two young men associated with the neo-Nazi scene were charged with the crime eight months later. The defendants initially confessed, but later retracted their self-incriminating statements. In October 1993, the Potsdam District Court acquitted them of all charges. The presiding judge moved up the pronouncement of the verdict so that "*Ruhe* [peace and quiet] prevail."[66] The prosecution appealed successfully; in August 1994, the Federal Court ordered a retrial. In October 1995, more than three years after the arson attack, the two men were convicted and sentenced to two-and-a-half and three years imprisonment. Unlike Sonnemann, the two convicted arsonists were inarticulate and small fry. They were not capable of explaining their deed in the context of a coherent ideology. But then, nobody was really interested in the motives and background of the defendants. Publicly voiced anti-anti-Semitic concern was least of all concerned with anti-Semites. I return to the second question, namely, what to do with the remains of the barracks, in chapter 10.

Remembering Twenty Victims and One Perpetrator

On 27 April 1980, some twelve years before the Jewish barracks at Sachsenhausen fell victim to arsonists, a bomb exploded in front of a building housing a memorial in Hamburg and injured two women who happened to be walking past. The memorial itself, inside a school at Bullenhuser Damm, was not damaged. Four months after the attack, the perpetrators were caught. They belonged to the circle around Manfred Roeder, then one of West Germany's most notorious neo-Nazis. The memorial marks the site of a mass murder. Here, twenty children and twenty-eight adults were killed by members of the SS in the night of 20 April 1945, less than two weeks before the liberation of Hamburg. In 1980, a memorial plaque in the school and a small exhibition commemorated the lives and death of those murdered. Texts in the exhibition indicted the FRG justice system that had failed to prosecute one of the men implicated in the murders. The public memories that circulated as a result of commemorative ceremonies at the school and of published accounts of what happened on 20 April 1945 were prominently concerned with the presence of Nazi perpetrators in West Germany. It was probably this aspect of the memorial that had provoked the ire of Roeder and his followers.

The memorial at Bullenhuser Damm was largely born out of the antifascism of the West German left. In its emphasis on working-class resistance, and its concern with continuities between Nazi Germany and the Federal Republic, West German antifascism often mirrored the antifascism that was so crucial to the identity constructed by the SED in the German Democratic Republic. The memorial was also the result of a concerted effort by West German antifascists and the descendants of non-German victims of Nazi Germany. What makes the memorial at Bullenhuser Damm unique, however, is its focus on the death *and lives* of individual victims of the Shoah.

Every Human Being Has a Name

For a long time, it was an individual child alone whose biography captured the imagination of West Germans and made them confront the Shoah.[1] In 1956, when Frances Goodrich and Albert Hackett's play *The Diary of Anne Frank* opened simultaneously in seven West German theaters, it left audiences stunned. Within three years, the play had been performed 2,150 times in front of audiences totaling 1.75 million. By 1960, between 4 and 4.5 million Germans had seen the film based on the diary, and seven hundred thousand copies had been sold of the book, making it the highest print-run of any paperback published in the FRG in the 1950s. For many Germans who grew up in the 1950s and 1960s, *The Diary of Anne Frank* was the only detailed account of the persecution of Jews that they ever read or saw performed during their teens. Young Germans, in particular, identified with Anne Frank. Through her, Auschwitz and Bergen-Belsen could be imagined as places designed to kill one particular Jewish girl. Anne Frank's biography may, however, have conveyed nothing to its German readers about the scope of the killings in Auschwitz and Bergen-Belsen.

Is it at all possible to imagine a genocide, to comprehend figures such as 33,000, 500,000 or 6,000,000? What do we grasp when we try to imagine that about 33,000 Jews were shot at Babi Yar in September 1941; that some 500,000 Sinti and Roma were killed in the name of Nazi Germany; that approximately 6,000,000 Jews were murdered in the Shoah? When posing this question, I do not merely want to draw attention to the impossibility of representing what lies behind such figures, but to ask how it is possible to remember and mourn those murdered in the genocides of Jews, Sinti, and Roma.

War memorials tend to commemorate the dead by listing names. Recent German *Mahnmale* in memory of the victims of the Nazi past often do the same: the so-called *Spiegelwand* (mirror wall) in Berlin-Steglitz and a memorial for Hannover's Jews are the two most prominent examples.[2] The effect of such a listing of names may depend on who does the listing now, as much as on the reference points for such lists. German authorities kept track of many of those murdered in Nazi Germany; thus we know of the fate of many of Hildesheim's Jews because of lists that accounted for Jews deported to ghettos and concentration camps. When the Salzgitter funeral director who was charged with burying the dead of Lager 21 and of the various Neuengamme satellite camps wrote down their names, he probably did so out of a sense of punctiliousness, as part of his commitment to his business and profession, rather than because he intended to help others commemorate the dead. The idea, much discussed in 1995, to inscribe the names of the 4.5 million Jewish victims whose names are

known on a gigantic memorial plaque in Berlin was championed by the descendants of the victimizers rather than requested by the descendants of victims and survivors. If only for that reason, it was dubious—notwithstanding the fact that for members of Germany's Jewish communities, the recalling of the names of the dead has been one of the most important means of remembering those killed in the Shoah.

Since 1996, Jewish organizations in Berlin have staged public readings of the 55,696 names listed in a memorial book for the local victims of the Shoah. In 1998, that alphabetical reading—lasting twenty-eight hours—took place in Große Hamburger Straße, a few hundred meters from Koppenplatz.[3] In the early 1940s, a Jewish old people's home in this street had been turned into a transit camp, from where Berlin's Jews had been deported to ghettos and concentration camps. In 1997, Jewish students in Hamburg followed the Berlin example. The last of the names read out in Hamburg that year was that of Ruchla Zylberberg, a Jewish girl born in Zawichost in Poland on 6 May 1936 and murdered in Hamburg on 20 April 1945.[4]

Such recallings of names serve to remind us of the fact that a figure such as 55,696 is a multiplier: fiftyfivethousandsixhundredandninetysix times one human being. Names remind us that the figure, 55,696, needs to be thought of as one individual plus one individual plus one individual plus one individual . . . But while a twenty-eight-hour reading of names— or a seemingly endless reciting of names as in the Children's Memorial at Yad Vashem—may allow people to imagine or comprehend a figure representing a large number of individuals, it hardly enables them to remember those individuals. Nor would a compilation of names, photographs, and short biographies, as in Serge Klarsfeld's memorial to the "French children of the Holocaust" necessarily facilitate such a remembering, although it would go a long way toward enabling readers to imagine the human beings who once carried the names.[5] For such a remembering to become possible, the number of victims to be recalled probably needs to be much smaller. Unlike 6,000,000 or 55,696, twenty dead could be conceptualized as twenty individuals, for example by thinking of them as Ruchla Zylberberg and nineteen others like her but not identical with her.

Twenty Jewish children were murdered at Bullenhuser Damm in Hamburg in the night of 20 April 1945:

Georges-André Kohn
Jacqueline Morgenstern
W. Junglieb
Roman Zeller
Lelka Birnbaum
Eduard Hornemann

Marek Steinbaum
Eduard Reichenbaum
Bluma Mekler
Surcis Goldinger
Ruchla Zylberberg
Alexander Hornemann
Sergio de Simone
H. Wasserman
Lea Klygerman
Riwka Herszberg
Roman Witonski
Marek James
Eleonora Witonska
Mania Altmann

Unlike Anne Frank, none of these children left a diary behind. In fact, nearly all of what is known about four of them is known because of data collected by their murderers. Yet twenty-three years after the play about Anne Frank first stirred German theatergoers, the story of the twenty children of Bullenhuser Damm provoked similar emotions in Hamburg. In the following, I explore how that story has been told. I am particularly interested in how the biographies of the victims and those of the victimizers have intersected in the telling of the children's story. Before scrutinizing different narrative strategies, however, I need to tell the stories of the children myself.

The Children and Their Murderers

In March 1944, medical doctor Kurt Heißmeyer and high-ranking SS officers discussed the possibility of conducting a series of human experiments in a concentration camp.[6] He was then working at a sanatorium in Hohenlychen, a small town north of Berlin, and had just established his credentials by publishing an article in a medical journal in which he suggested providing treatment foremost to patients "who are most important for the preservation of the nation and the race."[7] Heißmeyer's reasoning for distinguishing between "racially inferior" and "racially superior" patients is remarkable for his apparent self-identification as somebody who let himself be seized by the Nazi weltanschauung.

> There can be no doubt that our times are in the grip of a new weltanschauung and that this weltanschauung extends to the arts and sciences. It can be anticipated with certainty that this weltanschauung will catch hold of the medical doctor's thinking and striving in gen-

eral, and permeate it with the ideas that form the basis of this weltan-schauung. This basis in turn is rooted in the concept of *Volk und Rasse* [nation and race].[8]

In his discussions with the SS, Heißmeyer proposed to test the hypothesis that tuberculosis of the lung could be cured if the patient was infected with a less virulent form of that disease. Posited about fifteen years earlier by two Austrian researchers, the Kutschera-Aichbergens, this hypothesis had already been sufficiently discredited by other lung special-ists and qualified by its authors.[9] Heißmeyer also tried to collect evidence for a theory he had developed himself, namely that tuberculosis was, strictly speaking, not an infectious disease because it only affected organ-isms susceptible to it; in his view, "racially inferior" human beings were particularly likely to contract the disease. A paper outlining this theory had been ridiculed by other specialists—apparently to the extent that it could not be published in a medical journal.[10]

SS general Oswald Pohl, in charge of all concentration camps, advised Heißmeyer to conduct the experiments in Neuengamme. There, a barrack, designed to house the prisoners made available to him, was enclosed by a separate barbed-wire fence and thus isolated from the rest of the camp. Its windows were painted white to prevent other prisoners from observing what went on inside. In Neuengamme, Heißmeyer infected probably more than one hundred men, some of whom were not previously suffering of tuberculosis, with the disease. Most of the Russian and Polish prisoners selected to be Heißmeyer's guinea pigs died of tuberculosis. Oth-ers were shot dead. Apparently, only one of the men survived.[11]

After Heißmeyer finished the experiments on adults, he conducted a second series with ten girls and ten boys, aged between five and twelve years old. They had been selected by SS doctor Josef Mengele in Auschwitz and housed there in a separate barrack. Fourteen of them came from Poland, two each from France and Holland, and one each from Italy and Yugoslavia. All of them were Jewish. They received better food than other Auschwitz prisoners, and all had their own bed with sheets. In November 1944, Ruchla Zylberberg and the other nineteen children whose names I listed above were transferred to Neuengamme.

On their way from Auschwitz, the children were accompanied by four women prisoners. Of these, two Polish nurses and a Hungarian pharmacist were killed soon after their arrival in Neuengamme.[12] The fourth woman, Paulina Trocki, was a Polish-born Jew who had been deported from Bel-gium, where she had lived since the 1920s. She survived, possibly because her skills as a medical doctor were needed at one of Neuengamme's satel-lite camps. More than ten years after the war, Trocki recalled her encounter with the children:

The transport [from Auschwitz] was accompanied by an SS guard. There were twenty children, one female medical doctor, three nurses. [The transport] was in a separate carriage that was coupled on a normal train. Presented in this manner, it appeared to be [an] ordinary [carriage]. While traveling, we had to take off the Stars of David lest we attract people's attention. To prevent people from approaching us, they said that it was a transport of people suffering from typhoid . . . The food was excellent on that journey: we were given chocolate and milk. After a two-day trip, we arrived in Neuengamme at ten o'clock at night . . . I saw somebody crying when he saw the children.[13]

From January 1945, Heißmeyer infected the children with tuberculosis. In early 1945, he had the children's lymph glands removed to check them for antibodies. He asked a colleague at the Hohenlychen hospital, Hans Klein, to analyze the glands for him. All children were photographed with one of their arms raised to show where the glands had been removed. None of them had developed the antibodies that Heißmeyer was looking for. The Dutch prisoners Dirk Deutekom and Anton Hölzel and two imprisoned medical doctors from France, René Quenouille and Gabriel Florence, all of them in Neuengamme because they had been accused of anti-German activities, were detailed to look after the children. Although the children were isolated from the rest of the camp, most other prisoners knew about them and made toys or saved food for them.[14]

At the end of March 1945, about eight thousand Scandinavians held in German concentration camps, as well as some thirteen thousand prisoners of other nationalities, were evacuated to Sweden. Scandinavians from camps in southern and eastern Germany were first transferred to Neuengamme and from there taken in especially marked white buses across the German-Danish border.[15] Before leaving Neuengamme, Danish prisoner Henry Meyer, himself a medical doctor, wrote down the children's surnames, their age, and their countries of origin.

The last Red Cross buses departed from Neuengamme on 20 April 1945. British troops were less than ten kilometers from Hamburg. That same day, Neuengamme's commandant, Max Pauly, received a cable from his superiors in Berlin, telling him to "disband Heißmeyer's department." Pauly understood this order to mean that the children and their guardians were to be killed. On the evening of 20 April, the children, the four prisoners who had looked after them, and six Red Army POWs left Neuengamme. They were accompanied by three SS guards (Wilhelm Dreimann, Adolf Speck, and Heinrich Wienhagen), a driver (Hans Friedrich Petersen), and the chief medical doctor of Neuengamme (Alfred Trzebinski). Other prisoners in Neuengamme, as well as the children themselves, were told that they were being sent to Theresienstadt.

The SS men accompanying the prisoners first called on Arnold Strippel, a thirty-three-year-old SS officer. Strippel had been transferred to Hamburg from a previous assignment in Salzgitter, where he had been in charge of the Drütte satellite camp. In April 1945, Strippel had the command over all of Neuengamme's satellites in Hamburg. Trzebinski told Strippel that he had been ordered to kill the children by giving them lethal injections, but that he deliberately had not brought any poison from Neuengamme. According to Trzebinski, Strippel then said: "If you are such a coward, then I'll have to take charge."

One of the many satellite camps under Strippel's command was in the suburb of Rothenburgsort, not far from his headquarters in Spaldingstraße in the center of Hamburg. In July 1943, Hamburg had been targeted by a massive Allied bombing raid, the result of which had been visible as far away as Celle. Rothenburgsort was particularly badly hit. The massive redbrick building of a school at Bullenhuser Damm was one of the few larger structures that had been only partly damaged. There was no more need for a school in a suburb that had been all but wiped out. In 1943, the SS took over the building, enclosed it with a fence, and used it to house prisoners from Neuengamme who were detailed to take part in cleanup operations after Allied bombing. As Allied troops were advancing on Hamburg, this satellite camp was evacuated on 11 April 1945. It was here, to the former school at Bullenhuser Damm, which on 20 April was empty but for two SS guards, Johann Frahm and Ewald Jauch, and a janitor, that the SS took the children and the ten men. Later another twenty-four POWs were delivered to the school.

Except for six of the POWs who managed to escape while being transferred from a truck to the school and another three who were shot dead while trying to do so, all the adult prisoners were hanged in one of the cellars of the school.[16] While Quenouille, Florence, Deutekom, and Hölzel were murdered because they had witnessed the experiments, it is unknown whether or not the death of the prisoners of war was also related to Heißmeyer's experiments in Neuengamme. Trzebinski injected the children with small doses of morphine; once they were asleep, the SS men hanged them, too. The next day, their bodies were brought back to Neuengamme for cremation.

Former SS guards stationed in Neuengamme who were arrested in 1945 and 1946 were questioned about the whereabouts of the children. Eventually, the story of their death came to light. In 1946, British military courts charged several members of the SS with the children's murder. All those who were directly implicated in the killing and had been caught within a year of the end of the war—Pauly, Trzebinski, Dreimann, Speck, Jauch, and Frahm—were sentenced to death and executed in late 1946. However, two of those responsible for the children's suffering and death

remained at large: Kurt Heißmeyer, who had initiated and masterminded the experiments, and Arnold Strippel, who had insisted that the order from Berlin be carried out and who had then taken part in the killings. Nobody was looking for Heißmeyer's colleague, Klein, who had analyzed the children's lymph glands.

Before his postings in Salzgitter and Hamburg, Strippel had served in several other concentration camps: Buchenwald, Peenemünde, and Sachsenhausen in Germany, Natzweiler in France, Vught in Holland, and Majdanek in Poland. He was arrested in 1948, after a former Buchenwald prisoner had recognized him in a Frankfurt street. Buchenwald survivors remembered him for his role in killing Jewish prisoners in retaliation for an attempted assassination of Hitler on 9 November 1939 at the Munich Bürgerbräukeller.[17] In 1949, a Frankfurt court tried Strippel on charges of murdering twenty-one men in Buchenwald, and imposed twenty-one life sentences. After his release in 1969, Strippel successfully applied for a retrial. In 1970, his original conviction was quashed. Now Strippel was found guilty only of being an accessory to the murders in Buchenwald and sentenced to six years imprisonment. As he had been in prison fourteen years longer than the court had stipulated after retrying him in 1970, Strippel received a total of DM 121,477.92 compensation.

The trials in 1949 and 1970 dealt only with crimes committed by Strippel in Buchenwald; he was not charged in relation to his activities in other camps. In 1964, the public prosecutor's office in Hamburg began a judicial investigation in relation to Strippel's involvement in the murders at Bullenhuser Damm. Because the statute of limitations did not allow for Strippel to be charged with manslaughter, the prosecution had to show that Strippel had committed murder. The prosecution was guided by set criteria: usually it had to prove that the murderer had acted cruelly, insidiously, or out of base motives (such as hatred of people belonging to a particular ethnic group).[18] In 1967, the investigation into Strippel's involvement in the murders at Bullenhuser Damm was abandoned for lack of evidence. In his ruling, the investigating prosecutor Helmut Münzberg found that Strippel had not acted cruelly, as the children "had not been harmed beyond the extinction of their lives."[19]

The School at Bullenhuser Damm

In May 1945, the British military government took over the school at Bullenhuser Damm to set up a transit camp for German prisoners. Two years later, the building was returned to the German authorities. It housed the Hydrographical Institute's meteorological service for a couple of years and became a school again in 1949, accommodating approximately eight hundred boys. One of the school's former teachers recalled that the older

students were required to bring tools from home to remove traces of the building's former use, such as the barbed-wire fence and the bunk beds. The teachers were aware of the murders in the school. They could have learned about them from the media coverage of the Neuengamme trials and from the janitor, Wilhelm Wede, who was in the school when the murders happened and was still looking after the building in the 1950s.[20]

During the 1950s, a small group of committed antifascists, most of them former political prisoners of Neuengamme who were now living in or near Hamburg, occasionally met on 20 April at the school to honor the children.[21] Visiting delegations of Neuengamme survivors from other European countries also visited the school to lay wreaths. In 1959, the organization representing survivors in Germany, Arbeitsgemeinschaft Neuengamme, proposed that a memorial plaque be put up in the school. The school inspector wrote to the Arbeitsgemeinschaft:

> We would like to take up your suggestion because we share your opinion that such crimes must not be forgotten and that the memory of them should remain an eternal reminder [*Mahnung*] for our people. We are still concerned about the inscription, as two aspects need to be taken into account. The school is a place where children are to grow up happy and carefree. Therefore the text must not make the horror too obvious. On the other hand, it needs to be vivid. It will not be easy to strike the right balance. Hence I ask you to bear with me if we take our time to identify the best inscription.[22]

It took four years until the authorities finally approved of a text and installed a memorial plaque at the school. The inscription's typeface was reminiscent of the runic letters cherished by the Nazis. Also the text itself was a curious choice:

> In the night from 20 to 21 April 1945, a few days before the end of the war, twenty foreign [*ausländische*] children and four adult companions were murdered here by henchmen of the National Socialist tyranny [*Gewaltherrschaft*]
>
> Remember the victims with love * Learn to respect human beings and their lives.[23]

The text does not mention the Red Army soldiers who were hanged together with the children. It refers only to anonymous victims—the authorities claimed that they did not possess any information concerning the children's identity. It does not mention that the children were Jewish— as if any suggestion that their murder was part of a larger context had to be avoided. The plaque was unveiled by the state minister for education on 30 January 1963.[24]

Vierlande Jail

The reluctance of Hamburg's authorities to mark the site of the murder in the school at Bullenhuser Damm has to be seen in the contexts of the post-war history of Neuengamme and of the relations between Hamburg's state government and organizations representing German Neuengamme survivors.

In April 1945, the SS successively evacuated the concentration camp, moving inmates first to Bergen-Belsen and other camps and, when that was no longer possible, taking most of the remaining ten thousand prisoners to the Baltic Sea.[25] In Lübeck, they were loaded onto three ships. On 3 May, British planes bombed two of these ships, *Cap Arcona* and *Thielbeck,* after mistaking them for troop carriers. About seven thousand prisoners perished, taking the total number of deaths from Neuengamme and its satellites to about fifty-five thousand. The SS kept a small contingent of prisoners in Neuengamme to destroy evidence of the camp's operations, paint its buildings, and clean up the area, before sending them on 29 and 30 April on death marches toward Flensburg. British troops reached Neuengamme on 5 May. They found a tidy but empty camp. They immediately utilized the barracks, first to house German prisoners of war, then to accommodate Russian DPs. From June 1945, Neuengamme served the British occupying forces for more than two years as an internment camp for German civilians.

With the crime rate increasing after the end of the war, Hamburg's Department of Correctional Services identified Neuengamme as the potential site of an additional, much-needed jail. In a letter to the state government, the head of the department, Buhl, found in October 1947 that "like a curse, Neuengamme Concentration Camp weighs heavily on Hamburg's conscience, its honor, and its reputation." Buhl thought it was desirable that the horror of the camp be erased from memory: "Now is the opportunity to do so by establishing an exemplary prison that restores the reputation of Neuengamme, and hence, of Hamburg."[26] One week after Buhl's initiative, the state government successfully petitioned the occupying forces to hand back the facilities at Neuengamme. Only the British resident officer at nearby Bergedorf objected. He would have liked "to see the destruction of the whole settlement and the ploughing up of the ground and the removal of all traces of this unsavoury place."[27]

In 1948 the German authorities took over the entire area once occupied by the concentration camp and set up a prison there. While the prison complex incorporated some of the brick buildings of the former camp, the barracks were pulled down in 1949 and replaced by a new building to accommodate prisoners. In 1970, the prison, Vierlande Jail, was extended with new buildings being added at the site of the former camp. Ironically,

the use of Neuengamme as a prison ensured that traces of the concentration camp have been preserved to a far greater degree than was the case in Dachau, Flossenbürg, Buchenwald, Ravensbrück, Bergen-Belsen, or Sachsenhausen.[28]

When French survivors, who after the war regularly organized *pelerinages* to the sites of their suffering, asked to be granted access to the site of the concentration camp's crematorium—which had probably been demolished in 1947—Hamburg's mayor, Max Brauer turned down their request because he was concerned about the psychological impact on the prison's inmates and because he felt that "in the interest of a developing reconciliation between nations—in particular, between the French and the German nation—anything that would touch old wounds and provoke painful memories should be avoided."[29] Brauer used phrases drafted by the Department of Correctional Services; however, he stopped short of citing another argument provided to him by his administration, namely that there was no need for a concentration camp memorial, as the "labor of love" done in the prison constituted "after all the noblest *Ehrenmal* [memorial]."[30]

Brauer could have also claimed that Hamburg had already chosen to commemorate the victims of Neuengamme at the city's central cemetery in Ohlsdorf. On 4 November 1945, an urn containing the ashes of an unknown concentration camp prisoner was installed at the cemetery. Fifteen thousand people attended the ceremony and heard speeches by representatives of all major parties.[31] In July 1946, the state government decided to take up a suggestion by Communist Party government minister Franz Heitgres, and fund a memorial for all those murdered by the Nazis.[32] The memorial by architect Hans Jürgen Ruscheweyh, dedicated in 1949, is a sixteen-meter-high concrete frame with 105 urns containing soil from twenty-six concentration camps and located at the entrance to the Ohlsdorf cemetery. The inscriptions read "1933–1945," "Injustice brought us death. Let the living recognize their obligation," and "Remember our pain, reflect on our death, man be man's brother."

Interventions by the French high commissioner eventually led Hamburg's authorities to put up a memorial at Neuengamme itself: in 1953 a seven-meter-high column to honor the concentration camp's victims was erected at the site of the former nursery, where the ashes from the crematorium had been used as fertilizer. The memorial had the inscription, "For the victims 1938–1945"; in 1960, a smaller memorial stone was added to further explain the column: "Erected in 1952 [*sic*] by the Hamburg State Government in the memory of thousands of victims of many nations in Neuengamme Concentration Camp."[33] The Amicale Internationale de Neuengamme (AIN), representing the camp's survivors, kept lobbying for a larger memorial. In 1960, Mayor Brauer accepted the AIN's demands in

principle. In 1962, the state government rejected the design submitted by the AIN but approved funding for a new memorial complex, also at the site of the former nursery. It was dedicated in 1965 in front of four thousand people, many of them Neuengamme survivors. At the same time, the memorials of 1953 and 1960 were removed.[34] The Neuengamme memorial museum, with a permanent exhibition about the concentration camp, opened only in 1981.

The postwar use of Neuengamme, first as an internment camp and then as a prison, delayed the establishment of a *Gedenkstätte*. Detlef Garbe has identified other aspects that have shaped the postwar response to Neuengamme in Hamburg. First, the camp was established as a joint venture between the SS and the City of Hamburg; the latter expected the prisoners to provide cheap labor for the projected construction of a new city center. With Hamburg's pre-1945 administration having been heavily implicated in the setting up of the camp, its postwar successor tried to avoid a discussion about local responsibilities. Second, unlike in Dachau or Buchenwald, only about 10 percent of Neuengamme's inmates were Germans, and only a third of these were political prisoners. At a time when the political climate would have otherwise favored a memorialization of Neuengamme's victims, in the second half of the 1940s, Germans showed little interest in non-German victims and in the plight of concentration camp prisoners who were not either Jews, antifascists, or committed Christians. Third, Neuengamme's prisoners were employed by several large companies that continued to operate in Hamburg after the war. The state government did not condone a memorialization that made explicit the part Hamburg's corporate taxpayers played in the Nazi *Gewaltherrschaft*. On the 1965 memorial, No. in ignammo ɔ atellites were listed according to topographical names to avoid references to existing companies; the Blohm & Voss satellite camp, for instance, was referred to as "Steinwerder" to avoid mentioning the name of Hamburg's largest shipbuilder.

When Hamburg's authorities negotiated with the AIN in the early 1960s about the establishment of a larger memorial complex at Neuengamme, they refused to involve the organization representing German survivors, Arbeitsgemeinschaft Neuengamme, which they considered to be run by Communists. The SPD-led state government had from about early 1949 taken a hard-line approach to organizations representing former German political prisoners. It deliberately scheduled the dedication of the memorial at the Ohlsdorf cemetery for 3 May 1949, five days before a VVN-organized national commemorative ceremony on the occasion of the third anniversary of Liberation. The VVN and Heitgres's party, the KPD, were not invited to attend the dedication. In turn, Walter Bartel and other speakers used the event on 8 May to attack Hamburg's Social Democrats.[35] The separate commemorations of May 1949 sealed the

Fig. 24. Exhibit in the Neuengamme memorial museum; the signs read: "Concentration Camp Memorial Neuengamme" and "Vierlande Prison."

ostracizing of the VVN in Hamburg. In 1951, the Hamburg state government banned the organization. For the next sixteen years, repeated attempts to challenge the ban in the courts were unsuccessful. The authorities regarded the Arbeitsgemeinschaft Neuengamme as an organization that continued the work of the VVN and consequently did not invite their representatives to attend the unveiling of the 1953 memorial at Neuengamme.[36]

The anxieties of the West German authorities that the commemoration of Neuengamme's victims might compromise their anti-Communist stance had bizarre results. In the early 1950s, the authorities pretended that the concentration camp's prisoners had all come from Western European countries. In 1954, the Federal Ministry for Refugees went so far as to recommend that a memorial book of Neuengamme's victims not include the dead from the Soviet Union—who constituted the largest national group. In 1965, after the dedication of the new memorial, police cut off ribbons attached to the wreaths laid by a delegation of survivors from East Germany. The ribbons depicted the GDR flag, or, to quote the police's subsequent press release, "the emblem of the Soviet zone, the *Spalterflagge* [flag of divisiveness]."[37]

The *Stern* Articles

My account of the children's murder is the gist of a story that the West German journalist Günther Schwarberg first brought to the attention of a mass audience in a series of six articles published in early 1979 in the Hamburg-based magazine *Stern*.[38] *Stern* republished the articles in book form later that same year.[39] *Stern* was then the most widely read magazine in West Germany. Politically, it supported the Social Democrats. With the publication of the articles, the magazine intervened in a public debate about the statute of limitations. Already the limitation period for murder had twice been extended: in 1965, effectively from twenty to twenty-four years by counting the limitation period for Nazi murders from the establishment of the Federal Republic rather than from the end of the war; and in 1969 from twenty to thirty years. The debate in 1978–79 was about whether or not the statute of limitations should be abolished altogether for murders committed under Nazi rule. Most Social Democrats supported such a solution but needed to persuade their coalition partner, the Liberals, who were reluctant to pass legislation that applied retroactively. The publication of Schwarberg's and similar articles was obviously intended to strengthen the case of the SPD majority (who in the end succeeded in parliament).

While Schwarberg could take credit for letting a wider audience know about the children of Bullenhuser Damm, he by no means uncovered a secret when making the murders and Strippel's involvement public. Long before the publication of the *Stern* series, the children's story circulated outside of Germany. In 1945, Henry Meyer published a list of the names of the children in a report for the Danish Red Cross.[40] He then did not mention, and probably did not know, that the children had been killed. A detailed description of the children's murder appeared in *Tragédie de la déportation,* a compilation of eyewitness accounts about concentration camps that was published in France in 1954.[41] Lord Russell provided a briefer and more erroneous account in his *The Scourge of the Swastika.*[42]

In one of the so-called Curio-Haus trials of Neuengamme's SS guards in 1946, the prosecutor highlighted the case of the children both in his introductory statement and in his summing up. The German media reported the Neuengamme trials extensively and paid particular attention to the murders at Bullenhuser Damm.[43] But when in 1956 the fourteen-year-old daughter of Fritz Bringmann, a former political prisoner in Neuengamme, wrote an article about the events of 20 April 1945 for the young readers' page of a regional left-wing newspaper, her parents were questioned by members of the police's special branch. The police claimed that the story told by the girl was so improbable that it had to be Communist propaganda.[44] In 1959 a *Stern* editorial drew attention to the murders

at Bullenhuser Damm.[45] This editorial was apparently responsible for the unmasking of Heißmeyer's identity, who then lived in Magdeburg in the German Democratic Republic and practiced as a lung specialist. In 1960, former prisoners of Neuengamme published a book that dealt with, among other issues, the children of Bullenhuser Damm.[46] In 1978, Fritz Bringmann wrote a book about the children.[47]

Between 1945 and the beginning of 1979, the story of the children was known, but it was not known to many, particularly in Germany. All that changed with the publication of Schwarberg's articles. On 20 April 1979, a crowd of more than two thousand people gathered at Bullenhuser Damm to commemorate the children's death. In the following years, the story of the children was taught regularly in many Hamburg schools.[48]

When Schwarberg's articles appeared in *Stern,* his readers had just sat through the American television miniseries *Holocaust.* The decision to buy and broadcast this NBC production had been controversial in Germany. Critics pointed out that the series was an unabashed attempt to use the Holocaust for commercial purposes and represented "the ultimate insult to its victims."[49] The series was criticized for suggesting that it was possible to represent the Holocaust at all, that is, convey its horrors to an audience who had no firsthand experience of them. The series trivialized the past by dramatizing it, Elie Wiesel claimed in an influential *New York Times* article, and his indictment was cited frequently by critics in Germany.[50] As *Holocaust* encouraged viewers to identify emotionally with the victims (rather than to reflect on their own role), its release in Germany and Austria was considered to be particularly problematic.

The intense public debate about the merits of the docudrama preceding its screening in late January 1979 paled into insignificance compared with the discussion following its showing. An estimated audience of 20 million West Germans watched each of the four segments of the series. Many West Germans of all ages genuinely believed that they had—for the first time in their lives—become aware of the genocide perpetrated under Nazi rule. With the publication of articles about the children of Bullenhuser Damm, Stern was riding on the wave of interest generated by the television series. Schwarberg could count on a receptive audience.

It could be argued that Schwarberg's original narrative shares some of the problematic features of NBC's docudrama. The *Stern* articles also to some extent dramatize the events, and they construct simplistic dichotomies. Like the makers of *Holocaust,* Schwarberg appealed to his readers' emotions. The *Stern* articles contrast a group of innocent children with two devils incarnate: Kurt Heißmeyer, the doctor who initiated the experiments, and Arnold Strippel, the SS officer who took charge of the murder of the children. The focus on Strippel in the *Stern* series, and on Erik Dorf in *Holocaust,* offered audiences an avenue that allowed them to

avoid reflecting on their own or their parents' and grandparents' histories. In *Holocaust,* the viewer's empathy is directed toward the Jewish Weiss family; in the *Stern* series, the reader's compassion is directed toward twenty Jewish children. Both narratives suggest that it is possible to address the larger issue of the Shoah, of six million victims and millions of victimizers, accomplices, and bystanders by focusing on an example (in the case of *Holocaust,* a fictional example).

A Plethora of Memorials

While there are obvious parallels between the narrative strategies of *Holocaust* and the *Stern* series, the memorialization of the children that was triggered by the *Stern* articles has differed markedly from that of the Weiss family in the NBC miniseries. *Holocaust* told a story that is firmly located in the past. Schwarberg brought the past into the present by writing about his search for the children's relatives. After starting his research into the story of the children, he extended it. He never intended simply to rehash the account presented by Fritz Bringmann in 1978, that is, just talk about what Heißmeyer, Strippel, and others did to the children. All that was known about the children when Bringmann published his book were their names (which had been recorded by Henry Meyer), what they looked like with one arm raised to show where their lymph glands had been removed (the photos surfaced after Heißmeyer was arrested in 1964 in the German Democratic Republic), and stories of their time in Neuengamme and of their death at Bullenhuser Damm.

Schwarberg wanted to find out about the lives of the children before their arrival in Auschwitz. Thus he began to search for their surviving relatives. By the time the first *Stern* article was published, Schwarberg had identified the relatives of only three of the children. Over the years, he traced the stories of most of the children. He became close friends with some of their relatives and was able to amend the account of the crime by individual biographies: of the children, and of some of their surviving relatives. In 1998, there remained only one child about whom virtually nothing was known.

Until 1979, histories of the children of Bullenhuser Damm had focused on the children's murder. Accounts of the murders made extensive use of the testimonies of two of the murderers. In histories of the children up to and including the *Stern* articles, the only voices that could be heard loud and clear were those of Johann Frahm and Alfred Trzebinski, both of whom confessed before being executed in 1946.[51] Frahm, who came across as slow-witted and inarticulate in the trial, was quoted to illustrate the mindless brutality of the SS. He described how he hung the children on hooks, "like pictures on the wall."[52] The words of eloquent and intelligent

Trzebinski were used to dramatize Frahm's account. In the trial, Trzebinski tried to distance himself from the brutality of the likes of Frahm and therefore described his own horror at watching Frahm hang the children.

There were no survivors at Bullenhuser Damm (the prisoners of war, who possibly got away, never went inside the school). Any account of the hanging, relying on the eyewitness accounts of the SS men, was in danger of relating the murder from the perspective of the murderers. There was a fine, and not always visible, line between Frahm's depiction of the children as objects, and a history that took for granted that the children had been made into objects; and between Trzebinski's "empathy," on the one hand, and the empathy to be elicited from a postwar reader, on the other. The surviving relatives stood in for the children. Even though they had not been in Hamburg on 20 April 1945, they could speak about their brothers, sisters, nieces, cousins, daughters, and sons in ways which gave the children back their humanity.

Schwarberg located the story of the children in the present also by focusing on Arnold Strippel. Erik Dorf's ubiquitousness (in *Holocaust*, he advises Heydrich after the 1938 pogrom, draws up plans for Auschwitz, and is involved in the Babi Yar massacre) could be cited as evidence of the fictionality of the character. Strippel was as ubiquitous as Dorf, but there could never be any doubt that this crude cutout of the "bad German" was part of the same reality that was inhabited by Schwarberg's readers. This was not only because Strippel lived near Frankfurt but also because the Prosecutor's Office in Hamburg was implicated in the failure to make Strippel atone for his deeds. What made Strippel appear to be a contemporary—unlike Dorf, who appeared to belong to a long-gone past—was Münzberg's contemporary interpretation of the murders.

As a result of the *Stern* articles, in 1979 Strippel's case was reopened, without, however, proceeding swiftly. In 1986, the Association of the Children of Bullenhuser Damm convened an international tribunal, which severely criticized the West German justice system for failing to try Strippel. The Hamburg prosecution abandoned the case once again in 1987—this time because Strippel was supposedly too frail to stand trial.[53] After Strippel's death in 1995, the story of the children changed significantly. The articles that Schwarberg wrote in 1979, demanded and, in a sense, anticipated a conclusion. By the late 1990s, it had become very difficult to construct such a conclusion and to reduce the story to a moral tale.

Günther Schwarberg's life history overlaps with the biography of the memorial at Bullenhuser Damm in the same way in which Gerd Wysocki's, Hermann Siemer's, and Hans-Jürgen Hahn's life histories overlap with the biographies of the memorial at Drütte, the monument at Lappenberg, and the restored mortuary at Hildesheim's Jewish cemetery. Schwarberg made this overlapping explicit when publishing an

autobiography that combines an account of his life with accounts of the lives of most of the children and of his efforts to learn about their lives—efforts that have dominated much of Schwarberg's own life since 1979.[54] Thus not only the biographies of the children, but also the effort to reconstruct their lives, became part of the story of the children of Bullenhuser Damm.

Since the publication of the *Stern* series, the story of the children of Bullenhuser Damm has been told many times and in many different formats: in speeches delivered to mark the day the children were killed, in a novel, in a feature film starring Liv Ullmann and Maximilian Schell and based on that novel, in poems, in two plays, in numerous newspaper articles, in a booklet given to residents of streets, in a suburb of Hamburg, that are named after the children (see chap. 11), and on numerous other occasions.[55] There are many memorials to commemorate the children—not only in Hamburg: in Naples (Italy), for example, a primary school is named after Sergio de Simone.

The children of Bullenhuser Damm are remembered through an ensemble of stories, rituals, and other commemorative signs and practices. This ensemble constantly changes. The memorial at Bullenhuser Damm evidences many different attempts to remember and encourages visitors to contribute to an ongoing process of remembering the children. Many visitors have planted roses in a memorial garden adjacent to the building where the children were murdered. Following a Jewish tradition, others have left stones in a basket provided for that purpose in one of the rooms of the memorial. Children have scribbled messages on those stones, which are addressed to the victims of the murder on 20 April 1945. Visitors remember the children and attempt to do the work of mourning, that is, come to terms with their own grief.[56]

The memorial at Bullenhuser Damm and, more generally, the history of the twenty children invite questions that cannot be answered satisfactorily: why did Strippel do what he did? How could Pauly not think of the experiments when he was playing with his own children? The children's story as it has been told by Schwarberg and at the site of their murder after Strippel's death helps people to bear posing questions that cannot be answered. Perhaps this history, more so than those of the Celle *Hasenjagd* and of the hangings in Hildesheim's market square, allows its audience to resist the yearning for closure. It does so by familiarizing the audience with individual children, by making the crime one that affected Ruchla Zylberberg and nineteen others like, but not identical with, her. The fact that twenty of those murdered at Bullenhuser Damm were children makes it the more difficult to reach a sense of closure, as their lives had so obviously only just begun.[57]

My own uneasiness about certain congruities between the television

series *Holocaust* and Günther Schwarberg's narrative "betray[s]"—to quote Andreas Huyssen's observation of German *Holocaust* criticism—"a fear of emotions and subjectivity which itself has to be understood historically as in part a legacy of the Third Reich."[58] *Holocaust*'s critics were suspicious of the emotions provoked by the film. They remembered all too well how the Nazis had kept the majority of Germans on side by skillfully arousing and manipulating their emotions. During my first visit to the memorial at Bullenhuser Damm on a guided tour led by somebody from the Association of the Children of Bullenhuser Damm, I could not bring myself to go into the cellar where the children had been murdered. I was overwhelmed by a sense of grief, but I was also angry at being so susceptible to such powerful emotions—when visits to museums that documented horrors affecting so many more people had left me comparatively cold. I was unsettled by the experience of being *instantaneously* moved by what the guide said, without being able to reflect on what he said. I trusted neither the message that moved me, nor the messenger, nor, of course, my emotions. I was angry that the privileging of twenty children entailed a neglect of all the other children murdered in the Shoah (or so I thought at the time).[59]

The events told in *Holocaust* were sufficiently distant to enable non-Jewish German viewers to empathize with the film's Jewish protagonists and not draw any connection between themselves and the Shoah. It can be easy to be on the side of the victims. But the uneasiness I just articulated is likely to get in the way of a neat distinction between the events to be remembered, and the contexts in which the remembering takes place. The story of the children of Bullenhuser Damm—no: their death!—still troubles me deeply. This is also because my remembering of their death has entailed a remembering of my own reaction to being told about their murder. In these acts of remembering the distinction between the past and the present is blurred. Not only could my fear of being manipulated be traced back to the images of Nazis rallies and clips from Leni Riefenstahl films that were so prominent in my generation's education. I was also reminded of Klaus Theweleit's disturbing analysis of the fear of dissolution, of the angst of being swamped or swallowed by emotions, of the desire to build dykes that stem the emotional tide.[60] This reminder adds a new twist to the question, so commonly asked of my generation: "what would you have done in those circumstances?"

When the superiors of Neuengamme's commandant Pauly gave the order to "disband Heißmeyer's department," they did so hoping that by murdering the children no evidence of the tuberculosis experiments would remain. Those issuing the order in Berlin were then already concerned about what was going to happen to them after the war: they did not want, and did not expect, to be haunted by crimes they committed or condoned

during the war. By killing the children, the murderers also hoped to close off the past. Those remembering the children today foil the intention of the SS. Every occasion when their names are recited contradicts their murderers' scheme.

"The Children Were Twice Dead"

After Liberation, the children's surviving relatives began searching for traces of their sons and daughters, brothers and sisters. The mother of Roman and Eleonora Witonski wrote to every conceivable organization to find out about her children. In 1946, she was put in touch with Paulina Trocki. While Trocki could not confirm that Roman and Eleonora had been part of the transport she accompanied in 1944, it appeared likely that this had been the case.[61] But their mother was not able to establish what had happened to them after their arrival in Neuengamme, and she only learned of their murder in the late 1970s, from Günther Schwarberg.

Being Communists, Ruchla Zylberberg's father and the father's brother and his wife fled from their native Zawichost to the Soviet Union when Germany occupied the western part of Poland. When the German army invaded the Soviet Union, they moved on to Uzbekistan. They returned to Poland in 1946. Ruchla's father migrated to the United States. Her uncle and aunt settled in Szczecin in what had been Pomerania and became part of Poland after the war. The pervasiveness and longevity of Polish anti-Semitism made the Zylberbergs decide to emigrate. They intended to follow another of Ruchla's uncles to Colombia and left Poland in 1958 for South America via Hamburg, where the nearest Colombian consulate was located. When they arrived in Hamburg, a message from their relative was awaiting them: he had decided to leave South America and asked them to wait for him in Hamburg. Thus the Zylberbergs by accident and unknowingly settled in the city where their niece had been murdered thirteen years earlier. They only learned about Ruchla's death in 1979 when they read Schwarberg's *Stern* articles and recognized her from the picture taken in Neuengamme.

"You have to know that the children were twice dead as we did not hear about them for thirty-five years,"[62] Jacqueline Morgenstern's brother Henri wrote to Günther Schwarberg in 1979. Together with other French Jews, Henri Morgenstern staged a demonstration during the Majdanek trial in Düsseldorf. "This day is the most wonderful day of my life, and I shall never forget it. I thank God who has granted me the favor to see with my own eyes the murderer of my cousin," he remembered having said to the court.[63]

Visitors to the memorial at Bullenhuser Damm are invited to record their comments in a visitors' book. Those visiting the former school on the

fifty-third anniversary of the children's death probably noticed what was then one of the last entries in that book (I have retained the original spelling and omitted part of the address):

> There was no a man and mankind in those horrible last days of the war, in Hamburg and whole Germany, that made an afford, or tried to save the poor twenty children. We shall never forget them! Even the Mighty God was shoked, looked from above, did not help, did nothing!
>
> Reichenbaum Itzhak
> Brother of Eduard Reichenbaum
> Haifa Israel
> 16. 4. 1998

Itzhak Reichenbaum, a survivor of Auschwitz, Sachsenhausen, and Mauthausen, had learned about his brother's death from an article on Schwarberg's research in the Israeli newspaper *Ma'ariv* in 1984.[64]

Seven years later, Bluma Mekler's sister Shifra Mor also found out about Bullenhuser Damm from a *Ma'ariv* article. She had been seven when the Germans raided the ghetto and her mother shouted to her: "Run! Run!" Shifra survived in hiding in Poland and, being an orphan, was after the war taken by a Zionist organization to Palestine. As a Tel Aviv-based travel agent, she later frequently visited Europe but was careful not to set foot in Germany. Shifra Mor traveled to Germany for the first time in 1998, more than fifty years after the war, after accepting an invitation from a child care center in Hamburg named after her murdered sister just a year earlier.

The project to remember the children of Bullenhuser Damm initiated by Günther Schwarberg extends well beyond the recalling of twenty names. This is because of the convergence of very different efforts to remember: those initiated by non-Jewish Germans for whom the story of the children of Bullenhuser Damm also offered an opportunity to expose the presence of "old" Nazis in West Germany, and those by the children's surviving relatives. The relatives' biographies, their urge to remember, and their attempts to engage in a conversation with non-Jewish Germans about the children have become part of the public memories of the children of Bullenhuser Damm. They have allowed many visitors to the memorial at Bullenhuser Damm to let themselves be unsettled by a story that in the end could not be more different from that told in *Holocaust*.

The Contested Life of
Wilhelm Hammann

Before 1979, most West Germans willing to confront the Nazi past tended to be critical of the West German political status quo. In support of their critical stance, they cited the presence of a large number of "old" Nazis who were occupying influential positions as judges, senior bureaucrats, or politicians or who had never been charged with crimes they were suspected of having committed between 1933 and 1945. This antifascist engagement with the present continued to be influential in the Federal Republic well into the second half of the 1980s. The memorial museum at Bullenhuser Damm, set up in the wake of the *Stern* series in 1979, was to commemorate the death of the children, but it was also to draw attention to Arnold Strippel's career and to the fact that he had never been tried for the murders of 20 April 1945. In Salzgitter, founding members of the Arbeitskreis Stadtgeschichte intended to commemorate the suffering of prisoners at Drütte, but they also wanted to suggest that former Reichswerke manager Paul Rheinländer should have been held responsible for the company's exploitation of slave labor, and not appointed to the board of the Reichswerke's postwar successor.

From an official East German perspective—which was shared by many West German antifascists—most "old" Nazis had sought refuge in the West; those who were found living in the GDR and suspected of having committed crimes before 1945 were all swiftly brought to trial. The case of the murders at Bullenhuser Damm was considered a good example of the different approaches in the two Germanys. GDR resident Heißmeyer was tried and convicted, whereas Strippel and Klein, who both lived in the FRG, went scot-free courtesy of a justice system that harbored old Nazis and their sympathizers. While the inadequacies of the West German prosecution were obvious, the claim that the GDR justice system was comparatively thorough rests on statistics that include figures from the infamous Waldheim trials of 1950, which took place after the

Soviet authorities had handed over 3,442 internees to the GDR's Ministry of the Interior for the passing of sentence. Excluding these cases, courts in the GDR convicted remarkably few defendants for crimes committed before 1945.[1]

Official East German antifascism was also preoccupied with the prevalence of neofascism in the Federal Republic. Incidents of right-wing extremism were cited as proof that Nazism had not been eradicated in West Germany, while the alleged absence of neo-Nazis in the German Democratic Republic was considered evidence of a new beginning after 1945. How erroneous this latter assessment was became only too apparent with the spate of racist violence in the East German states after 1989.

As part of their search for a "better" Germany, West German antifascists of the 1970s were looking for role models in the past and identified with left-wing opponents of the Nazis. But these never became widely accepted in the FRG. Their lives were publicized only locally. In the FRG, no socialist member of the German resistance gained the prominence of Claus Graf Schenk von Stauffenberg, the army officer who tried to assassinate Hitler on 20 July 1944, or of the Munich students Sophie and Hans Scholl, who were executed for distributing anti-Nazi leaflets. In the GDR, identification with Hitler's left-wing opponents was official state policy. Certified survivors (see chap. 5) received generous state pensions. Streets and schools were named after prominent Communists and, to a lesser extent, Social Democrats who were murdered by the Nazis. One of those whose life was held up as exemplary in the GDR was Wilhelm Hammann, a former KPD member of the Hessen legislature and for seven years prisoner in Buchenwald.

A Career

Wilhelm Hammann was born on 25 February 1897, the eldest of nine children of a railway worker and a midwife.[2] Having been granted a fee exemption, Hammann enrolled in a teachers training college. In 1922, his first posting took Hammann to a school in Wixhausen, not far from his native Biebesheim in the south of Hessen. The same year, he married fellow teacher Marie Weiß; their only child, Trude, was born the following year.

In 1918, Hammann became a member of the socialist Independent Social Democratic Party, USPD, which had broken away from the SPD in 1917. He joined the KPD in 1919, led the party's local branch, and was member of the Wixhausen council from 1925 to 1928. In 1927, Hammann was elected to the Hessen state parliament. When he called the police involved in suppressing a strike at the Opel plant in Rüsselsheim "hordes

of the social fascist, Leuschner"—Wilhelm Leuschner was a Social Democrat and state premier—Hammann was sentenced to one month in prison in 1930 and removed from the state teaching service the following year. In 1932, he was given another prison sentence for his involvement in violent protests against the dismissal of the Communist mayor of Mörfelden. This time the SPD-led state government had the sentence, fifteen months in prison, suspended—possibly to spite the strong NSDAP faction in parliament that would have liked to see one of their most vocal critics locked up and silenced. In 1933, Hammann was arrested twice and spent much of the year in prison. In 1935, after having been linked to a group of young antifascists in the Groß-Gerau district, he was arrested again, charged with intent to commit high treason, and sentenced to three years in jail. After having served his prison sentence, on 16 August 1938 Hammann was transferred to Buchenwald Concentration Camp, where he remained a prisoner until Liberation on 11 April 1945.

In August 1938, Buchenwald had about eight thousand inmates. Nearly two thousand of them were German political prisoners. Most of the others were either so-called *Asoziale* or so-called professional criminals who were committed to concentration camps as multiple offenders. On account of the color of the triangular patches they had to wear, the latter were referred to as "green" prisoners (as opposed to the "red," political prisoners). In Buchenwald and other concentration camps, the SS had instituted a system of indirect rule.[3] Each work detail and each barrack (Block) was led by a prisoner (*Kapo* and *Blockältester,* respectively) who in turn was responsible to an SS guard (*Arbeitskommandoführer* and *Block-führer*). A camp elder (*Lagerältester*) was at the top of the prisoners' hierarchy. He could nominate Kapos and Blockältesten and acted as a conduit between the SS and the prisoners. Whichever group of prisoners controlled the internal organization of the camp could secure privileges for its members and exert some control over the lives of others. In Buchenwald, members of the KPD from the beginning occupied strategic positions within this internal organization. While they had to share power with "green" prisoners during most of the first six years, in 1942 they succeeded in assuming control of the camp's internal organization in a power struggle that cost the lives of several "green" and "red" inmates. In effect this control meant that Communist Party members had a better chance of survival than other prisoners. It also meant that with the SS increasingly relying on this system of indirect rule, "red" prisoners were in an ambivalent position: they might be reducing the impact of SS policies but were also guaranteeing the functioning of the camp. "The SS were at our, the German political prisoners', mercy," Kurt Köhler, a Communist who like Hammann was in Buchenwald from 1938 to 1945, remembered:

We spoke the same language. We knew their weaknesses. Without us, they could not have mastered this complex structure with ten thousand or twenty thousand people. The laundry needed to be done, hygiene observed, the sick cared for. We fought hard to provide this assistance in order to invert the orders.[4]

Being a prominent Communist, Hammann was protected by the clandestine Communist network in Buchenwald. "This would have been crucial for him," his biographer, Bernd Heyl, commented. "For he had never learned a trade, was said to be an unredeemable Communist, was short in stature, and was thus predestined to incur the hatred of the SS."[5] From 1942, Hammann worked in the camp registry, one of the strongholds of the Communist network in Buchenwald. In 1944, he was a member of a short-lived clandestine education committee, which also included Walter Wolf, Hans Brumme, and Hermann Brill. In 1944, anticipating the collapse of Nazi rule, the four prisoners met regularly for several months to draw up plans for a new democratic education system under a popular-front government.

During Buchenwald's last months, Hammann was appointed *Blockältester* of Block 8. Since 1943, this former quarantine barrack, cordoned off by a fence from the rest of the camp, had housed only boys and young men up to the age of twenty.[6] They were thus protected from being molested by older prisoners and even received some education in a clandestine school. Block 8 was part of the main camp and initially did not accommodate any Jews. After the arrival of large numbers of Jewish prisoners in Buchenwald, the underground Internationales Lager-Komitee (International Camp Committee), ILK, which through its control of the registry had a lot of influence on the day-to-day running of the camp, moved some Jewish children from the so-called Kleines Lager (small camp) to Block 8. The small camp was by then totally overcrowded with mainly Jewish prisoners who had been evacuated from Auschwitz and Groß-Rosen; living conditions were immeasurably better in the main camp.

When the SS tried to evacuate Buchenwald in April 1945, the ILK decided to sabotage their plans. The ILK rightly believed that prisoners who remained in Buchenwald had a much better chance of survival than those sent on evacuation marches—later more aptly known as death marches—only days before the arrival of the Americans. They urged Jewish prisoners to take off the Stars of David that marked them as Jews. Jewish prisoners themselves sensed that it had become possible to disobey the SS and get away with it and thus often did not need much encouragement from the ILK.[7] By handing out patches that were used to identify non-Jewish prisoners and by instructing his charges to deny that they were Jewish, Hammann thwarted efforts of the SS guards to identify, and evacuate,

the Jewish prisoners of Block 8. Among the 328 children and youths of Block 8 who were liberated on 11 April were 159 Jews.

In April 1945, Hammann returned to Hessen and joined his wife in Groß-Gerau, a small town some twenty-five kilometers from Frankfurt. In July, the Americans installed him as *Landrat,* that is, head of the administration of the Groß-Gerau district; his appointment was made official by the state premier in October. By then, however, the American authorities had already replaced Hammann with a Social Democrat. In December 1945, Hammann was arrested on charges of letting his work as *Landrat* be influenced by his political beliefs, but acquitted by an American military court three months later. In March 1946, the Americans arrested him again, this time because they suspected him of having collaborated with the SS in Buchenwald. Together with other former Buchenwald prisoners accused of the maltreatment of fellow inmates, and with former SS guards, Hammann was imprisoned in Dachau to be one of the defendants in the so-called Buchenwald trial. After the court had received numerous affidavits from Buchenwald survivors, including prominent non-Communist former political prisoners, who vouched for him, Hammann was set free in May 1947 and given a letter that testified to his innocence. He became once more politically active in Groß-Gerau and represented the KPD in the district assembly. However, he never again achieved the kind of political prominence that he had enjoyed before 1933, which had led to his imprisonment after 1933 but probably also saved his life in Buchenwald. In the night of 26 July 1955, Wilhelm Hammann died when his car ran into an American tank parked on the bend of the road.

An Exemplary Antifascist

In the German Democratic Republic, an account of Hammann's role in Block 8 fitted neatly into the SED-sanctioned history about the heroic resistance of Buchenwald's political prisoners. This history became one of the foundational myths of the GDR (see also chap. 8). It became particularly salient after 1958, with the dedication of the Buchenwald memorial (see chap. 5) and the publication of Bruno Apitz's autobiographical novel *Nackt unter Wölfen.*[8] Apitz had been one of Buchenwald's political prisoners, and the novel is a gripping account of life in the camp. It centers on the story of a child who was smuggled into Buchenwald in a suitcase and whose life was saved by members of the ILK. The novel became a canonical text about the experiences of Buchenwald and had a worldwide print-run of 1.5 million copies within seven years of its publication.[9]

One year after the publication of Apitz's novel (which contains no reference to Hammann or Block 8), a journal for East German teachers serialized a detailed account of Hammann's life, by Klaus Drobisch and

Fig. 25. Wilhelm Hammann, c. 1950. (Photograph courtesy of Rudi Hechler.)

Martin Hackethal.[10] In the following I look briefly at one of Drobisch's subsequent articles, which is representative of the biographical sketches that circulated about Hammann and other exemplary antifascists in the GDR. Being a dramatized rendering of Hammann's life, the style of Drobisch's article resembled that of Apitz's novel. Drobisch assumed the position of the eyewitness who had accompanied Hammann throughout his life, as in this passage:

When the rule of the SS had been broken, Wilhelm Hammann ran back to Block 8. The children rushed toward him. And while they rejoiced and wrapped their skinny arms around his neck, tears were streaming down his face. He was overwhelmed by the joy of victory.[11]

Drobisch emphasized Hammann's working-class background and portrayed him as a proponent of working-class interests, both when a member of parliament and in his work as a teacher.

The working-class kids [at Wixhausen] were his only love. After he had once noticed how they longingly gazed after a fellow student from a middle-class family, who was allowed to ride on his father's motorbike, he often brought along his own bike. After classes, he took the working-class kids for rides around the school. (KD, 120)

Drobisch depicted Hammann as a man who could not be corrupted and believed in symbolic gestures. In teachers college, Drobisch wrote, students were required to learn to play the organ. The skill was to enable them later to help out in church. Hammann loved classical music but refused on ideological grounds to take the organ lessons—a stance that made him an outsider in the college (KD, 118–19).

According to Drobisch, Hammann proved his maturity by leaving the USPD and joining the KPD: "Now, his class instinct joined by his knowledge of the Weltanschauung of the proletariat, he became a wiser revolutionary" (KD, 120). Repeatedly, Drobisch mentioned Hammann's allegiance to the Soviet Union as evidence of his ideological maturity. For Drobisch, Hammann was foremost a Communist, as the following list demonstrates: "Wilhelm Hammann, member of the Communist Party of Germany, teacher at Wixhausen, member of state parliament in Hessen, prisoner in Nazi dungeons, teacher and savior of the children of Buchenwald, prisoner of the American occupying forces, fighter for peace and democracy in all of Germany" (KD, 148). All of these are public roles; Drobisch did not write about Hammann as a son, lover, husband, or father.

Significantly, Drobisch did not call Hammann a "savior of *Jewish* children," although he quoted at length an account of Hammann's refusal to hand over the Jews among his charges. This account—by Ludwig Wolf—in turn quoted Hammann: "I'd rather die than become implicated in the murder of Jewish children" (KD, 142). But it appears as if for Drobisch and like-minded authors, the fact that the Jewish children, in particular, were threatened with evacuation, and hence needed to be saved from the SS more than any other children, added an unwarranted complexity to Hammann's story. An obituary published in the West German weekly *Die*

Tat, whose editors subscribed to the kind of antifascism promoted by SED and KPD, concluded, "Former Buchenwald prisoners will always remember how Wilhelm Hammann . . . saved the children in the children's barrack from being shot dead by the SS, when he was well aware that he was risking his own life."[12] The author(s) of the text that commemorated the children of Bullenhuser Damm on the 1963 memorial plaque omitted a reference to the children's Jewish background to avoid placing the murders in Hamburg into the wider context of Auschwitz. Drobisch and the writer of the *Tat* obituary played down the fact that Hammann saved Jewish children because according to the orthodoxy to which they subscribed, members of the KPD were the main targets of the German fascists.

In Drobisch's narrative, Hammann grew in stature as he faced a lifelong series of tribulations: he was discriminated against as a child and young adult, persecuted for his political beliefs when a member of parliament, locked away by the Nazis, and then again imprisoned by the Americans. The Wilhelm Hammann depicted by Drobisch led an unblemished life. "'You have not wasted one day of your life,'" he let mourners at Hammann's grave site say (KD, 148). Of course Hammann's death could hardly have been better suited to round off the life of a martyr and hero.

Drobisch's hagiographical writings notwithstanding, the attention devoted to Hammann in the GDR (or by West German antifascists) before 1984 was limited. Hammann was not considered one of the prominent Buchenwald personalities. Before 1984, his name did not appear in general histories of Buchenwald, or in widely read memoirs by former political prisoners. The fact that he was not mentioned in either the "Buchenwald Report" that was prepared by a special intelligence team from the U.S. Army's Psychological Warfare Division and ten Buchenwald survivors in April and May 1945, or in Eugen Kogon's magisterial book about the concentration camp system, which is closely based on that report, suggests that his fellow prisoners did not attribute much import to Hammann's contribution.[13]

A Notorious Communist

A Frankfurt newspaper reported Hammann's death under the headline "KP [Communist Party] Official Crashes into U.S. Tank":

> A list with the names of Communist agents in West Germany was, according to United Press, found in the wrecked Volkswagen of fifty-eight-year-old leading Communist Party official, Wilhelm Hammann, of Groß-Gerau, who collided with an American tank on federal highway 26, Darmstadt–Mainz. Hammann died shortly after [the accident]. With his car full of Communist Party propaganda material

that called for the withdrawal of the occupying forces, Hammann was returning from a meeting at a Communist Party headquarters in Mainz or Wiesbaden and got entangled in the heavy traffic of American military vehicles that were involved in war games in the area.

After briefly describing the accident, the report continues:

> Even before 1933, Hammann represented the KPD in the Hessian state parliament. In 1935 he was brought to the Dachau Concentration Camp. After the end of the war, he was installed as *Landrat* of Groß-Gerau. He headed the district administration of Groß-Gerau for a while. During the first elections, he was not reelected. Most recently, Hammann was leader of the Communist Party in the district parliament. It has become known to [this newspaper] that the Bundesamt für Verfassungsschutz [the Federal Republic's domestic intelligence service], the American secret service, the special branch of the German Criminal Investigation Department and the Public Prosecutor's Office have begun analyzing the documents found in the car.[14]

When Hammann died, the campaign against his party was reaching its peak. About a year after his fatal accident, in August 1956, the Bundesverfassungsgericht, the Federal Republic's highest court, banned the KPD. The newspaper article is symptomatic of the treatment the party was given by the mainstream West German media in the years before the High Court decision. With few exceptions, published opinion in West Germany portrayed the KPD as Moscow's fifth column. In the fight between the forces of good and evil, the KPD was considered a rather pathetic aux illary, however. "KP crashes into U.S." was the gist of the newspaper's message. The outcome was unsurprising: in foolishly trying to pierce the American armor, the assailant not only succumbed to his injuries but also revealed the extent of his more dangerous, subversive activities.

The article is also symptomatic of the posthumous treatment Hammann received for more than twenty years in the FRG in general, and in the Groß-Gerau district in particular. He was identified foremost as a die-hard Communist, his involvement with the party reaching back to before 1933. The writer of the Frankfurt newspaper article would not have taken issue with Drobisch's giving such prominence to Hammann's role as a member of the KPD, but would have drawn a different conclusion from such an emphasis. While the article acknowledged Hammann's imprisonment in a concentration camp, it did not provide any further details (and erred regarding both the year of his transfer to the concentration camp and its name). The reference to Hammann's imprisonment implies that his being "brought" to a concentration camp did not require an explanation

(in the same way in which the fact that a patient suffering from tuberculosis is "brought" to a sanatorium does not warrant an explanation). The article stressed that Hammann was appointed but never elected *Landrat*—in fact, he supposedly lost his office as soon as the first election took place.

Portraits of all former postwar *Landräte* hang in the offices of the Groß-Gerau district administration. In the 1950s, 1960s, and 1970s, Hammann's portrait was the only one not there. Then, only Groß-Gerau's Communists and VVN members, who were of course often identical, were trying to keep alive the memory of the first postwar *Landrat*. But until 1980, this memory was private rather than public. In February 1980, the executive of the local branch of the VVN addressed the Groß-Gerau district assembly in an open letter. It was prompted by news that several schools in the district were to be named after members of the German resistance. The VVN put forward suggestions for five names: Rudolf Breitscheid; Sophie and Hans Scholl; Carl von Ossietzky; Paul Schneider, a priest murdered in Buchenwald; and, the only Communist on the list, Wilhelm Hammann.[15] The proposal to name a school after Hammann was vehemently rejected by Social Democrats and Christian Democrats alike and proved unsuccessful. While a publication to mark the 125th anniversary of the district of Groß-Gerau had not mentioned Hammann, the official brochure celebrating the district's sesquicentenary stressed that Hammann had been appointed by the Americans rather than elected, and that only with the appointment of his successor, *Ruhe* (peace and quiet) came to the district's administration.[16]

A Righteous among the Nations

Since 1973, German secondary school students have regularly been invited to take part in a nationwide history essay competition, Schülerwettbewerb Deutsche Geschichte, the brainchild of entrepreneur Gustav A. Körber and of the federal president, Gustav Heinemann, who wanted young Germans to appreciate and unearth Germany's democratic traditions and locate the roots of a "better" Germany in the past. In the Schülerwettbewerb's two most successful competitions in 1980 and 1982, students were asked to write about local aspects of everyday life in Nazi Germany. Under the tutelage of their teacher, Geert Platner, a group of students in Kassel, in the north of Hessen, were among the thousands of secondary school students who researched the history of Nazi rule in preparation for the 1980 competition. The students interviewed local Buchenwald survivor Max Mayr. Mayr had been a member of the socialist splinter group Internationaler Sozialistischer Kampfbund and was arrested in 1936. In Buchenwald, he worked in the registry. Mayr told them about Hammann and about the children of Block 8. The students decided to pursue the issue.

In their search for further evidence Platner and his students found an ally in Deborah Goldberger, a staff member of the Israeli embassy in Bonn. In 1982, Goldberger encouraged the Yad Vashem Martyrs' and Heroes' Remembrance Authority in Jerusalem to take an active interest in Hammann: if it could be proven that Hammann saved a Jewish life, then he would qualify for the title of Righteous among the Nations. Yad Vashem's Department for the Righteous solicited testimonies from some of the Jewish survivors of Block 8. The testimonies confirmed Hammann's pivotal role in saving the Jewish inmates of Block 8 from being selected for evacuation. At the same time, these accounts lacked the theatrical flourish of those published by Drobisch and the Buchenwald memorial museum. Zoltan S. Blau, a Hungarian Jew then living in the United States, wrote:

> As I recall, there was only one instance in which a person could be credited with saving my life and to be quite honest, I do not remember his name. During the last days of Buchenwald, when a massive liquidation of Jews was being carried-out, the children's barrack (#8) in which I was "housed," was ordered to line-up outside for a head-count. Although we had managed to avoid the most brutal elements of the camp—we were designated a model barrack and were even visited by the Red Cross from time to time—this head count had especially ominous implications. The German soldiers [*sic*] demanded that all Jews step forward. No one did. One of the soldiers asked the head of the barrack, a political prisoner of some kind, I think, whether or not there were any Jews present. "To my knowledge," he answered, "there are children of all nationalities in this group— Czechs, Poles, Ukranians [*sic*]—but there are no Jews." Clearly, this was a lie. Just the previous night, he had personally distributed various identification patches and instructed the Jewish children to quickly replace their Stars of David. Approximately ten days later Buchenwald was liberated. The head of this barrack may or may not have been Hammann Wilhelm. There is no way I can be certain.[17]

No eyewitness of the incident described by Blau had publicized Hammann's deed during his lifetime. Hammann himself apparently kept quiet about it. There was no conceivable context that would have allowed the SS guards to publicly testify to his insubordination. Only when Yad Vashem began its investigations did those whose life had been saved by Hammann come forward. This is not surprising: while they may have realized the full import of his instructions, many of them had escaped death on other, more dramatic occasions. Many of them had lost their parents and other members of their family. All of them had come to Buchenwald via

Auschwitz or other camps in Poland. For the children who had spent some time in the small camp, their transfer to Block 8 would have been at least as miraculous as their escape from evacuation.[18] There were more important things to remember—and forget—in April 1945 than the care they had experienced from a German political prisoner. Until 1983, contemporary accounts of what had happened in April 1945 in Block 8 had exclusively been provided by Hammann's fellow political prisoners. His story had formed but a small part of the corpus of stories told about Buchenwald's clandestine prisoners' organization. These stories were not told to enhance the reputation of any one former prisoner in particular but to depict the heroism and humanity of the collective.

One of these fellow prisoners was Emil Carlebach. Like Hammann, Carlebach was a Communist from Hessen and had been imprisoned in Buchenwald from 1938 to 1945. Like Hammann, Carlebach was prominently involved in the KPD-led clandestine organization in Buchenwald. He was classified as Jewish, and for five years *Blockältester* of Block 22, the Jewish barrack in the main camp. After Liberation, the Americans appointed Carlebach editor-in-chief of the Frankfurt daily newspaper, *Frankfurter Rundschau*. He was one of those who intervened on Hammann's behalf when the latter was arrested in 1946.

Carlebach had long been an active member of the Lagergemeinschaft Buchenwald-Dora, the organization representing former German prisoners of the Buchenwald and Dora concentration camps. In early 1983, he learned of the initiative to honor Hammann in Israel. Writing on behalf of the Lagergemeinschaft, Carlebach told Deborah Goldberger:

> We are most delighted about this initiative and will support it unreservedly. Surely we don't have to explain to you why in this country, of which I am a citizen, an *SS-Sturmbannführer* Strippel is running around free and even received compensation for wrongful imprisonment, whereas the name of a true hero of resistance, like that of Wilhelm Hammann, is taboo.[19]

When the process of recognizing Hammann as Righteous among the Nations stalled because of concerns over his imprisonment by the Americans in 1946, Carlebach mobilized fellow Buchenwald survivors to sign a statement in support of Hammann.[20] On 18 July 1984, Yad Vashem's Department for the Righteous declared Hammann to be worthy of the title, Righteous among the Nations. In October, Geert Platner, some of his former students, Emil Carlebach, and a representative of the Groß-Gerau district administration traveled to Israel to plant a tree in Hammann's honor. From then on, Hammann played a prominent role in the antifascist narrative of Buchenwald.[21]

Fig. 26. "Wilhelm Hammann, Germany": a plaque and a tree commemorating
the Groß-Gerau Communist at Yad Vashem, Jerusalem

Competing Histories

In 1983, Platner and the Kassel students published *Schule im Dritten
Reich,* a book with more than fifty autobiographical accounts of going to
school in Nazi Germany, as well as the results of their own research on
education and National Socialism, including their findings about Ham-
mann. The book is dedicated to Hammann's memory. In their account of

Block 8 and of Hammann's role, the authors drew on East German scholarship and on testimonies of fellow survivors. The 1983 edition of the book does not include any information about Hammann that is not directly related to his years in Buchenwald.[22]

In the course of their research, the Kassel students had approached the Groß-Gerau district administration. Why, they wanted to know, had Hammann not been honored in his hometown for what he did in Buchenwald? Why had no school in Groß-Gerau been named after this outstanding educator? "Should the other, better Germany completely disappear from memory, while the erstwhile murderers mockingly celebrate their bloody deeds?" the students asked. They demanded that Hammann be honored "in the name of a youth [of today] that in other times may also have been imprisoned in Buchenwald's children's *Block.*"[23] The publication of the book and Hammann's recognition by Yad Vashem led to a renewal of calls to name a school in the Groß-Gerau district after him and provoked a public controversy in Groß-Gerau about his life. This controversy pitted the governing Social Democrats, who were reluctant to honor a prominent Communist, against the Communists, who had been quick to exploit the honor posthumously bestowed on Hammann. The latter were traditionally comparatively strong in the Groß-Gerau district and, in particular, in the town of Mörfelden-Walldorf, where they have been represented in the local parliament ever since the reestablishment of an orthodox Communist Party in 1968 under the name of Deutsche Kommunistische Partei (DKP).[24] The main issue of contention revolved around Hammann's imprisonment by the Americans: What did Hammann do during his time as *Landrat* to incur the wrath of the occupying forces? A second possible question, what Hammann did in Buchenwald that led the Americans to arrest him in 1946, was then not publicly asked.

Any appraisal of Hammann's brief occupation of the office of *Landrat* must rest largely on oral testimonies, for the available American records contain only scant references. Reports from the American army's Counter Intelligence Corps (CIC) point out that Hammann stacked the local administrations with fellow Communists. On 16 October 1945, the local administrator, Major Raymond L. Patten, wrote in his monthly report on political activities in the *Landkreis* (district) of Groß-Gerau:

> There have been very definite signs of underground political activity of the Communist Party Leaders in this Kreis supervised and authorized by the former Landrat Hammann. The various local governments under the Landkreis were packed by the Landrat with persons of Communistic backgrounds. Communist meetings were authorized by the Landrat without permission of this office. This type of illicit political activity has resulted in the dismissal of the Landrat Ham-

mann and caused the arrest of several of his collaborators by this detachment during the past week.[25]

While they did not deny that Hammann looked after his comrades, fellow Communists who had been his contemporaries insisted that the real reasons for his dismissal and imprisonment had nothing to do with those offered by the American authorities. According to them, Hammann clashed with the local military authorities, and, in particular, with a CIC officer by the name of Wanner, because he publicly demanded the removal of Nazis from the management of the General Motors subsidary, Opel, the largest employer in the district, and because he accused Wanner of requisitioning food earmarked for a hospital and of being involved in black-marketeering.[26] In 1984, the local DKP published these accounts in a booklet designed to celebrate Hammann's achievements.[27]

The SPD-dominated local district assembly responded by commissioning its own brochure about Hammann. Its author Arnold Busch chose to ignore oral sources and hence found the following:

> The reports by the secret service and the military government of the United States convey the impression that Hammann was dismissed from office because he neglected his duties as *Landrat* and gave gross preferential treatment to KPD members. There is no evidence to suggest that he was dismissed because of his alleged criticism of an American officer's black-marketeering.[28]

Groß-Gerau's Social Democrats were also concerned to put into per-
spective Hammann and his party's role in the local struggle against the Nazi regime. In a book commissioned in 1986 by the district assembly, Busch subsumed a wide range of oppositional attitudes and practices under the rubric of resistance, and could therefore describe the local Communist network as merely one of many sources of anti-Nazi resistance. In the 1980s, many historians interested in microscopic explorations of the Nazi past used loose definitions of what constituted anti-Nazi resistance. They had been seduced by their oral sources to empathize with "ordinary" Germans who remembered what they retrospectively would have liked to have done to oppose the Nazi regime. Busch's book, however, was the result not so much of an oral history project as of an analysis of trial transcripts—an analysis that at times uncritically accepted the perspective of Nazi judges and prosecutors.[29]

Groß-Gerau's Communists and others who felt that Hammann should be publicly honored at home gained political mileage from his recognition in Israel. The leaders of the governing Social Democrats were on the defensive as soon as they failed to embrace this recognition. Their

failure was made public when neither the *Landrat* nor the speaker of the district assembly attended the Yad Vashem ceremony in Hammann's honor in October 1984. Then, the debate concerning Hammann was at least as much about how the district of Groß-Gerau ought to commemorate the former *Landrat* as it was about his achievements. As in many similar cases in West Germany, antifascists, supported by the liberal media, tried to shame the authorities into paying homage to Hammann.[30] They claimed quite incorrectly that the *Landrat* should have attended the ceremony in Yad Vashem since Hammann was only the fourth German thus honored (when in fact dozens of Germans had been honored before him, and it was unusual for political representatives of their hometowns to travel to Israel to attend a tree planting ceremony; usually, a Righteous among the Nations or his or her descendants were presented with a certificate at the nearest Israeli embassy).[31] Unlike the district, the town of Groß-Gerau did honor Hammann following the Yad Vashem ceremony. It named a street and a child care center after him.

In 1985, the regional television station, Hessischer Rundfunk, broadcast a documentary about Hammann and the controversies about him.[32] The film quoted former Buchenwald prisoners, the Kassel students, Groß-Gerau politicians, and contemporaries of Hammann and was highly critical of the position taken by the SPD *Landrat* and the majority of the Groß-Gerau district assembly. The filmmakers painted a picture of Hammann's life that was not focused on his brief role as a *Blockältester* in Buchenwald. Like the authors of the DKP booklet about Hammann before them, they interviewed former students of Hammann, who fondly remembered their teacher if only because he, very uncharacteristically of his time, rejected corporal punishment.[33] In fact, one of Hammann's initiatives as a member of state parliament concerned the abolition of corporal punishment in schools.[34]

A Suitable Patron?

While the district assembly in Groß-Gerau and teachers, parents, and students of concerned schools debated the merits of naming a school in the district after Hammann, he became the patron of a school in Erfurt in the German Democratic Republic. Not long before the end of that republic, the Collective of the Polytechnic High School 55 "Wilhelm Hammann" wrote—"with socialist greetings"—to the Buchenwald memorial museum:

Dear comrades,

We would like to take the opportunity of 11 April, the forty-fourth anniversary of the day the prisoners of the concentration camp freed

themselves, to send you our warm greetings. We assure you that through their educational and pedagogical efforts educators and students of the Wilhelm Hammann High School want to contribute to actively maintaining peace and ensuring that never again human beings will be allowed to decide about the lives of others in destructive ways. For us, the preparation of the Ninth Conference on Education and the implementation of our party's decisions in accomplishing our educational policies mean to raise our efforts and improve the quality of our work in fulfilling our task in the classroom and beyond. With great concern we have been following the elections in Hessen and the neofascist tendencies in the FRG. Since Wilhelm Hammann was from Hessen, teachers and students are particularly concerned about the neofascists now being represented in [state] parliament. We would like to express our protest through an ever more rigorous antifascist education of our students. We would like to use the festive days on the occasion of the anniversary of the naming of our school to commemorate the work of Wilhelm Hammann and of all other antifascists.[35]

Such sentiments became an anachronism less than a year later. Many in East Germany believed that the honoring of Buchenwald's political prisoners had likewise become an anachronism. In 1991, like so many other East German public buildings and streets that had been named after Communists and Socialists who fought against the Nazis, the school in Erfurt was stripped of its name. For the third time in twentieth-century East German history—after nazification from 1933, and Soviet-style democratization from 1945—the change of the political system was followed by a comprehensive overhaul of the arsenal of political symbols. Following the 1918 revolution, and Liberation in West Germany, there were no such comprehensive overhauls. In Erfurt alone, sixteen streets named after Communists who had been members of the antifascist resistance (including five former Buchenwald prisoners), were renamed after 1989.[36]

The renaming of former Polytechnical High School 55 did not go unnoticed. One of the first in West Germany to learn about it was Rudi Hechler, leader of the German Communist Party in Walldorf. Exploiting the anxieties of German politicians, Hechler wrote to the Yad Vashem Remembrance Authority, alerting its director to the changes. In his letter, Hechler presented himself as somebody who had known and admired Hammann, and as a good German:

I am writing to you because I, like many others in our country, actively oppose right-wing tendencies, and because of a recent event that has made me very angry . . . I was delighted when [Hammann]

became a Righteous among the Nations. I am ashamed of those who today want to erase the memory of antifascists from our history. They are partly to blame for today's frightening right-wing tendencies.[37]

Yad Vashem's director Benjamin Armon in turn wrote to Erfurt's mayor, expressing his concern and enclosing a copy of Hechler's letter.[38] Mayor Manfred Ruge responded immediately. He claimed that the restructuring of primary and secondary education in Erfurt had led to all schools being stripped of their old names. It was the responsibility of individual schools to find new names, Ruge explained. But Erfurt's administration, the mayor promised, was to formally enquire why the name *Wilhelm Hammann* had not been reallocated. Such a reallocation was also demanded by Erfurt's Jewish congregation. A few months after Armon's enquiry, the local government minister for education wrote to all school principals in Erfurt, urging them, "against the background of the current xenophobic incidents in Germany," to consider suggesting to their staff that they name their school after Hammann.[39] In the end, two schools competed for the name. In November 1993, in a ceremony involving Emil Carlebach, Estrongo Nachama, and Israel's Consul General in Berlin, the school adjacent to former Polytechnical High School 55 was named Wilhelm Hammann School. Until 1991, it had borne the name of the Nicaraguan revolutionary Augusto César Sandino.

Meanwhile attempts to name a school in the Groß-Gerau district after Hammann continued.[40] After heated debates over several months, in 1994, parents, teachers, and community leaders in Biebesheim decided against naming the local primary school after Hammann. In 1996, the Association of the Friends of Jewish History and Culture in Groß-Gerau, which earlier had set up a small museum in the restored Erfelden synagogue, endowed a Wilhelm Hammann Prize. The prize was awarded for the first time in 1998 for the winners of an essay competition for secondary-school students. The competition was titled "Wilhelm Hammann: Role Model in the Past—Role Model Today?" and the students were particularly asked to explore the question of whether or not a Communist could be a role model for young people in the united Germany. The competition was a success in that it again drew attention to Hammann, and to the fact that he had not been officially honored in the Groß-Gerau district. But it attracted only four entries—the question itself seemed to be of little relevance to secondary-school students. It did remain relevant for an older generation. When the establishment of the Hammann Prize was announced, the leader of the Christian Democrats in the Groß-Gerau district assembly, Rudi Hasel-bach, acknowledged Hammann's "splendid act" in Buchenwald but found that it was "overshadowed by his lifelong public engagement against our state and our democracy in a way that makes it impossible to present him as a role model for our youth, in particular."[41]

In May 1998, I was invited to visit Wilhelm Hammann School in Erfurt, a secondary school for grades five to ten. The principal had chosen a grade-nine class to talk to me about Hammann. Knowing that I came from Australia, the students had decorated their classroom with Australian paraphernalia, including the national flag that one of the mothers had apparently sewn the night before my visit. The students and two of their teachers told me about visiting Buchenwald and about a small exhibition they had put up in the corridor. The students' contributions were well rehearsed, and the whole event appeared to have been carefully planned. The teachers later said that they were not comfortable with the project-oriented teaching methods imported from West Germany. When I left, I noticed that the round-table seating arrangement was changed (back?) to one where all students were facing the blackboard. I was touched by the effort made by the students and teachers not only to make me feel welcome but also to commemorate Wilhelm Hammann. But leaving Erfurt that day, I also felt depressed, having witnessed a pedagogy that conceived of students as empty receptacles who could be filled with antifascist or humanist rhetoric. Wilhelm Hammann, who abhorred the authoritarian aspects of the education system of his time and believed so strongly in the creative and intellectual capacities of his students, would have turned in his grave had he known how his history was taught in Erfurt.

The school was concerned about its public profile. My visit was an opportunity for the school to be featured in the local newspapers; in fact the principal had invited the local media to witness my meeting with the students. The school was situated in a suburb dominated by high-density public housing; what before 1990 had been one of the most attractive parts of Erfurt had after 1990, like many public housing estates in East Germany, been deserted by its middle-class residents and become a ghetto for the socially disadvantaged. The teachers I talked to were aware of the school's need to raise its reputation lest it was seen as an institution without any particular academic or extracurricular merits, and catering only for students from underprivileged families. But rather than priding itself on Wilhelm Hammann, the school was proud of the visitors that were attracted to the school because of its name. They included the chairman of the Zentralrat der Juden in Deutschland, Ignatz Bubis. Hammann's name was nowhere to be found at the school's entrance. None of the ten locals whom I asked about directions on the way from the tram stop knew of the school's name.

"For us, the name *Wilhelm Hammann* constitutes an obligation," one of the teachers said in class. But in Erfurt, the connection between the name and the person was tenuous. "There must be a form of remembering that means the person and not the symbol," Annette Leo says in her wonderful book about Dagobert Lubinski.[42] Killed in Auschwitz, he was a grandfather she never met. "Was Dagobert perhaps a role model? In any case, he

did not have much in common with the role models I knew. In his history there were many riddles and contradictions."[43] The Nazis imprisoned Lubinski because he was a Communist and a Jew. Through her book, Leo remembered him as the father of Nora and Hannah, the husband of Charlotte, the lover of Gitta, and a member of the anti-Stalinist KPO. Educators and political activists who would like Hammann to become a role model for young people in Erfurt and elsewhere have shown little interest in remembering the person—the husband, father, and lover—rather than the symbol. But some Erfurt students knew of the problems involved in remembering a public persona. Responding to the theme of the 1997 essay competition initiated by the Groß-Gerau Association, a group of grade-nine students from Wilhelm Hammann School wrote:

> We established that a role model's most important attributes include self-confidence, honesty, and readiness to help . . . Young people who have role models, have very specific images of them. We found out that Wilhelm Hammann is not a role model for today's young people, because they never knew him personally and do not know about him as a human being. But if he was to be a role model for young people, then it would be because he risked his own life to save the lives of 159 Jewish children.[44]

In the 1990s, those demanding that Hammann be honored (or that his name constitute "an obligation") focused exclusively on Hammann's role as *Blockältester* of Block 8 in Buchenwald. His contribution in the camp was universally recognized, since such an acknowledgment had been authorized by the Yad Vashem Remembrance Authority in 1984. His contribution as a teacher, which in the mid-1980s had still been stressed by some of those lobbying for a memorialization of Hammann's life, no longer mattered. As a person—as somebody one could know about as a human being, as the Erfurt students put it—Hammann had been forgotten.

What attributes are required for an opponent of Hitler and savior of Jewish lives to be officially honored and widely recognized in the new Germany? Hammann has proven unsuitable for two reasons: he was a committed Communist, and he was officially honored by a state that put great value on the fact that he had been a committed Communist. The ideal hero or heroine in the new Germany may be somebody whose deeds were ignored in the GDR. While in West Germany Communists who had fought against Hitler were only reluctantly acknowledged by the state, local councils, or public institutions,[45] the same could be said for East Germany about men or women who had opposed Nazi policies or practices but had not done so as committed antifascists. Wilhelm Krützfeld was one such person.[46]

Krützfeld, born in 1880 in a village in Schleswig-Holstein, had been a policeman since 1907. In 1938, he was in charge of the Hackescher Markt precinct in the center of Berlin. He was not a member of the NSDAP, but neither had he been politically active for any other political organization before or after 1933. On 10 November 1938 he warned at least one Jewish family of their impending arrest and then singlehandedly saved the New Synagogue in Oranienburger Straße (see chap. 5). At gunpoint, he chased away the arsonists (who were members of the SA but not in uniform) and made sure that the fire brigade had access to the building. Krützfeld was reprimanded by his superiors, repeatedly transferred, and in 1943 took early retirement. He saw out the final stages of Nazi rule in Schleswig-Holstein, and after the war returned to (East) Berlin. He died in 1953, without his deeds ever having been officially acknowledged.

After the war, most people would not have suspected that Krützfeld's stance had been effectual, as a photo of the burning synagogue at Oranienburger Straße became one of the classic images of the Kristallnacht pogrom. That the picture was almost definitely a fake was established by the East German writer Heinz Knobloch, who accidentally had learned about the policeman and in 1984 begun researching a book about him. A first edition was published in 1990. A year later, Berlin's police commissioner paid homage to Krützfeld at his gravesite, saying that he had opposed injustice out of a sense of decency. A plaque at the New Synagogue commemorates the policeman. In 1993, Schleswig-Holstein's police academy was named after Krützfeld. The students at the Wilhelm Krützfeld Police Academy would not know any more about Krützfeld than students at the Erfurt school know about Hammann. Krützfeld deserved to be remembered, but those who put his name on the police academy were less concerned with him as a person and more interested in showing that the police in Nazi Germany had not been universally complicit with the regime.

Initiatives to acknowledge Krützfeld and Hammann were also driven by a patriotic agenda: they were intended to produce positive *German* histories that could be used to contrast the unredeemable history of Nazi Germany. "The issue of honoring Hammann," Emil Carlebach said in 1984, "is not so much about honoring him as a person—however much he deserves to be honored a thousand times—but about rescuing Germany's honor, about making it clear that Germans not only abducted children, but that they also rescued them."[47] Krützfeld's biography has become only relevant insofar as it did not include any incriminating aspects (such as an active membership in either NSDAP or KPD). Hammann's biography, as it has been publicly remembered in the 1990s, has been reduced to his deed in Buchenwald and, for his foes, his incriminating political activities.

CHAPTER 8

Weimar and "the Great Intellectual Designs of the Past"

In 1944–45, there were eight major concentration camps in what is now the Federal Republic of Germany: Neuengamme and Bergen-Belsen in the north, Dachau and Flossenbürg in Bavaria, Sachsenhausen and Ravensbrück in the northeast, and Buchenwald and Dora-Mittelbau in Thüringen. In this and the following chapter, I discuss local and national discourses concerning two East German camps, Ravensbrück and Buchenwald. I am particularly interested in how distinct local narratives have intersected with the histories of Ravensbrück and Buchenwald. The towns hosting the two concentration camps could hardly be more different: Fürstenberg is a small country town in the Mecklenburg Lakes area that would be unremarkable if it was not for the camp's remains, whereas Weimar is probably the most famous German town of its size on account of its association with German classicism.

Ettersberg Concentration Camp

When it was decided to establish a third major concentration camp—after Sachsenhausen and Dachau—in central Germany, Thüringen's *Gauleiter* Fritz Sauckel proposed to select a suitable site in his state. He put this suggestion to Theodor Eicke, the SS officer in charge of the reorganization of Germany's concentration camp system at the time. Not least in response to Sauckel's lobbying, Eicke chose a site near Weimar, then the capital of Thüringen and residence of the *Gauleiter*.[1] On 16 July 1937, the first 149 prisoners arrived at the new Ettersberg Concentration Camp. Some two weeks later, that name was dropped. On 24 July, Eicke had informed his superior, Heinrich Himmler, that Weimar's literary establishment had protested against the name first chosen, "because Ettersberg is connected with the life of the poet Goethe."[2] Naming the concentration camp after the nearby village of Hottelstedt would have upset the guards stationed at

the camp: their pay, Eicke explained to Himmler, would be lower if the camp was nominally part of a village. Eicke proposed to call the camp Hochwald (timber forest). Himmler settled the issue by decreeing that its name be Buchenwald, Post Weimar, the name referring to the beech forest covering much of Ettersberg. Hochwald could have reminded Weimar's sensitive citizens of another nineteenth-century writer, Adalbert Stifter, and of his novella of that name.[3] The leader of the SS may have been anxious to avoid associating the name of a concentration camp with an author whose writings the Nazis were reading "as catechisms against liberal modernity."[4]

On 26 September 1827, Goethe visited Ettersberg accompanied by his trusted secretary, Eckermann:

> "This is a good place to be," Goethe said . . . "I think we may as well try how a little breakfast would please us in this good air." . . . We seated ourselves with our backs against the oaks to have during our breakfast a view of more than half of Thüringen before us . . . "I have very often been in this spot," he said, "and of late years I have often thought it would be the last time that I should look down hence on the kingdoms of the world, and their splendor . . . We tend to shrink in the domestic confinement. Here we feel great and free . . . as we always ought to be."[5]

When Buchenwald's first prisoners cleared the site on top of Ettersberg to put up the buildings of the concentration camp, their guards ordered them to leave standing a large oak tree, supposedly *the* oak, Goethe's oak. Far from being an expression of "Nazi black humor,"[6] the oak tree at Buchenwald was an important symbol for the SS. What could have been more fitting for establishing a link between Goethe and the sort of Germanic ancestry the SS was trying to construct for itself? For Buchenwald's prisoners the tree symbolized the world outside the camp and another Germany—one that was removed in space and time from the Germany that held them captive. The importance prisoners attached to the tree is seen in several descriptions of it in the writings of survivors.[7] In August 1944 the oak tree was hit during an air raid. The charred trunk was cut down. Georges Angeli, a prisoner who in July 1944 had taken a photograph of the tree, remembered that many of Buchenwald's prisoners wanted to keep a chip.[8]

Those protesting against the naming of the concentration camp after a place associated with Goethe were afraid of the contagious properties of the name. Ettersberg could have become an associative link between its past and future connotations, between Goethe on the one hand, and the enemies of the German *Volksgemeinschaft* on the other. The oak tree did

Fig. 27. Goethe's oak, Buchenwald Concentration Camp, July 1944. (Photograph by G. Angeli, courtesy of Archiv Gedenkstätte Buchenwald.)

not serve as such a link. For the SS, as for many of its prisoners, the tree represented the opposite of an aberration. For both, the tree was the epitome of a German intellectual and artistic genealogy that needed to be upheld (be that against Jews and Communists, or against Nazis). Both the SS and Buchenwald's prisoners claimed, and believed, to have Goethe on their side.

One could argue that Weimar's main function has been to provide the stage on which the memorialization of Goethe could be enacted. If one took "Goethe" to be a shorthand symbol—that is, if "Goethe" encompassed Schiller, Wieland, Herder, Nietzsche, Bach, Liszt, and other famous writers and composers who resided in Weimar—then one could argue that there is no Weimar without "Goethe." But not only does the reference to the fact that a particular building and a particular town were once inhabited by Goethe create an aura for both building and town; Goethe's presence in the present appears to require the tangible link to the past that such a building and such a town could provide. At least that is Weimar's implicit claim: without Weimar, there is no Goethe. Weimar's self-proclaimed custodians of the material world that once had been dignified by the master's presence were naturally dismayed about plans for a concentration camp at Ettersberg. But at least they managed to rescue

the name. Goethe's visits to Ettersberg had of course entailed visits to the beech forest at Ettersberg, but that did not matter to them. In the intellectual climate of 1937, a beech forest was not as loaded a concept as a lone oak tree. Incidentally, Goethe did not care much about Germanic forests—there were other famous Weimar residents, such as Herder, who did—but the "Goethe" whose ancestral presence has been invoked since Johann Wolfgang Goethe's death has proven to be a malleable character.

When, shortly before the end of the war, the Nazi leadership decided to erase Germany from the map rather than surrender it to the Allies, the fate of Goethe's remains, which had earlier been evacuated to nearby Jena, seemed to be sealed.[9] But, as with the order to destroy Germany's infrastructure, the order to destroy Goethe's and Schiller's coffins was not carried out. On 12 April 1945, the Third U.S. Army under General Patton occupied Weimar. One month later, the Americans arranged for the return of the coffins from Jena to Weimar. The American commandant of Weimar, Major William Brown, and the director of Weimar's Klassische Stätten (classicist sites), Professor Hans Wahl, accompanied the transport. In a ceremony involving speeches by Brown and Wahl, Goethe and Schiller were installed once more in their Weimar tomb. On 3 July 1945, Soviet troops took over Weimar, and the town's new commandant laid wreaths at Goethe and Schiller's final resting place. On 5 August, four hundred Communist Party delegates met in Weimar. After a speech by Walter Ulbricht, delegates proceeded to the poets' tomb to attend a ceremony organized by the Red Army. There were further speeches, a Red Army orchestra played Beethoven's Funeral March, and more wreaths were laid.

I have not simply furnished accounts of what happened in 1827 (Goethe and Eckermann's recorded visit to Ettersberg), 1937 (the establishment of Buchenwald Concentration Camp), and 1945 (the repatriation of Goethe's and Schiller's remains to Weimar). I am talking about, drawing on, and juggling with histories of 1827, 1937, and 1945. The ceremonies in honor of Goethe, to which I just referred, are listed in a recently published chronicle of Weimar in 1945.[10] The intervention of Weimar's intelligentsia in 1937 is mentioned in several recent histories of Buchenwald, even though the only historical evidence we have is Eicke's letter to Himmler (rather than a letter to Eicke, or the memoir of somebody involved in writing such a letter).

Histories linking Goethe to Ettersberg draw on the account penned by his secretary. By 1937, it no longer mattered how often and exactly when Goethe had been to Ettersberg. His visits had become part of the wider mythology surrounding his former presence in Weimar. They have assumed greater significance after the establishment of the concentration camp. So has the oak tree: the only tree at Ettersberg that had been

specifically mentioned by Eckermann was a beech tree, on which Goethe once cut his name.[11] Maps drawn before 1937 document a large oak tree ("dicke Eiche") but do not refer to it as Goethe's oak.

Weimar—Buchenwald

When confronting the issue of Buchenwald's place in Weimar, we are faced with histories, rather than with a past that reveals itself to us. If we follow the dominant histories told after 1945, then Buchenwald's presence does not seem to have weighed heavily on Weimar between 1937 and 1945. Buchenwald, and all that was associated with it, stayed "up there," on Ettersberg. Or so it seemed. Weimar remained "down here." Or so it seemed.

In fact, large numbers of Buchenwald prisoners worked in Weimar. Between 1942 and 1945, at least sixty different Weimar businesses and government departments benefited from slave labor provided courtesy of the SS.[12] Companies based in Weimar supplied the camp with a wide range of goods and services. Weimar residents continued to go for walks near the concentration camp and visited the falcon house established by the SS at Buchenwald. There must have been many individual contacts between citizens of Weimar and SS guards; by January 1945, a total of 6,297 members of the SS and 532 female guards worked in Buchenwald. But recent exceptions aside, these visits of those up there, down here, and vice versa did not result in narratives of a past shared by Weimar and Buchenwald.

There is one instance in which the histories of Weimar and Buchenwald converged. On 15 April 1945, three days after Weimar's liberation, the American commandant of Weimar appointed a German acting mayor. He chose Erich Kloos, who had been mayor of Weimar between 1918 and 1934. Late at night on the same day, Kloos was ordered to see General Patton.

> The visitors had to remain standing. The general's staff kept in the background. Straight away, the general, whom I understood well, confirmed my appointment as acting mayor of Weimar. Then he said abruptly that he had to give me an order. Tomorrow morning at 12:00 noon at least one thousand citizens of Weimar, half of them men, the other half women, a third of them from the lower, and two-thirds from the upper classes, and as many party members as possible, were to walk to Buchenwald Concentration Camp to see for themselves the situation there. The people of Weimar were to see with their own eyes "what we let our leaders do."[13]

Kloos arranged for a sufficient number of citizens to assemble at Weimar's railway station. There he noticed

girls and women chatting animatedly, being curious and expectant. Hardly any of the men were visibly disgruntled. A few elderly people [who were not required to visit the camp] told me that they were coming along of their own free will . . . As the sun was shining, the whole affair resembled a spring excursion.[14]

Following the route taken by many of Buchenwald's prisoners, Weimar's citizens made their way up there, to stare at dead bodies, to squint at half-dead bodies, and to avert then the gaze from those whose bodies were marked for survival. Their facial expressions and body language, captured by American press photographers—most famously, Lee Miller, then working for *Vogue*—and film teams, betray their embarrassment about being caught red-handed on a spring excursion to an entirely inappropriate destination, but also suggest that they would have liked to keep up the appearance that their visit to Ettersberg was indeed simply such an excursion. Between 24 April and the beginning of June every day several hundred Weimar citizens were detailed for work in Buchenwald.[15] They had to clean up the camp, bury the dead, and help feed the survivors. When the citizens of Weimar returned to their homes, the memories of their visit(s) to the liberated camp stayed with them. But rather than prompting other memories (of visits to the falcon house, of dances with good-looking SS officers, or of encounters with prisoners in Weimar's streets), the trauma of a spring excursion gone awfully wrong made them quarantine their impressions of what they had seen up there.

Their leaders were unsettled by the level of attention the Allies devoted to Buchenwald.[16] They pleaded with the new authorities not to hold them responsible for what had happened in the concentration camp. On 1 May 1945, the mayor of Weimar, the leaders of the Protestant and Catholic churches, and Professor Wahl, chief custodian of the town's classicist heritage, wrote to the military government in Weimar. They argued that Weimar's administration and its citizens would have raised objections to the establishment of Buchenwald if their opinions had been sought. They foreshadowed an argument that Germans were to put forward many times over the next three decades and said that people in Weimar did not know, and could not have known, what went on in Nazi Germany. More specifically, like Bergen's community leaders (see chap. 2), they claimed that Weimar residents could not have known about what went on behind the barbed wire of the concentration camp in their immediate neighborhood. Apparently believing that such a profession of ignorance was not very credible, they added that had they known about the situation at Buchenwald and spoken out against it, their protests would have been futile. "The mayor and the undersigned . . . appeal to the world's sense of justice when they ask to believe these explanations and not to stigmatize

the old city of culture, Weimar, in a way that it has not deserved."[17] The protestations of innocence and ignorance made by Weimar's leaders were at least partly successful. In his memoirs, General Patton wrote about the visit of Weimar citizens in Buchenwald on 16 April 1945: "In honesty, I believe that most of them were ignorant of much that had gone on there."[18]

Did Weimar's citizens know about what happened at Ettersberg? Were they responsible for it? The Americans who asked these questions in 1945 largely assumed that they could be answered unequivocally. Weimar citizens who felt they did not have to answer these questions unequivocally in the affirmative were thus invited to deny their knowledge and responsibility altogether. Former Buchenwald prisoners may have thought that it was politically expedient to ask for an unequivocal answer, but at the same time they were aware of the complexity of the issue. Ernst Thape, a former political prisoner, wrote about the explanations provided by an American guide to Weimar residents in Buchenwald on 16 April 1945:

> When they claimed that they had been ignorant, he accused his listeners, saying that they could not have failed to know about all this. "Weimar is less than ten kilometers from Buchenwald, and you did not know. But we in America, we are separated [from Buchenwald] by an ocean, and we knew." *This is all true and false at the same time.*[19]

Weimar residents could profess ignorance regarding the concreteness of the regime of terror at Ettersberg. They could claim that they were surprised by what they saw on 16 April, such as piles of corpses and perfidious devices to punish prisoners. None of the *specific* images that constituted "Buchenwald" on 16 April was part of the knowledge of Buchenwald that circulated in Weimar between 1937 and Liberation. This knowledge consisted of sentences that could not be spoken and images that could not be visualized—not least for fear of compromising those "down here." In the first few months after the end of the war, however, the voices of Thape and of other survivors remained largely unheard. As on 16 April in Buchenwald, they were represented by the Allies, who were intent on reeducating Germans.

After 1945, distinct histories emerged that represented seemingly distinct trajectories. There is the history of Weimar, which once again became Goethe's Weimar. Between 1945 and the late 1980s, the history of Weimar during the Nazi years suffered from atrophy. In relation to Weimar's overall past since the late eighteenth century, the Nazi period shrunk. Whatever unpalatable reference to the period of 1933 to 1945 remained, was firmly located "up there." This allowed the citizens of Weimar to guard jealously Goethe's memory as if nothing untoward had happened.

In 1949, they celebrated the two hundredth birthday of the poet with much pomp. Buchenwald was considered external to Weimar. Eventually, even the occasion when those down here were first made to visit those up there was written out of history. A 1984 chronicle of events in Weimar in the first fifteen postwar years did not mention the visit on 16 April in its day-by-day recounting of events in 1945.[20]

In the first texts published in East Germany about Buchenwald and written by former political prisoners, the suffering of Jews and the conditions in the small camp still received attention. What later became known as "self-liberation," the liberation of the camp by armed prisoners shortly before the Americans arrived and after most of the SS guards had left, was not emphasized, if mentioned at all.[21] But by the early 1950s, the history of Buchenwald had become the history of Buchenwald's political prisoners. This history was told in the Museum for Resistance (from 1954) and set in concrete in the Buchenwald memorial of 1958 (see chap. 5).[22] There was little room in this history for the varied individual lives of either prisoners or guards. There was little room for the *experience* of Buchenwald. This was nowhere more apparent than in the way in which the site of the Buchenwald memorial, more than a kilometer removed from where the concentration camp had been, was privileged over the site of the actual camp. All barracks were pulled down; in fact, initially it was planned to reforest the area of the camp.

That in the German Democratic Republic only the voices of Buchenwald's political prisoners were heard could be explained by recourse to the fashioning of the GDR's genealogy and foundations. But then, it was also easier for former political prisoners to tell their stories. It was comparatively easy for audiences in both Germanies to comprehend the stories of former political prisoners who could make sense of the time spent in concentration camps. They could celebrate their survival because they had outlasted their tormentors and triumphed over them. For Jews, Sinti, and Roma, survival often meant being the only member of one's family who was not gassed, shot dead, hanged, or starved to death. Elie Wiesel, one of Buchenwald's Jewish survivors, remembered the day of Buchenwald's liberation, 11 April 1945:

> Strangely, we did not "feel" the victory. There were no joyous embraces, no shouts or songs to mark our happiness, for that word was meaningless to us. We were not happy. We wondered whether we ever would be . . . Yes, Hitler lost the war, but we didn't win it. We mourned too many dead to speak of victory.[23]

For Buchenwald's Jewish prisoners, Liberation was less likely to become associated with the words of German Communists than with those of

Fig. 28. Goethe's oak, Buchenwald concentration camp memorial, April 1998—
an "authentic site"

Rabbi Herschel Schacter, a Jewish American chaplain who reached
Buchenwald as part of the Third U.S. Army: "Sholem aleykhem yidn: Ihr
send frei. Ikh bin a Amerikaner ruv" [Greetings, Jews: You are free. I am
an American rabbi].[24]

In the history of Buchenwald, that is, in the history told at Buchen-
wald about Buchenwald, Weimar and its residents were almost left out.
Buchenwald was a national phenomenon; it had almost by accident been
established near Weimar. When the local population was mentioned, it
was apologetically. Instead of the complex complicity that Thape knew
about, Arnold Zweig, in a preface to a 1960 coffee-table book about
Buchenwald, simply ascribed the looking away and refusal to believe to
fear, "which spreads throughout the entire nation as long as the dictator-
ship lasts."[25]

In orthodox East German historiography, the event on 16 April 1945
was not considered an essential part of Buchenwald's history. A film pro-
duced by the Buchenwald memorial authority in 1984 for screening at the
memorial used footage of the visit by Weimar's citizens without identify-
ing the occasion at which it was shot.[26] By the end of the German Democ-
ratic Republic, even Goethe no longer received a mention. In a catalog
accompanying the last exhibition curated by Buchenwald staff during the
GDR era, the caption of Georges Angeli's photograph depicting Goethe's

oak refers only to the building behind the tree and does not draw attention to the tree itself.[27]

The desire of Weimar's citizens to keep Buchenwald out of histories of their town coincided with the intention of East Germany's new leaders to focus on Buchenwald as an exemplary site of antifascist struggle. Weimar was exceptional because of the national significance of both the antifascist *and* the classicist heritage. But then, in other East German towns that had hosted concentration camps—Fürstenberg, Oranienburg, and Nordhausen—the state-sponsored histories of these camps also excluded local references. In other words, Weimar was not spared out of consideration for Goethe. In the other Germany, the residents of towns such as Dachau, which had been closely associated with concentration camps during the Nazi years, were likewise trying to keep the camp out of their "own" histories.[28] As has been discussed in chapter 6, Hamburg's authorities hoped for a while that the building of a model prison in the present would somehow make unhappen their keen interest in a reservoir of cheap concentration camp labor in the past. In the FRG, such separatist histories were initially successful for a different reason: there, the excising of the concentration camps from local histories was matched by their exclusion from public discourse on a national scale.

Between 1958 and 1989, the people "down here" regularly went "up there" to take part in annual commemorations of the liberation of Buchenwald. But these visits only emphasized the gulf between the two distinct narratives. The ceremonies had nothing to do with Weimar. Buchenwald could have been anywhere. All that mattered was its location at the metaphorical navel of the German Democratic Republic. It was the nation's birthmark, the place where its parentage could be revealed. By the same token, the audiences of speakers celebrating the heroic struggle of Buchenwald in front of the Fritz Cremer sculpture could have been made up of East Germans from anywhere. For the sake of the annual rituals on 11 April, Weimar's residents, many of whom were expected to attend the commemorations, were generic citizens of the GDR.

The two dominant histories place the emphasis on continuity. Weimar between 1945 and 1989 was the direct descendant of Goethe's Weimar. As if to ensure that Goethe's presence in the present had not been corrupted by the time that had passed since his death, Weimar's history was sanitized, with Buchenwald and the town's Nazi past being relegated to the status of an irrelevant intermezzo. Buchenwald served to establish a link between the German Democratic Republic and antifascist resistance. The new state was the self-proclaimed guardian of the legacy of Buchenwald's political prisoners; and its armed forces continued the work of the prisoners who, according to the history told in the GDR, militarily defeated the SS on 11 April 1945.[29]

Visitors to Weimar were once again attracted by an aura seemingly created by Goethe and other representatives of German classicism. Ernst Rietschel's statue of Goethe and Schiller in front of the Weimar Playhouse served as the embodiment of the poets' presence in postwar Weimar. Buchenwald's visitors were attracted by an aura seemingly created by the martyrs and heroes of the antifascist struggle. Fritz Cremer's sculpture, the centerpiece of the Buchenwald memorial, seemed to be material evidence of that aura.

There is a direct relation between the aura experienced by a visitor to, say, Goethe's living room, and the trivialization of Goethe's life. The aura is not simply affected by authentic material relics, but relies on nonspecific anecdotes. That is, an aura related to a famous person is established not least by way of anecdotal narratives. In the absence of an Eckermann, Buchenwald's survivors—and that initially meant nearly always: its former political prisoners—told these anecdotes themselves, most famously Bruno Apitz in *Nackt unter Wölfen*. In the cases of both Weimar's and Buchenwald's histories, as they were told after 1945, the anecdotalization of the past did not jar with its emerging canonization.

The dominant narratives of Weimar and Buchenwald silenced or concealed other histories (such as those of Jewish survivors). In fact, retrospectively it appears as if they silenced much of the past itself. If for a moment we tried the impossible and imagined a past without the histories that are its prerequisite, then we might think of the past as unruly and messy. Histories enunciate the past—but they tend to do so in peculiar ways, imposing order upon it and containing it. And often only too eagerly we fashion, retell, and believe in histories that bury the past under words, weigh it down through rituals and monuments, and keep it out of the present.

Buchenwald's hidden histories were also distinct. There were the histories of those survivors who had not been represented by the Buchenwald memorial: most notably, Jews, Sinti and Roma, gay men, and those referred to by the Nazis as *Asoziale*. Their experiences were, they realized, incommunicable to people who had not been in Buchenwald. In Melbourne, Australia, a group of men who call themselves the Buchenwald Boys have gathered every year on 11 April to celebrate the anniversary of their liberation. But what would non-Jewish Australians have understood about Buchenwald?

> "We voz at a picnic," my father relates.
> A picnic for orphans, soon after he arrived in Australia.
> An Australian asks: "So where were you during the war?"
> "Buchenwald," my father answers.
> "Where's that? In the mountains? How was the air?"[30]

Fig. 29. Ernst Rietschel's 1857 statue of Goethe and Schiller, being shielded in 1997 from the effects of Weimar's transformation into a European City of Culture

Jewish, Sinti, and Roma survivors found it difficult enough to communicate their experiences to those whose struggle the Cremer sculpture memorialized.[31] They found it nearly impossible in the first decades after the war to communicate their experiences to audiences, including their closest relatives, that had not shared any of them.

There were the histories of people who were imprisoned in Buchenwald after 1945, when Buchenwald became a so-called *Speziallager,* an internment camp run by the Soviet Union's Ministry of the Interior. Many of the internees of Speziallager No. 2 were former Nazis. A few internees were imprisoned because they were heavily implicated in Nazi crimes; others had not even been members of the NSDAP but were arrested because they were perceived as political opponents of the Soviet administration. At least one internee had been in Buchenwald Concentration Camp on account of being Jewish and an "enemy of the state," and was in Speziallager No. 2 on account of being, or rather of being perceived to be, a political opponent of the Soviet administration.[32] Most of the inmates of Speziallager No. 2 were small-fry. The death rate in the internment camp was high. Probably between six thousand and eight thousand, and possibly more, of its more than thirty thousand internees died.[33] Those who lived in the German Democratic Republic after their release did not talk

about their time in the camp. Those who went to live in the other German republic did talk but were not listened to.

Weimar/Buchenwald

The GDR's collapse in the fall of 1989 resulted in two developments that are relevant to this chapter. First, with the demise of the East German state, it was inevitable that its foundational narrative would be attacked. The primacy of Buchenwald's political prisoners was challenged. Their integrity was questioned.[34] And the forms in which their suffering and struggle had been memorialized were criticized. Second, those who had been interned in the *Speziallager,* or who had lost relatives in the internment camp, began publicly talking about it.[35] Now their stories were lapped up eagerly. They fitted in only too well with the reemerging master narrative of the structural affinities between National Socialism and Stalinism. The issue of the *Speziallager* in East Germany in general, and on Ettersberg in particular, received extensive attention in the German media, including Weimar's daily press.

In Buchenwald, the representatives of victims other than political prisoners insisted on changes to the memorial ensemble. The government of Thüringen appointed a commission of West German historians headed by Eberhard Jäckel to advise on the future content and form of the Buchenwald memorial.[36] While the massive memorial built in the late 1950s was left standing—if only as a memorial to itself—the area of the actual camp underwent significant changes. A shrinelike memorial to Ernst Thälmann, the Communist Party leader in the Weimar Republic who had been murdered in Buchenwald, was removed. The display in the memorial museum was changed. The 1993 memorial commemorating the suffering of Jews in Buchenwald (see chap. 5) was in 1995 followed by Daniel Plaas's *Mahnmal* for Sinti and Roma.[37] A deliberately modest memorial by Hans Hoheisel now marks the site of the first commemorative ceremonies at Buchenwald on 19 April 1945 and honors all victims at the former camp's site.[38] After a lengthy and heated discussion, a second museum dedicated to the *Speziallager,* which had been recommended by the Jäckel Commission, opened on 25 May 1997. This new museum is located at the back of the concentration camp museum, but is only accessible from outside the area once taken up by the camp. The victims of the *Speziallager* are being commemorated separately through an ensemble of metal rods, also outside the camp boundaries.

What had been the dominant (and, in the GDR, the only) history of Buchenwald for forty years was reduced to the status of one among other histories. When the antifascist history of Buchenwald lost its authority, it became apparent how much the other dominant history, that of Weimar,

had depended on it. Three new historical narratives relating to Weimar emerged after 1989. One located Weimar's Nazi past in Weimar (rather than "up there"). Histories of this past attached themselves to two buildings in particular: a hotel facing Weimar's marketplace, Hotel Elephant, where Adolf Hitler used to stay during his frequent visits to Weimar; and the monumental Gauforum. The Gauforum consists of a square surrounded by a large hall on one side and massive office buildings on the three other sides. The buildings were erected to house offices of the NSDAP and of affiliated organizations; the square's main function was to provide a site for large rallies. Weimar's Gauforum was the first of a series of forty such complexes the Nazis intended to construct in the capital cities of every German *Gau,* the administrative districts of the NSDAP.[39] The second narrative concerns the histories of Weimar's nonclassicist heritage. Most importantly, it concerns the history of the Bauhaus, which was founded in Weimar but hounded from the town in the 1920s.[40] The third narrative is related to the expulsion of the Bauhaus and describes how the cultural elites who assumed responsibility for the preservation of the classicist heritage embraced the Nazi ideology long before the majority of the German population did, and how Weimar became one of the first NSDAP strongholds.

Most of the Gauforum was completed by the end of World War II. On 4 May 1945, the American authorities gave Weimar's civil administration approval to rename forty streets in the town.[41] The Gauforum's square, formerly Platz des Führers (Führer Square) was renamed Karl-Marx-Platz. The office buildings, which had survived the war unscathed, were used by the Soviet military administration between 1946 and 1950, and by tertiary education institutions between 1950 and 1990. In 1955, a statue of Stalin was erected on the square; it was removed about a year later. The name Gauforum was no longer used after 1945. The square had its own, new name, and the individual buildings were referred to according to their function: for example, Fachschule für Staatswissenschaften (College of Political Sciences). After the Communist regime's collapse, Weimar's city council decided that the name Karl-Marx-Platz be removed. The street bisecting the eastern end of the square, Adolf-Hitler-Straße until 1945, and Karl-Liebknecht-Straße from 1945, was renamed Carl-August-Allee. The aldermen did not settle on a new name for the square itself. In late 1990, the buildings surrounding the nameless square were catapulted back into the public conscience. If Weimar was to become capital of the reestablished state of Thüringen, then Thüringen's parliament could be housed in one of these buildings, it was suggested. This proposal, which was eventually unsuccessful, as nearby Erfurt was chosen as the new capital city, led to a public unearthing of the history of the former Gauforum. How to refer to the buildings? Their future function was uncertain,

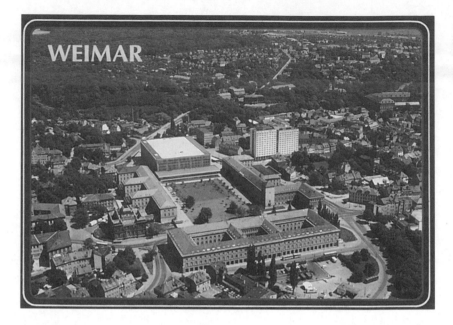

Fig. 30. Gauforum, Weimar (postcard). (Photograph courtesy of Schöning & Co.)

and they surrounded a square that no longer had a name. Thus, while the history of the architectural complex was debated, its old name, Gauforum, resurfaced. By 1997, most Weimar residents I met unself-consciously referred to the square and surrounding buildings (again) as Gauforum.

This was not what Weimar's first post-Communist council had intended. Since it became apparent that the removal of the name that had once been approved by the Americans resulted in a reemergence of the complex's original designation, the Gauforum has been an embarrassment to Weimar. While in 1937 the leading lights of Weimar's cultural scene prevented the association of the concentration camp with Weimar and Goethe by protesting against the name "Ettersberg Concentration Camp," their successors in the 1990s were unable to quarantine Weimar from the name "Gauforum," which proved to possess properties as contagious as those ascribed to "Ettersberg Concentration Camp" in 1937. In both cases, it was the name itself rather than the presence of the named that mattered.

Unlike in 1937, when Weimar citizens protested against the naming of the concentration camp on Ettersberg, or in 1945, when they rejected responsibility for Buchenwald, in the late 1990s there was nobody they

could have petitioned for an untainted name. They could not be relieved of the Gauforum (which cannot be demolished because of a heritage order) by some superior authority.[42] In fact, they were to explain it to the many international visitors expected in Weimar in 1999.

European City of Culture

In times of competing historical narratives—and perhaps only in such times—the past is accorded a chance to be heard. Space is opened up for people who are intent on listening publicly to what has been buried or pushed aside. In Weimar, this space existed in the early 1990s, when the two dominant narratives of Weimar and Buchenwald—one administered by the self-appointed executors of Goethe's will, and the other shaped by the self-styled executors of the will of Buchenwald's prisoners—were dethroned. It was at this time that Weimar applied to become the European City of Culture in 1999.

The European City of Culture program was launched by the European Community in 1984 to encourage cities to present themselves, their region, and country to a European audience, and to invite European artists to use these cities as a base for presenting European cultures to a regional or national forum.[43] Between 1985 and 1998, the title (and concomitant funding) were awarded to Athens, Florence, Amsterdam, Berlin, Paris, Glasgow, Dublin, Madrid, Antwerp, Lisbon, Luxembourg, Copenhagen, Thessaloniki, and Stockholm. Weimar, by far the smallest city chosen so far, was to be the fifteenth European City of Culture in 1999.

Weimar's application in 1993 emphasized its intellectual heritage and the symbolic importance of 1999,

> an exceptionally important date for Weimar. It will be a year of great anniversaries which are inextricably linked with the name of this city. 1999 will be the international memorial year commemorating the 250th birthday of Johann Wolfgang Goethe. It will be the 80th anniversary of the establishment of the Bauhaus and of the proclamation of the Weimar Republic. Both the commemoration of Germany's first democratic constitution, which was adopted in Weimar, and the 50th anniversary of the foundation of the Federal Republic of Germany carry a special political meaning for the whole of the country . . . Like no other European city, Weimar with its eventful history, its heritage and the strength of its intellectual influence conveys a tangible sense of the great intellectual designs of the past.[44]

The authors of the application made no attempt to gloss over Buchenwald. Under the heading, "What Qualifies Weimar for the Title of

'European City of Culture,'" they included a comparatively detailed reference to the concentration camp:

> Ever since Buchenwald, the Nazi concentration camp, was built on the Ettersberg (Etters Hill) in the vicinity of Weimar—almost within view of the sites of German classicism—the name of the city has become linked with the darkest hours of Germany's history and the betrayal of the humanistic ideals and values, conceived in Weimar. This was a disgraceful injustice which had an infamous sequel, when the Soviets ran their own detention camp on the same site from 1946–1952 [*sic*].
>
> Therefore, Weimar is quite possibly unique in representing the fateful ambivalence and the Janus-faced character of German history. Like no other place, Weimar raises the question of whether a humanistic culture is strong enough to resist all forms of political barbarism. In a time of newly arising antagonisms in Europe, of political fundamentalism and national egotism, Weimar presents itself as a place of calm reflection and thoughtfulness, and as a source of humanitarian visions for the next millenium [*sic*].[45]

The program for 1999, which consisted of a series of so-called *Bausteine,* or modules, moved beyond the talk of German history's supposed fateful ambivalence, which would only once again have emphasized the distinctness of the histories of Weimar and Buchenwald.[46] Projects planned for 1999 included the recutting of a two-hundred-year-old fire break linking Buchenwald with Ettersburg Castle, one of the key sites of German classicism.[47] This and other projects aimed to produce histories as entangled as that told in a novel by the Buchenwald survivor Jorge Semprun, which has Goethe visit Buchenwald.[48] The production of entangled histories was assisted by the fact that Weimar's political leaders, in an attempt to distance themselves from their predecessors, welcomed Buchenwald survivors (other than those put on a hero's pedestal by the Socialist Unity Party) to Weimar. Survivors were offered a chance to speak and found an audience willing to listen.

As the text of Weimar's application suggests, however, 1999 would not automatically amount to a refutation of histories that close off the past by turning it into history. Ever since 16 April 1945, Weimar's citizens have tried to publicly distance themselves from Buchenwald,[49] and from Weimar's Nazi past. Weimar's association with National Socialism, dominant local assertions about the past suggested, was an involuntary one: Hitler grew fond of Weimar, rather than vice versa. Public historical discourse in Weimar tended to be about containing the Nazi past rather than listening to it.

Weimar's citizens have told local versions of a powerful and cohesive

narrative. It proved particularly effective in moments of crisis, such as in 1945 or in 1989–90. Then it allowed people in Weimar to avoid becoming entangled in a messy past, even when previously dominant historical discourses disintegrated. According to this narrative, Weimar's citizens were always victims. The SS established a concentration camp without consulting them, ruined the reputation of their town, and took away the Ettersberg, their favorite destination for Sunday picnics. They felt that a "disgraceful injustice" had been committed, to quote the rather curious term used by the authors of Weimar's 1993 application. In 1945, the Americans held Weimar's citizens responsible for what others had done and then made them suffer by ordering them to visit, and work in, Buchenwald. Then the Russians came, established another camp, again also without consulting people in Weimar, and took over large parts of their town for military purposes. They, the good citizens of Weimar, suffered at the hands of the East German Communists, not least because the latter frequently made them revisit Buchenwald to take part in commemorations. After 1989, they suffered at the hands of West Germans, who took over their town. In 1997–98, they were suffering as a result of having been chosen as the European City of Culture; Weimar had become one big construction site, with numerous detours and bottlenecks in the city due to roadworks. In 1999 their town was expected to be swamped by tourists interested in contemporary art (rather than in straightforward productions of *Faust*), and then expense-account tourists would, it was feared, contribute to a dramatic rise in the costs of living in Weimar. The application and program for 1999, Weimar residents complained, had anyway been West German ideas. Such attitudes are not merely a local phenomenon, but resonate with national discourses about Germans being the quintessential victims in the twentieth century.[50]

The New Germany

The new Germany is not just a nation of self-professed victims. Nor is it one whose citizens do not want to know about the past. In fact, many of them consider it a mark of the nation's maturity that it comprehensively and emphatically acknowledges the past. Emphatically, many Germans have embraced the Goldhagen thesis, which highlights the role of "ordinary Germans" in the Shoah; emphatically, they have endorsed the message of the so-called *Wehrmachtsausstellung,* an exhibition touring Germany since 1996, which draws attention to atrocities committed by German soldiers in World War II.[51]

In very peculiar ways, "Buchenwald" and "Auschwitz" have become referents for Germans' understanding of "Germany."[52] Between the 1950s and 1989, Buchenwald stood for German antifascism: a tradition that

rather unsuccessfully was intended to be the cornerstone of East German national identity. To some extent, Buchenwald instilled pride. While the new Germany does not pride itself on Auschwitz or Buchenwald, there is an elective affinity, to use Goethe's term, between the pride with which one might cite past achievements, and the emphatic *Betroffenheit* provoked by Auschwitz and Buchenwald. Put another way: the line between the pride with which many Germans register their *Betroffenheit* in the face of "Auschwitz," and their awe for its scope, is at times incredibly fine.

The new Germany's comprehensive acceptance of its past entails a genuine pride in the nation's supposedly unproblematic achievements. An emphatic acknowledgment of Buchenwald goes hand-in-hand with an emphatic celebration of Goethe's 250th birthday. The new master narrative for the German nation is woven between opposite poles: Goethe and Buchenwald, the Weimar Republic and Sauckel, Faust and Mephisto, the glamor and the underside of German culture. The authors of Weimar's application for the European City of Culture program may have recognized the comprehensive appropriation of the past after Reunification, when they claimed that no place would be better suited to epitomize German history than Weimar.

3 October, the day the German Democratic Republic joined the Federal Republic in 1990, is the new Germany's national holiday. On 3 October 1996 at prime viewing time, the public ARD television station broadcast a feature film set in Weimar.[53] The film is about a love story involving Mafalda, a young woman from Munich, and Hauke, a young East German from Weimar. Mafalda, her mother, and her Italian grandfather visit Weimar to buy a building in which mother and daughter want to open an Italian restaurant. The mother is convinced that such a restaurant will be a gold mine. Besides, as she explains to Mafalda, she would like to own property in Thüringen, the area she originally came from. During a visit to the Goethe Museum, Mafalda meets, and falls in love with, Hauke, a former civics teacher who lost his job after 1989 because he continued to consider himself a Communist. Mafalda does not tell Hauke about the reason for her stay in Weimar because she senses that he disapproves of the West German takeover of East Germany.

Meanwhile, Mafalda's grandfather Francesco, a professed Communist and winemaker from Monte S. Biagio, has supposedly accompanied the two women to Weimar to sell his wine to local restaurants and shops. It turns out, however, that Francesco was a prisoner in Buchenwald—something neither his German daughter-in-law nor Mafalda are aware of—and has come to Weimar to meet up with two of his Buchenwald mates. It was Francesco who proposed that his granddaughter be called Mafalda—after Mafalda di Savoia, the daughter of the Italian king, Victor Emanuel III, who was interned at Buchenwald and died there in 1944.[54]

When Mafalda and her mother meet a real estate agent in front of the coveted building, Hauke overhears their conversation. He feels betrayed, beats up the real estate agent, screams insults at Mafalda, and slaps her face. The scene is observed by the three Buchenwald survivors, who then decide to engineer a reconciliation between Mafalda and Hauke. The survivors' plot is eventually successful. The film ends with some noisy love-making between Mafalda and Hauke, and Francesco commenting that now "little Francesco," Mafalda's child, has been conceived.

The film is a parable about the two Germanys. "They are so silly," Francesco remarks. Even though they are obviously made for each other, they are too preoccupied with their respective agendas and thus initially botch the love story. The film stresses the importance of Mafalda's bicultural upbringing; the survivors observe that the two Germans would not be able to find each other if it was not for Mafalda's being half-Italian. Most importantly, the happy ending only becomes possible thanks to the survivors' intervention.

The new Germany, the film suggests, cannot do without those who suffered at the hands of the old Germany. In the film the survivors' experiences, however, are irrelevant; the fact that they were in Buchenwald is not revealed to either Hauke or Mafalda. Not one of the three survivors in the film is Jewish: they include a Catholic priest from southwestern Germany, an aristocratic Russian from St. Petersburg, and an Italian Communist who keeps a bust of Lenin on his bookshelf and an image of Mafalda di Savoia in his heart. But the survivors who serve as catalysts for new, unified national discourses in Germany do include Jews. They may even include the 4.5 million murdered Jews whose names were very nearly listed on a national memorial in Berlin.

The film is testimony to the importance assigned to Weimar in the construction of a new national identity, and of the narratives underlying that identity. The people of Weimar do not necessarily share views held by other Germans about their town, about Buchenwald, or about the local Nazi past. They are interested in the tourist mark (or euro) and tend the aura their town has acquired. Is there room for the Nazi past in their telling and retelling of Weimar history? If the anecdotalization of the past—which, as I suggested earlier, is congruent with the emergence of an aura—is any indication, then the history of Weimar, as told by many of its residents today, resonates with the new narrative many Germans tell about their nation. I heard people in Weimar tell two main stories about the local Nazi past, and both are anecdotal and nonspecific. One refers to Hitler's frequent visits. Whenever he was staying at the Hotel Elephant, a crowd would gather in front of the hotel and shout, "Lieber Führer komm heraus / aus dem Elephantenhaus," urging Hitler to greet the assembled Weimar residents. The other tells of the transport of prisoners' dead bod-

ies from Buchenwald to the local crematorium, and how, on one occasion, the lorry carrying the bodies lost part of its load.[55]

We may currently be witnessing the emergence of a locally specific new master narrative, but its hold on the collective historical imagination in Weimar is still tenuous. The Gauforum's irrevocable and inconvenient presence may play its part in such tenuousness. Ugly and conspicuous, the Gauforum presents a unique opportunity for Weimar's citizens to engage with their past.[56] And even if attempts to rename the square proved successful,[57] the contagious properties of the name that has circulated since 1990 have had a profound effect on Weimar's capacity to either comprehensively take pride in its past or again tell a sanitized history of Goethe's Weimar.

CHAPTER 9

The Lakes and Locks
of Fürstenberg

Few Germans associate anything with Fürstenberg. If prompted, they
may remember that in 1991 the town briefly came to epitomize (East) Ger-
man insensitivity and pettiness. In fact, if there was anything that linked
the images outsiders have of Weimar and Fürstenberg, it would be that the
cosmopolitanism and tolerance of Goethe's Weimar could serve as a
reverse mirror image of the parochialism and intolerance that was demon-
strated in 1991 in Fürstenberg.

The circumstances of the establishment of Ravensbrück Concentra-
tion Camp had little in common with those surrounding the setting up of
other major camps in Germany. Unlike Hamburg's authorities, Fürsten-
berg's local leaders were not dreaming of ambitious public works projects
supposedly requiring slave labor. Unlike people in Dachau, Fürstenberg's
residents did not seem to have associated the building of the concentration
camp with the coming of prosperity.[1] Fürstenberg did not have a Sauckel
who worked to have a concentration camp established near his residence.
In Fürstenberg, locals did not register their protest regarding the name
chosen by the SS, either. The SS named the concentration camp after the
settlement closest to it: a formerly autonomous village that only recently
had been amalgamated with the town of Fürstenberg. Not that the town's
residents would have had no reason to complain: Fürstenberg, a small
town about eighty kilometers north of Berlin, was a spa that had been
granted permission to carry the title *Luftkurort* (climatic health resort). In
the 1920s and 1930s, about a dozen hotels and numerous guest-houses
attested to its popularity with Berlin holidaymakers. Wealthy Berliners
retired in Fürstenberg. Surely the sight of emaciated prisoners and the
stench of the camp's crematorium must have detracted from the town's
appeal and put off any tourists venturing to the Mecklenburg Lakes area
in the war years.

Concentration Camp—Army Barracks—
Mahn- und Gedenkstätte

It is not known exactly why the SS chose the site near Fürstenberg to set up a camp.[2] Fürstenberg was an average country town, with average election results and an average degree of support for the Nazi regime. Heinrich Himmler was probably familiar with the area because of frequent sojourns at his retreat in Hohenlychen, a few kilometers to the north of Fürstenberg. It is likely that the choice was influenced by the fact that on the one hand Fürstenberg was easily accessible by road, waterways, and rail, and on the other the site selected for the camp was comparatively secluded. In 1934, the SS began negotiations to buy land near Fürstenberg. Ravensbrück Concentration Camp was built between 1938 and 1939 and began operating in May 1939.

Initially the camp was laid out for three thousand women prisoners. But by May 1940, its population already exceeded that projected in 1938. In 1941 a section for male prisoners was added. In 1942, the SS established the Uckermark camp for girls next to the main camp. Toward the end of the war, Uckermark was used as a death camp for women from Ravensbrück. Up to 50,000 prisoners at a time were housed at Ravensbrück. A total of some 130,000 women and 20,000 men were imprisoned in Ravensbrück. About a third of the woman prisoners were from Poland. In the early 1940s, Ravensbrück housed several thousand Roma women and children from Austria. The death rate among this group of prisoners was particularly high. Probably less than 15 percent of Ravensbrück's inmates were Jews. In the early 1940s, for many Jews the camp was little more than a temporary stop on their way to death camps in the East. More Jews reached Ravensbrück from mid-1944, when eastern camps such as Majdanek and Auschwitz were evacuated, and their survivors transferred to Germany.

In 1942, some two thousand men and women from Ravensbrück, many of them Jews, were killed in gas chambers set up at the Bernburg psychiatric hospital. From about January 1945, about six thousand Ravensbrück prisoners were murdered in a gas chamber built next to the camp. Little is known about this part of Ravensbrück's history, as only one prisoner who witnessed the operation of this gas chamber survived.[3] As in other concentration camps, in Ravensbrück some prisoners were subjected to "medical" experiments; many of the so-called *Kaninchen* (guinea pigs) did not survive these experiments. Like other camps, Ravensbrück was a reservoir of cheap labor. Prisoners were employed by SS-owned companies and leased to other businesses. In 1942, Siemens & Halske built a factory at Ravensbrück to manufacture various electronic appliances for the military. Several thousand prisoners worked for the

company. Ravensbrück prisoners were also accommodated in some sixty satellites located near major industrial complexes. Between January and April 1945, prisoners from concentration camps closer to the front line (such as Watenstedt/Leinde, which was evacuated in early April), were moved to Ravensbrück. At the end of April, the SS began evacuating Ravensbrück, and made some twenty thousand men and women walk toward the Baltic Sea, away from the advancing Red Army. On 28 April 1945, the Red Army liberated the prisoners who had remained in the concentration camp. Some ninety thousand prisoners did not survive Ravensbrück.

After the war, the Red Army made Fürstenberg one of its most important garrisons in East Germany. It took over the area and buildings formerly occupied by the concentration camp and the Siemens factory. Between 1945 and 1994, Fürstenberg accommodated up to thirty thousand Red Army (later, Russian Army) personnel at a time. They lived partly in houses requisitioned after the war, but mostly in purpose-built barracks. Tourists no longer flocked to Fürstenberg, and it ceased to be a recognized spa. Some six hundred of the town's five thousand German inhabitants worked for the occupation forces.

In 1959, the Ravensbrück *Mahn- und Gedenkstätte* was opened as the second of three national memorials in the GDR (the others being Buchenwald, dedicated in 1958, and Sachsenhausen, opened in 1961).[4] Its centerpiece was a statue by Will Lammert that sits on top of a fifteen-meter-high pylon on the shore of Schwedtsee, one of three interconnected lakes that dominate the area's topography. The sculpture depicts a woman prisoner carrying another woman in her arms and looking across the lake toward Fürstenberg. The area reserved for the *Mahn- und Gedenkstätte* was located outside the walls that once enclosed the camp, but incorporated the camp prison and the crematorium. In 1982 the Red Army vacated the former SS headquarters, where two years later a small museum was opened. Individual cells in the former camp prison were dedicated to woman prisoners from seventeen different countries; many of the small displays in these cells were curated by Ravensbrück survivors. There were no separate rooms to represent the plight of German, Jewish, or Roma prisoners.

The Supermarket Affair

There were as many links between Fürstenberg and Ravensbrück as there were between Weimar and Buchenwald, Hamburg-Bergedorf and Neuengamme, or Oranienburg and Sachsenhausen. Local residents were employed in Ravensbrück or otherwise interacted with its guards. Ravensbrück prisoners worked for local businesses and farmers. One could be

excused for forgetting these links when looking at Fürstenberg from the site of the Lammert memorial. This is a hauntingly peaceful place. "The dignity of this place nearly takes my breath away," the daughter of a Dutch survivor thought when first visiting the memorial.[5] The twittering of the birds, the realization that no atmospheric traces of the camp linger at this site that is meant to commemorate those who died here, might remind the visitor of the gulf between the past and a memory of that past. Standing at the foot of the Lammert memorial, the visitor's gaze is directed away from the remnants of the camp, and across the lake. It may fix upon what has since the mid-nineteenth century been the town's landmark: its Protestant church, a massive yellow brick building in the neo-Byzantine style. The Schwedtsee, which separates Fürstenberg and Ravensbrück, seems to guarantee the peacefulness of the memorial site. Undisturbed by speedboats or other noisy craft, it holds the outside world at bay.

While the lake appears to function as a barrier between the town and the memorial, there is a place where town and memorial have converged. In 1990, Fürstenberg's citizens elected their first council after the collapse of the Communist regime. The councillors identified the improvement of the town's infrastructure, namely the extension of the sewage system to all households, and the establishment of a supermarket, as their main priorities. In December 1990, they voted unanimously to invite a West German developer to build a supermarket on a piece of public land along the road leading from the town to the Ravensbrück memorial.[6] The developer entered into a contract with the West German Tengelmann Corporation, which owns the Kaiser's supermarket chain. Around the time the council approved the development proposal, the director of the institution administering the memorial was formally asked for his opinion. Neither he nor any of the councillors thought the construction of the supermarket a problem because of its proximity to the former concentration camp—after all the site chosen for the supermarket is more than half a kilometer from the memorial. Also the *Gedenkstätte* would have been shielded from the supermarket by a little wood.

As has frequently happened elsewhere in the former GDR, it was difficult to establish who owned the land that appeared to be available for development. In Fürstenberg there was the additional problem that much land had been taken up by the Red Army. The area along the road to Ravensbrück was one of the few parcels of land readily available for commercial development in 1990. Local business people wanting to start a café and a Renault franchise quickly joined the developer in staking a claim at Ravensbrück.

Only when the building designated to house the supermarket was near completion did the first formal complaints reach Fürstenberg's

Fig. 31. *Die Tragende* **by Will Lammert, Ravensbrück Concentration Camp memorial**

administration and the town's mayor. In April 1991, delegates at the annual meeting of the International Ravensbrück Committee, which represents survivors from many different countries, learned about the supermarket. Individual survivors and organizations acting on their behalf sent letters to the mayor of Fürstenberg to protest against the planned commercial activity.[7] On 15 May, the director of the Ravensbrück memorial wrote to the mayor of Fürstenberg and to the *Landrat* of Gransee, the dis-

trict that includes Fürstenberg, to register his protest against the building of the supermarket and to demand that the *Mahn- und Gedenkstätte* be extended to include the entire area once covered by the camp. At that stage, this area was still largely occupied by the Russians, who were, however, expected to leave East Germany soon. Neither the mayor nor any other representative of Fürstenberg's administration replied to the letter.

Four weeks later, representatives of German Ravensbrück survivors met with envoys of the state government, staff of the *Mahn- und Gedenkstätte,* and the deputy mayor. The meeting was also attended by Eberhard Erdmann, Fürstenberg's Protestant priest and an SPD alderman. The state government demanded that the planning and building permissions for the café and for the car dealer be withdrawn, that the supermarket be cordoned off from the road leading to the memorial by a hedge, and that an alternative access road for the supermarket be built. For a short while, this solution seemed to be acceptable to all. But soon Fürstenberg's mayor, Wolfgang Engler, sensed that such a compromise would not be welcomed by his electorate and dug his heels in. Ravensbrück survivors and organizations representing them sent off another round of letters— this time directed not just at Engler but also at the Brandenburg state government, calling on Premier Stolpe to intervene.

While the pressure on the state government mounted through the month of June, the whole affair only became widely publicized in early July, when the height of the summer holiday reduces news to trivia. Possibly the first consequential account of the affair appeared on 3 July in a local paper published not far from Fürstenberg.

> There is a pile of international mail on the desk of Wolfgang Engler, mayor of Fürstenberg. These are letters written by former prisoners of the Ravensbrück Concentration Camp in protest against the plans of the municipal administration to build a supermarket and a garage on the area of the *Nationale Mahn- und Gedenkstätte.* "Some of them are in French. I don't have them translated," Wolfgang Engler says. "The official language is German."[8]

It was Engler's much-publicized arrogance more than anything else that from then on fueled the conflict. On 6 July, the Berlin-based left-wing daily *Die Tageszeitung* published an article that again quoted Engler: "We can't possibly allow the memorial to suffocate the town of Fürstenberg."[9] That same day, a coalition of women's groups from Berlin organized a rally in Fürstenberg. Some fifty women followed the call, among them Georgia Peet-Taneva, a Ravensbrück survivor living in East Berlin. Now, other German newspapers ran feature articles about the planned supermarket in Fürstenberg.

While municipal, district, and state administrations were arguing about who actually owned the land on which the supermarket had been built, and who had the right or obligation to allow or disallow the construction of the building, journalists from around the world descended on Fürstenberg. They found apparently selfish, ignorant, and obstinate citizens who desperately wanted to have a supermarket, did not care about where it was built, and loudly claimed to have been victimized since 1939. In Engler, they found a redneck local politician who whenever he opened his mouth seemed to put his foot in it. They found angry survivors; a small group of protesters, most of them young women from Berlin, who supported the survivors; incompetent and/or inflexible local government and state administrations; a West German company, Tengelmann, seemingly blindly intent on reaping profits; and—the sole "reasonable" voice in Fürstenberg—a Lutheran priest who opposed the building of the supermarket and was wrongly said to have been the only alderman voting against the supermarket proposal at the crucial council meeting in December 1990.[10] For about two weeks, the various parties enacted their respective roles well.

On 19 July, Tengelmann indicated that it would not insist on opening the supermarket (the Renault company had ten days earlier withdrawn its support for a local car dealer's plans to open a franchise near the memorial). On Sunday, 22 July, some fifty woman demonstrators clashed with local inhabitants at the supermarket site in front of a throng of journalists covering the conflict. Georgia Peet-Taneva cried when local residents shouted insults at her. The same day, Manfred Stolpe visited Fürstenberg to attend Erdmann's church service and seek a solution. On Monday, the premier summoned local politicians and representatives of Tengelmann and of the developer to the state capital, Potsdam. Under Stolpe's tutelage, all parties agreed that the supermarket not be opened and the building be used for a noncommercial purpose. When news of this agreement reached Fürstenberg, the conflict culminated with local residents blocking the highway that bisects their town.

After the tumultuous night of 23 July, Fürstenberg residents accepted the state premier's decision without much further ado. Eventually, another site was found for Kaiser's. The Department of Disaster Services took over the controversial building as a warehouse. Having been painted a stark red and white, within a few years it no longer appeared new—as if it had weathered quickly to blend into an environment of dilapidated buildings abandoned by the Russian Army. In 1998, Fürstenberg had three supermarkets. But they had not done much to reverse to rise of unemployment—the rate lay still above 30 percent. In fact, as could have been expected, the opening of the supermarket forced local retailers to close or shed staff. Wolfgang Engler was found to have had Stasi connec-

Fig. 32. "Supermarket" building, Ravensbrück, 1997

tions and quit politics soon after the supermarket scandal. The Russians left in 1993.

Discourses

In the controversy about the planned supermarket, several different discourses intersected. Those confined to Germany reflected different and sometimes overlapping identities: West German, East German, antifascist, local, and feminist, the latter belonging to the survivors' young female supporters who had found role models in their parents' and grandparents' generations.

The nasty scenes on 22 July appeared to pit Ravensbrück survivors against the town's residents. The latter, however, perceived those administering the memorial, the nonlocal media, and the state government, rather than former prisoners, as their adversaries. The aggression on 22 July resulted from a lack of empathy as much as a lack of comprehension. The site where the Tengelmann company wanted to open a Kaiser's supermarket had been used by the Red Army after 1945. Traveling circuses had pitched their tents there. Fürstenberg residents refused to accept that different rules should apply to the Red Army and to "their" supermarket.

The confrontation at the supermarket site afforded Fürstenberg's citizens an opportunity to gauge the enormous difference between the level on which they were talking, and the level on which the survivors were talking. Until early this century, many of the town's inhabitants worked on boats that made use of the waterways around Berlin. If on 22 July 1991, Fürstenberg's residents had been blessed with a less fractured historical consciousness, they might have remembered how their ancestors negotiated the Mecklenburg Lakes. If they wanted to take their boats from one lake to another, they needed to construct a lock to navigate the different water levels. A canal by itself would have just drained the higher lake.

Survivors protested against the intended commercial use of the site because shoppers would have used the road leading to the camp. This road had been built by the prisoners. Its construction had cost many lives. The survivors also pointed out that the site itself had been part of the camp—here potatoes had been stored. These details, or rather, the extent to which the supermarket was going to squat on an authentic site integral to the camp and to the way it should be remembered hardly mattered in the public outcry that followed the discovery of the Kaiser's building by the media. At issue was a symbolic violation—which could be proven by recourse to rhetoric rather than to argument. Depending on their ideological allegiances, journalists were enraged that the temples of West German capitalism encroached on the shrines of East German antifascism, or they pitched the profane activity of shopping against the aura of Ravensbrück as a sacred site. Opponents of the supermarket as well as journalists invoked a "soil soaked with the prisoners' blood, sweat, and tears."[11] Such bodily expenditure was juxtaposed with the consumption promoted by Kaiser's It is incredible," one West German newspaper editorial found. "Where once the concentration camp's potatoes were kept, now fresh potatoes are to be piled into shopping carts."[12] Because of the symbolic status of the supermarket, the other projects, the Renault franchise and the café, or an already existing gym opposite the supermarket site hardly featured in the public debate. Neither did it seem relevant that Tengelmann was the proposed lessee rather than the owner of either land or building.

The antisupermarket rhetoric could borrow its images from East German literature available at the time. Christa Wagner's *Geboren am See der Tränen*—literally, "Born at the lake of tears"—is the Ravensbrück equivalent of Bruno Apitz's novel about Buchenwald. The text, published in 1987, provides a dramatized account of life in the concentration camp. It is structured around the author's recollections of her ten-year research for the book. Like *Nackt unter Wölfen*, it emphasizes the prisoners' heroism. Prompted by the concrete roller exhibited at the Ravensbrück memorial, Wagner wrote:

Women, yoked like draught animals, also leveled the street that led me to this place. Were the stones not groaning? Did they not want to whisper their stories to me? Stories from two thousand and yet one more night, when [these stones] lay in the small and clumsy hands of a girl, or hurt the hands of a mother ill with fever, or slipped from the trembling hands of an old woman; when women moved along their knees over sharp gravel, with the lash coming down hard on their backs, when there were countless gaping wounds, countless bleeding women's hands, when sweat poured from women's foreheads, tears fell from women's eyes . . . [13]

For a long time, Premier Stolpe assumed that the issue could be resolved by balancing two conflicting interests.[14] He thereby also ignored the incompatibility of the concerns of survivors and local residents. He eventually decided to end the conflict by committing his government to buying out the developer—not because he had taken the side of the survivors in an argument centered on a locally specific problem, but because the conflict had become an embarrassment, and the government was worried about Brandenburg's image. When the German government and Salzgitter's city council were worried about Germany's and Salzgitter's images in 1957, they tried to contain the damage by quickly repairing the Jewish memorial and allocating resources toward identifying the culprit(s), lest the desecration be seen as symptomatic of a German or a Salzgitter problem. In 1991, the Brandenburg state government overruled local interests lest the supermarket be seen as symptomatic of a Brandenburg approach to the memorialization of the Nazi past.

Much postwar public discourse in Germany about *Vergangenheitsbewältigung* has not so much been about the past as such as about the way others are not coming to terms with that past. It has been directed away from self, or from the larger unit that self identifies with, be that a party, a social class, or a particular part of Germany. West German journalists, who through their extensive coverage of the supermarket conflict contributed to its outcome, had mostly nothing but scorn for the residents of Fürstenberg.[15] They implied that the "scandal" was a logical product of East German backwardness as much as of forty years of Communist rule, and displayed the kind of self-righteousness that also marked public reactions to the 1992 arson attack in Sachsenhausen and the 1994 violation of the Buchenwald *Gedenkstätte*. West German journalists reporting the conflict also reveled in their amazement about the locals' insensitivity—not toward the pain caused to former woman prisoners, but toward the bad name the residents gave themselves, East Germans, and Germany generally.[16] But East Germans have not always been at the receiving end of such smugness. When I visited Wilhelm Hammann School in 1998, one

of the teachers repeatedly commented that a comparison between Erfurt and Groß-Gerau revealed a less fraught and comparatively uninhibited engagement with the Nazi past in East Germany. Similarly, an East German historian still committed to the kind of antifascism practiced in the GDR found that the 1993 naming of an Erfurt school after Wilhelm Hammann was

> an important sign of a sense of historical responsibility, of a democratic ethos, and of tolerance . . . After all, under flimsy pretexts this has not been possible in [Hammann's] Hessian hometown of Groß-Gerau up to today. Therefore, above all, the result of a democratic understanding of civic duties [*demokratischer Bürgersinn*] in Thüringen is to be applauded.[17]

Rapprochements

The most remarkable outcome of the supermarket affair was a subtle but noticeable change in the attitudes of Fürstenberg's residents to the memorial. The Ravensbrück memorial, which from the perspective of the town's residents had seemed like a distant mirage across the lake, became, however marginally, part of Fürstenberg. In the late 1990s, many of Fürstenberg's residents still suspected that the state and federal governments were not interested in their plight and instead wasted large amounts of money on the memorial. But compared to those at other similar sites in both West and East Germany, the relations of the *Mahn- und Gedenkstätte* with its neighbors in Fürstenberg were no longer particularly problematic. In fact they seemed less fraught than those experienced by similar memorials in Bergen-Belsen and Sachsenhausen.

This turnaround had to do with some of the principal actors: Eberhard Erdmann, the Protestant pastor, who before leaving Fürstenberg in 1995 did much to ease tensions; Sigrid Jacobeit, an East German historian peripherally involved with the memorial before 1990, who took over as director of the *Mahn- und Gedenkstätte* after the supermarket affair; Raimund Aymanns, a young West German who was appointed to head Fürstenberg's administration in the wake of the supermarket affair; and Gudrun Appel, a history teacher who came to live in Fürstenberg in the early 1970s and succeeded Engler as mayor. Before 1989, Appel had been a staunch member of the ruling SED. She remained committed to left-wing politics but distanced herself from her former party and its successor. Her political reorientation has been respected by the majority of Fürstenberg's residents. Appel has had a strong commitment to Ravensbrück. Appel, Jacobeit, and Erdmann all advocated a qualified revisionism, rather than a radical break with the past. Neither of them tried to educate

Fürstenberg's residents, thereby acknowledging that the supermarket affair could not be explained only by reference to the supposed ignorance of the local population.

In Weimar/Buchenwald or Dachau, any rapprochement between the memorial and the nearby town was mostly negotiated between the town's political leaders and its residents on the one hand, and the institution administering the memorial on the other. In Fürstenberg, the fiftieth anniversary of the camp's liberation by the Red Army offered much scope for quite different negotiations—between town residents and survivors. In 1995, some thirteen hundred survivors returned to Ravensbrück, many of them for the first time. Fürstenberg had never hosted that many visitors, and many of its residents took the opportunity to meet and talk to survivors. They appreciated such conversations: a Dutch survivor visiting Ravensbrück for the first time after fifty years wrote afterward to the *Gedenkstätte:* "The memories, with their emotions that arise suddenly, remain, but next to them you have created something very special for us. You have shown us how you now live and think."[18]

Fürstenberg's residents made a big mistake in 1991: they did not pay any attention to how their words and actions would be read by others. In one sense, this was merely a tactical mistake; they gave their town a bad name and at first did not even notice. In another sense, however, their lack of concern for the way others saw them was at the root of the conflict itself. In itself, it was not wrong to build a supermarket close to the Ravensbrück memorial. It was wrong not to consult survivors and it was wrong to insist on pursuing the project after survivors had opposed it. In the late 1990s, a small group of people in Fürstenberg, the Friends of Ravensbrück, actively supported the *Mahn- und Gedenkstätte.* I talked to several of them—not one thought that the initial idea to build a supermarket near Ravensbrück was wrong or even problematic in principle. The lesson that was learned then concerned the relationship between town residents and survivors: the conflict escalated because the people of Fürstenberg failed to respect Ravensbrück survivors and their concerns.

Vergangenheitsbewältigung, in the sense of a mastering of the recent German past, is not desirable, neither in Fürstenberg nor anywhere else in Germany. What is needed is a genuine engagement with that past in the present. What would such a genuine engagement involve? On the part of the descendants of the German perpetrators, it would require a respectful listening to the voices of the victims, however feeble they may be. Since the early 1990s, a growing preparedness to listen to survivors—and to listen to them respectfully—has coincided with a growing willingness on the part of many survivors to tell their stories. Sites such as the Ravensbrück memorial could facilitate such a listening.

The respect of those listening to survivors could demand an active

response to their stories. When shortly after the war Celle's aldermen listened to Rosa Kameinskiy's story, they reportedly empathized with her. Yet they did not feel responsible when she expected the council to assist her in setting up a business. After 1992, the Preussag AG and the City of Salzgitter both supported the establishment of a *Gedenkstätte* at Drütte. Since then, the company's senior managers have always been well represented at the annual commemorations, and one of them has always contributed a speech. In these speeches, the managers empathized with the plight of the prisoners and expressed their regret over what happened in Drütte between 1942 and 1945. Since 1986, survivors have publicly demanded restitution from the Reichswerke's successor. But the company was adamant that it should not be held responsible for what the Reichswerke did and therefore rejected such claims. The respect Salzgitter's citizens showed to the survivors visiting their city could be measured by the extent to which they supported the claims of former forced laborers and concentration camp prisoners for restitution.

When the group of Italian former prisoners of war visited Hildesheim in 1995, they asked to be taken to what once was the VDM plant, where many of them had worked. The VDM's successor, Senking, refused, as the company was afraid of being confronted with demands for restitution. Hildesheim mayor Kurt Machens accompanied the Italians to the gate of the Senking plant and was then, in front of a running television camera, together with the Italians thrown off the company grounds. It was this show of support that most clearly distinguished Machens's engagement with the local Nazi past from that of his colleagues in Celle. Hoping to create a precedent, a Ravensbrück survivor, Waltraud Blass, sued the Siemens corporation for DM 2,400 in outstanding wages, accrued while she was working for the company in Ravensbrück.[19] Siemens denied its responsibility; in early July 1991 the Supreme Court in Munich dismissed the case, arguing that it came under the statute of limitations. At the same time as Tengelmann was widely castigated for being rapacious, the meanness of Siemens was hardly noticed. The respect shown by Fürstenberg's residents for the survivors of Ravensbrück could also be measured by the extent to which the former supported the latter in their claims for restitution.

Given the paucity of the research that was done on Ravensbrück until very recently, it is only reasonable that energies are now concentrated on documenting the life histories of the last remaining survivors. But the few guards still alive could also be interviewed, and so could the old people of Fürstenberg, who for six years lived in the shadow of the camp. A museum about Ravensbrück's SS guards is in fact next on the list of the historians working at the memorial.[20] For Fürstenberg residents, the historians' interest in the memories of local bystanders could provide opportunities

for reflecting on their and their parents and grandparents' role in Nazi Germany. Such reflections may be facilitated by an acknowledgment made unanimously by political leaders and historians after the supermarket conflict: the local residents did not need to feel any more responsible than other Germans for the concentration camp across the lake. Such self-critical reflections could also extend to the postwar past. Did Fürstenberg's residents attend the annual ceremonies at Ravensbrück voluntarily, or were they "driven" to the memorial, as some residents put it? It appears in fact that the supermarket affair served as an important catalyst: it forced people to think about their stances toward the Ravensbrück memorial in the present as well as in the past.

Remembering Ravensbrück's Prisoners

Until 1990, East German histories of Buchenwald emphasized the role played by German political prisoners. These histories reflected the dominant history of Germany under Nazi rule: Buchenwald was the site of an epic struggle between the SS guards and political prisoners (particularly those who were members of the KPD), or, at another level, between fascists and antifascists. Histories of Ravensbrück published in the GDR also stressed the heroism of prisoners wearing the red triangle.[21] But there were marked differences between the role assigned in the GDR to Buchenwald's prisoners and that assigned to the victims and survivors of Ravensbrück. The latter were rarely said to have taken on their tormentors—unlike the Communists at Buchenwald, who in the end were said to have militarily beaten the SS.

Buchenwald was the subject of several detailed accounts that depicted the system installed by the SS as well as the Communist-led resistance. Most of the memoirs published about Buchenwald before the establishment of the two postwar Germanys, and then in the GDR, did not highlight personal achievements or sufferings but instead stressed the accomplishments of the collective. Bruno Apitz's novel is the most poignant example: although Apitz was in Buchenwald as a political prisoner, he erased himself from the novel. In West Germany, the most influential text on the concentration camp system, Eugen Kogon's *Der SS-Staat,* first published in 1946, was largely based on the Buchenwald experience and did not pay attention to the fact that Ravensbrück was a camp mainly for women. Memoirs by Ravensbrück survivors published in East Germany tended to be much more personal than those written by former Buchenwald prisoners and emphasized individual lives. Even when authored by former political prisoners, these accounts painted a more inclusive picture of Ravensbrück than equivalent memoirs published in the GDR by Buchenwald survivors. Books published about Ravensbrück in West Ger-

many before 1990 were autobiographical.[22] In comparison to the texts published in the GDR, they did not have particularly high print-runs. The most comprehensive study about the camp remains a 1973 book by the French anthropologist Germain Tillion, herself a Ravensbrück survivor, that was only published in German in 1998.[23] Since 1990, the picture that German readers can gain of Ravensbrück has been complemented by more life histories of survivors.[24]

From the beginning of commemorations at Ravensbrück, the concentration camp was represented as a place of suffering for women and, to a lesser extent, children.[25] All the sculptures that became part of the *Mahn- und Gedenkstätte* depict women and children. The emphasis on the suffering of female prisoners did not change after 1990. In spite of the twenty-thousand men who were imprisoned in Ravensbrück, all references have been to a women's concentration camp. Christa Wagner's dramatized nonfiction mentions only in passing that men were also imprisoned in Ravensbrück. The book's only reference to male prisoners suggests, quite incorrectly, that the men accommodated at Ravensbrück were prisoners from Buchenwald, Dachau, and Sachsenhausen who were there to extend the camp.[26]

Histories published in the GDR depict Nazi Germany as the site of an epic struggle. The fascist villains could only maintain their grip on power by imprisoning and killing the Communist heroes. The leading roles on both sides were taken by men. There was little room in such accounts for female actors. Exceptions aside, women were essentially noncombatants. While the men were viewed according to their public roles—Hammann, Drobisch said, was a Communist politician, teacher and "fighter for peace and democracy" (see chap. 7)—women were above all mothers, daughters, and sisters. According to this logic, the imprisonment of women marked an excessive aspect of fascist terror and was *particularly* reprehensible. "Concentration camps reflect a perverse ideology of racial mania, terror, and annihilation. A concentration camp for women is particularly inhuman," Manfred Stolpe said in his speech to mark the fiftieth anniversary of Ravensbrück's liberation.[27] (On such an absurd scale of inhumanity, the suffering of women is considered a close second to the suffering of children. But why should the deportation of Jewish men, for example, have been any less reprehensible than the deportation of Jewish women?)

Of the large concentration camp memorials in Germany, the Ravensbrück ensemble appeared the least dated in the 1990s as far as the actual monuments and memorial architecture were concerned. Unlike other East German memorials, the *Mahn- und Gedenkstätte* did not glorify the struggle of prisoners, nor situate them, or Germans identifying with their legacy, on the side of the victors. The difference between the pre-1989

memorialization of the Buchenwald experience, on the one hand, and of the Ravensbrück experience, on the other, is illustrated by the difference between the Fritz Cremer sculpture that depicts the heroic (and victorious) struggle of prisoners, and the ensemble of sculptures at the Ravensbrück memorial. This ensemble includes a work by Cremer, depicting three women carrying a stretcher with a dead child, with another child clutching one of the women's skirt.

After 1989, the exhibitions in East German memorial museums were revised. Commissions appointed by the state governments of Thüringen and Brandenburg issued a series of recommendations concerning the emphases of future exhibitions.[28] In Buchenwald and Sachsenhausen, the implementation of these recommendations has been a protracted and controversial process. In Ravensbrück, it was done comparatively smoothly; the 1984 exhibition was removed without much ado, even before the Faulenbach Commission's report was tabled. In Buchenwald, the Jäckel Commission contested the interpretation of the past in the pre-1989 Buchenwald museum; in Ravensbrück very little research had been done about the camp before 1989, and therefore the pre-1989 interpretation had not established a committed engagement with the specific history of Ravensbrück. Because there was no elaborate exhibition before 1989, there was no need to produce an elaborate counterexhibition that set in concrete a post-antifascism (as happened in Buchenwald). Between 1993 and 1998, the Ravensbrück museums contained a colorful variety of displays, all of which were labeled as provisional.

An important component of the pre-1990 *Mahn- und Gedenkstätte,* the exhibition in the former camp prison, was enlarged but not removed after Reunification. Unlike the International Museum in Sachsenhausen (see chap. 5), individual cells curated in conjunction with survivors suggested a variety of approaches to remembering Ravensbrück. Before 1989, the Ravensbrück memorial had also been a survivors' memorial—more so than any other concentration camp memorial in Germany. After 1991, it became even more so a memorial for *and of* the prisoners—or, more precisely, of the women and children—who suffered there. An exhibition opened in 1993, *Ravensbrückerinnen,* portrays the lives of twenty-seven women from different countries and of different backgrounds.[29] Likewise, videos shown to visitors at the museum deal with the lives of female Ravensbrück survivors. Since 1996, the annual ceremonies to commemorate the liberation of the camp in 1945 have been organized by the survivors and not by the *Mahn- und Gedenkstätte.* In Buchenwald, in contrast, there have been two anniversary ceremonies each year since 1994, one conducted at the Cremer memorial by the organization representing survivors, and one organized by the Buchenwald *Gedenkstätte* at the site of the former camp.

The "Russians"

Both the Jaeckel Commission in Thüringen and the Faulenbach Commission in Brandenburg demanded that the postwar uses of the sites of former concentration camps be researched and documented. In Ravensbrück, Sachsenhausen, and Buchenwald, *Gedenkstätte* staff were required to engage critically with pre-1989 memorial practices. In Buchenwald and Sachsenhausen, they were instructed to investigate and document the *Speziallager* complex. There was no internment camp in Ravensbrück. The comparatively unspectacular history of Ravensbrück's use by the Red Army hardly seemed to warrant the level of attention devoted elsewhere to the *Speziallager*. For Fürstenberg's residents, however, it has been crucial to deal with the presence of the Red Army. My discussions with local residents suggest that the occupation of their town by the Red Army functioned as a screen that kept the town's pre-1945 past out of sight.

Only if the complexity of relations between the Red Army and local residents is acknowledged can the history of relations between the concentration camp and Fürstenberg be seen as something other than a precursor, with local residents in the role of unpaid extras in a play scripted by forces beyond their control. Between 1945 and 1989, the people of Fürstenberg would not say publicly what they thought of the Red Army. But since 1990, local residents have been able to reflect in public on their relations with the soldiers referred to most often as "Russians."[30] The more they do, the easier it will be to understand the differences and parallels between the contexts before and after 1945, and to appreciate the complexity of relations between the town and the concentration camp.[31]

A tragic incident in 1987 has served as the focal point of such reflections and drawn attention to the site of Drögen, in the south of the town.[32] On 11 June 1987, nineteen-year-old Uwe Baer and his sixteen-year-old brother Christian were shot dead by Anatoli Knish, a Red Army soldier from Moldavia stationed in Fürstenberg.[33] Knish claimed that the two brothers had trespassed and had attacked him when he had tried to arrest them. The Soviet military authorities closed an investigation into the shootings after finding that Knish had acted in self-defense. Neither they nor the East German police released any details about what had happened on 11 June. Uwe and Christian's father, Horst Baer, and many others in Fürstenberg were unconvinced by the official finding of events. They also suspected that Christian Baer had bled to death and that his life could have been saved by the Red Army soldiers first arriving at the scene.

The GDR secret police, Stasi, grew alarmed about this and other rumors circulating in Fürstenberg, and about local residents' widespread outrage about the killings. A Stasi report noted with much concern that one day after the shootings local youths attending a disco had observed a

one-minute silence in honor of the brothers. At the funeral service, Fürstenberg residents turned up in droves, and the Stasi descended on the town to record proceedings and prevent any public demonstrations of discontent. To quell one of the sources of criticism, Horst Baer was offered the opportunity to emigrate to West Germany. He declined and in turn insisted on being told about what really happened on 11 June and on writing on the gravestone of his sons that they had been shot dead. Both requests were turned down. Only after the collapse of the Communist regime was Horst Baer allowed to have the gravestone inscribed with words of his choice, and to see the results of the 1987 investigations. In 1997, Baer learned that back in 1987 Knish was found to have lied about acting in self-defense and to have shot Uwe Baer from behind.

Fürstenberg arguably suffered at the hands of the Red Army.[34] If the specific relationship between Fürstenberg and the Red Army could be explored and publicly discussed, then it would be easier to distinguish more clearly between that relationship and the one between Fürstenberg and Ravensbrück. If Fürstenberg's residents publicly remembered incidents such as the death of the Baer brothers as well as contours of everyday interactions between Germans and Russians, they might no longer easily be able to identify as victims, both before and after 1945. In fact it appears that the very specific memories of their victimization by Russian soldiers have enabled people in Fürstenberg to question the dichotomy of perpetrators and victims that has proven so convenient a pattern in Weimar.

Tourist Destination Fürstenberg

Fürstenberg is an attractive town with a rich history reaching back to the thirteenth century. Material evidence of this history is exhibited in a small museum. A group of dedicated citizens has formed an historical society that looks after the museum and collects stories and material relics from the town's past. When showing me through the museum and telling me about Fürstenberg's history, Ilse Korsinski, a member of both the historical society and the Friends of Ravensbrück, regretted not being able to identify anybody famous who had been born or had died in Fürstenberg. In the absence of such celebrities, the town made do with Heinrich Schliemann, the archaeologist and rediscoverer of Troy, who between 1836 and 1841 had been an apprentice in a local grocery shop. His time in Fürstenberg is commemorated by a memorial plaque and by an oak tree planted next to a rock inscribed with his name in the local park.

In the 1990s, Fürstenberg's economic problems were huge, even by East German standards. Not only did the Russians—and that meant, the region's largest employer—leave, but also all major industries in Fürsten-

berg and the Gransee district closed down. The town tried to attract companies to move to Fürstenberg, but by 1998 these attempts had not been very successful. Tourism was becoming the only industry of note in Fürstenberg. Tourists who in the 1990s visited the town for weekends or summer holidays did so because they were attracted by its environment. In the long term, I expect many people will stay in Fürstenberg's hotels because they want to visit Ravensbrück—not just for a couple of hours, but for two or three days, to work in the library or just to wander about the site of the former camp, which, as this book goes to press, was expected soon to become accessible in its entirety.

In the second half of the 1990s, Fürstenberg's visitor's bureau was careful not to advertise Ravensbrück as if it was one of Fürstenberg's drawing cards. When Ilse Korsinski told me that she could not think of anybody famous who died in Fürstenberg, I was at first puzzled. Why did it not occur to her to consider any of the famous women murdered in the camp? But what if she had named Milena Jesenská,[35] Kafka's friend, or one of the other well-known women who died in Fürstenberg between 1939 and 1945? The line between a respectful listening and shameless appropriation is fine.

For many years, visitors to the Dachau Concentration Camp memorial were given brochures urging them to see the town's other sites.[36] To Ravensbrück's visitors, Fürstenberg has presented itself as an image across the lake. Only survivors were given something tangible to take home: in 1995, local amateur artists painted views of Fürstenberg. They produced a small catalog and presented copies to women who survived Ravensbrück and visited the memorial on the fiftieth anniversary of Liberation. The prisoners, one of the editors of the catalog told me, had often wistfully looked across the lake. While in the camp, however, they could not have seen the town, as it would have been hidden by the camp walls. In order to draw the picture of the town on the *other* side of the Schwedtsee that survivors saw, the artist had to follow the road from Fürstenberg to Ravensbrück, past a large red-white building. As if it was a symbolic lock, this building connects and separates the two places. Survivors now pass that lock in the opposite direction: the Friends of Ravensbrück offer to take survivors visiting the memorial on a guided tour of the town. (I hope that they will not demolish the supermarket building too soon: not unlike the Gauforum in Weimar, it functions as a constant obstacle and reminder of histories that many locals would rather forget.)

Fürstenberg's citizens have been searching for a new identity—one that could serve them in their relations with outsiders. In 1991, they tried to tell themselves and others that they had been twice victims. The reputation of their town had been ruined first by the SS, and then by the Russians. In the second half of the 1990s, they were more concerned with the

Fig. 33. A local artist's impression of Fürstenberg: *Ravensbrück* **by Wolfgang Rau. (Courtesy of the artist.)**

future: they would have liked to have been able to present their town once again as a *Luftkurort* and as an attractive holiday destination. They knew, however, that Fürstenberg at the end of the twentieth century could not be a replica of the Fürstenberg of 1937. It might be possible, though, to imagine and portray Fürstenberg again as the peaceful town on the shores of the Schwedtsee—as long as it was remembered that this image had once been conjured by prisoners in Ravensbrück.

The Search for a Comprehensive Memorialization

Wiesbaden is the capital of the West German state of Hessen. In the 1990s, it presented itself as a stylish city with an illustrious albeit recent tradition. Its population of about 270,000 then included comparatively many public servants and wealthy retirees. For more than one hundred years, Wiesbaden had been a spa for the rich and famous. Local historians and many of the city's residents often wistfully pointed out that the German emperor had once been a regular guest. In the 1990s, the wealthy, be they titled or untitled, flocked to the city less because of its mineral springs but rather to patronize its casino, designer clothes shops, and three-star restaurants.

While Wiesbaden has been remarkable on account of the number of millionaires residing in or visiting the city—225 are said to have lived in Wiesbaden as early as 1912—it was unremarkable in other respects. Between 1933 and 1945, for Jews, Sinti, Communists, or Jehovah's Witnesses, Wiesbaden was not a better (or worse) place to be than most other German cities of a similar size. Many of Wiesbaden's Jewish and Sinti inhabitants were deported to ghettos and concentration camps and murdered; children and adults with disabilities fell victim to the Nazis' euthanasia program; women and men classed as social deviants (so-called *Asoziale*) and gays ended up in concentration camps; locals who opposed the Nazi regime for religious or political reasons were tortured, imprisoned and sometimes executed. Besides, non-German prisoners of war, conscripted laborers, and inmates of concentration camps were forced to work in Wiesbaden under often barbaric conditions.[1]

Wiesbaden's Memorial Landscape

Between 1945 and 1998, thirty-nine streets and eleven schools in Wiesbaden were named after opponents and victims of the Nazis. Unlike in Hildesheim, more than a third of the men and women thus honored were

locals. As in Hildesheim, no street or school in Wiesbaden was named after a Communist.[2] The first substantial publication about the local Nazi past was a book that emphasized politically motivated resistance, paid comparatively little attention to the persecution of Jews, and did not mention the deportation and systematic murder of Sinti. *Nicht alle sind tot, die begraben sind* (Not everyone buried is dead), by Lothar Bembenek and Fritz Schumacher, was published in 1980.[3] Both authors were then associated with the VVN. Capitalizing on the post-*Holocaust* interest in the Nazi years, they drew attention to specific events that took place in an environment familiar to their readers. Like Teich in Hildesheim and Wysocki in Salzgitter, Bembenek and Schumacher reminded their audience that the Nazi past entailed more than could comfortably be associated with the fictitious Weiss and Dorf families and located in faraway times and places. What they called "fascism" happened in streets one walked every day and concerned people whose descendants lived next door.

Like Salzgitter with the *Gedenkstätte* at Drütte, and Hamburg with the memorial museum at Bullenhuser Damm, Wiesbaden also has a *Gedenkstätte* at the site of a former satellite camp. Unter den Eichen had been a satellite of the Hinzert SS Special Camp.[4] The initiative to establish a memorial goes back to 1974, when a group of survivors from Luxembourg visited Wiesbaden and searched for traces of the camp. All that remained then was a concrete bunker that had once been used by the SS guards. The visit drew attention to Unter den Eichen, the existence of which had until then been conveniently erased from collective historical consciousness in Wiesbaden. Lothar Bembenek, at times supported by others who like him were broadly associated with the Left, began researching the camp and lobbying the city council for the establishment of a memorial. In 1991, a small permanent exhibition was opened in the bunker.[5] It recounts the history of the Unter den Eichen camp, establishes the wider context of the SS Special Camp at Hinzert, and introduces the men from Luxembourg who were imprisoned in Wiesbaden. The exhibition includes a text about a prominent local perpetrator, SS officer Jürgen Stroop, who had directed the destruction of the Warsaw ghetto and was hanged in Poland in 1952. In 1996–98, few people in Wiesbaden were aware of the *Gedenkstätte*. It was open once a week, during the summer months only.

The *Gedenkstätte* at Unter den Eichen is an exemplary didactic memorial. Usually set up by institutions or individuals who acted as if on behalf of victims and opponents of the Nazi regime, such memorials are intended to educate visitors and viewers by providing information about Nazi crimes. Their message is usually encapsulated by the dictum, "The past must not recur." It is a message directed at an audience in the present and addressing present-day concerns. The curators of the exhibition in the bunker relied on the content rather than the form of the display to convey

their message. They did not claim to have engaged with the issue at hand, the imprisonment of political prisoners from Luxembourg in Wiesbaden, in an aesthetically pleasing or challenging way. While visitors were meant to be affected by the site's aura, their response was meant to be a rational one, based on the information provided in the museum. The rooms in the bunker were painted white; the bunker's "authenticity" was downplayed rather than emphasized.

Other memorials mark the site of Wiesbaden's largest synagogue. It was built in the heart of the city, at Michelsberg, between 1863 and 1869. Like the synagogue in Hildesheim, it was destroyed in the Kristallnacht pogrom of 9 and 10 November 1938.[6] Its foundations survived until 1950, when they, too, were demolished. In 1951, the city council decided to mark the site with a memorial. After several proposals that had been generated internally were deemed unsatisfactory—including one for a monument with the inscription, "Forgive us our sins"—the city commissioned a local artist to design a memorial: for four thousand marks, Egon Altdorf created a stele, a red basalt block that carries an inscription also developed by the artist, "Der Welt Gewissen ist die Liebe" [Love is the world's conscience].

After 1945, a substantial Jewish community again established itself in Wiesbaden. Unlike the Jewish congregations in Celle and Hildesheim, Wiesbaden's postwar Jewish congregation survived beyond the early 1950s. When consulted about the memorial, the congregation consented to Altdorf's solution but insisted that an additional text be added: "In memory of the synagogue that stood here until 9 November 1938." The memorial was unveiled in August 1953.[7] Apparently the city administration and the council would both have been content with a memorial that made no reference to the synagogue. After the modifications requested by the Jewish community, there could be no doubt about the stele's function. But even with the additional inscription, there was no explicit reference to what happened on 9 November 1938. Readers of Wiesbaden's main daily newspaper would not have been any wiser. In anticipation of the dedication ceremony, the paper noted, "When tomorrow the memorial stone . . . at Michelsberg is dedicated and the inscription, 'Love is the world's conscience,' becomes visible, people will think back to the days when a festive congregation assembled in the beautiful synagogue for a service." After describing in some detail the origins of the building, the article concluded: "During the [synagogue's] fiftieth anniversary it was hoped that the magnificent building would witness its centenary. But things turned out otherwise. The Wiesbaden synagogue, too, fell victim to the shameful events of fall 1938, which this simple memorial stone . . . is to remember."[8]

In 1970–72 an overpass was built across the site where the synagogue had once stood, and the Altdorf memorial was moved. In the 1980s, two

Fig. 34. Demolition of the burned-out ruins of the synagogue at Michelsberg, c. 1939. (Photograph courtesy of Foto-Rudolph, Wiesbaden.)

more memorial plaques were put up next to it. In 1989, during a festival of arts, the installation artist Udo Gottfried used the space under the overpass for an ephemeral memorial.[9] Although it soon became apparent that the new road did not improve the traffic flow and ruined an attractive vista, the demolition of the overpass was not seriously contemplated until the 1990s. In 1994, Heinrich Lessing, an architecture student at a college in nearby Mainz, did his final-year thesis and project on the overpass. He proposed removing all but a small section of the new road and making the site of the synagogue visible.[10] His engagement with the issues on an academic level led him to embark on a practical project. Between 1995 and 1997, Lessing marked the site of the synagogue. He painted the building's ground plan on the road, put up three wooden structures under the overpass, and installed several panels that detail the synagogue's history. Initially, his installation, entitled *Fragmente,* was intended to be temporary; but it soon became a permanent feature of Michelsberg. Lessing was assisted by friends and by the Förderkreis Aktives Museum Deutsch-Jüdischer Geschichte in Wiesbaden, a group of local residents committed to keeping alive the local Jewish past. His project was also supported—tacitly at first—by the municipal authorities. Interestingly, Lessing at first only dealt with the Department of Town Planning rather than the Depart-

Fig. 35. *Fragmente* installation by Heinrich Lessing (detail). The glass plate allows the viewer to glimpse the interior of the synagogue; the wooden structures under the overpass mark the site of the synagogue (they are illuminated at night).

ment of Cultural Affairs: at least initially, his installation was not primarily seen as a work of art.

Memorials such as that by Heinrich Lessing are commemorative acts in the first-person singular. Through his installation at Michelsberg, Lessing publicly remembered Jewish life in pre-1942 Wiesbaden. Such memorials are often ephemeral. They intervene at specific moments. Their authors are not aiming to ossify their own act of remembering.[11] Memorials in the first-person singular can also be the outcome of a collective endeavor. On 30 August 1992, on the fiftieth anniversary of the last deportation of Jews from Wiesbaden, the Förderkreis organized a silent demonstration in Wiesbaden. About twelve hundred of the participants carried placards, each bearing the name of a local victim of the Shoah. They walked from the center of the city to a loading ramp that once belonged to the local abattoir, from where Wiesbaden's Jews were made to board trains to the Theresienstadt ghetto camp.

In a speech at the ramp, Günter Retzlaff, speaker of the city council, committed the city of Wiesbaden to document, at a central location, the names of all Jews deported from Wiesbaden during the Nazi years. In 1996, the local Department of Cultural Affairs commissioned Wiesbaden-based Belgian artist Marc van den Broek to design a memorial for the town hall that could meet Retzlaff's commitment. Van den Broek suggested putting up a two-meter-high column in the foyer. This column was to conceal a computer and to have some twelve hundred name plates and corresponding bell buttons; by pushing the buttons, visitors would have been able to access information about particular individuals.[12]

"In Memory of All Victims of National Socialist Terror"

On 19 September 1985, the Christian Democratic Party (CDU) aldermen in the Wiesbaden City Council moved that

1. Council lament that forty years after the end of World War II not all Germans enjoy the rights inscribed in the United Nations' Declaration of Human Rights of 10 December 1948.
2. Council lament in particular the many victims of the expulsion [of ethnic Germans] from the German territories in the East that are now administered by Soviet or Polish authorities.
3. Council lament the loss of many lives . . . during the uprising on 17 June 1953 in the German Democratic Republic.
4. Local government be instructed to erect a *Mahnmal* for the victims of the expulsion and the victims of the uprising of 17 June 1953 at a representative site in Wiesbaden.[13]

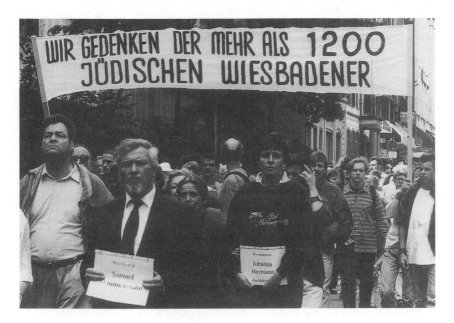

Fig. 36. On 30 August 1992, some 2000 people walked silently from Wiesbaden's market square to a ramp from which local Jews had been deported to ghettos and concentration camps. The banner reads: "We remember more than 1,200 Jewish Wiesbadeners." (Photograph by R. Fischenich, courtesy of Förderkreis Aktives Museum Deutsch-Jüdischer Geschichte in Wiesbaden e.V.)

Such a *Mahnmal* for the Germans who became the victims of the redrawing of boundaries after World War II and for the victims of Stalinism in East Germany would have been in line with what the conservative side of West German politics had championed since the 1950s. In this case, however, it appears that the Christian Democrats were making an ambit claim and trying to preempt a motion foreshadowed by the local SPD, which had been on the cards since at least May 1985 when the City of Wiesbaden commemorated the end of World War II. The Social Democrats wanted—as they stated in their own motion on 24 October 1985—"the City of Wiesbaden to erect, at an appropriate site, a *Mahnmal* to commemorate the victims of the National Socialist terror."[14] No vote was taken, and both motions were referred to a parliamentary committee.

Günther Retzlaff became one of the key proponents of a memorial for the Nazis' opponents and victims. Although in 1985 still comparatively young, he was already considered a kind of local elder statesman, whose appearance conveyed dignity and sincerity. When talking to him in 1997, I

was struck by the urgency of his arguments for a central memorial. Retz-laff's personal investment in the *Mahnmal* issue was apparent.

> I did not experience persecution and oppression myself. I was born in
> '32, so grew up in the Nazi era. I was completely indoctrinated. Until
> February '45, I was a little Nazi. I reckon I can't be blamed for that,
> though, because we all were then, unless one had very strong contrary
> influences through the family or some other context. In February '45,
> I commuted every day from a small village near Berlin to my school in
> Strausberg. I traveled on suburban trains. These were trains mainly
> used by [blue-collar] workers. I was terribly dismayed to realize how
> [they] were slandering our führer and calling him a criminal. I was
> utterly devastated and went home and told my mother and my uncle,
> with whom I was living at the time. And to my great surprise, they
> said, and I never thought they would, "Yes, they are right." . . . So
> within three or four or eight hours, my whole world collapsed . . . In
> the first weeks and months [after the end of the war], I was made aware
> of the whole hideousness of Nazi crimes . . . I am from East Prussia
> myself and lost my home . . . All this generated a terrible hatred in me
> against anything that could be termed right-wing extremism . . . The
> other [reason I have fought for the *Mahnmal*] is that I . . . met people
> in Israel whom as a child I [would have] regarded as scum and vermin,
> and whose sophisticated culture and humanity I was now made aware
> of . . . who represented German culture at its best.[15]

In 1985, Retzlaff's party, the SPD, together with the Greens, com-manded a majority in the city council. But the Speaker was convinced that the issue required a bipartisan approach and drafted a motion that even-tually found the approval of both sides of Wiesbaden's local parliament. This compromise mentioned human rights abuses in the GDR, the loss of German territories in Eastern Europe, and the division of Germany. The crucial part of the motion, which was passed on 19 June 1986, reads: "In memory of all victims of National Socialist terror and particularly in honor of those who resisted, a memorial that is in accordance with their significance, is to be created at a prominent site."[16]

The added reference to the opponents of the Nazis, which distin-guished the decision of Wiesbaden's council from that taken by other West German local parliaments at around the same time,[17] arguably acknowl-edged one local opponent in particular: Georg ("Schorsch") Buch (1903–1995) was a local leader of the Social Democrats' youth organiza-tion, Sozialistische Arbeiterjugend (SAJ). In 1933, he was elected leader of Wiesbaden's now illegal SPD. Over the next eight years, Buch regularly met with other SAJ members to swap information and illegal brochures

smuggled to Germany. In 1941, Buch was arrested. Although his conspir-
atorial activities could not be proven, he spent the next four years in pris-
ons and concentration camps.[18] After the war, Buch became a leading
figure in local and state politics. He served as Wiesbaden's mayor and as
speaker of Hessen's state parliament. At a time when many West German
politicians had to conceal or play down their pre-1945 careers, Buch's cre-
dentials, which could be seen to have reflected on the city he was serving as
a mayor, were impeccable, at least from the point of view of the Social
Democrats.[19] It was Buch, too, who in 1985 had passed on to his fellow
Social Democrats a suggestion by the VVN to memorialize the Nazis' local
victims and opponents.

But Is It Art?

The *Mahnmal* project was the responsibility of the local government min-
ister for cultural affairs and education, Margarethe Goldmann, who had
come into office in 1986. As Goldmann recalled in 1997, in her first years
in office she had been preoccupied with more pressing matters and had
been looking for ways of avoiding a purely administrative implementation
of the 1986 decision. That is, she was hoping for a public debate about the
Nazi past and its commemoration.[20] That she swung into action somewhat
belatedly in 1991 could also be attributed to Volker Rattemayer, the new
director of the Wiesbaden-based state museum. The museum had an eclec-
tic collection ranging from stuffed animals, rocks, and historical artifacts
to modern art. Rattemayer had little time for the history and natural his-
tory collections and was committed to making the Wiesbaden Museum
one of the leading contemporary art museums in Germany. He saw the
potential of the 1986 decision—that it could provide substantial public
funding for a prominent work of art—and offered professional advice on
how the decision could be implemented. Both Goldmann and Rattemayer
envisaged a memorial that could be understood as the latest statement in
the artistic memorialization of the Nazi past in Germany and Austria.

 Since Wiesbaden's aldermen had first considered the issue of a pub-
licly funded memorial, artists had provided some widely discussed answers
to the questions of how to present and how to publicly remember
"Auschwitz." In 1985, the Austrian artist Alfred Hrdlicka completed the
first part of a *Mahnmal* in Hamburg's city center. Conceived as a response
to a contentious war memorial created in 1936, Hrdlicka's work soon
became one of the most talked-about postwar monuments in West Ger-
many.[21] In 1986, Jochen Gerz and Esther Shalev-Gerz created a *Mahnmal*
in Hamburg-Harburg, which consisted of a twelve-meter-high square col-
umn enclosed by a mantle of lead, on which passers-by were invited to
inscribe their names.[22] Once the available space was covered by signatures

(or other graffiti), the column was lowered into the ground to bring a new segment within reach. In 1987, fifty-four artists were invited to put up temporary installations in public spaces of their own choosing in the city of Münster; some of these artworks directly addressed Germany's Nazi past. Of the latter, Sol LeWitt's *Black Form (Dedicated to the Missing Jews)* received probably the most attention.[23] In 1988, as his contribution to the Styrian Autumn art festival in Graz, Hans Haacke reconstructed an obelisk that Austrian Nazis had used to cover a statue of the Virgin Mary in the center of Graz to celebrate the Nazi takeover of Austria.[24] In 1989, Sol LeWitt re-created the *Black Form* in Hamburg-Altona, and Hrdlicka made a controversial sculpture for Albertinaplatz in Vienna.[25] *The Missing House,* an installation by Christian Boltanski in Berlin's Große Hamburger Straße, drew attention to the deportation of Jews and to the former existence of a transit camp in the street (see introduction).[26]

In 1991 and 1992, Goldmann convened a panel of experts—renowned art historians, art administrators, and art critics—to advise local politicians and bureaucrats on how best to proceed. In three meetings, the invited experts discussed relevant memorials elsewhere and aired their views on who would be capable of creating an appropriate work of art in Wiesbaden. One expert argued that the shortlisted artists needed to be known abroad as "very German."[27] Another thought that Hans Haacke ought to be deleted from the shortlist because his work was "visually and aesthetically unsatisfactory."[28] The third meeting, in February 1992, generated a shortlist of twelve well-known artists, among them Gerhard Richter, Jochen Gerz and Esther Shalev-Gerz, Jenny Holzer, Bogumir Ecker, Anselm Kiefer, and Rebecca Horn. Shortlisted artists were asked to visit Wiesbaden and talk to members of the city council about their ideas for a memorial. None of the invited artists was from Wiesbaden; Rattemayer and Goldmann were convinced that no local artist would be up to the task.

While the aldermen were made aware of precedents elsewhere in Germany, they were apparently not asked to reflect on the specific historical contexts of their discussions in 1985–86 and 1991–92. The minutes of the three meetings and articles in the local press that reported the *Mahnmal* discussion in Wiesbaden do not mention that the context of the panel discussions was very different from that in which the original vote had been taken in June 1986. Whereas in 1985 the Social Democrats could have hoped for a memorial that prominently commemorated the struggle and sacrifices of their comrades, the discrediting of East German antifascism after 1989 made a publicly funded memorial for the opponents (rather than the victims) of Nazi Germany a highly unlikely outcome.

Neither the aldermen nor Wiesbaden's interested public paid attention to the fact that the local government had once before, in the early

1960s, decided to erect a memorial for the war dead and the victims of Nazi Germany. The decision was not implemented, partly because the church bell earmarked for the memorial was later used as a font in one of Wiesbaden's churches.[29]

Proponents of the central *Mahnmal* also chose to ignore the presence of the 1992 memorial for Wiesbaden's murdered Sinti (see chap. 4). In 1992, the Christian Democrats had conveniently invoked the city council's *Mahnmal* decision and voted against the Sinti memorial on the grounds that it would be wrong to distinguish between different categories of victims and that the realization of a separate memorial for Sinti would undermine the decision the council had taken on 19 June 1986.[30] The leaders of Wiesbaden's Gesellschaft für Christlich-Jüdische Zusammenarbeit (Association for Christian-Jewish Cooperation), which has often purported to represent Jewish interests, protested against what they called a *Sondermahnmal* (special memorial) and voiced their concern that it could "devalue the notions of shame and sorrow that underlie the *Gesamtopfermahnmal* [*Mahnmal* for *all* victims]."[31] In 1997, the proposal to fund Marc van den Broek's computer installation was unsuccessful when its opponents also cited the 1986 council decision, arguing that the funding of a memorial for Wiesbaden's Jews would jeopardize a *Mahnmal* for all victims.

In 1992 and 1993, six artists accepted the invitation to visit Wiesbaden and discuss the possibility of designing a *Mahnmal*. Only Bogumir Ecker and Jenny Holzer submitted models. A third, Jochen Gerz, proposed a project that required a budget several million marks in excess of the approximately one million marks originally allowed for the memorial. Ecker and Holzer both suggested sound installations. Both favored solutions that would have been antithetical to the conventional notion of monumental sculpture. Only Holzer's design attracted support from among local politicians and art administrators. In her proposal, the artist wrote:

> I propose a hole in your earth from which speech, noise and songs come. The audio program is talk and sounds from and about the war time, and appropriate music . . . Around the monument are concentric stone benches that provide a surface for a dedication and seating for visitors. Surrounding the benches are a variety of black, somber plants, photographs of which are enclosed. My hope is that the combination of real voices, a terrible garden, and a black opening in the ground will make memory.[32]

By the time Ecker and Holzer were submitting their proposals in 1993 and 1994 respectively, German politicians, artists, and public intellectuals were debating a projected national memorial in Berlin.[33] Since 1964, the Federal Republic's national memorial "for the victims of the wars and of

Gewaltherrschaft" was located in Bonn, first in front of the Museum of Art, and from 1980 at a local cemetery. The memorial, and the wreath-laying rituals at its site, were considered necessary parts of the visits of foreign dignitaries. From 1983, West German politicians and organizations such as the Volksbund Deutsche Kriegsgräberfürsorge and the Zentralrat der Juden in Deutschland were discussing proposals to build a national memorial that could supersede the one at the cemetery. After Reunification, the Kohl government opted for the Neue Wache in Berlin as a national memorial for the new Germany.

The Neue Wache, a classicist building designed by Friedrich Wilhelm Schinkel, was completed in 1818. It formed the backdrop to victory parades held by Prussia's rulers in the nineteenth century. From Neue Wache, the mobilization order of Wilhelm II was announced on 1 August 1914. In 1931, the Prussian state government turned the building into a memorial for the dead of World War I. After 1933, the building was refurbished but its use retained. Heavily damaged in World War II, the Neue Wache was restored by the GDR authorities. In 1960, it was reopened as a *Mahnmal* "for the victims of fascism and of the two world wars." When rededicated in 1993, it became a national memorial "for the victims of war and *Gewaltherrschaft,*" thus resembling many local memorials—such as the memorial plaque at the war memorial in front of the Celle palace (see chap. 2)—that had been put in place ostensibly to honor the victims of Germans. After loud protests the federal government decided that a plaque be affixed to the building to specify who exactly was to be commemorated:

Neue Wache is the site of memory to remember the victims of war and *Gewaltherrschaft.*

We remember the nations who suffered through the war. We remember their citizens who were persecuted and lost their lives. We remember the soldiers killed in the world wars. We remember the innocent who died in their native country because of the war or its consequences, those who died as prisoners, and those who died when they were driven from their homes.

We remember the millions of murdered Jews. We remember the murdered Gypsies. We remember all those who were killed because of their ethnic origins, their homosexuality, or because they were sick and weak. We remember all those killed whose right to live was denied.

We remember the men and women who had to die on account of their religious or political beliefs. We remember all those who became the innocent victims of the *Gewaltherrschaft.*

We remember the women and men who sacrificed their lives when

they resisted the *Gewaltherrschaft*. We honor all those who died rather than betray their conscience.

We remember the women and men who were persecuted and murdered because they resisted totalitarian dictatorship after 1945.

Had Wiesbaden's aldermen paid more attention to the extensive public debate accompanying the rededication of Neue Wache in Berlin, they might have become more suspicious about their own striving for comprehensiveness.

Days of Remembrance

Hermann Simon, director of the Centrum Judaicum, was one of the invited speakers at the dedication ceremony for the Koppenplatz memorial in Berlin. In conclusion, he said: "We should all be able now to say: 'It's done! The memorial is there!' But this is only the very beginning. Now we have to think about what to do with this memorial." Indeed, a memorial's visibility also depends on how and when people talk about it, or more generally, on how it is used.

The proponents of a central *Mahnmal* in Wiesbaden did not put forward any ideas on what to do with it if it were ever built. Should the city's political leaders lay wreaths at such a memorial? If so, on which occasions? The only memorial in the center of Wiesbaden that in the late 1990s provided the backdrop to regular civic ceremonies was Lessing's *Fragmente* installation at Michelsberg. There were no regular commemorations at the Sinti memorial in Bahnhofsallee. Annually on 9 November, for the anniversary of the 1938 pogrom, the city's office of protocol organized commemorative ceremonies; before 1995 most of them took place in the outer Wiesbaden suburb of Schierstein, at the former site of another synagogue. The Schierstein ceremonies were not attended by many people; but perhaps the organizers thought it more important that the event not cause traffic problems.

While the Neue Wache in Berlin and its predecessor in Bonn have been used mainly on the occasions of state visits, most memorials have been sites for local annual commemorations. At the *Gedenkstätte* in Salzgitter-Drütte, for example, such commemorations have, since 1985, been held annually on 11 April, the anniversary of Liberation. The new monument at Lappenberg in Hildesheim has regularly been the center of two annual commemorations, at Yom Hashoah and on 9 November to commemorate the Reichskristallnacht pogrom. In 1997, the Förderkreis Aktives Museum in Wiesbaden circulated a discussion paper that called for three local memorial days:

"The day of the deportation of Wiesbaden's Jewish citizens in 1942," 30 August, represents the crime's local relevance in our city. "The day of the attack on synagogues and German-Jewish citizens in 1938," 9–10 November, represents the visible assault on a previously defined and defamed minority, the Christian churches' silence about the destruction of the Jewish places of worship, and the preparation of the genocide. "The day of the victims of the Nazi regime in memory of the liberation of Auschwitz," 27 January, makes the public aware of all victims of National Socialism.[34]

With its initiative, the Förderkreis tried to put forward an argument for a locally specific commemoration of the Holocaust, while at the same time incorporating a national memorial day. In 1995, the German president Roman Herzog had proposed to commemorate the liberation of Auschwitz. Since 1996, 27 January has been observed as a national day of remembrance (but not a public holiday).

While the citizens of many other nations celebrate national holidays that have been chosen to mark foundational moments in their histories, Germans have had a problematic relationship to such holidays. There has been no equivalent in Germany to, say, France's Bastille Day. The first attempt to inaugurate a German national holiday at the beginning of the nineteenth century failed: the nationalist writer Ernst Moritz Arndt proposed to celebrate the anniversary of the Battle of the Nations at Leipzig, the victory of the combined Russian, Austrian, and German armies over Napoleon's troops in 1813, but the rulers of the German states were wary that such celebrations could foster a pan-German patriotism.[35] After German unification in 1871, Prussian Protestants suggested declaring 2 September, the day the Prussian-led forces delivered a decisive blow to the French army at Verdun, a national holiday. Schools and the army celebrated the Verdun anniversary, but it never became an official national holiday.

In the Weimar Republic, the parliament commemorated 11 August, the day the Weimar constitution came into force, but did not legislate a public holiday. Civil servants were expected to celebrate the republic's constitutional birthday but were generally no more enthusiastic than the population at large. In Celle, as in many other towns, the speeches on 11 August were usually marked by the speaker's regret over losing the war rather than his joy at the opportunity to create a democratic society.[36] The Volksbund Deutsche Kriegsgräberfürsorge successfully declared the second Sunday of Lent (Reminiscere) to be a Remembrance Day (Volkstrauertag) for the dead of World War I.

The Hitler government introduced several secular national holidays in Germany: 1 May as Feiertag der nationalen Arbeit (National Labor

Day), the Nazis thereby usurping the internationalist and socialist associations previously attached to 1 May; Remembrance Day, now called Heldengedenktag, to commemorate the heroes fallen in war rather than to mourn the dead, and moved to the Sunday preceding 16 March, when conscription had been reintroduced in Germany; and Erntedankfest, Harvest Festival Day, in November. The Nazis also introduced several annual days of commemoration, the most important of which was 9 November, the day of Hitler's failed coup in Munich. As Wilhelminian Germany had observed the emperor's birthday, so Nazi Germany celebrated 20 April, the führer's birthday.

Both the FRG and the GDR retained 1 May as a public holiday. After the workers' uprising on 17 June 1953 in East Germany, the Social Democrats in Bonn successfully argued for 17 June to become the Day of German Unity and thus West Germany's only other secular national holiday. Remembrance Day was also retained, although moved from Lent to the sixth Sunday before Christmas. The FRG government announced opaquely that Volkstrauertag was to "remember all those who gave their lives for the good of humankind [*für die Güter der Menschheit*]."[37] The other Germany declared 8 May (the surrender of Nazi Germany) and 7 October (the founding of the GDR) to be national holidays.

The GDR also recognized twenty-eight memorial days, which were not public holidays but were officially observed and occasions for state-sponsored commemorations. Until 1978, the FRG had only two equivalents: 20 July and 13 August, to commemorate the failed attempt to assassinate Hitler, and the erection of the Berlin Wall. From 1978, the anniversary of the Kristallnacht pogrom was commemorated in many West German towns. In the FRG, the commemoration of 17 June, 20 July, 13 August, 9 November, and Volkstrauertag usually involved the laying of wreaths and the delivery of speeches by civic leaders. The occasions for all these days demanded contemplation rather than celebration. West Germans welcomed the anniversary of 17 June 1953 as a day off work and otherwise usually paid little attention to any memorial day—the mourning and remembering were delegated to political leaders.

With Reunification, 17 June became obsolete as a national holiday. Suggestions to celebrate instead 9 November, the day the Berlin Wall came down, were countered with references to the other anniversaries that fall on 9 November: the declaration of the republic in 1918, the failed Nazi coup in 1923, and the Kristallnacht pogrom in 1938. Parliament shied away from the opportunity that the entangled histories of 9 November offered, and settled for 3 October, the day the five East German states and East Berlin joined the Federal Republic.

Since the Kristallnacht anniversary was first commemorated in many West German cities in 1978, West Germans have increasingly drawn on

anniversaries—such as the fiftieth anniversaries on 30 January 1983, 9 November 1988, and 1 September 1989—to publicly remember the Nazi past. The preoccupation with anniversaries was most pronounced in the first half of 1995. The interest in memorial days hardly flagged after 1995: in 1996, 1997, and 1998, the anniversaries of the liberation of Buchenwald, Neuengamme, Bergen-Belsen, Dachau, Sachsenhausen, and Ravensbrück concentration camps continued to attract sizable crowds.

Experts

Margarethe Goldmann, Volker Rattemayer, and Jochen Gerz, all of them well versed in the debates about how artists could publicly remember the Nazi past, told me that Wiesbaden's politicians were not able to articulate what they really wanted. But maybe they just wanted too much. They wanted a memorial in memory of all victims—possibly even including the postwar victims of Stalinism in the GDR. The aldermen wanted a memorial that would educate and admonish their constituencies. They wanted a memorial by a renowned artist. The aldermen wanted something that would put Wiesbaden at the forefront of the debate about the memorialization of the Nazi past. They wanted authoritative advice on how to proceed. And they wanted somebody else to do the remembering for them.

When *Holocaust* was broadcast on West German television in early 1979, the networks were well prepared. Following the screening of the individual segments, panels of experts debated issues arising from the film, and responded to viewers who called in to ask questions or offer comments. Academic historians specializing in twentieth-century Germany were then prominently entrusted with assessing the Nazi past. In West Germany, the *Holocaust* panels marked the peak of the historians' authority. During the early 1980s, academic historians came increasingly under attack from amateurs organized in local history workshops who recognized the poverty of historical scholarship on the Nazi period and insisted on analyzing the Nazi past "from below," by privileging local perspectives and interviewing eyewitnesses. The so-called *Historikerstreit* of the 1980s—the historians' controversy about the exceptionality of "Auschwitz"—was arguably also an attempt to reassert the authority of the profession. The eagerness with which historians on both sides of the ideological divide joined the debate about the merits of historicizing the Nazi past seemed to reflect their interest in making the debate into a *historians'* controversy (rather than into one about the telling or writing of history). In 1996, the publication of *Hitler's Willing Executioners* sparked another loud debate about the interpretation of the Nazi past. In panel discussions on television and in front of large audiences, historians were again invited to give their expert opinions. Unlike in 1979, however, this time their authority was

contested by audiences who sided with Goldhagen and his thesis (without having read the book itself).

While historians in the 1980s supposedly knew best what happened in the past, artists in the 1990s supposedly knew best how to represent that past symbolically. "Tell me of a *Mahnmal* that you consider appropriate," I asked Günther Retzlaff. "I don't have the competence to presume to have an opinion about it," he replied, adding that he would not want to challenge the aesthetic judgements of experts.[38] The discourse about forms of public remembrance has been a discourse of experts, who have been expected to be able to make comprehensive statements about the past. Like historians in the 1970s and 1980s, in the 1980s and 1990s many artists willingly accepted the responsibility thrust upon them, not least because the social role assigned to artists generated significant funding for art projects in public places.

Local politicians—in Wiesbaden and elsewhere in Germany—have taken for granted the distinction between professional artists (and professional art critics and art administrators) on the one hand, and amateurs on the other. They have been little concerned about the respective contexts in which the alleged experts operated. Those who have wanted historians or artists to deliver authoritative interpretations of the past have rarely been curious about the peculiar environment in which such interpretations were produced. Who among those turning to professional historians to "read" the past for them has wanted to know about the politics of securing grants and jobs that plays such an important role in determining who speaks publicly on particular issues? Wiesbaden's politicians asked to be briefed about the issues discussed in the artists' discourse about Holocaust remembrance; they did not ask to be briefed about how the production of art is influenced by the art market or the vagaries of public funding.

Experts also played a significant role in public debates about what to do with *Gedenkstätten* in post-Communist East Germany. Commissions of experts issued recommendations about the revision of the Ravensbrück, Sachsenhausen, and Buchenwald memorial museums. Experts were again called upon after the 1992 arson attack on the Jewish barracks in Sachsenhausen (see chap. 5). Educators championing an anti-anti-Semitic pedagogy, conservationists, historians providing authoritative representations of the past, and artists specializing in its public memorialization dominated the debate about what to do with the barracks' charred remains. Three alternatives suggested themselves: demolition of the ruins, possibly followed by the erection of a memorial; preservation of the remains, to serve as a memorial; and reconstruction of the barracks. After a protracted debate it was decided to preserve traces of the fire but integrate them into a new building to house a permanent exhibition about Jews in Sachsenhausen. The new museum opened in November 1997.

Fig. 37. Barrack 38 and Barrack 39, Sachsenhausen, 1998

While the building contained traces of its fire that could be seen and smelled, and the exhibition documented previous uses of the two barracks, the new memorial did not betray traces of the various solutions offered in the debate. Soon after the arson attack, a group of about sixty traveling journeymen and -women, including carpenters, stonemasons, tailors, and others, decided to get involved in repairing the damage done by the arsonists. For them, becoming involved meant getting in touch with the Zentralrat as well as with survivors to find out about their ideas for what should happen to the barracks. As one of the carpenters explained: "For us the main thing was that we cooperate with those who'd been imprisoned there."[39] Although the response from survivors they contacted (most of them former political prisoners) was positive, getting involved was much more difficult than the young people thought. They were keen to do something quickly. They saw the survivors also as wanting a quick solution, because their own time was running out. In response to what the young tradespeople experienced as bureaucratic wrangling, they proposed to prefabricate the parts for a barrack somewhere in Oranienburg, and then at night break into the *Gedenkstätte* and rebuild the destroyed barrack in nearly as little time as it took to burn down. A busload of survivors, they thought, should accompany them and keep the police at bay

while they finished their job. Although the initial reactions from survivors and from the Zentralrat were positive, the idea never materialized. This was partly because of concerns the young people themselves had about the illegality of their proposed action. More importantly, however, those responsible for the *Gedenkstätte* distrusted any spontaneous solution that was not authorized by panels of experts, while at the same time wanting to involve the tradespeople because such involvement would have signaled to a non-German public that young Germans rejected anti-Semitism and xenophobia.

The Skip

In the 1993 local government elections, Wiesbaden's SPD lost its absolute majority and had to form a coalition with the Christian Democrats and the Liberals. The new local government minister for cultural affairs, Peter Joachim Riedle of the CDU, did not pursue the project. Neither he nor his party had ever been enthusiastic about the city council's *Mahnmal* resolution; for different reasons, both the Christian Democrats and the Liberals withdrew from the 1986 consensus without openly saying so. In 1995, even the Social Democrats committed themselves again to realizing the *Mahnmal* project only after Retzlaff had threatened to resign.

From 1996, Riedle advocated a new idea: he suggested to spend the money that was once earmarked for the *Mahnmal* on a large number of smaller projects. He said that he was afraid that a *Mahnmal* could be considered the last word in debates about the Nazi past. The conservative Catholic, and former parliamentary leader of the Christian Democrats, became one of the most vocal advocates of an active process of remembering the Nazi past. Rather than to build a central *Mahnmal*, Riedle wanted to extend the opening hours of the small museum at Unter den Eichen, provide additional funding for the Förderkreis Aktives Museum, and encourage an active engagement with the existing memorials at Michelsberg and in Bahnhofstraße:

> Over the past ten years, I have recognized that the [council decision of June 1986] does not work. Anyway, I'm asking myself: what's the point of having memorials? . . . You get together on 9 November. That's a bit like celebrating Father's Day . . . It becomes a chore for initiates . . . Perhaps I'm also against memorials because I need something for the everyday side of life. Not for the Sunday, when I dress up and go to church—for that's not my life if I then mess about from Monday to Saturday . . . I don't expect people to think day and night about the Holocaust and the atrocities committed by Germans. But they ought to be aware every now and again of the fact that they don't

need a Bosnia to ponder these issues. I want people to reflect once in a while, and of their own accord.[40]

From 1997, however, a coalition of Social Democrats and Greens again commanded a majority on the council and was theoretically in a position to instruct Riedle to implement the 1986 council decision.[41] In 1997, both coalition partners reaffirmed their commitment to having a central *Mahnmal* in Wiesbaden. But by mid-1998, the *Mahnmal* was not any closer to being realized than it had been in June 1986.

Jochen Gerz, Hans Haacke, Christian Boltanski, and other artists provoked many Germans and Austrians to reflect on their own memories of the Nazi past. They enriched the public debate about how to remember the crimes perpetrated under Nazi rule. Their interventions were crucial—particularly on occasions when they were literally uncalled for. In 1998, Gerz and similar artists were unlikely to supply Wiesbaden's local politicians with a conclusive statement that could bring the twelve-year gestation about a central *Mahnmal* to an end. But would not a decision *not* to build this *Mahnmal* in Wiesbaden have been the best possible ending this story could have had? And would not memories of the embarrassing twelve-year discussion about the *Mahnmal* have made a fitting memorial for Wiesbaden?

"Memory can't have a site outside ourselves,"[42] Jochen Gerz said in an interview when commenting on his countermonument in Saarbrücken (see introduction). In his view, a work of art could be about memory, be it the artist's or the viewer's; it must not take memory's place. By claiming that a work of art commissioned by the city council would commemorate the victims of Nazi rule, Wiesbaden's aldermen attributed to a *Mahnmal* (and to the artist creating it) a task that only they and their fellow citizens could attempt to accomplish: to remember the Nazi past and its legacy in the present—and in this context it does not matter whether that would entail remembering details about train journeys to Strausberg, or about the building of an overpass in the early 1970s.

The misunderstanding that a *Mahnmal* itself could remember, that it could be a substitute for memories, or that, to (mis)use Jenny Holzer's words, it could "make memory,"[43] are partly responsible for the anxiety regarding a memorial's possible defacement. How could the vandalizing of a memorial reflect badly on politicians who were ostensibly supporting its erection, if it was not (meant to be) mistaken for a representation of their remembering? As soon as Lessing's installation was adopted by the municipal authorities, Riedle arranged for the wooden structures to be painted with a fire-resistant varnish. Evidently, he was more concerned about the prospect of somebody setting fire to them than the artist. But surely Riedle was not afraid that he would be suspected of being an arsonist?

In June 1998, proponents and opponents of a memorial for all victims of the Nazis organized two public meetings in Wiesbaden that again drew on the expert advice of historians, educators, and art administrators. It was in response to the anxieties and expectations of Wiesbaden's local politicians that Heinrich Lessing and I intervened in the debate about a central *Mahnmal* at the meetings. We suggested that the funds that had been earmarked for the memorial be used for what we called *The Skip.* We took the term from the detachable material containers used for rubbish on building and urban sites. *The Skip* was to consist of two components. One was a walk-through skip. As a mobile memorial it was to move around Wiesbaden, never staying more than one month at one site. The skip's movement would be random; we expected that more than five hundred possible sites could be identified, and that *The Skip*'s actual sites would be chosen by computer. One of the inside walls of the skip would be covered with wedding photos of the years 1933 to 1945 that would be collected from Wiesbaden residents. This wall could be covered by six panels. Interested parties were given the opportunity to put up exhibitions on no more than five of these panels for no more than one month; thus at least one sixth of the wall showing the photos had always to be incorporated into the exhibition. The drawing up of a register of possible sites, the collection of photographs, and the curating of exhibitions were to involve the Wiesbaden public. Any individual or group could apply to put up an exhibition, and successful contenders would be chosen by drawing lots if necessary. We expected groups of secondary-school students to be particularly interested in the opportunities offered by the skip.

The Skip's second and more costly component was a database to be set up by the city of Wiesbaden. It would contain material about local history between 1933 and 1945, as well as about postwar history related to the Nazi past. This database was to be accessible through the Internet and from designated terminals in the town hall and in various local libraries. The database was to compensate for the fact that Wiesbaden, unlike most other German cities of the same size, did not have a local history museum.

The Skip, we argued, would not be a *Mahnmal* addressing an imaginary audience and designed by experts. It would be a vehicle that could be used by individuals to remember. It was not vandal-proof; in fact, one of the inside walls was to be deliberately left white to allow people to add their comments (which would then from time to time be painted over to create space for new comments). It was not a memorial that required commemorative rituals. It would not provide a focus for memorial days, be that one of the three days suggested by the Förderkreis, or Volkstrauertag. It was not a work of high art that would add to the city's attractions. Rather, it was to be an unwieldy and utilitarian part of the everyday that would appear in front of suburban shopping centers as well as on public

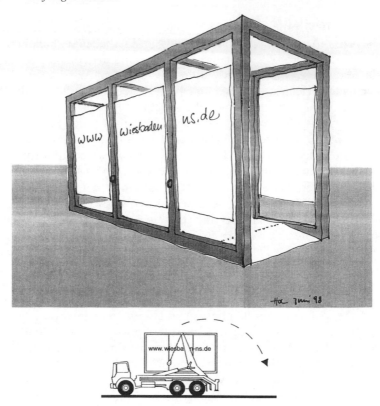

Fig. 38. "The Skip," sketch by Heinrich Lessing

places in the center of the city. The opponents of the central memorial for all victims, who by 1998 included Margarethe Goldmann, Peter Joachim Riedle, many of Wiesbaden's public intellectuals, and the Förderkreis Aktives Museum, wanted to commemorate the victims of Nazis Germany at "authentic sites" (see chap. 1) rather than conspicuously in the center of the city. Such sites included, for example, the bunker at Unter den Eichen and the ramp from where Wiesbaden's Jews had been deported.[44] *The Skip* would not privilege such sites, thus maintaining that the Nazi past was ubiquitous and part of the everyday, and in fact as normal as a memorial that from afar looked like a skip waiting to be filled with trash.

CHAPTER 11

Streets of Memory

The content and form of public remembrance have been hotly contested in postwar Germany. Debates have often focused on how collectives (for examples, "non-Jewish Germans," or "the citizens of Wiesbaden") *ought* to remember the Nazi past. Even where such debates were initiated by individuals and fueled by their—often very personal—attempts to remember, individual memories hardly entered such debates. The push for a central *Mahnmal* in Wiesbaden was led by Günter Retzlaff, the speaker of the city council. While his stance was influenced by his recollections of growing up in Nazi Germany, these memories were not part of the public debate about the *Mahnmal*. Neither were the *personal* responses of Retzlaff—or of other Wiesbaden residents, for that matter—to existing memorials in the city.

Individual memories are themselves influenced by collective discourses. But if one reduced individual memories to articulations or derivations of collective memories, one would understand little about Germans' obfuscation of individual responsibilities after 1945. While changes to collective memories could usefully be interpreted sociologically, that is, for example, put down to changing external circumstances affecting a group, such explanations by themselves are insufficient. As collective memories comprise individual memories, and as the latter can be the outcome of a willful remembering, German discourses about the Nazi past are also shaped by individual acts of remembrance, however much these may echo collective sentiments.

This last chapter is concerned with individual responses to a public memorialization. They reflect attitudes in the wider community and are therefore illustrative of many of the observations made earlier in the book. But they also serve as a reminder that "German" memories of the Nazi past are partly determined by the investment individual Germans have in these issues, and the effort they are willing to put into thinking about them.

Ruchla Zylberberg Street or Snowy White Crescent?

With the exception of Anne Frank and Sophie and Hans Scholl, since 1979 no other individual victims of Nazi Germany have been commemorated in as wide a variety of forms and on as many occasions as the children of Bullenhuser Damm. These forms include the one most commonly chosen in postwar Germany to honor individual victims: since 1992, seventeen streets in Burgwedel, a subdivision in the suburb of Schnelsen in the northeast of Hamburg, have been named after the children.

On 29 April 1981, a traveling exhibition about the life and death of the children opened in the foyer of the Lokstedt *Ortsamt,* the local suboffices of the borough of Eimsbüttel's municipal administration.[1] Günther Schwarberg, who had curated the exhibition, read from his book, *Der SS-Arzt und die Kinder.* Afterward, many of those present at the opening, including relatives of Ruchla Zylberberg, signed a spontaneously drafted petition that called upon the authorities to name the streets in a projected new subdivision in the north of Schnelsen after the children.

As was the case with the central *Mahnmal* in Wiesbaden and numerous other memorials in West Germany, the VVN initially played a part in lobbying the authorities. In May 1981, Hilde Benthien, chairperson of the VVN in Schnelsen, forwarded the petition and a list of the children's names to the speaker of the *Ortsausschuß,* a body responsible for recommending street names to the local parliament of the borough of Eimsbüttel (which in turn would pass on this recommendation to the state government). In September 1981, Benthien followed up the issue in another letter to the *Ortsausschuß.* She argued that the naming of streets was a means of rescuing the victims of mass murder from anonymity and thus encouraged people to engage with the past.[2] In a separate letter, six relatives of Ruchla Zylberberg supported the VVN initiative. They added a very personal argument to those listed by Benthien:

> We would also like to point out that it was outrageous that two families of Zylberbergs lived for twenty years in Hamburg, that our children attended school here, without ever learning about the fate of their niece or cousin, Ruchla, even though the names of the children were known since 1946.[3]

The Lokstedt *Ortsausschuß* did not deal with the issue until ten years later. In March 1991, the Christian Democrat members proposed naming the streets in Burgwedel after characters from fairy tales, thereby treating the new housing estate as an extension of an adjoining subdivision of Schnelsen where eight streets had been named after characters such as Dornröschen (Sleeping Beauty) or Rumpelstilzchen. The Social Demo-

crats in turn recalled the VVN initiative and, when the issue was debated in April 1991 in the *Ortsausschuß*'s Standing Committee for General Affairs, tabled a motion that called for the naming of initially ten streets in the subdivision of Burgwedel after children murdered at Bullenhuser Damm. The motion was carried with the votes of the Social Democrats and Greens; the Christian Democrats voted against the proposal. On 13 May 1991, the *Ortsausschuß* ratified the standing committee's recommendation, with nine members voting in favor and six abstaining. In September 1992, the *Ortsausschuß* recommended that another seven streets in Burgwedel be named after children killed at Bullenhuser Damm.

The position of the Christian Democrats was supported by some prospective residents of Burgwedel, and the debates in the *Ortsausschuß* were accompanied by a debate in the letters pages of a local weekly newspaper. In April 1992, a concerned would-be resident wrote to the *Ortsamt* to register her protest against naming her street "Georges-André-Kohn-Straße":

> I am of the opinion that the naming could have been used, for example, to express solidarity with the new states [that is, with the people in the former GDR] . . . Besides, I noted that the current name is so long that, to give one example, it does not even fit onto the space provided for the address on a lotto coupon.[4]

Problems of Orthography

In the 1980s and 1990s, Hamburg's authorities tried to learn from mistakes they made in the 1960s and 1970s when designing medium- or high-density housing estates. There are probably few places in West Germany whose notoriety is matched by that of Mümmelmannsberg in the southeast of Hamburg, where social problems have been exacerbated by an inhospitable architecture and lack of services. Burgwedel, with its mix of multistory apartment blocks and townhouses, may have been conceived as an antithesis to Mümmelmannsberg. The subdivision has parks and shops and is comparatively well serviced by public transport. It was designed for five thousand people and houses a diverse population that includes welfare recipients as well as middle-class families with two incomes. In 1998, a disproportionately large number of couples with small children lived in Burgwedel, making it one of the demographically youngest subdivisions in Hamburg.

Many of the residents who were interviewed for this book in 1997 and 1998 stressed that Burgwedel was particularly suitable for families with children. The views of Torsten, an economist who worked as a senior public servant for the state government, reflect those of many other interviewees:

Well, I like it a lot here. We have lived here for nearly three years now. And for the kids in particular, this is an ideal environment, where even small children can play by themselves in the nearby meadows and at the playgrounds. And that's the main consideration for us.[5]

The sample of Burgwedel residents, whose opinions I am quoting in the following, is not necessarily representative of the area's population. Many of those who were indifferent or antagonistic to the names of the street they lived in did not agree to be interviewed. The Burgwedel interviewees speak only for themselves. It was never my intention to conduct an opinion poll; rather I wanted to shed light on how public memories (as encoded in street names, for instance) interact with individual memories of the Nazi past.

The names of the streets in Burgwedel are unusual not just because of the fact that they refer to murdered children. As the would-be resident of Georges-André-Kohn-Straße noted in her letter of complaint to the authorities in Lokstedt, the name of that street is unusually long. And it is, she could have added, foreign. Karsten, a singer in his thirties, commented: "At first I was simply annoyed about the name, because I thought, 'now we again live in a street [the name of] which has to be spelled.'" For the interviewees, the name often also functioned as a decoy that allowed them to express their sense of discomfort about having to live in a street named after a murdered child. "Of course it is somewhat difficult, also given the orthography," Andrea, a student in her twenties who lived in Zylberbergstraße, said. The "it" that worried many residents is that the name is unwieldy—"a fat and heavy lump in one's throat," as thirty-five-year-old Beate put it. "It" extends far beyond the difficulty in spelling the name of a Polish Jew.

For some interviewees, one strategy of not acknowledging their sense of discomfort was to turn the conversation away from themselves. Ursula, a teacher in her fifties, said:

Everybody notices the name. It's so long that people say they won't write to us any more. Yes, that's the funny side of it. Georges-André-Kohn-Straße—well, we shorten that to GAK. That's apparently common practice . . . So that's a bit funny. And when we point out what it's all about, people grow more quiet and say, they'll continue to write to us after all.

In fact, most interviewees tried to gloss over their own discomfort by identifying a sense of bewilderment or repulsion in others. It was in relation to those unfamiliar with the experience of living in a street named after a murdered Jewish child that interviewees tried to portray themselves

as men or women seasoned in the art of *Vergangenheitsbewältigung*. By contrasting those who are interested in the street names with those who are not, the interviewees who evidently felt most uncomfortable about the names of their streets were able to position themselves on the side of what in the late 1990s was seen as a "correct" way of dealing with the past: Ursula implied that she was "of course" interested in the history of the children and thereby on the correct side of the fence when she claimed: "Of course it's always the same ones who ask questions. And others will never be interested. It will always be like that. There'll always be some who would like to know and are interested, and others who would like to remain ignorant."

Some residents adopted a stance similar to that of the West German journalists who heaped scorn on the Fürstenbergers and their desire to go shopping at Ravensbrück. For some interviewees, the reference to others supposedly less willing to engage with the past was also an opportunity to draw attention to class differences: they regarded the sophistication allegedly required for a successful *Vergangenheitsbewältigung* to be an attribute of their superior social standing. Thus when the university student Andrea and her flatmate Paula thought that the many "ordinary" people living in Burgwedel were not interested in the history of the children of Bullenhuser Damm, they revealed an unself-conscious snobbishness.

Victims and Victimizers

All Burgwedel residents interviewed for this book would have agreed that it was good to be on the side of those who wanted to know. They all had had ample opportunities to learn about the history of the children, as it had been recounted many times in the Hamburg newspapers, particularly on the anniversaries of the murder. But most interviewees said they had been unaware of the events of 20 April 1945 at Bullenhuser Damm when living elsewhere in Hamburg. Upon moving to Burgwedel, most of them were sent or picked up a free twenty-page brochure about the history of the children, *Straßen der Erinnerung* (streets of memory), which the Association of the Children of Bullenhuser Damm had published with some funding from the borough of Eimsbüttel. Many had subsequently also read Schwarberg's *Der SS-Arzt und die Kinder.* Some said that they had read about the children in the local weekly paper, *Niendorfer Wochenblatt.* None of the interviewees mentioned Fons Rademakers's film, *Der Rosengarten,* or the Thalia Theater productions about the children.

Despite having read about the children in recent years, most interviewees possessed only scant relevant knowledge. They remembered best that the children were Jewish and that they had been selected for medical experiments, but were often hazy about the remainder of the story. Thea, a

thirty-three-year-old tax consultant, for instance, apparently conflated the story of the children with that of Janusz Korczak, after whom the school at Bullenhuser Damm was named in 1980:

> Yes, that was a class of Jewish, or rather, non-German, schoolchildren who were brought in for a test, in the Nazi era. Shortly before the end of the war, they wanted to hush it up. And so they hanged them, and the teacher, he then hanged himself. Or that was somebody from the church, that I'm not sure about now. So that's what I know: that the children were hanged, and the teacher, too, out of solidarity, so to speak.

Some of the interviewees were better informed about the child after whom their street was named. Karin, a woman in her midfifties, recalled that Georges-André Kohn was the oldest of the children and concluded that he therefore must have experienced the experiments more consciously than the others. Jens, a teacher in his forties who lives in Jacqueline-Morgenstern-Weg, knew that Jacqueline had been from France and that her father had been a hairdresser. Others merged the story of a particular child with other stock narratives about Nazi Germany: Andreas mused that his street had been named after a "resistance fighter," and Maria suspected that Sergio Simone had been gassed.

In 1997–98, few of the interviewees knew anything about Arnold Strippel, the SS officer whose biography had played such a significant role in the *Stern* series and in the early work of the Association of the Children of Bullenhuser Damm. When told about his part in the murder, the interviewees were often incredulous and asked for more details. But generally their sense of outrage was not directed at the West German justice system that had failed to prosecute Strippel, or, even more generally, at the postwar ruling elites of the Federal Republic who included and had protected former Nazis. Strippel was perceived as a devious individual who went scot-free, rather than as the symbol of a failed national *Vergangenheitsbewältigung.*

All interviewees said that they were in principle in favor of memorializing the Nazi past and commemorating the victims of Nazi Germany. When asked to elaborate on why they took this view, some of them drew on set phrases such as "lest we forget this part of history, lest something like this happens again." Björn, a retired lecturer in his sixties, thought that it was important "to keep alive the memory of these terrible times." Others invoked more recent developments in Germany. Stefanie, a public servant in her late twenties, said: "Many people say . . . that this is such a long time ago and no longer of concern to us. But when you look at it in the context of today's xenophobia, it is important to commemorate it."

Stefanie did not want to suggest that she was xenophobic; rather she envisaged unenlightened others supposedly in need of memorials. Few interviewees wanted a personal reminder. Björn, for instance, confidently declared that he had been able to put aside the issue of the Shoah.

In a sense I dealt with [*verarbeitete*] National Socialism shortly after the end of the war, particularly when the murder of the Jews became known . . . [Then] I became aware of these terrible deeds and this terrible regime, something that I wasn't aware of during the war, given the well-known propaganda. So in effect I had this Saul-Paul experience, as it were, in 1945 after the end of the war.

Ursula paraded a rhetorical commitment to remembering the Nazi past. In the interview, she first tried to play down the murders at Bullenhuser Damm by referring to other, ostensibly comparable, crimes:

I think it is important that these children are remembered, and anyway this whole tragedy, with those experiments. But perhaps you also have read in the paper that at that time, experiments were done on orphans in other countries as well. Unfortunately, I didn't keep the article. I reckon times haven't changed and there'll always be people who exploit the weaker ones, or those who happen to be on the side of the weaker ones. Now I don't know whether it was in Peru or in Colombia, where they also used orphans to conduct medical experiments.

From there, she moved on to identify the *real* victims. An emphasis on the crimes of Nazi Germany would supposedly lead to the victimization of the victimizers:

This must not be carried too far . . . Of course, I am somebody who is in favor of memories happening [*daß da Erinnerungen stattfinden*]. But as I said, it must not be imposed on people. It must not go too far . . . One can't be reminded of it all the time, in such an artificial manner. That then also provokes aggression, I think. Then some people get angry.

While her tone was increasingly becoming aggressive, Ursula did not have herself in mind when referring to Germans' anger at being confronted with their history. Instead she recounted her experiences with a group of German tourists who, when attending a church service in Norway, were told about German atrocities during the war:

Then some got really angry during the service. I was really startled, I must say. People don't want to be reminded all the time. And certainly not while they are on holidays. A service, yes—they wanted that. But not once again "the bad Germans." I also reckon that this is not a problem of "the bad Germans," but rather a universal problem. It concerns everyone, not just the Germans. That's the statement I would like to make here: I don't want always to be addressed as a German, but as a human being . . . Remembrance, yes. But as I said, one shouldn't overdo these things.

"Why Us?"

One of the most disconcerting features of the street names in Burgwedel is their apparent unrelatedness to the new subdivision and to the people living there. Or, as Karsten put it:

This feeling that there is a new, nice, clean housing estate that is designed according to the best knowledge available in the 1990s, with one-story townhouses and single houses and four-story apartment blocks, and then there are such names, and they are a reminder of a rather dark past. This is seemingly a contradiction, and it hangs in the air.

Only three of the interviewees could establish links between the story of the children and their own biographies. Sonja, for example, had lived in Rothenburgsort, in the vicinity of the Bullenhuser Damm school and had regularly attended sports training sessions at the school's gymnasium. Only one interviewee assumed that the names were chosen because the children had been killed in or near Burgwedel. All others had—to very different degrees—been troubled by the question: "Why us? What do we have to do with the children?" It was this question, more than anything else, that set in motion processes of remembering.

For the interviewees, one obvious way out of attempting to deal with that question was to assume that it did not warrant an answer, as there were other residents whose connection to the children was evident. Kerstin, a thirty-four-year-old mother of three, thought it had been a good idea to name the street she lived in after one of the children of Bullenhuser Damm. When the sign for her street was put up, some members of the Association of the Children of Bullenhuser Damm, including relatives of some of the children, had met for a small dedication ceremony. When she noticed the group, she "of course joined them and listened to them." She was clearly interested in the children's story and determined to tell her own children about it. Wondering about how others in Burgwedel might feel about it, she mused:

I don't know what it's like in the large blocks of flats. For there are a lot of foreigners living there. They should be particularly interested. There are Poles, and I think there are also a few Gypsies. And something like this, I would think, should interest them far more urgently than us.

While Kerstin was identifying descendants of the victims of Nazi Germany as a group who should be better able to relate to the story of the children of Bullenhuser Damm (in a move reminiscent of Hermann Siemer's suggestion that Jews in Germany ought to be particularly interested in his initiative to build a memorial for Hildesheim's synagogue; see chap. 4), Thea, the same age as Kerstin and also a mother of small children, approached this issue from the opposite direction. Thea lived in the street named after Jacqueline Morgenstern.

I actually think it's a good idea. On the one hand, I think it's a good idea to remember it. On the other hand, I don't think it's all that good for me that I am constantly reminded of it, because I didn't have anything to do with it . . . Because that always affects me, and because I then think about how terrible that was, and again and again am reminded of how terrible it was. And of what the children must have experienced . . . Our generation has actually got nothing to do with it, but we are now being burdened with it here.

At this stage in the interview, Thea grew very agitated. She continued:

That should be somewhere in an old folks home. That's where such a street [name] should be, I think. Well, I think, it was really tragic; that's why I'm of two minds about it now. And when I read this book [that is, Schwarberg's *Der SS-Arzt und die Kinder*], I became even more affected. And every time, I get [home] and read the name, I think: "The poor girl! What she went through at her age!" And then my children are of that age, and then I project that onto them, how terrible that is.

The remembering that could be triggered by the street names did evidently not depend on whether or not residents approved of the naming of their streets. Torsten, for example, at first articulated a concern shared by several other interviewees:

I think it's good and appropriate that ways and means are found to somewhere remember these events. Be it through memorials, through displays, or otherwise. But I have a problem with the wholesale nam-

ing of streets after victims just because these names are associated with atrocities and they are thereby remembered as victims. As a person affected by it, however, I think it's depressing to be living in a street that's named after a murdered child. You are always confronted by it, and virtually face it and are aware of it all the time.

At this stage in the interview, Torsten changed tack. He hastened to add: "I don't have a problem with that in principle. It's not that I think about it every day. I just think it's generally difficult." Trying to put forward another argument, which would not require a reflection on his own reaction to the street names, he became entangled in the question of how to represent the magnitude of "Auschwitz":

There are far more victims. During National Socialism, tens of millions of people perished, particularly Jews . . . I'm going to exaggerate here: Let's imagine that streets were named after, say, all 4.5 million murdered Jews who are known by name. Then you would have such street names everywhere in Germany. Therefore I don't understand what's so special about these events [at Bullenhuser Damm], why streets are named in relation to them. Do you know what I mean? What's the particular, in quotation marks: "quality of the victims" [*Opferqualität*]? That they were children: that's particularly reprehensible, that's abominable. It goes without saying. But there were children who perished in the concentration camps. Perhaps even in Neuengamme, other children died . . . Therefore I don't quite understand why, in the final analysis, streets are named after these children.

Torsten's question, What's so special about these twenty children, when we could name every single street in Germany after a Jew who perished in the Shoah? is akin to the question, Why does my family have to live in a street named after a victim of Nazi Germany, when nothing distinguishes us from other descendants of the victimizers? Ursula, Thea, and Torsten all grappled with the issue of whether or not they could in some sense be held responsible for what happened to the twenty children, or, more generally, for the crimes committed in the name of Nazi Germany. While Thea tried to dissociate herself from her parents' and grandparents' generations, she did not try to keep the past out of the present. She was genuinely distressed about Jacqueline Morgenstern's murder. And Torsten, while attempting to question the rationality of the decision to name his street after a murdered Jewish child, came to realize the monstrosity of "Auschwitz": there are at least as many victims of the Shoah as there are streets in Germany.

Such flashes of recognition are seemingly triggered by pragmatism. In

1995, a *Tagesspiegel* reader commented on the proposal to commemorate the Shoah by engraving a gigantic memorial plaque with the names of all murdered Jews:

> We are dealing with six million Jews. If each name were engraved in a field of twenty-five by four centimeters, the "memorial slab" would measure 245 by 245 meters . . . If the engraving of a single name took one hour, then six million hours were required. An engraver would take thirty-five hundred years; one hundred engravers would still need thirty-five years. At fifty marks an hour, the costs would amount to 300 million marks.[6]

The new Germany's emerging national identity is based on an acknowledgment of the Nazi past. According to a powerful discourse circulating in the new Germany, the nation's distinctness is no longer merely evidenced by Goethe and other presentable features of the pre-1933 past, but by Auschwitz and Buchenwald, and by tangible manifestations of German acknowledgments of Auschwitz and Buchenwald, such as the Buchenwald *Gedenkstätte* and the new national day of mourning on 27 January. The naming of streets after Jewish children killed by the SS could be seen as another proof that the new Germany acknowledges its past. The naming of the streets in Schnelsen was a protracted and contested affair, Jens recounted.

> But in the end [the proposal] was successful. And I think it's very good that it happened to be us who were affected, as it were. I think that it is also somewhat of an honor to live in these streets. Not something non-committal, meaningless. This is something else, something more meaningful. I think that's good.

Another resident identified the visible evidence of *Vergangenheitsbewältigung* as an asset. Asked whether he found it depressing to live in a street named after the Hornemann children, Andreas, an economist in his early thirties, replied: "No, I don't think that that's depressing. I am rather a bit proud of it that Hamburg has made sure that it becomes known. That such a street name endures for a long time, and will be visible to many."

The street names, Andreas seemed to suggest, were material evidence of a successful engagement with the Nazi past: rather than acting as catalysts for an ongoing process of remembering, they were the product of such a process. In that sense, the *Gedenkstätte* at Bullenhuser Damm could be perceived as another such product. What distinguishes the *Gedenkstätte* from the streets in Burgwedel, however, is its recognized function as a site for public rituals. Every time new streets were named,

Günther Schwarberg, relatives of the murdered children, and other members of the Association of the Children of Bullenhuser Damm met for dedication ceremonies in Burgwedel. And for several years on 20 April, Burgwedel residents tied bunches of flowers to street signs. Such gestures suggested that the street names are more than final products and caused concern among interviewees who prefer to regard the Burgwedel memorial as an endpoint rather than a beginning. Stefanie did not want to deny the relatives' right to conduct dedication ceremonies in Burgwedel: "Personally, I think it's a good idea, if it's possible for the relatives to observe [such occasions]. However, I also think it would be more fitting at the memorial site in the school."

Other interviewees shared Stefanie's belief that the school at Bullenhuser Damm was a more appropriate site for a memorial. It is striking, then, that none of the interviewees visited the school after moving to Burgwedel, although the majority said that they intended to do so one day. The only interviewee who vehemently rejected that idea was sixty-five-year-old Silke, whose late husband had grown up in Rothenburgsort. When she asked him to visit the school, he said, he would rather not, because

> he lived nearby. And he said, "Gosh," he said, "that's truly horrible. So we went to school just a bit further down the road, and there the kids were brutally murdered." He said, "That's not something I want to be reminded of." By the way, my father-in-law was a big Nazi. Not a bad Nazi, but a good one . . . He also socialized with Communists and people like that . . . Well, I would have liked to look at [the memorial at Bullenhuser Damm], but my husband said no, and so I couldn't look at it either.

Maybe the reluctance of some to confront the story of the children at the site of their murder would dissipate if they could indeed regard the *Gedenkstätte* as a finished product to be proud of. One of the two interviewees who did visit the school before moving to Burgwedel was former Rothenburgsort resident Sonja, an accountant in her forties. She appeared to be talking about a beautification of the past as much as about the tangible manifestation of its acknowledgment:

> Years ago, fifteen years ago, this was all pretty dismal: there was only a memorial plaque about the children in the basement [of the school]. Later, the students from the school at Bullenhuser Damm and, I think, also some university students, planted this nice hedge of roses halfway around the school. It looks very nice now, and there is also a nice memorial plaque.

The hedge of roses that Sonja referred to could hardly be mistaken for the rose garden that has been planted in memory of the children. The imagined hedge is the memorial's outward appearance, its packaging. Or was Sonja perhaps thinking not of her own street name but of that of a street in the adjoining subdivision of Schnelsen, which the local Christian Democrats cited when in 1991 proposing names for streets in Burgwedel? Did Sonja stray in her mind from Zylberbergstraße to Dornröschenweg, Sleeping Beauty Lane, when imagining a building enclosed by an impenetrable hedge? In the fairy tale, the past is inaccessible, and because of the hedge enclosing it, it is all but forgotten.

A "Matter of Grasping That Something Like That Happened"

In 1998, I visited Burgwedel on the day before the fifty-third anniversary of the children's murder. It was a Sunday morning when I arrived. As on previous visits, I was struck by the number of young children who were playing in the streets. Red roses and the kind of candles that are usually found on cemeteries were tied to the street signs. Texts with short biographies of individual children were also fixed to the poles. Those taking the initiative to commemorate the children had been careful to identify themselves: "Jusos Eimsbüttel," the texts were marked, informing passers-by that flowers and candles had been put up by members of the Eimsbüttel branch of the SPD's youth organization, Young Socialists. A poster in the window of the local pharmacy advertised an excursion to the *Gedenkstätte* at Bullenhuser Damm. At noon, eleven adults, a teenage girl, and six children met to take the light rail to Rothenburgsort. None of them had been to the *Gedenkstätte* before; a woman who was accompanied by her daughter said that between 1968 and 1972 she had been a student at the Bullenhuser Damm primary school.

A young woman who belonged to both the Association of the Children of Bullenhuser Damm and to the Young Socialists accompanied us. For eight years, she had been conducting guided tours at the *Gedenkstätte*. Entering the building, I remembered how angry I was during my first visit in 1996, and how moved when I visited the *Gedenkstätte* again the following year with Günther Schwarberg and a group of Norwegian high school students. During this current visit, my overwhelming sense was that of embarrassment. Our guide was oblivious to the presence of the children in our group, who very soon were visibly disturbed by what she said. None of them was older than twelve; I could not imagine that any of them comprehended what the guide was telling us. What was it that made this constellation possible: an earnest young woman who armed with a missionary zeal was giving a lecture about the murder of twenty Jewish children; and

a group of Germans, most of them living in streets named after the children, who did not need to be told that the murder of Jewish children was utterly reprehensible but who nevertheless listened dutifully and did not seem to be afraid that their own children would have nightmares for weeks to come?

The next day, 20 April, some two hundred local residents, most of them children, went for a walk through Burgwedel. The walk was organized by a youth club, the local Protestant church, and the local school. Most of the children had brought flowers to lay at the street signs. Some of the thirteen- and fourteen-year-olds attending confirmation classes read texts about individual children. The texts had, however, not been written by them and were repeated by the local pastor, who felt that his charges could not be clearly heard by everybody in the crowd. He was new to the area and had taken the lead also because he wanted to raise the profile of his church. In the evening, the Lachmann Family, a Hamburg-based klezmer band, played at the church. The music was interrupted by short speeches. In one of them, a man who, as I learned later, was active for Amnesty International and the local CDU talked about two thirteen-year-olds, one of them a Kurdish boy killed by the Iraqi police, and the other a Pakistani Christian tried for blasphemy and seriously injured in a bomb that went off when he came out of the courthouse. "It's not over yet," the man said, with the "it" apparently referring to the murders at Bullenhuser Damm. Another speaker talked about neo-Nazis and xenophobia and about the refugees living in a container village next to the Burgwedel housing estate. The pastor concluded the event by saying that everybody, whether Christian or non-Christian, was welcome to come to his church, but that nobody was allowed to leave until after he had blessed the audience. We were all asked to stand when he gave his blessing. Later, at the local pub, I overheard a group of middle-aged men and women remembering another anniversary, the führer's birthday.

The following morning, the commemorations continued with the visit of Shifra Mor at the Red Cross child care center in Burgwedel that was named after her sister, Bluma Mekler, one of the children of Bullenhuser Damm. I wished the children who had two days earlier visited the *Gedenkstätte* could have met the Israeli woman rather than the relentless young German guide. "How did the child die?" a boy of about five wanted to know. "She disappeared in 1943; I don't know." "Did she die when hit by a canon?" "No, she died here in Hamburg, but I wasn't there." "Was she killed with bow and arrow?" "I don't really know how she died. She died in the war." "Was it a big war?" "Very big; a world war." Another boy joined in: "Shifra, how did you look after yourself?" "It was very difficult. I was alone. There were good people, Polish people, who took me in. Enjoy your childhood, don't grow up quickly!"

Fig. 39. Burgwedel, 20 April 1998

Many interviewees were faced with the question of whether or not they should tell their own children about the child after whom their street is named, and if so, how they should go about it. Not many residents would be as determined to make the past part of their family's present as Jens, who put up a picture of Jacqueline Morgenstern in his house and told his children about her. But would his children understand the sense of pride that he developed as a way of coming to terms with living in Jacqueline-Morgenstern-Weg? And to what extent would he allow for the possibility that his children may not be able to understand the events that led to the naming of their street? In that sense, Kerstin, whose oldest child was in grade three at the time of the interview and who had not yet talked to her children about the story, was probably more realistic when she anticipated problems:

> I think that it is difficult to explain that to them. That it is particularly difficult to explain how human beings can do that—to children . . . It is not just a problem for us to get the story across, but also for the children to understand it. In fact there won't be any understanding in that sense; rather it will be a matter of grasping that something like that happened.

Fig. 40. Shifra Mor and children of the Bluma Mekler Child Care Center, Hamburg, 21 April 1998.

Perhaps such apparent helplessness is enabling Germans to face the past and live with the legacy of the Nazi years. Rather than state-sponsored memorials and commemorations, or the work of well-meaning pedagogues, the preparedness of individual Germans such as many of those living in Burgwedel to be touched, to attempt facing the past, and to remember, subverts the notion of a mastering of the past that has been so powerful in both Germanys. Surprisingly many people in Burgwedel did remember the children of Bullenhuser Damm, even if they could not recall specific details about their lives and deaths. They let the past intrude in their lives without assimilating it. Karin talked about the strangeness of the names, and of their propensity, even four years after moving to Georges-André-Kohn-Straße, to have a disconcerting effect, which provoked reflection. "I often go for a walk around here, and I read "Riwka-Herszberg-Stieg" or "Mania-Altmann-Weg", and then I really think about it," Karsten remarked, like so many residents referring to an unnameable "it" rather than to the children.

Of course she would rather live in a street with some innocuous name "where you don't have to become sad every time you write your address." But it was this preparedness to let herself be affected by the name that made Stefanie qualify this statement, saying that she would prefer it if the

event that made the children famous had not occurred. Rather than wishing for a different street name, she now wished for a present built on a different past. Veronika, a thirty-five-year-old mother of four, made a similar point when she said there was nothing depressing about having to face the name of her street, Jacqueline-Morgenstern-Weg, every day: "That something like [the murders] happened, *that* is depressing."

Those interviewees who were reluctant to confront the past were often quick to point out how others did, ought to, or would remember the children of Bullenhuser Damm. Memorials that commemorate aspects of the Nazi past in Germany are often meant to educate or remind others. Thus the projected central *Mahnmal* in Wiesbaden was supposed to have an impact on the citizens of Wiesbaden; those who argued for its construction did not do so because of concerns about their own remembering. Having witnessed Günther Schwarberg telling the story of the children of Bullenhuser Damm to a group of students, however, I am aware that the intention to make others remember could go hand in hand with a remembering. Asked whether she thought a separate monument in Burgwedel could supplement the role performed by the street names, Karin replied:

> I could imagine a scenario whereby once or twice a year we invite people and take them for a walk through these streets. And we tell them the story of the children . . . simply tell their histories. I think that that would be more important in terms of the historiography and in terms of what could move people than to somehow put up a memorial.

Commenting on the memorialization of the story of the children of Bullenhuser Damm, Jürgen, a forty-year-old sales representative, merely appeared to be invoking a cliché: "It is important that this will never be forgotten." But then he added: "Lest something like this happens again in Germany—well, lest something like this happens anywhere in the world, but then I don't have that much influence on [what's happening outside Germany]." Unlike Stefanie, who, when commenting on contemporary xenophobia, conceived of herself as a passive—and innocent—bystander, Jürgen thought of himself as an historical actor. Whether or not the past repeated itself is not a matter of memorials, he suggested, but of one's own active involvement in the present.

Many if not most Germans who are genuinely concerned about addressing the past do so as didactic antifascists or from the position of moral righteousness. When discussing the story of the children of Bullenhuser Damm with a wide range of people in Germany, I initially expected such righteousness also to be articulated by survivors. I was wrong. In 1997, two Neuengamme survivors, Fritz Bringmann and Herbert Schemmel, whom I interviewed separately about the children of Bullenhuser

Damm, and Felicja Zylberberg, aunt of Ruchla Zylberberg, told me a story that seemingly had nothing to do with what I was asking them about. Independently of each other, all three apparently felt that this story was relevant for my research project, even though they did not make the connection explicit. It concerned an incident that had happened in Hamburg not long before my conversations with them and had been widely reported in the local media. A young woman was raped in a suburban train. The rapist was on his own. There were other passengers in the carriage who witnessed the rape but did not intervene.

Matters of Responsibility

The cases explored in *Shifting Memories* are sufficiently diverse to preclude me from drawing neat conclusions about the Nazi past in postwar Germany. To demonstrate the diversity, lack of organic linearity, and local and historical specificity of German attempts to talk—or not to talk—about "Auschwitz," is in fact one of the aims of the book.

On the face of it, *Shifting Memories* is a book about memorials and about public discourses related to them. "[N]o one takes their memorials more seriously than the Germans," James Young observed.[7] They often vigorously debate the size, shape, message, and location of memorials. I have followed some such discussions in detail and referred to many others in passing. I contend that the genealogies of particular memorials provide the easiest avenue to understanding how local communities have collectively and publicly related to the Nazi past.

Individual contributions to such discussions are more than mere components of public discourse. To understand public memories, we need to pay attention to individuals whose contributions help shape such memories. Ideally the "biographies" of particular memorials would be matched with the biographies of individuals involved in debating these memorials—even in instances in which individuals appear only as members of groups such as the AG Beth Shalom in Hildesheim or the Friends of Ravensbrück in Fürstenberg. Ideally, to provide an in-depth understanding of the issues involved in the controversies concerning Wiesbaden's central *Mahnmal,* for example, one would need to write the lives of Günter Retzlaff, Schorsch Buch, Margarethe Goldmann, Heinrich Lessing, and other actors. Such an "ideal" text would be unwieldy; I have made do with repeatedly reminding the reader that references to collectives and publics are often shortcuts—not least by ending *Shifting Memories* with a discussion of individual memories.

Between the second half of the 1940s and the second half of the 1980s, public remembrance in the FRG tended to be nonspecific. "Auschwitz" was vaguely alluded to; the precision of the language of Nelly Sachs, who

in "O the Chimneys" called "the various objects of the extermination camp reality by their names,"[8] was absent from inscriptions on German memorials. Victims and perpetrators, if mentioned at all, were usually referred to summarily. Memorials built in the 1990s are more specific about victims and sometimes name them, while the victimizers are still more often than not hidden beneath terms such as *Gewaltherrschaft* (as at the Neue Wache in Berlin; see chap. 10). I have tried to draw the readers' attention to the discrepancy between Germans' willingness to list the names of victims and their reluctance to name victimizers other than a select few: when telling the story of the children of Bullenhuser Damm, I have not only listed the children's names but also named as many of those implicated in their murder as was feasible.

Prominent perpetrators such as Adolf Eichmann aside, there was little interest in Germany until the 1990s in exploring the biographies of "ordinary Germans" who became victimizers. Research done in the 1990s often focused on woman perpetrators. Female guards and *kapos* were then perhaps considered more ambiguously implicated than their male counterparts and lent themselves more easily to differentiated analyses.[9]

Maybe the cautious exploration of perpetrator biographies could be pushed much further and extended to those of other nonvictims. For a while the discussion about the projected national memorial for the victims of the Shoah centered on the question of how to represent an unimaginable number of names. What if non-Jewish Germans recorded the names of all those who did not become victims? What if people in Hamburg not only volunteered to read out the names listed in the memorial book for the local victims of Nazi Germany (see chap. 6), but also the names listed in the 1943 *Adreßbuch,* the last directory of the heads of all households registered in Hamburg, which was published during the war? The 1943 edition does of course not have a listing for Zylberberg: on the page for names beginning with *Zw* and *Zy,* there are eleven Zwergs, sixteen Zwicks, and nine Zwiebelings; "Zylau, Wilh." is immediately followed by "Zylka, Jos."[10] A reading of these and other names could be a form of remembrance that keeps asking: how could it be that Ruchla Zylberberg was killed? An exploration of the lives of "ordinary Germans," of the Zwicks and Zwiebelings, that is driven by this question could perhaps subvert the all too easy identification of today's Germans with individual victims of Nazi Germany.

I have written this book as somebody who for many years has lived outside Germany but grew up as a non-Jewish German. Hildesheim (where I was born and went to school) and Wiesbaden (where I lived intermittently between the late 1970s and early 1990s) were obvious case studies not just because I knew more about these towns than about others, but because it seemed disingenuous to bypass them (and thereby part of my

own history). As somebody who grew up in Germany, I have views on how Germans remember the Nazi past, if only because I ask myself: how can and do I remember this past? While I can hardly avoid sharing some of these views with the reader, I have tried to avoid as much as possible exposing others as a means of keeping the past out of my present. An awareness of the extent to which such sidestepping maneuvers have shaped public discourses about the Nazi past (as I tried to show in chapters 5 and 9) has made me take recourse to the power of quotations. Readers expecting more explicit statements from an author may forgive me.

I offered a brief history of dominant East German discourses about the Nazi past but evaded doing the equivalent for West Germany. I hope that a broad pattern—commemorative activities organized by survivors until about 1949, followed by nearly three decades of comparative silence, and an awakening from about 1979 in the wake of *Holocaust* and the 1978–79 debate about the statute of limitations—became visible in the chapters dealing with Salzgitter, Hildesheim, Celle, Hamburg, and Wiesbaden. I also tried to show how the different approaches to the Nazi past in the GDR and in the old FRG have had a legacy in post-Reunification Germany.

But *Shifting Memories* is about public memories in Germany, rather than about German memories. I have been concerned with national histories primarily in order to locate and contextualize local histories, rather than used locally specific cases to explicate broader trends. When writing about Salzgitter, Celle, Hildesheim, Wiesbaden, Hamburg, Weimar, and Fürstenberg, I have been interested in more than just the local memories of the Nazi past. I have tried to show that accounts of such remembrance can be usefully juxtaposed with seemingly unrelated local histories: in Hildesheim, with the history of the rebuilding of the Knochenhaueramtshaus; in Fürstenberg, with an account of the death of the Baer brothers; in Salzgitter, with a narrative about the dismantling of the Reichswerke plants. Such juxtapositions are fruitful not least because local anxieties about how to approach the Nazi years have regularly been embedded in concerns about how to fashion local identities and create images for outside audiences.

When writing the biographies of particular memorials, I talked at some length about their subject matter: thus I provided some detail about the role of slave labor in the establishment of Salzgitter and wrote about the murders of 20 April 1945, to give but two examples. Other histories that I felt needed to be told concern long-forgotten instances when non-Jewish Germans were brought face-to-face with the horror they allegedly knew nothing about (as on 12 April at Heidekaserne in Celle, or on 16 April 1945 in Buchenwald) and attempts to commemorate the victims of Nazi Germany in the immediate postwar years. These attempts—and the

fact that they preceded attempts to commemorate the victims of the Allied bombing—were largely forgotten in the 1990s. They often failed: in Celle and Salzgitter, memorials were planned but never built; in Hildesheim, a memorial (erected by Italian survivors) disappeared without trace. *Shifting Memories* is deliberately anti-Whiggish in that it pays particular attention to these and similar dead ends of history.

German attempts to memorialize the Nazi past differ depending on the extent to which the past is thereby kept out of the present. In the 1990s, memorial projects were often intended to make people face the past in the present by focusing on "authentic sites." But the demarcation of sites of persecution could have the effect of isolating the Nazi past from the everyday of the present. And a yearning for access to an authentic past appeared often related to a narcissist yearning to experience *Betroffenheit* in the face of this past. *Betroffenheit* is concerned foremost with one's self; listening with *Betroffenheit* to the plight of others tends to become a means of exploring one's own subjectivity.

But in the 1990s many Germans did listen to survivors, and they often listened with respect, recognizing "a duty to the story of the other."[11] Such a listening became possible also because many survivors were, after four or five decades of silence, willing to share their experiences, even with the victimizers' descendants. The story of how Germans have related to the Nazi past could not be written without taking into account the disruptive effects the voices of survivors have had on the self-centered public discourses of the victimizers' society.

Shifting Memories is an attempt to address the issue of "Auschwitz" in a roundabout way: by writing about how "Auschwitz" has been publicly remembered. Such a writing strategy assumes that the historical phenomenon "Auschwitz" did not altogether end on 8 May 1945. Not only does it recur in the nightmares of survivors; its traces also resurfaced in the accounts collected by Hanna Fueß in the district of Celle, in statements made by Salzgitter's civic leaders about pioneering, and in stories told by Wiesbaden residents, on the quiet, about why the city funded the Sinti memorial.

Since 1945, Germans have often assumed that for them the main issue arising out of "Auschwitz" was that of guilt. But the question "Are you guilty?" never made sense except when related to personal behavior. And the further "Auschwitz" appears to be removed in time, the easier it has become to reject the past's intrusion into the present by declaring oneself not guilty. But, as Hannah Arendt noted in 1950 (see chap. 2), the crucial issue is that of responsibility, rather than that of guilt. By retreating into an indifferent silence (or by keeping up a chatter about the crimes of Nazi Germany), by making heroes out of members of the antifascist German resistance (or by vilifying them on account of their political beliefs), by not

listening to survivors (or by listening to them only in order to hear one's own heartbeat), and by designing elaborate tombstones (or by neglecting to look after existing cemeteries), Germans have attempted to bury "Auschwitz." They may have thereby hoped to escape from responsibility.

At the beginning of the twenty-first century, the vast majority of Germans cannot accept individual responsibility for anything that happened before 1945: they were simply too young or, in most cases, not yet born. Their responsibility can only extend to the postwar traces and legacies of Auschwitz, to a commitment to grapple with what the overwhelming majority of those listed in a 1943 *Adreßbuch* did (and act differently if the situation ever demanded it—in suburban trains, or elsewhere). More so than a responsibility for, it could (still) be a responsibility to: to the survivors. Accepting responsibility also means letting the past, however unsettling it may be, intrude into the present. When moving to Burgwedel in early 1995, Peter, a forty-year-old clerk, had expected that the novelty of the street names would quickly wear off:

> But I noted that I reflect on it every now and again, perhaps also because occasionally I outline to strangers the background to the street names. So it has a lasting effect. And if that did not happen just to me but to others in this neighborhood, then that would already be something positive.

Glossary

AG	*Arbeitsgemeinschaft* (association; working group)
AIN	Amicale Internationale de Neuengamme
Asoziale	antisocial elements; *Asoziale* were imprisoned in concentration camps and marked by a black triangle; the term has strong derogatory connotations and is still used frequently in Germany to refer to the homeless
Ausländerfriedhof	cemetery for foreigners
Betriebsrat	council representing workers vis-à-vis the management
Betroffenheit	dismay; consternation
BRD	Bundesrepublik Deutschland (Federal Republic of Germany)
CDU	Christlich-Demokratische Union (Christian Democratic Party)
Denkmal	memorial
DKP	Deutsche Kommunistische Partei (German Communist Party; established in 1968 as a KPD-successor in the FRG)
Dokumentationsstätte	memorial museum
DPs	displaced persons
Drittes Reich	Third Reich
Ehrenfriedhof	"cemetery of honor" (the term is now often used for cemeteries accommodating victims of Nazi Germany)
Ehrenmal	memorial
Ewiggestriger	person wedded to the past
Faschismus	fascism

FRG	Federal Republic of Germany
Gau	district (administrative district run by a *Gauleiter*)
Gauforum	architectural complex to accommodate offices of the NSDAP and affiliated organizations in the capital of a *Gau*
Gauleiter	Nazi regional chief
GDR	German Democratic Republic
Gedenkstätte	memorial
Gewaltherrschaft	tyranny (term frequently used in postwar Germany to refer to Nazi rule)
Halbjude/Halbjüdin	term used in Nazi Germany to refer to a man/woman with one Jewish and one non-Jewish parent
Hasenjagd	hare hunt
IG Metall	Industriegewerkschaft Metall (metalworkers union in the FRG)
ILK	Internationales Lagerkomitee (International Camp Committee; clandestine organization of Buchenwald prisoners)
Jagdszene	hunting scene
judenrein	cleansed of Jews (term used by the Nazis to denote the absence of Jews from a particular area due to their emigration or deportation)
Kaninchen	term used to refer to women who were mutilated in the course of "medical" experiments in Ravensbrück Concentration Camp; derived from: *Versuchskaninchen* (guinea pigs)
Kapo	prisoner appointed to head a group of fellow prisoners
KPD	Kommunistische Partei Deutschlands (Communist Party of Germany; founded in 1919, reestablished in 1945, banned in the Federal Republic in 1956)
Kriegsgräberstätte	war cemetery
Kristallnacht	Germany-wide pogrom on 9 and 10 November 1938 (also: *Reichskristallnacht*)
KZ	*Konzentrationslager* (concentration camp)
KZ-Leute	Term used in the 1940s to denote inmates or liberated prisoners of a concentration camp

Landkreis	district (administrative unit)
Landrat	head of the administration of a *Landkreis*
Machtergreifung	seizure of power; the 1933 Nazi take-over of the German government (also: *Machtübernahme*)
mahnen	to warn; to remind; to admonish
Mahnmal	memorial
Mahn- und Gedenkstätte	memorial
Mitbürger	fellow citizen
Nationalsozialismus	National Socialism
NSDAP	Nationalsozialistische Deutsche Arbeiterpartei (National Socialist German Workers' Party)
Oberlandesgericht	provincial high court and court of appeal
Oberstadtdirektor	head of a municipal administration
OdF	*Opfer des Faschismus* (victim of fascism)
Ostarbeiter	forced laborers from the Soviet Union who worked in Germany between 1941 and 1945
P+S	Peine + Salzgitter AG (state-owned company, successor to Salzgitter AG, created in 1970 through the merging of companies owning steelworks in Salzgitter and Ilsede, taken over by Preussag AG in 1989)
RAD	Reichsarbeitsdienst (organization in charge of compulsory labor service in Nazi Germany)
Ruhe	peace; quiet; silence
SA	Sturmabteilungen (storm troopers; NSDAP paramilitary organization)
SED	Sozialistische Einheitspartei Deutschlands (Socialist Unity Party of Germany; established in 1946 through amalgamation of SPD and KPD in East Germany)
SPD	Sozialdemokratische Partei Deutschlands (Social Democratic Party of Germany)
Speziallager	internment camp in East Germany run by the Soviet Union's Ministry of the Interior between 1945 and 1950
SS	Schutzstaffel (Nazi guard corps; initially NSDAP paramilitary organization)
Stasi	Staatssicherheitsdienst (GDR intelligence and internal security service)

Verfassungsschutz	(Office for the) Protection of the Constitution (FRG intelligence and internal security service)
Vergangenheitsbewältigung	coming to terms with the past; mastering the past
Volksbund Deutsche Kriegsgräberfürsorge	Association for the Maintenance of German War Cemeteries
Volksgemeinschaft	national community
Volkshochschule	institute of adult education, funded by a municipal or district administration
Volkstrauertag	Remembrance Day
VVN	Vereinigung der Verfolgten des Naziregimes; from 1971, VVN/BdA (Bund der Antifaschisten; Confederation of Antifascists)
Wehrmacht	German army (1935–45)
Werwolf	werewolf
Widerstand	resistance; opposition
würdig	dignified
Zentralrat der Juden in Deutschland	Central Council of Jews in Germany
Zigeuner	Gypsy (term often used to refer to both Sinti and Roma people; term can have derogatory connotations)

Notes

Abbreviations used in the Notes

CZ *Cellesche Zeitung,* Celle
FAZ *Frankfurter Allgemeine Zeitung,* Frankfurt am Main
GS Sammlung Günther Schwarberg, Archiv KZ-Gedenkstätte
 Neuengamme, Hamburg
HAZ *Hildesheimer Allgemeine Zeitung,* Hildesheim
HF Sammlung Hanna Fueß (T 142), Stadtarchiv Celle
NdsHSA Niedersächsisches Hauptstaatsarchiv, Hannover and Pattensen
STACe Stadtarchiv Celle
StAHi Stadtarchiv Hildesheim
SK *Salzgitter-Kurier,* Salzgitter
StAWi Stadtarchiv Wiesbaden
SZ *Salzgitter-Zeitung,* Salzgitter
WB Benz, Wolfgang, ed. *Salzgitter: Geschichte und Gegenwart einer*
 deutschen Stadt 1942–1992. München. C. H. Beck, 1992.
WK *Wiesbadener Kurier,* Wiesbaden
WT *Wiesbadener Tagblatt,* Wiesbaden

Introduction

1. Quoted from Abba Kovner and Nelly Sachs, *Selected Poems* (Harmondsworth: Penguin, 1971), 79. Suhrkamp Verlag's and Michael Roloff's permissions to quote the translation are gratefully acknowledged.

2. Andreas Huyssen, *Twilight Memories: Marking Time in a Culture of Amnesia* (New York: Routledge, 1995), 8.

3. Büro für architekturbezogene Kunst Berlin, "Arbeitsunterlagen für den Wettbewerb für eine Denkmalsanlage über das Wirken jüdischer Bürger in Berlin, zum Gedenken an ihre Verfolgung und zur Würdigung ihres Widerstandes" (1988), courtesy of Karl Biedermann. For this and the following, taped interview with Karl Biedermann, Berlin, 3 June 1998 (interviewer: Linde Apel).

4. "Wettbewerb 'Koppenplatz'—Bemerkungen zum Entwurf der Teilnehmernummer 101225" (1989), courtesy of Karl Biedermann, emphasis added.

5. Sabine Sülflohn, "Eine zutiefst öffentliche Angelegenheit," *Neue Zeit,* 21 Oct. 1989.

6. "Ein Zeichen für die Hast, mit der die Nachbarn gemordet wurden," *Berliner Abendblatt,* 9 Oct. 1996.

7. Robert Musil, *Posthumous Papers of a Living Author,* trans. Peter Wortsmann (Hygiene: Eridanos Press, 1987), 61.

8. Jochen Gerz, *2146 Steine: Mahnmal gegen Rassismus Saarbrücken* (Stuttgart: Gerd Hatje, 1993). Timm Ulrichs is another contemporary artist whose memorials are seemingly deliberately hidden from view; see Timm Ulrichs, "Anwesend abwesend and abwesend anwesend: Vorstellungen zur Situation der Denkmalskunst," in *Deutsche Nationaldenkmale 1790–1990,* ed. Sekretariat für kulturelle Zusammenarbeit nichttheatertragender Städte und Gemeinden in Nordrhein-Westfalen, Gütersloh (Bielefeld: Verlag für Regionalgeschichte, 1993), 174–81.

9. Hubertus Adam, "Bestimmtheit, Unbestimmtheit, Unsichtbarkeit: Wirkungen und Wirkungsweisen neuester NS-Mahnmäler," in *Denkmäler: Ein Reader für Unterricht und Studium,* ed. Eberhard Grillparzer, Günter Ludig, and Peter Schubert (Hannover: Bund Deutscher Kunsterzieher, 1994), 36.

10. "Ehrenmal am Schloß verschmiert"; and "Propagandistischer Kraftakt der jungen Nationaldemokraten in der Fußgängerzone," *CZ,* 16 May 1977.

11. Klaus Neumann, "Cropped Images," *Humanities Research* 2, no. 1 (1998): 24–27; compare Heinz Dieter Kittsteiner, "Überlegungen zum Denkmal," in *Der Angriff der Gegenwart auf die Vergangenheit: Denkmale auf dem Gelände ehemaliger Konzentrationslager,* ed. Detlef Hoffmann (Loccum: Evangelische Akademie Loccum, 1996), 93–101.

12. Walter Benjamin, *One-Way Street and Other Writings,* trans. Edmund Jephcott and Kingsley Shorter (London: Verso, 1997), 360.

13. Quoted in Walter Benjamin, "N [Theoretics of Knowledge; Theory of Progress]," trans. Leigh Hafrey and Richard Sieburth, *Philosophical Forum* 15, nos. 1–2 (1983): 18.

14. Walter Benjamin, *Illuminations,* ed. Hannah Arendt, trans. Harry Zohn (New York: Schocken, 1969), 257–58. Benjamin scholars, most of whom would disagree with my idiosyncratic reading of the painting and of the ninth thesis, may forgive me for not engaging here with their interpretations.

15. Such an argument often invokes the Borgesian figure of Funes the Memorious: Jorge Luis Borges, *Labyrinths: Selected Stories and Other Writings,* trans. James E. Irby (London: Penguin, 1970), 87–95.

16. Peter Brückner, *Versuch, uns und anderen die Bundesrepublik zu erklären* (Berlin: Klaus Wagenbach, 1978), 7–10. See also Fritz Hermanns, "Brisante Wörter: Zur lexikographischen Behandlung parteisprachlicher Wörter und Wendungen in Wörterbüchern der deutschen Gegenwartssprache," in *Studien zur neuhochdeutschen Lexikographie II,* ed. Herbert Ernst Wiegand (Hildesheim: Georg Olms, 1982), 88.

17. See Gerhard Strauß, Ulrike Haß, and Gisela Harras, *Brisante Wörter von Agitation bis Zeitgeist: Ein Lexikon zum öffentlichen Sprachgebrauch* (Berlin: Walter de Gruyter, 1989), 151–70.

18. For the following, see James E. Young, *Writing and Rewriting the Holocaust: Narrative and the Consequences of Interpretation* (Bloomington: Indiana University Press, 1988), 85–89; Norbert Frei, "Auschwitz und Holocaust: Begriff und Historiographie," in *Holocaust: Die Grenzen des Verstehens: Eine Debatte über die Besetzung der Geschichte,* ed. Hanno Loewy (Reinbek: Rowohlt Taschenbuch Verlag, 1992), 101–5; Matthias Heyl, "Von den Metaphern und der geteilten Erinnerung—Auschwitz, Holocaust, Schoah, Churban, 'Endlösung,'" in *Die Gegenwart der Schoah: Zur Aktualität des Mordes an den europäischen Juden,* ed. Helmut Schreier and Matthias Heyl (Hamburg: Krämer, 1994), 11–32; Omer Bartov, *Murder in Our Midst: The Holocaust, Industrial Killing, and Representation* (New York: Oxford University Press, 1996), 56–60; Annegret Ehmann, "Über Sprache, Begriffe und Deutungen des nationalsozialistischen Massen- und Völkermords: Aspekte des Erinnerns," in *Praxis der Gedenkstättenpädagogik: Erfahrungen und Perspektiven,* ed. Annegret Ehmann et al. (Opladen: Leske + Budrich, 1995), 75–87.

19. Constantin Goschler, *Wiedergutmachung: Westdeutschland und die Verfolgten des Nationalsozialismus (1945–1954)* (Munich: R. Oldenbourg, 1992), 87.

20. For the so-called "forgotten victims," see, for example, Projektgruppe für die vergessenen Opfer des NS-Regimes in Hamburg e.V., ed., *Verachtet—verfolgt—vernichtet—zu den "vergessenen" Opfern des NS-Regimes,* 2d ed. (Hamburg: VSA, 1988).

21. Peter Dudek, "'Vergangenheitsbewältigung': Zur Problematik eines umstrittenen Begriffs," *Aus Politik und Zeitgeschichte* B1–2/92 (1992): 44–53.

22. See Eckhard Henscheid, *Dummdeutsch: Ein Wörterbuch* (Stuttgart: Philipp Reclam jun., 1993), 39–43. In his dictionary of German newspeak, Henscheid devoted the second-longest entry to the word *Betroffenheit,* reflecting the prominence of the term in West German political culture since the early 1980s.

23. Hannah Arendt, *Men in Dark Times* (London: Jonathan Cape, 1970), 204.

24. Victor Klemperer, *LTI: Notizbuch eines Philologen* (Leipzig: Philipp Reclam jun., 1947).

25. Benjamin, "N" (see n. 13), 5.

26. Benjamin, *One-Way Street* (see n. 12), 95.

27. Quoted in Regina Scheer, *Die dünne Kruste unter dem Denkmal,* radio feature first broadcast on the *Kulturtermin* program, Sender Freies Berlin III, 14 April 1997.

28. A review that did justice to the scope and richness of the relevant literature could in itself fill a book. I limit myself to mentioning a few English-language titles that would prove useful background reading for anybody interested in further contextualizing the partial and specific observations offered in *Shifting Memories.* Charles Maier's *The Unmasterable Past: History, Holocaust, and German National Identity* (Cambridge: Harvard University Press, 1988) unravels issues of postwar German *Vergangenheitsbewältigung* by analyzing the historians' controversy. Eric L. Santner provides a fascinating psychoanalytical reading of these same issues in his study of postwar German films: *Stranded Objects: Mourning, Memory, and Film in Postwar Germany* (Ithaca: Cornell University Press, 1990).

Ian Buruma with *Wages of Guilt: Memories of War in Germany and Japan* (London: Jonathan Cape, 1994) and Jane Kramer with *The Politics of Memory: Looking for Germany in the New Germany* (New York: Random House, 1996) offer less academic and more polemical (but nevertheless astute) observations. As a text about the commemoration of the Shoah, James E. Young's *The Texture of Memory: Holocaust Memorials and Meaning* (New Haven: Yale University Press, 1993) is unsurpassed, despite some factual errors in the section on Germany. For other inspiring texts see the select bibliography at the end of this book.

29. Notable exceptions are Harold Marcuse, "Nazi Crimes and Identity in West Germany: Collective Memories of the Dachau Concentration Camp, 1945–1990," Ph.D. diss., University of Michigan, 1992; and Daphne Berdahl, *Where the World Ended: Transition and Identity in the German Borderland* (Berkeley: University of California Press, 1999). There are numerous such ethnographic studies in German; see, for example, Franziska Becker, *Gewalt und Gedächtnis: Erinnerungen an die nationalsozialistische Verfolgung einer jüdischen Landgemeinde* (Göttingen: Schmerse, 1994); and Peter Engelbrecht, *Touristenidylle und KZ-Grauen: Vergangenheitsbewältigung in Pottenstein* (Bayreuth: Rabenstein, 1997).

30. Compare Lynn Rapaport, *Jews in Germany after the Holocaust: Memory, Identity, and Jewish-German Relations* (Cambridge: Cambridge University Press, 1997), 43–66.

31. One of the most blatant attempts to bury a Jewish past took place in Frankfurt, a comparatively worldly city in a comparatively liberal state, where in 1987 the local authorities called in the police to remove Jewish protesters who were unsuccessfully trying to prevent the destruction of the remains of Frankfurt's medieval Jewish ghetto. See Roswitha Nees and Dieter Bartetzko, eds., *Stationen des Vergessens: Der Börneplatz-Konflikt* (Frankfurt am Main: Jüdisches Museum, 1992).

32. The most up-to-date register of such memorials covers only West Germany: Ulrike Puvogel and Martin Stankowski with Ursula Graf, *Gedenkstätten für die Opfer des Nationalsozialismus: Eine Dokumentation,* 2d ed., vol. 1 (Bonn: Bundeszentrale für Politische Bildung, 1995). See also <http://www.dhm.de/ausstellungen/ns_gedenk/e/index.html> for an English-language list of all major "memorial museums for the victims of National Socialism in Germany."

33. See, for example, Sigrid Meuschel, "The Search for 'Normality' in the Relationships between Germans and Jews," *New German Critique* 38 (1986): 39–56.

Chapter 1

1. Wolfgang Bittner and Andreas Baier, *Salzgitter: Eine deutsche Geschichte* (Salzgitter: Stadt Salzgitter, 1992), [52].

2. Salzgitter is one of three German cities that were created this century to provide living quarters for the workers of newly established large industrial complexes; the other two are Wolfsburg in Lower Saxony, which was founded in 1938 to serve the Volkswagen factory, and Stalinstadt—amalgamated with nearby Fürstenberg/Oder in 1961 to create the new city of Eisenhüttenstadt—in Branden-

burg, which was established in 1950 to serve a steelworks. For comparisons, see Susanne Fritzsche, "Stadtgründungen im 20. Jahrhundert—Salzgitter im internationalen Vergleich," in WB, 233–80; Erhard Forndran, *Die Stadt- und Industriegründungen Wolfsburg und Salzgitter: Entscheidungsprozesse im nationalsozialistischen Herrschaftssystem* (Frankfurt am Main: Campus, 1984); and Christian Schneider, *Stadtgründung im Dritten Reich: Wolfsburg und Salzgitter: Ideologie, Ressortpolitik, Repräsentation* (Munich: Heinz Moos, 1979).

 3. See, also for the following, Heinz Kolbe, "Eisenerz-Bergbau im Salzgittergebiet," in WB, 574–88; Rainer Haus, *Lothringen und Salzgitter in der Eisenerzpolitik der deutschen Schwerindustrie von 1871–1940* (Salzgitter: Archiv der Stadt Salzgitter, 1991); and Matthias Riedel, "Gründung und Entwicklung der Reichswerke 'Hermann Göring' und deren Position in der Wirtschaftspolitik des Dritten Reiches 1935–1945," in WB, 41–77.

 4. See Matthias Riedel, *Eisen und Kohle für das Dritte Reich: Paul Pleigers Stellung in der NS-Wirtschaft* (Göttingen: Musterschmidt, 1973). The full name of the company set up in 1937 was Reichswerke Aktiengesellschaft für Erzbergbau und Eisenhütten "Hermann Göring." Its expansion, during which the company repeatedly changed its corporate form, has been traced in August Meyer, *Das Syndikat: Reichswerke "Hermann Göring"* (Braunschweig: Steinweg, 1986); Gerhard Th. Mollin, "Das Imperium der Reichswerke 'Hermann Göring' im deutsch beherrschten Europa 1938–1945," in WB, 92–110; and Gerd Wysocki, *Arbeit für den Krieg: Herrschaftsmechanismen in der Rüstungsindustrie des "Dritten Reiches": Arbeitseinsatz, Sozialpolitik und staatspolizeiliche Repression bei den Reichswerken "Hermann Göring" im Salzgitter-Gebiet 1937/38 bis 1945* (Braunschweig: Steinweg, 1992), 27–35. In the following, *Reichswerke* refers to the corporation's operations in the Salzgitter area, unless stated otherwise.

 5. Wysocki, *Arbeit für den Krieg* (see n. 4), 69.

 6. Gudrun Pischke, *"Europa arbeitet bei den Reichswerken": Das nationalsozialistische Lagersystem in Salzgitter* (Salzgitter: Archiv der Stadt Salzgitter, 1995), 65.

 7. Ibid., 84–88; Wysocki, *Arbeit für den Krieg* (see n. 4), 67–82. For an overview of the role of non-German forced laborers in the German war economy, see Ulrich Herbert, *Fremdarbeiter: Politik und Praxis des "Ausländer-Einsatzes" in der Kriegswirtschaft des Dritten Reiches* (Berlin: J. H. W. Dietz Nachf., 1985).

 8. Pischke, *Europa* (see n. 6), 111–19; see also Brunello Mantelli, "Von der Wanderarbeit zur Deportation: Die italienischen Arbeiter in Deutschland 1938–1945," in *Europa und der "Reichseinsatz": Ausländische Zivilarbeiter, Kriegsgefangene und KZ-Häftlinge in Deutschland 1938–1945,* ed. Ulrich Herbert (Essen: Klartext, 1991), 51–89.

 9. Pischke, *Europa* (see n. 6), 168–82.

 10. The steel used to construct the steelworks in Salzgitter would have apparently been sufficient for some seven thousand tanks: Rainer Haus, "Das Salzgitter-Erz in der Rohstoffpolitik der deutschen Montanindustrie zwischen Versailler Vertrag und Gründung der Reichswerke," in WB, 40.

 11. Riedel, "Gründung und Entwicklung" (see n. 3), 77; Mollin, "Das Imperium der Reichswerke" (see n. 4), 92.

12. Wysocki, *Arbeit für den Krieg* (see n. 4). For a summary of Wysocki's argument, see Gerd Wysocki, "Arbeit, Sozialpolitik und staatspolizeiliche Repression bei den Reichswerken 'Hermann Göring' in Salzgitter: Forschungsergebnisse des Projektes 'Arbeit für den Krieg,'" in *Konzentrationslager und deutsche Wirtschaft 1939–1945,* ed. Hermann Kaienburg (Opladen: Leske + Budrich, 1996), 113–25.

13. Marie-Luise Recker, "Das Leben in der neuen Stadt: Zwischen sozialpolitischem Anspruch und sozialer Realität," in WB, 161; Christian Schneider, "Stadt-Bau Salzgitter 1937–1990," in WB, 194–95.

14. Beatrix Herlemann, "Verweigerung, Opposition, Widerstand unter den Arbeitern der Reichswerke," in WB, 141; Gerhard Wysocki, *Die Geheime Staatspolizei im Land Braunschweig: Polizeirecht und Polizeipraxis im Nationalsozialismus* (Frankfurt am Main: Campus, 1997), 130–67. See also, Wysocki, *Arbeit für den Krieg* (see n. 4), 138–40; Pischke, *Europa* (see n. 6), 243–64. On *Arbeitserziehungslager* in general, see Detlef Korte, *"Erziehung" ins Massengrab: Die Geschichte des "Arbeitserziehungslagers Nordmark" Kiel Russee 1944–1945* (Kiel: Neuer Malik Verlag, 1991), 32–43.

15. See Pischke, *Europa* (see n. 6), 243–90. According to Pischke (288–89), prisoners from Buchenwald Concentration Camp who worked in the iron ore mines were briefly accommodated in a fourth satellite camp, Haverlahwiese, in summer 1944.

16. For the Drütte camp, see ibid., 272–81; Gerd Wysocki, *Häftlinge in der Kriegsproduktion des "Dritten Reiches": Das KZ Drütte bei den Hermann-Göring-Werken in Watenstedt-Salzgitter Oktober 1942 bis April 1945* (Salzgitter: Arbeitskreis Stadtgeschichte e.V., 1986); Gerd Wysocki, "Das Konzentrationslager Drütte: Sklavenarbeit für die Reichswerke," in WB, 115–30.

17. For this and the following, see Pischke, *Europa* (see n. 6), 292–94; Gerd Wysocki, *Zwangsarbeit im Stahlkonzern: Salzgitter und die Reichswerke "Hermann Göring" 1937–1945* (Braunschweig: Magni-Buchladen, 1982), 184–92; "Neues Mahnmal im 'Jammertal' errichtet," *SZ,* 5 July 1975; "Friedhof Jammertal ist neu gestaltet," *SZ,* 11 Oct. 1977.

18. For the following, see "Ehrenmalweihe in Lebenstedt," *Braunschweiger Zeitung,* 24 Sept. 1946; "'Vergeßt nie, daß wir zusammengehören,'" *Jüdisches Gemeindeblatt für die Britische Zone,* 9 June 1948; "Morgen Denkmalsweihe," *Norddeutsche Zeitung,* 8 Oct. 1949.

19. *Stadtplan Salzgitter mit Umgebungskarte: Straßenverzeichnis: Mit Postleitzahlen,* 5th ed. (Hamburg: Falk-Verlag [1996]).

20. For a (celebratory) history of the VVN, see Ulrich Schneider, *Zukunftsentwurf Antifaschismus: 50 Jahre Wirken der VVN für "eine neue Welt des Friedens und der Freiheit"* (Bonn: Pahl-Rugenstein, 1997). In 1971, the VVN changed its name to Vereinigung der Verfolgten des Naziregimes/Bund der Antifaschisten (Confederation of Antifascists) (VVN/BdA).

21. Of 12,119 survivors in Hamburg who by March 1947 had been recognized as former political prisoners, 6,469 had been members of the KPD or affiliated organizations; of the former about two-thirds were then also members of the VVN. Of the fifteen-member VVN executive in February 1948, four were Com-

munists: Wolf-Dietrich Schmidt, "'Wir sind die Verfolgten geblieben': Zur Geschichte der Vereinigung der Verfolgten des Naziregimes (VVN) in Hamburg 1945–1951," in *Das andere Hamburg: Freiheitliche Bestrebungen in der Hansestadt seit dem Spätmittelalter,* ed. Jörg Berlin (Cologne: Pahl-Rugenstein, 1981), 343–44.

22. Regina Hennig, *Entschädigung und Interessenvertretung der NS-Verfolgten in Niedersachsen 1945–1949* (Bielefeld: Verlag für Regionalgeschichte, 1991), 87–88.

23. Reinhard Försterling, "Neubeginn politischen Lebens nach 1945: Parteigründungen und Wahlen," in WB, 341. Breitscheid's popularity in 1945–46, and also later in official GDR histories, had to do with his promotion of a popular front in the 1930s; see Maoz Azaryahu, *Von Wilhelmplatz zu Thälmannplatz: Politische Symbole im öffentlichen Leben der DDR,* trans. Kerstin Amrani and Alma Mandelbaum (Gerlingen: Bleicher, 1991), 192.

24. This and the following is based on conversations with Heinz and Lotte Mannel on 10 and 12 April 1997 in Salzgitter.

25. Herlemann, "Verweigerung" (see n. 14), 132–33; Astrid Lehr, Martina Markus, Bernhild Vögel, and Gerd Wysocki, *50 Jahre Arbeitskraft für den Salzgitter-Konzern* (Salzgitter: Arbeitskreis Stadtgeschichte e.V., 1987), 24.

26. For the following, see Jörg Leuschner, Astrid Voß, and Sigrid Lux, eds., *Die Demontage der Reichswerke (1945–1951)* (Salzgitter: Archiv der Stadt Salzgitter, 1990); Horst Thum, "Betriebsräte und Gewerkschaften 1945–1952," in WB, 358–87; Rainer Schulze, "Salzgitter aus britischer Sicht: Besatzungszeit und Besatzungspolitik 1945–1950/51," in WB, 325–34; and Lehr et al., *50 Jahre Arbeitskraft* (see n. 25), 8–10.

27. Försterling, "Neubeginn politischen Lebens" (see n. 23), 355–57.

28. Schulze, "Salzgitter aus britischer Sicht" (see n. 26), 322; see also Hendrik Gröttrup, "Die zweite Stadtgründung im Spannungsfeld Bund—Land—Kommune—Konzern: Die finanzielle Erstausstattung: Anspruch und Realisierung 1949–1969," in WB, 752 n. 72.

29. Juliane Wetzel, "Die Barackenstadt: Arbeit und Leben im Lageralltag," in WB, 309; Schulze, "Salzgitter aus britischer Sicht" (see n. 26), 331–34.

30. Wolfgang Benz, "Vom Nationalsozialismus zur Bundesrepublik: Salzgitter als exemplarische Stadtgründung im 20. Jahrhundert," in WB, 18; see also Jürgen Peters, "Warum Heinrich Heine an Salzgitter vorbeifuhr: 50 Jahre IG Metall Salzgitter—Symbol des Widerstandes," in *Von außen gesehen: IGM Salzgitter* (Salzgitter: IG Metall Verwaltungsstelle Salzgitter, 1998), 162.

31. Quoted in Jörg Leuschner, "Die Märzunruhen in den Reichswerken," in Leuschner, Voß, and Lux, *Die Demontage der Reichswerke* (see n. 26), 132–33.

32. See Klaus Peter Wittemann, *Kommunistische Politik in Westdeutschland nach 1945: Der Ansatz der Gruppe Arbeiterpolitik: Darstellung ihrer grundlegenden politischen Auffassungen und ihrer Entwicklung zwischen 1945 und 1952* (Hannover: SOAK, 1977). For the Arpo in Salzgitter, see ibid., 223–51; Astrid Voß et al., "Die Anfänge von Arbeiterorganisationen in Watenstedt-Salzgitter," in Leuschner, Voß, and Lux, *Die Demontage der Reichswerke* (see n. 26), 158–70; and Ralf

Bergmann, *Stahl oder Rüben: Die Entwicklung der Industriegewerkschaft Metall in Salzgitter nach dem Zweiten Weltkrieg* (Marburg: SP-Verlag N. Schüren, 1990), 45–49.

33. In the 1950s and 1960s, the trade unions were otherwise little interested in engaging with the Nazi past, possibly because this would have entailed a reflection on their own questionable stance in the 1930s; see Heinrich Potthoff, "Die Auseinandersetzung der SPD und der Gewerkschaften mit dem NS-System und dem Holocaust," in *Schwieriges Erbe: Der Umgang mit Nationalsozialismus und Antisemitismus in Österreich, der DDR und der Bundesrepublik Deutschland,* ed. Werner Bergmann, Rainer Erb, and Albert Lichtblau (Frankfurt am Main: Campus, 1995), 122–24.

34. "Vorschlag für eine würdige Gedenkstätte," *SZ,* 22 Dec. 1960; F. Busch, "Ein offener Brief an den Oberbürgermeister," *SK,* 7 Jan. 1961; "Ausländerfriedhof soll erhalten bleiben," *SK,* 28 Jan. 1961; Klaus Rusticus, "In memory of our brothers," *SK,* 28 Jan. 1961; "'Jammertal' darf nicht anders werden," *Salzgitter-Presse,* 28–29 Jan. 1961; "Gegen die Umgestaltung von 'Jammertal,'" *SZ,* 28–29 Jan. 1961.

35. Schulze, "Salzgitter aus britischer Sicht" (see n. 26), 324. See also for the following, ibid., 323–25; Bernhild Vögel and Andreas Ehrhardt, *Entwurzelt: Displaced Persons im Salzgittergebiet* (Salzgitter: Arbeitskreis Stadtgeschichte e.V., 1994); Wetzel, "Die Barackenstadt" (see n. 29), 298–311.

36. Lehr et al., *50 Jahre Arbeitskraft* (see n. 25), 22.

37. Wilhelm Höck, "Salzgitter lebt!" in *10 Jahre Stadt Salzgitter,* ed. Kultur- und Presseamt der Stadt Salzgitter (Salzgitter: E. Appelhans, 1952), 10; see also Kurt Seibt, "Salzgitters Werden," in *10 Jahre Stadt Salzgitter,* 19.

38. Seibt, "Salzgitters Werden" (see n. 37), 16. Höck, some thirty years later, remembered the "enemy camp inmates forming a mob" on the eve of Liberation: Wilhelm Höck, "Von 'Watenstedt-Salzgitter' nach 'Salzgitter' (1945–1952)," *Salzgitter Jahrbuch* 3 (1981): 52.

39. Seibt, "Salzgitters Werden" (see n. 37), 24.

40. *Unsere Stadt Salzgitter,* ed. Verkehrsverein Salzgitter e.V. (Salzgitter-Bad: Appelhans, 1967), 2.

41. Klaus Karich, "Metamorphosen einer Landschaft," in ibid., 8.

42. Erich Söchtig, "Die Bewältigung einer Vergangenheit," in *Salzgitter: 25 Jahre Salzgitter-Industrie, 20 Jahre Stadtwerdung: Sonderdruck des Salzgitter-Kurier,* ed. Erich Paykowski (Goslar: Goslarsche Zeitung Karl Krause, 1962); Erich Sewald, "Aus der Sicht der Arbeitnehmerschaft," in *Salzgitter—Stadt ohne Beispiel am Zonenrand,* ed. Erich Paykowski (Goslar: Goslarsche Zeitung, 1967).

43. *Braunschweigisches Biographisches Lexikon 19. und 20. Jahrhundert,* ed. Horst-Rüdiger Jarck and Günter Scheel (Hannover: Hahnsche Buchhandlung, 1996), 486.

44. "Bittgottesdienst auf dem Jammertal," *SZ,* 16 Nov. 1981; "Jugend ehrte Tote im Westerholz," *SZ,* 21 Nov. 1981.

45. Martina Markus and Gerd Wysocki, *Die Opfer sind immer die anderen: Zur Notwendigkeit einer Gedenk- und Dokumentationsstätte im ehemaligen KZ Drütte (Salzgitter)* (Salzgitter: Arbeitskreis Stadtgeschichte e.V., 1984), 16–24.

46. Matthias Riedel, "Vorgeschichte und Entstehung der Reichswerke und der Stadt Salzgitter," *Salzgitter Forum* 3 (1982): 3–9. Riedel had written his doctoral dissertation and another book on the Reichswerke: "Vorgeschichte, Entstehung und Demontage der Reichswerke im Salzgittergebiet," Ph.D. diss., Technische Hochschule Hannover, 1966; Riedel, *Eisen und Kohle* (see n. 4).

47. Lehr et al., *50 Jahre Arbeitskraft* (see n. 25), 14.

48. "'Wahrhaft groß, fast ungeheuerlich,'" *SZ,* 8 May 1982, quoted in Markus and Wysocki, *Die Opfer* (see n. 45), 33.

49. "Eine Liebeserklärung an Salzgitter," *SZ,* 4 April 1982, quoted in Markus and Wysocki, *Die Opfer* (see n. 45), 29.

50. Quoted in Markus and Wysocki, *Die Opfer* (see n. 45), 27. The women Höck was referring to were initially from Ravensbrück Concentration Camp. The authorized transcript differs slightly from that quoted here: "40 Jahre Stadt Salzgitter—Podiumsgespräch mit Zeitzeugen," ed. Nordert Uhde, *Salzgitter Forum* 5 (1982): 7.

51. Markus and Wysocki, *Die Opfer* (see n. 45), 71.

52. Ibid., 34.

53. For the history of the Bergen-Belsen memorial, see Peter Reichel, *Politik mit der Erinnerung: Gedächtnisorte im Streit um die nationalsozialistische Vergangenheit* (Munich: Carl Hanser, 1995), 154–61.

54. For an overview of relevant memorials in Lower Saxony, see *Spurensuche—Erinnerungen wachhalten: Gedenkstättenarbeit in Niedersachsen,* ed. Barbara Hartung, Wolfgang Kurtz, Thomas Lutz, and Wilfried Wiedemann (Hannover: Niedersächsisches Ministerium für Bundes- und Europaangelegenheiten, 1994).

55. "Protokoll über die Sitzung des Komitees zur Errichtung einer Gedenkstätte in den Gebäuden des ehemaligen KZ Drütte: Gespräch mit dem Vorstand (H. Stähler, H. Kehl, H. Dr. Geisler) über die Errichtung einer Gedenkstätte in den Gebäuden des ehemaligen KZ Drütte," 4 March 1986, 7, 11. Archives Arbeitskreis Stadtgeschichte Salzgitter, Betriebsrat Preussag Stahl AG Salzgitter files, Sonderakte 257 Gedenk- und Dokumentationsstätte KZ-Drütte I.

56. "Gründungsaufruf des Komitees 'Dokumentationsstätte KZ Drütte,'" in *Gedenk- und Dokumentationsstätte im ehemaligen KZ Drütte: Konzeption, Argumente,* ed. Komitee Dokumentationsstätte Drütte (Salzgitter: Komitee Dokumentationsstätte Drütte, 1986), 5.

57. Lehr et al., *50 Jahre Arbeitskraft* (see n. 25), 5; the other stock formula used by the Arbeitskreis to argue for a memorial at Drütte said that "there is no other site where the close interconnection between the National Socialist state, big industry, concentration camps, and forced labor is visually and atmospherically as apparent": "Gründungsaufruf des Komitees" (see n. 56), 5.

58. Quoted in "Protokoll über die Sitzung des Komitees" (see n. 55), 12.

59. Monika Breuhan-Brunke, *Pressespiegel und Dokumentation: Zur Forderung einer Gedenk- und Dokumentationsstätte im ehemaligen KZ Drütte* ([Salzgitter]: Komitee Dokumentationsstätte Drütte [1986]), 38–47.

60. *Konzentrationslager und Sklavenarbeit in der "Stadt der Hermann-Göring-Werke": Internationales Treffen in Salzgitter vom 8.–12. 4. 1992: Eine*

Dokumentation (Salzgitter: Arbeitskreis Stadtgeschichte, 1992); 2. *Internationales Treffen ehemaliger KZ-Häftlinge, Zwangsarbeiterinnen und Zwangsarbeiter vom 09.–12. April 1995 veranstaltet vom Arbeitskreis Stadtgeschichte e.V., Salzgitter: Eine Dokumentation* (Salzgitter: Arbeitskreis Stadtgeschichte, 1995).

61. For this and the following, see "Pflegemaßnahmen Gedenktafel + Jammertal," undated notes, Archives Arbeitskreis Stadtgeschichte Salzgitter, Betriebsrat Preussag Stahl AG Salzgitter files, Sonderakte 257 Gedenk- und Dokumentationsstätte KZ-Drütte II; Arbeitskreis Stadtgeschichte Salzgitter archives; "Presseerklärung des Betriebsrates der Stahlwerke Peine-Salzgitter AG, Werk Salzgitter, zu den Pflegearbeiten am 16. 11. 85 an der Gedenkstätte für die Opfer des Faschismus, Jammertal," not dated, ibid.; "Gemeinsame Arbeit von Vorstand und Betriebsrat," *SZ*, 19 Nov. 1985.

62. WB.

63. Telephone interview with Andreas Baier, 13 May 1998. Previous, conventional pictorial histories of Salzgitter include Jutta Müller, *Salzgitter: Ein Bildband* (Salzgitter-Lebenstedt: Niedersachsen-Foto, 1962); Jutta Müller, *Salzgitter: Ein Bildband* (Salzgitter-Lebenstedt: Niedersachsen-Foto, 1969); and Alfred E. Müller, *Salzgitter—ein Bildband* (Salzgitter-Lebenstedt: Bildverlag AEM-Studio, 1982).

64. For this and the following, see *Monument zur Stadtgeschichte: Turm der Arbeit,* ed. Klaus Karich (Salzgitter: Stadt Salzgitter, Referat für Öffentlichkeitsarbeit [c. 1995]); interview with Hendrik Gröttrup, Berlin, 22 April 1998.

65. "Denkmal für die Opfer des Faschismus," *SZ*, c. May 1948, Archives Arbeitskreis Stadtgeschichte Salzgitter, Sammlung Jammertal.

66. This formula has been used regularly by Salzgitter's political leaders. See, e.g., Hermann Struck and Hendrik Gröttrup, "Vitalität der Stadt: Salzgitter setzt Akzente," in *50 Jahre Salzgitter . . . 50 Jahre Zukunft!* ed. Edgar Hartmann (Osterode: Edgar Hartmann Verlag, 1992), 8; and Rudolf Rückert, "Stadt Salzgitter—Aufbauleistung einer Generation," *Salzgitter Forum* 3 (1982): 10.

Chapter 2

1. Gudrun Pischke, *"Europa arbeitet bei den Reichswerken": Das nationalsozialistische Lagersystem in Salzgitter* (Salzgitter: Archiv der Stadt Salzgitter, 1995), 287–88; for a survivor's testimony of the journey from Watenstedt to Ravensbrück, see Jean Bizien, *Sous l'habitat rayé: A chacun son destin* (Brest: Éditions de la Cité, 1987), 143–51.

2. For the following see Mijndert Bertram, *April 1945: Der Luftangriff auf Celle und das Schicksal der KZ-Häftlinge aus Drütte* (Celle: Stadt Celle, Stadtarchiv, 1989); Mijndert Bertram, "Bombenhagel und 'Hasenjagd'—Die Häftlingstransporte von Holzen nach Bergen-Belsen," in *Zwangsarbeit für die Wunderwaffen in Südniedersachsen 1943–1945,* ed. Detlef Creydt and August Meyer, vol. 1 (Braunschweig: Steinweg-Verlag, 1993), 226–30.

3. Wilhelm Sommer, recorded on 8 June 1989, quoted in Bertram, *April 1945* (see n. 2), 15–16.

4. Bertram, *April 1945* (see n. 2), 16–17.

5. H. G. Martin, *The History of the Fifteenth Scottish Division* (Edinburgh: William Blackwood and Sons, 1948), 309.

6. Rainer Schulze, "Einleitung: Nachkriegsleben in einem ländlichen Raum: Der Landkreis Celle und die Sammlung Hanna Fueß," in *Unruhige Zeiten: Erlebnisberichte aus dem Landkreis Celle 1945–1949,* ed. Rainer Schulze (Munich: R. Oldenbourg, 1991), 9–52. Further references to this collection, abbreviated *UZ,* appear parenthetically in the text. The town of Celle today comprises several suburbs that were in 1946 still independent villages and part of the district of Celle.

7. Other accounts from the Fueß collection have been published elsewhere: "Unruhige Zeiten im Landkreis Celle: Zwei weitere Erlebnisberichte aus der 'Sammlung Hanna Fueß,' " ed. Rainer Schulze, in *Heimatkalender für die Lüneburger Heide 1991,* ed. Adolf Meyer (Celle: Schweiger und Pick, 1990), 48–52; "Unruhige Zeiten im Landkreis Celle (II): Berichte aus der 'Sammlung Hanna Fueß,' " ed. Rainer Schulze, in *Heimatkalender für die Lüneburger Heide 1992,* ed. Adolf Meyer (Celle: Schweiger und Pick, 1991), 71–74; "Unruhige Zeiten im Landkreis Celle (III): Noch einmal Berichte aus der 'Sammlung Hanna Fueß,' " ed. Rainer Schulze, in *Heimatkalender für die Lüneburger Heide 1993,* ed. Adolf Meyer (Celle: Schweiger und Pick, 1992), 46–52. When quoting accounts from the Fueß collection, I have used the published versions whenever possible.

8. Daniela Münkel, *Bauern und Nationalsozialismus: Der Landkreis Celle im Dritten Reich* (Bielefeld: Verlag für Regionalgeschichte, 1991), 38–110; see also, for a more general account of the acceptance of National Socialist ideology in rural Lower Saxony, Beatrix Herlemann, *"Der Bauer klebt am Hergebrachten": Bäuerliche Verhaltensweisen unterm Nationalsozialismus auf dem Gebiet des heutigen Landes Niedersachsen* (Hannover: Hahnsche Buchhandlung, 1993).

9. Angelica Hack, *"Displaced Persons* in Stadt und Landkreis Celle," in *Celle '45: Aspekte einer Zeitenwende: Begleitpublikation zur Ausstellung im Bomann-Museum Celle vom 13. April bis 24. September 1995,* ed. Mijndert Bertram (Celle: Bomann-Museum Celle, 1995), 90; Mijndert Bertram and Rainer Voss, "Vom Ende des NS-Regimes bis zu den ersten demokratischen Wahlen nach dem Krieg: Ein Abriß der Ereignisse," in *Celle '45,* 27.

10. Wilhelm Brese, *Erlebnisse und Erkenntnisse des langjährigen Bundestagsabgeordneten Wilhelm Brese von der Kaiserzeit bis heute* (Marwede: Eigenverlag Wilhelm Brese, 1976), 67.

11. Karl Habenicht, "Kriegserlebnisse vor und nach der Besetzung Hermannsburgs," 37, HF, vol. 3.

12. Marie Brockmann and Marie Kohrs, Dageförde, 23 April 1948, HF, vol. 2.

13. Käthe Lontzek, Bergen, 20 April 1960, HF, vol. 1.

14. For one such account, see Inge Siebernik, "Erinnerungen an Bergen-Belsen," in Meyer, *Heimatkalender 1993* (see n. 7), 52–53.

15. Juliane Wetzel, "Die Barackenstadt: Arbeit und Leben im Lageralltag," in WB, 310.

16. Stegmann, Bostel, 30 July 1946, HF, vol. 2.

17. Rainer Schulze, " 'Wir hoffen, daß diese stetige Verbesserung weiter anhält': Celle unter britischer Besatzung 1945/46," in Bertram, *Celle '45* (see n. 9),

46–47. On the British reactions to Bergen-Belsen, see also Joanne Reilly, *Belsen: The Liberation of a Concentration Camp* (London: Routledge, 1998), 24–33.

18. Hack, "Displaced Persons" (see n. 9), 98; Schulze, "Einleitung" (see n. 6), 38–40; Wolfgang Jacobmeyer, *Vom Zwangsarbeiter zum heimatlosen Ausländer: Die Displaced Persons in Westdeutschland 1945–1951* (Göttingen: Vandenhoeck und Ruprecht, 1985), 46–50.

19. Adele Penzhorn, Misselhorn, 7 August 1957, HF, vol. 4.

20. Reilly, *Belsen* (see n. 17), 152.

21. Hermann Bliefernicht of Oldendorf, quoted in Hack, "Displaced Persons" (see n. 9), 97; see also Ernst Lindemann, Altencelle, 23 June 1946, HF, vol. 1.

22. Sabine Maehnert, "Die Probleme bei der Versorgung mit Lebensmitteln und Heizmaterial," in Bertram, *Celle '45* (see n. 9), 136–38; Bertram and Voss, "Vom Ende des NS-Regimes" (see n. 9), 23.

23. Hannah Arendt, "The Aftermath of Nazi Rule: Report from Germany," *Commentary* 10, no. 4 (1950): 342–43. See also Ingeborg Nordmann's recent commentary: "Erfahrungen in einem Land, das die Realität verloren hat," in Hannah Arendt, *Besuch in Deutschland* (Berlin: Rotbuch, 1993), 67–96.

24. Uwe Nordhoff, Reinhard Otto, Peter Reck, Adolf Staack, and Jürgen Wulf, *Nur Gott der Herr kennt ihre Namen: KZ-Züge auf der Heidebahn* (Schneverdingen: Sigrun Wulf Selbstverlag, 1991), 43.

25. Annette Wienecke, *"Besondere Vorkommnisse nicht bekannt": Zwangsarbeiter in unterirdischen Rüstungsbetrieben: Wie ein Heidedorf kriegswichtig wurde* (Bonn: Pahl-Rugenstein, 1996), 168.

26. Nordhoff et al., *Nur Gott der Herr* (see n. 24), 89–93.

27. Gordon J. Horwitz, *In the Shadow of Death: Living Outside the Gates of Mauthausen* (New York: Free Press, 1990), 134.

28. Hermann Löns, "Hannoversche Städtbilder: Celle," in Leo Mielke, *Hermann Löns und Celle* (Celle: Stadt Celle, 1988), 18–25; these articles were first published in July 1893.

29. Hanna Fueß, "Hermann Löns und Celle," in *Celle: Ein Lesebuch: Die Stadt Celle einst und jetzt in Sagen und Geschichten, Erinnerungen und Berichten, Briefen und Gedichten,* ed. Diethard H. Klein and Heike Rosbach (Husum: Husum-Verlag, 1987), 96.

30. Marianne Weil, "Der Wehrwolf von Hermann Löns," in *Wehrwolf und Biene Maja: Der deutsche Bücherschrank zwischen den Kriegen,* ed. Marianne Weil (Berlin: Ästhetik und Kommunikation, 1986), 203–4, 224.

31. Hermann Löns, *Der Wehrwolf: Eine Bauernchronik* (Hannover: Adolf Sponholtz, 1996), 49. Further references to this book, abbreviated HL, appear parenthetically in the text.

32. Hanna Fueß, "Parallelen zum Nationalsozialismus im Wehrwolf von Hermann Löns: Zum 28. August Hermann Löns Geburtstage 1933" (manuscript, 1933), StACe, L9 159; see also Erich Griebel, *Hermann Löns der Niederdeutsche: Eine Einfühlung in Leben und Werk* (Berlin: Wolf Heyer, 1934), 346–47.

33. Mijndert Bertram, *Celle—Eine deutsche Stadt vom Kaiserreich zur Bundesrepublik,* vol. 1: *Das Zeitalter der Weltkriege* (Celle: Stadt Celle [1992]), 295.

34. Perry Biddiscombe, *Werwolf! The History of the National Socialist Guerilla Movement, 1944–1946* (Toronto: University of Toronto Press, 1998). Biddiscombe convincingly argues that the name chosen for the guerilla movement was taken from the Löns novel and that the difference in spelling was due to concerns that guerillas could be confused with the militia, Bund Wehrwolf of the 1920s (13–14).

35. *Hildesheimer Zeitung,* 7 April 1945, quoted in Menno Aden, *Hildesheim lebt: Zerstörung und Wiederaufbau: Eine Chronik* (Hildesheim: Gebrüder Gerstenberg, 1994), 145. The article was actually published on the morning of the very day the first American tanks entered Hildesheim. Hildesheim achieved some prominence in the context of *Werwölfe* activities: the *Werwölfe* involved in the assassination of the mayor of Aachen, probably the most notable murder ascribed to the German guerilla, started out from Hildesheim (ibid., 135).

36. Marianne Weil, introduction to *Wehrwolf und Biene Maja* (see n. 30), 19–22, 34–35.

37. Weil, "Der Wehrwolf von Löns" (see n. 30), 224.

38. Biddiscombe, *Werwolf!* (see n. 34), 153.

39. See, for example, on the one hand: Walter Klotz, "Hanna Fueß—Klosterdame, Redakteurin und Heimatschriftstellerin," *Celler Chronik* 3 (1987): 157–64; and on the other: Griebel, *Hermann Löns der Niederdeutsche* (see n. 32), 395–97.

40. Swaantje Swantenius [Hanna Fueß], *Hermann Löns und die Swaantje* (Berlin: Deutsche Landbuchhandlung, 1920); by 1934, about 130,000 copies of this book had been printed (Mielke, *Hermann Löns* [see n. 28], 9).

41. See, for example, Auguste Oelker, Altencelle, 26 June 1946, HF, vol. 1; Stegmann, Bostel, 30 July 1946, HF, vol. 2.

42. Heinrich Homann, Wathlingen, 25 August 1948, HF, vol. 5.

43. See Weil, "Der Wehrwolf von Löns" (see n. 30), 219–21.

44. While *Der Wehrwolf* provided the blueprint for a fantasy that could only be lived within limits set by the British after April 1945, few such limits existed in Russia, Serbia, and other parts of Eastern Europe in the early 1940s, when German soldiers were appropriating the role of the country's indigenous defenders; the German army's representation of its war against partisans, and particularly of the way alleged partisans were tried and hanged, is strongly reminiscent of passages in *Der Wehrwolf* (for example, p. 108).

45. In three other instances the killing of soldiers is referred to as a hunt (*Der Wehrwolf,* 43, 45, 87).

46. Mijndert Bertram, "Celles ausgefallene Jubiläumsfeier: Festplanung und Kriegswirklichkeit in den Jahren 1941/42," *Celler Chronik* 5 (1992): 7–19.

47. Bertram and Voss, "Vom Ende des NS-Regimes" (see n. 9), 9, 36–37 n. 2; Bertram, *Celle* (see n. 33), 261–62.

48. Bertram, *April 1945* (see n. 2), 14.

49. Bertram, *Celle* (see n. 33), 196–223.

50. Brese, *Erlebnisse und Erkenntnisse* (see n. 10), 68.

51. Quoted in Hack, "Displaced Persons" (see n. 9), 100.

52. *CZ,* 29 April 1945, quoted in Bertram and Voss, "Vom Ende des NS-Regimes" (see n. 9), 26.

53. Senior Search Officer, Captain A. G. Eley, had in a letter to the Celle *Oberstadtdirektor* of 15 August 1946 ordered "a memorial to be erected by the K-Z Aushuss [*sic*]" (StACe, 5 O 124, 52). The council endorsed this order in principle five days later (minutes Sitzung des Hauptausschusses, 20 August 1946, StACe, 13 A 203, 59). The aldermen had actually contemplated the erection of a memorial before Eley's letter (minutes, Sitzung des Hauptausschusses, 16 July 1946, StACe, 13 A 203, 5).

54. Text of poster quoted in Hack, "Displaced Persons" (see n. 9), 111; see also StACe, 5 O 124, 57.

55. See the letters of Olga Borchard, who repeatedly approached Celle's authorities to find out about the whereabouts of her son Hans-Joachim, who had been imprisoned in Drütte: StACe, 5 O 124, 37–38, 59–61a.

56. Rat der Stadt Celle, Finanzverwaltung, to Regierungspräsident Lüneburg, 31 March 1947, NdsHSA, Nds. Lüneburg, Acc. 46/79, Nr. 9.

57. Rat der Stadt Celle, Finanzverwaltung, to Regierungspräsident Lüneburg, 27 January 1948 and 5 May 1948, NdsHSA, Nds. Lüneburg, Acc. 46/79, Nr. 9.

58. "Gräber mahnen zum Frieden," *Hannoversche Presse,* 22 Nov. 1947. See for the following also Hack, "Displaced Persons" (see n. 9), 111–12.

59. Minutes Celle council, 11 November 1947, StACe, 13A 201, vol. 1a, 263. When appointing members of the committee, the mayor did not expect its services to be required for long: Oberbürgermeister Celle to Regierungspräsident Lüneburg, 6 Sept. 1945, StACe, 5 O 124, 25.

60. Bertram, *April 1945* (see n. 2), 19–20.

61. StACe, 5 O 156.

62. Hack, "Displaced Persons" (see n. 9), 121 n. 131; A. Gericke to Rat der Stadt Celle, 1 Feb. 1950, StACe, 5 O 127.

63. Bertram, *Celle* (see n. 33), 108; Jürgen Ricklefs, *Geschichte der Stadt Celle* (Celle: Stadtarchiv Celle, 1992), 60–65.

64. *Celle: The Ancient Ducal Town on Lüneburg Heath* (Celle: Buch- und Kunstdruckerei August Pohl [c. 1930]), StACe, collection of brochures of the Celle Department of Tourism.

65. *Celle—die alte Herzogstadt der Heide,* ed. Verkehrsausschuß Celle, c. 1939, StACe, ibid.

66. Bertram, *Celle* (see n. 33), 105–62.

67. Quoted in Rainer Schröder, *". . . aber im Zivilrecht sind die Richter standhaft geblieben!" Die Urteile des OLG Celle aus dem Dritten Reich* (Baden-Baden: Nomos, 1988), 276.

68. In the 1980s, Schröder (ibid., 270) was still struck by what he called their *penetrant gutes Gewissen.* See, in particular, Hans Schmid, "Erinnerungen aus den Jahren 1930–1945," in *250 Jahre Oberlandesgericht Celle 1711–1961,* ed. Guido Schräder (Celle: Pohl, 1961), 101–19; and Frhr. v. Hodenberg, "Der Aufbau der Rechtspflege nach der Niederlage von 1945," in *250 Jahre Oberlandesgericht Celle,* 121–53. See also: Hinrich Rüping, *Staatsanwälte und Parteigenossen: Haltungen der Justiz zur nationalsozialistischen Vergangenheit zwischen 1945 und 1949 im*

Bezirk Celle (Baden-Baden: Nomos, 1994); Ulrich Vultejus, "Goldene Jugendzeit," in *Hinter den Fassaden: Geschichten aus einer deutschen Stadt,* ed. Werner Holtfort et al. (Göttingen: Steidl, 1982), 86–96. Fittingly, in this century Celle's most (in)famous son was Roland Freisler (1893–1945), president of the Nazi's People's Tribunal, and responsible for the death of many opponents of Hitler.

69. Hellmut Krohn, "Celle 1945–1972," in Ricklefs, *Geschichte der Stadt Celle* (see n. 63), 93.

70. Helmut Geiger, "Ansprache bei der Gedenkfeier des Volksbundes Deutsche Kriegsgräberfürsorge, Stadtverband Celle, am (Volkstrauertag) Sonntag, 16. Nov. 1980, 11 Uhr 15, am Ehrenmal vor dem Celler Schloß" (1980), photocopied typescript, courtesy of Hans-Heinrich Waack.

71. "Leser schreiben der 'CZ,'" *CZ,* 22 Nov. 1980; "Leser schreiben der 'CZ,'" *CZ,* 26 Nov. 1980; "Leser schreiben der 'CZ,'" *CZ,* 3 Dec. 1980.

72. Georg Eyring, "In Wehr und Waffen: Celle und sein Militär," in Holtfort et al., *Hinter den Fassaden* (see n. 68), 42. Other brief references to the events in publications in the 1980s include Bernd Polster and Reinhard Möller, *Das feste Haus: Geschichte einer Straffabrik* (Berlin, Transit, 1984), 95; and R. W. L. E. Möller, *Celle-Lexikon: Von Abbensen bis Zwische* (Hildesheim: August Lax, 1987), 113.

73. Klasse 9a GHS Groß Hehlen, "Celle vor fünfzig Jahren" (1983), mimeograph, courtesy of R. W. L. E. Möller. In 1988, an excerpt of the interview done by the Groß Hehlen students was published as part of a widely distributed "antifascist guide to Celle": R. W. L. E. Möller and Reinhard Rohde, *Antifaschistischer Stadtplan: Celle 1933–1945* (Celle: self-published, 1988).

74. Horstmann, draft manuscript for welcoming address for 1980 Stahlhelm meeting (n.d.), StACe, 10/130–22. While Horstmann did not deliver this speech, a few days later he made a speech expressing similar ideas at a local fair in Celle-Garssen (interview with Hans-Heinrich Waack, Celle, 12 May 1998).

75. "'Seht in jedem Menschen den Nächsten': Rund 50 Celler gedachten auf dem Waldfriedhof der Bombenopfer des 8. April 1945," *CZ,* 15 April 1985.

76. Amadore Kobus, "Schicksalstage in der Heide: 8. April 1945—Der Tag, an dem die Bomben fielen," *CZ,* 6 April 1985. Also in 1985, the events of April 1945 were mentioned in a compendium of sites of persecution and antifascist resistance in Lower-Saxony: *Heimatgeschichtlicher Wegweiser zu Stätten des Widerstandes und der Verfolgung 1933–1945,* vol. 2: *Niedersachsen I: Regierungsbezirke Braunschweig und Lüneburg,* ed. Studienkreis zur Erforschung und Vermittlung der Geschichte des Widerstandes 1933–1945 (Cologne: Pahl-Rugenstein, 1985), 75.

77. Ulrich Hamann, "Das Oberlandesgericht Celle im Dritten Reich: Justizverwaltung und Personalwesen," in *Festschrift zum 275jährigen Bestehen des Oberlandesgerichts Celle,* ed. Harald Franzki (Celle: Cellesche Zeitung Schweiger und Pick, 1986), 143–231.

78. Minutes Celle council *(Kulturausschuß),* 27 April 1989, courtesy of Mijndert Bertram. According to former alderman Hermann Wahnbaeck, the council would have happily settled for the plaque if only Deutsche Bundesbahn

had agreed to its location (interview with Hermann Wahnbaeck, Celle, 5 May 1998).

79. "Standort Trift für Mahnmal," *CZ,* 2 May 1989; Karin Toben, "Wie vor den Kopf geschlagen," *Süddeutsche Zeitung,* 30 June–1 July 1990.

80. Oskar Ansull, "Bescheidenheit: 700 Jahre Stadtjubiläum," *Zellesche Anzeigen,* 15 Dec. 1990.

81. "Celler Gefallenen-Ehrenmal geschändet," *CZ,* 16 Nov. 1987.

82. "Große Ernsthaftigkeit erwächst einer sehr einfachen Form," *CZ,* 19 Dec. 1990; "Damit die Unmenschlichkeit nie wieder vergessen wird," *Celler Kurier,* 24 Feb. 1991. All 281 models were documented; the relevant files in Celle's municipal archives are a wonderful source for the artistic engagement with the issue of the Nazi past in the FRG just prior to Reunification.

83. "Mahnmal: Künstlerischer Wettbewerb der Stadt Celle," mimeograph (1990), courtesy of R. W. L. E. Möller.

84. "Künstlerischer Wettbewerb für das Mahnmal Triftanlagen: Niederschrift des Kolloquiums vom 27. 07. 1990, 11.00 Uhr, Großer Festsaal des Schlosses," StACe.

85. Interview with Gertrud Schröter, Celle, 5 May 1998.

86. "Der wachsende Baum—die Hoffnung auf ein weiteres Leben," *CZ,* 8 April 1992.

87. Peter Schneider, "The Sins of the Grandfathers: How German Teen-Agers Confront the Holocaust, and How They Don't," *New York Times Magazine,* 3 Dec. 1995.

88. Kathrin Panne, "Der Nachkriegsalltag in Celle am Beispiel der Situation der Flüchtlinge," in Bertram, *Celle '45* (see n. 9), 61–88.

89. In this sense, Celle was unexceptional; see, for example, Dieter Brosius, "Zur Lage der Flüchtlinge im Regierungsbezirk Lüneburg zwischen Kriegsende und Währungsreform," in *Flüchtlinge im nordöstlichen Niedersachsen, 1945–1948,* ed. Dieter Brosius and Angelika Hohenstein (Hildesheim: August Lax, 1985), 1–86. But, for the problems refugees faced in Salzgitter, see Andreas Ehrhardt, *"Wie lästige Ausländer . . .": Flüchtlinge und Vertriebene in Salzgitter 1945–1953* (Salzgitter: Arbeitskreis Stadtgeschichte Salzgitter e.V., 1991).

90. Mijndert Bertram, "Aufschwung, Krisen, Katastrophen—Vom Kaiserreich bis zum Ende der NS-Herrschaft," in *700 Jahre junges Celle,* ed. Juliane Schmieglitz-Otten and Mijndert Bertram (Stadt Celle: Der Oberstadtdirektor, 1991), 143.

91. *Wir in Celle: 700 Jahre junges Celle,* undated brochure published by Stadt Celle, Amt für Wirtschaft und Tourismus, available at the local tourist information in June 1997.

92. The disowning of Löns has been contested. In 1992, the *Cellesche Zeitung* published a full-page article that questioned Löns's absence from the anniversary celebrations: "700 Jahre junges Celle—viel zu wenig Hermann Löns?!" *CZ,* 31 Dec. 1992.

93. I thank Elke Zacharias for this story.

94. Möller, *Celle-Lexikon* (see n. 72), 113.

95. See, for example, *Wir in Celle. . . : Entdecken Sie unsere Stadt: Rundgang Führungen Besichtigungen '97,* brochure available at the Celle tourist information in June 1997. Apparently brochures put out by the District of Celle in

the mid-1980s also mentioned the synagogue but still drew attention to Hermann Löns: Peter Reichel, *Politik mit der Erinnerung: Gedächtnisorte im Streit um die nationalsozialistische Vergangenheit* (Munich: Carl Hanser, 1995), 155.

96. For this and the following, see Sabine Glatter, Andrea Jensen, Katrin Keßler, and Ulrich Knufinke, *Die Bauwerke und Einrichtungen der jüdischen Gemeinde in Celle: Synagoge—Mikwe—Friedhof* (Bielefeld: Verlag für Regionalgeschichte, 1997), 13–21.

97. Jürgen Ricklefs, "Die jüdische Gemeinde," in *Zur Geschichte der Juden in Celle: Festschrift zur Wiederherstellung der Synagoge,* ed. John Busch and Jürgen Ricklefs (Celle: Stadt Celle, 1974), 26.

98. Hörstmann and Eichelberg, [Geleitwort der Stadt], in Busch and Ricklefs, *Juden in Celle* (see n. 97), 5.

99. Bertram, *Celle* (see n. 33), 243–44 n. 294; Möller, *Celle-Lexikon* (see n. 72), 69–70; Herbert Obenaus and Sibylle Obenaus, eds., *Schreiben wie es wirklich war! Aufzeichnungen Karl Dürkefäldens aus den Jahren 1933–1945* (Hannover: Fackelträger, 1985), 86 n. 190; AG 8. April 1945, "Vor knapp 60 Jahren· Die Reichspogromnacht in Celle," *Publiz* 29 (1998): 7–9.

100. Naftali Bar-Giora Bamberger, *Der jüdische Friedhof in Celle: Memor-Buch* (Heidelberg: Carl Winter Universitätsverlag, 1992), 18; Bamberger quotes *Celler Markt* of 9 Oct. 1986.

101. Glatter et al., *Die Bauwerke* (see n. 96), 13, 83.

102. Handwritten notes dated 8 April 1974 on letter Stadt Celle Hochbauamt to Amt für Stadtplanung und Bauordnung, 29 January 1974, StACe, 26 893.

103. Bamberger, *Der jüdische Friedhof in Celle* (see n. 100), 9.

104. *Juden in Celle: Biographische Skizzen aus drei Jahrhunderten,* ed. Brigitte Streich (Celle: Stadtarchiv Celle, 1996).

105. Bertram, *April 1945* (see n. 2), 4.

106. Bertram, *Celle* (see n. 33), 282.

107. Zwi Asaria, "Eine Chassidische Gemeinde in Celle (1945–1950)," in Busch and Ricklefs, *Juden in Celle* (see n. 97), 95–99.

108. Interview with Christian Burchard, Celle, 12 May 1998.

109. Rosa Kameinskiy to Oberbürgermeister der Stadt Celle, 27 Nov. 1945, StACe, 5 O 120, 221. See also Bertram, *Celle* (see n. 33), 281–82; and Sabine Maehnert, *Jüdische Spuren im Celler Stadtbild: Integration und Ausgrenzung am Beispiel von Geschäften jüdischer Mitbürger in der Celler Innenstadt vor 1933/38* (Celle: Stadtarchiv Celle [c. 1996]), 43–46.

110. Minutes Celle council meeting of 15 March 1946, StACe, 13A 203.

111. Minutes Celle council *(Hauptausschuß)* meeting, 25 June 1946, StACe, 13A 203.

112. Minutes Celle council *(Verwaltungsausschuß)* meeting, 18 Nov. 1947, StACe, 13A 203.

113. Minutes Celle council *(Hauptausschuß),* 14 June 1946, StACe, 13A 203.

Chapter 3

1. James E. Young, *The Texture of Memory: Holocaust Memorials and Meaning* (New Haven: Yale University Press, 1993), ix–x.

2. Erich Heinemann, "Hildesheim ist eine 'feine alte Dame,'" *HAZ,* 7 Oct. 1989.

3. For the Kristallnacht pogrom in Hildesheim, see Irene Alger, Günter Peters, Anja Gerdes, Friedrich-Wilhelm Rogge, Frank Timmermann, and Dirk Addicks, *Verfolgung der jüdischen Bürger/innen Hildesheims: Hintergründe, Berichte, Dokumente* (Hildesheim: Vereinigung der Verfolgten des Naziregimes— Bund der Antifaschisten, Kreisvereinigung Hildesheim, 1988), 37–41; Barbara Thimm, "Spuren des Nationalsozialismus in Hildesheim: Ein Stadtführer als Beitrag zur politischen Bildung," qualifying thesis, Kulturpädagogik, Universität Hildesheim, 1993, 50–56; Wolf Dieter Lüddecke, *Polizey-Diener der Stadt Hildesheim: Eine Darstellung der geschichtlichen Entwicklung der Hildesheimer Polizei* (Hildesheim: Bernward, 1987), 115–20; and Karl Sievert, "'Keine Angst, wenn Jehova brennt!' Was vor 50 Jahren nach einem Augenzeugenbericht in Hildesheim geschehen ist," *Hildesheimer Heimatkalender 1988* (1987), 129–33.

4. One of them recorded his experiences in the concentration camp: Fritz Schürmann, "'Schutzhaft' im KZ," in *Wir haben es gesehen: Augenzeugenberichte über die Judenverfolgung im Dritten Reich,* ed. Gerhard Schoenberner (Wiesbaden: Fourier, 1981), 61–66.

5. *HAZ,* 14 June 1940, quoted in Thimm, "Spuren" (see n. 2), 51.

6. Thimm, "Spuren" (see n. 2), 11.

7. Council minutes, session of 14 March 1947, StAHi, Best. 103, Nr. 1.

8. "Vorschlag für einen Gedenkstein am Lappenberg" (July 1947), StAHi, Best. 950, Nr. 1166.

9. See Ulrike Haß, "Mahnmaltexte 1945 bis 1988: Annäherung an eine schwierige Textsorte," *Dachauer Hefte* 6 (1994): 144.

10. "Synagogen-Gedenkstein enthüllt," *Hannoversche Neueste Nachrichten,* 24 Feb. 1948.

11. "Einladung zur Enthüllung des Gedenksteines zur Erinnerung an die Hildesheimer Synagoge," Yad Vashem Archives, 0-70/64.

12. "Zwiespältige Gedenkfeier," *Hannoversche Neueste Nachrichten,* 21 Sept. 1948.

13. "Euer Opfer—unsere Verpflichtung," *Hannoversche Presse,* 10 Sept. 1946.

14. "Sie waren in Ketten frei," *Hannoversche Neueste Nachrichten,* 11 Sept. 1946.

15. "Den Opfern des Faschismus," *Hannoversche Neueste Nachrichten,* 17 Sept. 1947.

16. "Heute vor 25 Jahren: Die Synagoge brennt," *Hildesheimer Presse,* 9–10 Nov. 1963.

17. For this law, see Norbert Frei, *Vergangenheitspolitik: Die Anfänge der Bundesrepublik und die NS-Vergangenheit* (Munich: C. H. Beck, 1997), 29–53.

18. Anton Joseph Knott, "Im Volksmund hieß das Viertel bald 'Genickschußviertel,'" *HAZ,* 2 July 1994.

19. Quoted in Zvi Asaria, *Die Juden in Niedersachsen: Von den ältesten Zeiten bis zur Gegenwart* (Leer: Gerhard Rautenberg, 1979), 357. See also Hans Krebs, *Reminiscences and Reflections* (Oxford: Clarendon Press, 1981), 6.

20. Krebs, *Reminiscences* (see n. 19), 61–82.

21. Niedersächsischer Minister des Innern to Bürgermeister der Stadt Peine, 25 March 1953, NdsHSA, Hann. 180 Hildesheim 14/79.

22. Mijndert Bertram, *Celle—Eine deutsche Stadt vom Kaiserreich zur Bundesrepublik,* vol. 1: *Das Zeitalter der Weltkriege* (Celle: Stadt Celle [1992]), 240.

23. For the destruction of Hildesheim during World War II, see Hermann Meyer-Hartmann, *Zielpunkt 52092N 09571O: Der Raum Hildesheim im Luftkrieg 1939–1945* (Hildesheim: Bernward, 1985); and Menno Aden, *Hildesheim lebt: Zerstörung und Wiederaufbau: Eine Chronik* (Hildesheim: Gebrüder Gerstenberg, 1994), 88–135.

24. For the campaign to reconstruct the Knochenhaueramtshaus, see Gerd Rump, *"Ein immerhin merkwürdiges Haus": Eine Dokumentation zum 25jährigen Bestehen der Gesellschaft für den Wiederaufbau des Knochenhauer-Amtshauses* (Hildesheim: Gebrüder Gerstenberg, 1995); and Werner Schmidt, *Der Hildesheimer Marktplatz seit 1945: Zwischen Expertenkultur und Bürgersinn* (Hildesheim: Bernward, 1990).

25. Aden, *Hildesheim lebt* (see n. 23), 198.

26. Ibid., 196–97, 205–19.

27. From 1963 to 1970, the brochures were titled *Romantische Residenz in der Lüneburger Heide* (Romantic residence on Lüneburg Heath), thereby rehearsing the older theme of Celle as an ancient ducal town. From 1971 to 1979, they were titled *Celle: Lüneburger Heide.* They then already included chapters that drew attention to the historic town center. The 1980 brochure was titled *Celle: Stadt der bunten Fachwerkhäuser* (Celle: Town of colorful half-timbered houses). (StACe, Collection of brochures published by the Department of Tourism)

28. Quoted in Rump, *"Ein immerhin merkwürdiges Haus"* (see n. 24), 146.

29. See, for example, H. Faltz, "Strukturpflege am Lappenberg," *Hildesheimer Heimatkalender* 1973 (1972), 38–63.

30. "Gedenken an die 'Kristallnacht,'" *HAZ,* 10 Nov. 1978.

31. "Gottesdienst zur Kristallnacht," *HAZ,* 9 Nov. 1978.

32. Martin Schneider, "Wie in Hildesheim im dritten Reich jüdische Mitbürger verfolgt wurden," *Aus der Heimat: Beilage der "Hildesheimer Allgemeine Zeitung,"* 9 Nov. 1978, 50–51, 56; Martin Schneider, "Die Vertreibung der Juden aus Hildesheim im III. Reich," Halbjahresarbeit Gemeinschaftskunde, Gymnasium Josephinum (1978), StAHi, WB 21613.

33. Frank Stern, *Im Anfang war Auschwitz: Antisemitismus und Philosemitismus im deutschen Nachkrieg* (Gerlingen: Bleicher, 1991), 237.

34. "Zerstörung der Synagoge jährt sich um 45. Mal," *HAZ,* 10 Nov. 1983.

35. "1933: Ein Jahr verändert die Weltgeschichte: Dokumentation der 'Hildesheimer Allgemeinen Zeitung' zur Machtübernahme durch die Nationalsozialisten," *HAZ,* 29–30 Jan. 1983.

36. "500 KZ-Häftlinge in die Stadthalle gebracht," *HAZ,* 30 March 1983; "'Es muß ein Geisterzug gewesen sein. . . ,'" *HAZ,* 31 March 1983; Oberbürgermeister der Stadt Hildesheim to Wilhelm Prinz, 1 March 1945, StAHi, Best. 803, Nr. 4.

37. Ewald Breloer, quoted in "Klinkerbauten sollen kleineren Häusern weichen," *HAZ,* 10 Feb. 1986.

38. This foundation, a brainchild of City Treasurer Hermann Siemer, was the result of the amalgamation of numerous small foundations, some dating back to the Middle Ages, in 1979. See Hermann Siemer, "Die Friedrich Weinhagen Stiftung," in *Stiftungen aus Vergangenheit und Gegenwart,* ed. Rolf Hauer, Jürgen Rossberg, and Winfrid Frhr. v. Pölnitz-Egloffstein (Tübingen: J. C. B. Mohr, 1982), 405–12.

39. Interview with Hermann Siemer, Hildesheim, 29 Aug. 1996, tape recording; "Das neue Denkmal ist bis zum 9. November in Holzkiste verpackt," *HAZ,* 15 Oct. 1988.

40. Siemer, interview (see n. 39). Another member of the Weimhagen Foundation's board of trustees, former deputy mayor Lore Auerbach of the Social Democratic Party, confirmed that there was much subtle opposition to the memorial (interview with Lore Auerbach, Hildesheim, 15 June 1997, tape recording).

41. "Widerstrebende Meinungen zum geplanten Lappenberg-Mahnmal," *Kehrwieder,* 22 Nov. 1987. For the results of the excavations, see Christian Popa, "Die ehemalige Synagoge am Lappenberg-Hildesheim: Dokumentation im Auftrag der Stadt Hildesheim, betreut von Untere Denkmalschutzbehörde Hildesheim und Institut für Denkmalpflege Hannover," unpublished report (23 November 1987) StAHi, Best. 504-61 Nr. 1.

42. Andreas Hartmann, "Nazi-Terror vor 50 Jahren: Ein Mahnmal soll erinnern," *Kehrwieder,* 29 March 1987; *Monument zur Stadtgeschichte: Turm der Arbeit,* ed. Klaus Karich (Salzgitter: Stadt Salzgitter, Referat für Öffentlichkeitsarbeit [c. 1995]), [12–13].

43. "Das neue Denkmal" (see n. 39).

44. Guy Stern, "'Ihr seid das Saatkorn einer neuen Welt,'" *HAZ,* 10 Nov. 1988. Siemer published his own detailed reading of the memorial. His book also includes the texts—in German and in English—of the speeches and prayers delivered on 9 November 1988: Hermann Siemer, *Hoffnung voll Unsterblichkeit: Das Mahnmal für die Synagoge am Lappenberg in Hildesheim: Entstehung, Gestaltung, Deutung* (Hildesheim: Bernward, 1989).

45. Siemer, *Hoffnung* (see n. 44), 93; for the debate that followed Siemer's speech, see, for example, "'Typische konservative Fehlleistung'?" *HAZ,* 15 Nov. 1988.

46. See Hermann Tallen, *Die Auseinandersetzung über §218 StGB: Zu einem Konflikt zwischen der SPD und der katholischen Kirche* (Munich: Ferdinand Schöningh, 1977).

47. Hans Teich, *Hildesheim und seine Antifaschisten: Widerstandskampf gegen den Hitlerfaschismus und demokratischer Neubeginn 1945 in Hildesheim,* ed. Dirk Addicks et al. (Hildesheim: Vereinigung der Verfolgten des Naziregimes/Bund der Antifaschisten, Kreisvereinigung Hildesheim, 1979).

48. Kurt Baumgarte, "Hans Teich—Sein Leben und Wirken," in Teich, *Hildesheim und seine Antifaschisten* (see n. 47), 3; for Teich's biography, see ibid., 4–10.

49. For this and the following, see "Auszug aus dem Protokoll über die

Sitzung des Rates vom 29. 3. 82" (courtesy of Herbert Weiler); "Auszug aus dem Protokoll über die Sitzung des Rates vom 7. 2. 83" (courtesy of Herbert Weiler); "Ehrenbürger-Resulotion [*sic*] mit allen Stimmen verabschiedet," *HAZ*, 8 Feb. 1983.

　　50. "Ehrenbürger-Resulotion [*sic*] mit allen Stimmen verabschiedet," *HAZ*, 8 Feb. 1983.

　　51. Quoted in "Bert Brecht statt Ehrlicher," *Huckup*, 6 April 1978; also in Teich, *Hildesheim und seine Antifaschisten* (see n. 47), 45.

　　52. Helmut v. Jan, "Schluß mit der Hetze gegen Ehrlicher!" *Huckup*, 13 April 1978, emphasis added; for an apologetic biography of Ehrlicher, see Klaus Arndt, *Ernst Ehrlicher* (Hildesheim: Bernward, 1983).

　　53. "'Heute habe ich meine Heimat wiedergefunden,'" *HAZ*, 7 July 1966. Did Krebs really make this statement? Ehrlicher is not mentioned in Krebs's memoirs; instead, there he writes approvingly about the honorary citizenship bestowed on local historian Johannes Gebauer: Krebs, *Reminiscences* (see n. 19), 157.

　　54. Notice to announce the death of Hans Adolf Krebs, *HAZ*, 24 Sept. 1981.

　　55. "Am Lappenberg werden alte Häuser saniert," *HAZ*, 29 April 1981; see also "Am Lappenberg fallen die letzten Mauern," *HAZ*, 3 May 1988; "Neubauten im Schatten des Kehrwiederturms," *HAZ*, 15 Nov. 1989. The term *Leidensgeschichte* is also used to refer to Christ's Passion.

　　56. Krebs, *Reminiscences* (see n. 19), 1.

　　57. *Hans Adolf Krebs: "Meine Liebe zu Hildesheim hat nie aufgehört,"* ed. Helga Stein (Hildesheim: Verein für Kunde der Natur und Kunst Hildesheim, 1990).

　　58. Krebs, *Reminiscences* (see n. 19), 3, 154.

　　59. Quoted in Ingrid Strobel, *Das Feld des Vergessens: Jüdischer Widerstand und deutsche "Vergangenheitsbewältigung"* (Berlin: ID-Archiv, 1994), 136.

　　60. Aden, *Hildesheim lebt* (see n. 23), 227.

　　61. "Stadt unterstützt Protest gegen Denkmal für 'Bomber-Harris,'" *HAZ*, 17 Oct. 1991.

　　62. Herbert Reyer, ed., "Zum Gedenken an die Zerstörung Hildesheims am 22. März 1945: Beiträge und Ansprachen aus Anlaß der Feierlichkeiten im März 1945," *Hildesheimer Jahrbuch für Stadt und Stift Hildesheim* 68 (1996), 313.

　　63. Notes about memorials in Hildesheim, provided by Kulturamt der Stadt Hildesheim [1996].

Chapter 4

　　1. Hermann Siemer, *Hoffnung voll Unsterblichkeit: Das Mahnmal für die Synagoge am Lappenberg in Hildesheim: Entstehung, Gestaltung, Deutung* (Hildesheim: Bernward, 1989), 88.

　　2. Siemer and the artists would have known: Pinchas Lapide, *Mit einem Juden die Bibel lesen* (Stuttgart: Calwer Verlag, 1982), which by 1988 had come out in its third edition.

　　3. Interview with Hermann Siemer, Hildesheim, 29 August 1996, tape

recording. In fact, the Department of Town Planning asked an outspoken member of Hannover's Jewish community to comment on the proposed memorial. His comments emphasized the importance of the former synagogue for the memorial ensemble. Although they were overall positive, they could not be read as a ringing endorsement of the proposal: Aram Tuvia, "Die Bewertung des Planes für die Errichtung eines Denkmals am Lappenberg in Hildesheim," unpublished report (December 1987), Stadtplanungsamt Hildesheim.

4. *HAZ,* 29 July 1957.

5. See Andrew Stuart Bergerson, "In the Shadow of the Towers: An Ethnography of a German-Israeli Exchange Program," *New German Critique* 71 (1997): 141–76.

6. Karl Sievert, "Dokumentation über die unversehrt und unzerstört erhaltenen jüdischen Friedhöfe und Begräbnisstellen in der Stadt Hildesheim," *Hildesheimer Heimatkalender 1974* (1973), 59–63.

7. *Das Projekt Jüdische Kapelle: Ein Zwischenbericht der Arbeitsgemeinschaft,* ed. Hans-J. Hahn (Hildesheim: AG Jüdische Kapelle an der RBG, 1982).

8. "Schweinekopf-Anschlag kostet Haupttäter 6000 Mark Geldstrafe," *HAZ,* 8 Sept. 1989. Pigs' heads are part of a traditional anti-Semitic imagery and have often featured in recent incidents of symbolic violence directed against Jews in Germany; see Karin Schittenhelm, *Zeichen, die Anstoß erregen: Mobilisierungsformen zu Mahnmalen und zeitgenössischen Außenskulpturen* (Opladen: Westdeutscher Verlag, 1996), 105–14.

9. "Jüdischer Friedhof geschändet," *HAZ,* 8 Nov. 1994.

10. Hans-Jürgen Hahn and Peter Moses-Krause, "Hildesheimer Nachwort," in *Gesichter der Juden in Auschwitz: Lili Meiers Album,* ed. Hans-Jürgen Hahn (Berlin: Arsenal, 1995), 197.

11. "Gedenken an die 'Kristallnacht,'" *HAZ,* 10 Nov. 1978.

12. Helmut von Jan, "Zur Geschichte der Hildesheimer Juden," nondated manuscript, StAHi, Best. 803, Nr. 2.

13. Dr. jur. Hugo Goldberg to Dr. Helmut von Jan, 29 Nov. 1971, StAHi, Best. 803, Nr. 2.

14. Helmut von Jan, "Die Katastrophe der Hildesheimer Juden 1938–1988: Zum Gedächtnis der 50jährigen Wiederkehr (nach Aufzeichnungen von Dr. Hugo Goldberg, Washington, und Dr. Julius Loeb, London)," *Alt-Hildesheim* 59 (1988): 97–109.

15. Interview with Peter Hirschfeld, Bockenem, 5 May 1997, tape recording.

16. A 1995 survey found that memories of the Shoah and German *Vergangenheitsbewältigung* loom large for recent Jewish immigrants from the former Soviet Union: Willi Jasper, Julius H. Schoeps, and Bernhard Vogt, "Jüdische Emigranten aus der ehemaligen Sowjetunion in Deutschland: Probleme der sozialen Integration und kulturell-religiösen Selbstbehauptung," in *Russische Juden in Deutschland: Integration und Selbstbehauptung in einem fremden Land,* ed. Julius H. Schoeps, Willi Jasper, and Bernhard Vogt (Weinheim: Beltz Athenäum, 1996), 67–69.

17. For the following, see Hildesheimer Geschichtswerkstatt e.V.,

Zwangsarbeit im Nationalsozialismus, catalog of exhibition in Hildesheim Town Hall, 2–19 May 1998 (Hildesheim: Hildesheimer Geschichtswerkstatt e.V., 1998).

18. See Luigi Cajani, "Die italienischen Militärinternierten im national-sozialistischen Deutschland," in *Europa und der "Reichseinsatz": Ausländische Zivilarbeiter, Kriegsgefangene und KZ-Häftlinge in Deutschland 1938–1945,* ed. Ulrich Herbert (Essen: Klartext, 1991), 295–316.

19. For this and the following, see Ricciotti Lazzero, *Gli schiavi di Hitler: I deportati italiani in Germania nella seconda guerra mondiale* (Milan: Arnoldo Mondadori, 1996), 237–51.

20. Menno Aden, *Hildesheim lebt: Zerstörung und Wiederaufbau: Eine Chronik* (Hildesheim: Gebrüder Gerstenberg, 1994), 122.

21. *Die Kriegsopfer der Stadt Hildesheim im II. Weltkriege* (Hildesheim: Statistisches Amt der Stadt Hildesheim, 1958), 3.

22. Hans Teich, *Hildesheim und seine Antifaschisten: Widerstandskampf gegen den Hitlerfaschismus und demokratischer Neubeginn 1945 in Hildesheim,* ed. Dirk Addicks, Kurt Baumgarte, Ulrich Sonnenberg, and Alexander Weil (Hildesheim: Vereinigung der Verfolgten des Naziregimes/Bund der Antifaschisten, Kreisvereinigung Hildesheim, 1979), v, 141.

23. Hermann Meyer-Hartmann, *Zielpunkt 52092N 09571O: Der Raum Hildesheim im Luftkrieg 1939–1945* (Hildesheim: Bernward, 1985), 72. The artist was Otto Schmieder, who in 1996 published a book with his recollections, which included the drawing: Otto Schmieder, *Hildesheim 1944/45: Rückblick auf eine schicksalsschwere Zeit* (Hildesheim: Gebrüder Gerstenberg, 1996), 57.

24. Aden, *Hildesheim lebt* (see n. 20), 121–22. The hangings were also mentioned in a book whose authors were associated with the VVN: *Heimat-geschichtlicher Wegweiser zu Stätten des Widerstandes und der Verfolgung 1933–1945,* vol. 3: *Niedersachsen II: Regierungsbezirke Hannover und Weser-Ems,* ed. Studienkreis zur Erforschung und Vermittlung der Geschichte des Wider-standes 1933–1945, und Präsidium der Vereinigung der Verfolgten des Naziregimes—Bund der Antifaschisten (Cologne: Pahl-Rugenstein, 1986), 75–76.

25. For the experiences of Italians in Hildesheim, see Giorgio Fossati and Enzo Bicchi, "I martiri di Hildesheim," in *Resistenza senz'armi: Un capitolo di storia italiana, 1943–1945, dalle testimonianze di militari toscani internati nei lager nazisti,* ed. Associazione Nazionale Ex-Internati (Florence: Le Monnier, 1984), 316–20.

26. For this and the following, interview with Leonardo Civale, Hildesheim, 7 May 1998.

27. Kurt Machens, "Hildesheim, 7 Aprile 1995," in Lazzero, *Gli schiavi di Hitler* (see n. 19), vii–viii.

28. Angelo Digiuni, recorded on 10 December 1994 and quoted in Lazzero, *Gli schiavi di Hitler* (see n. 19), 248.

29. Ibid., 249.

30. "Stadt ist Zigeunermetropole," *HAZ,* 16 Jan. 1981.

31. For this and the following, see Lukrezia Jochimsen, *Zigeuner heute: Untersuchung einer Aussenseitergruppe in einer deutschen Mittelstadt* (Stuttgart: Ferdinand Enke, 1963), 30–33; Norbert Schulz, "Versuche zur sozialen Sicherung

und Integration von Zigeunern," qualifying thesis, Sozialwesen, Fachhochschule Hildesheim/Holzminden, 1985, 137–47.

32. Jochimsen, *Zigeuner heute* (see n. 31), 97. Jochimsen did not reveal the location of her case study; however, anybody familiar with Hildesheim would easily have been able to recognize it.

33. See Herbert Heuß, "Die Migration von Roma aus Osteuropa im 19. und 20. Jahrhundert: Historische Anlässe und staatliche Reaktion—Überlegungen zum Funktionswandel des Zigeuner-Ressentiments," in *Die gesellschaftliche Konstruktion des Zigeuners: Zur Genese eines Vorurteils,* ed. Jacqueline Giere (Frankfurt am Main: Campus, 1996), 109–31; Wolfgang Wippermann, *"Wie die Zigeuner": Antisemitismus und Antiziganismus im Vergleich* (Berlin: Elefanten Press, 1997), 19–121.

34. Minutes Celle council (*Hauptausschuß*) meeting, 17 Sept. 1946, StACe, 13A 203, 65.

35. Willi Gosch, Entenfang, 14 July 1947, HF, vol. 2.

36. "'Sie entwickeln manchmal viel Phantasie,'" *HAZ,* 28 Jan. 1981.

37. Constantin Goschler, *Wiedergutmachung: Westdeutschland und die Verfolgten des Nationalsozialismus (1945–1954)* (Munich: R. Oldenbourg, 1992), 90.

38. Adam Strauß, Verband Deutscher Sinti und Roma, Landesverband Hessen, to Achim Exner, Oberbürgermeister der Landeshauptstadt Wiesbaden, 4 Feb. 1991, StAWi, Dienstakten Sinti und Roma I, Mahnmal; for the following, see also *Verband Deutscher Sinti und Roma, Landesverband Hessen, Rundbrief* (1992), 4–13.

39. "'Versuch, Würde der Opfer wiederherzustellen,'" *FAZ,* 23 May 1992.

40. Richard Huppertsberg, "Mahnmal," *WT,* 5 June 1992.

41. Dagobert Nolte, "'Wenn Mahnmal, dann für alle Opfer,'" *WT,* 5 June 1992.

42. Udo Engbring-Romang, *Wiesbaden—Auschwitz: Zur Verfolgung der Sinti in Wiesbaden* (Darmstadt: Verband Deutscher Sinti und Roma, Landesverband Hessen, 1997), 96–97. Lampert's recollections are documented pp. 64, 121–22; and in Lothar Bembeneck and Axel Ulrich, *Widerstand und Verfolgung in Wiesbaden 1933–1945: Eine Dokumentation* (Gießen: Anabas, 1990), 321–23.

Chapter 5

1. For the Bismarck monument, see Karen Lang, "Monumental Unease: Monuments and the Making of National Identity in Germany," in *Imagining Modern German Culture: 1889–1910,* ed. Françoise Forster-Hahn (Washington: National Gallery of Art, 1996), 275–77.

2. In 1958, prisoners were known to have come from thirty-six countries (in 1997, staff at the Buchenwald memorial museum knew of forty-nine countries represented in Buchenwald), and the selection of countries for the individual pylons was controversial: Volkhard Knigge, "Opfer, Tat, Aufstieg: Vom Konzentrationslager Buchenwald zur Nationalen Mahn- und Gedenkstätte der DDR," in Volkhard Knigge, Jürgen Maria Pietsch and Thomas A. Seidel, *Das Buchenwalder Mahnmal von 1958,* 2 vols. (Spröda: Edition Schwarz Weiss, 1997), 1:79–80 n. 265.

3. The literature on official East German discourses about the Holocaust, the position of Jews in the German Democratic Republic, and the East German state's approach to Israel is vast. See Siegfried Theodor Arndt, Helmut Eschwege, Peter Honigmann, and Lothar Mertens, *Juden in der DDR: Geschichte—Probleme—Perspektiven* (Sachsenheim: Burg, 1988); Robin Ostow, *Jews in Contemporary East Germany: The Children of Moses in the Land of Marx* (Basingstoke: Macmillan, 1989); Erica Burgauer, *Zwischen Erinnerung und Verdrängung—Juden in Deutschland nach 1945* (Reinbek: Rowohlt Taschenbuch, 1993), 137–264; Jeffrey Herf, *Divided Memory: The Nazi Past in the Two Germanys* (Cambridge: Harvard University Press, 1997); Mario Keßler, *Die SED und die Juden—zwischen Repression und Toleranz: Politische Entwicklungen bis 1967* (Berlin: Akademie, 1995); Peter Maser, "Juden und Jüdische Gemeinden in der Innenpolitik der DDR," in *Schwieriges Erbe: Der Umgang mit Nationalsozialismus und Antisemitismus in Österreich, der DDR und der Bundesrepublik Deutschland,* ed. Werner Bergmann, Rainer Erb, and Albert Lichtblau (Frankfurt am Main: Campus, 1995), 339–68; Angelika Timm, *Hammer, Zirkel, Davidstern: Das gestörte Verhältnis der DDR zu Zionismus und Staat Israel* (Bonn: Bouvier, 1997). For other relevant texts, see subsequent notes. There are also several instructive autobiographical accounts, such as Helmut Eschwege, *Fremd unter meinesgleichen: Erinnerungen eines Dresdner Juden* (Berlin: Christoph Links, 1991); and the interviews with East German Jews in *Zwischen Thora und Trabant: Juden in der DDR,* ed. Vincent von Wroblewsky (Berlin: Aufbau Taschenbuch, 1993). For the following, see, in particular, Olaf Groehler, "Der Umgang mit dem Holocaust in der DDR," in *Der Umgang mit dem Holocaust: Europa—USA—Israel,* ed. Rolf Steininger (Vienna: Böhlau, 1994), 234–39; Olaf Groehler, "Verfolgten- und Opfergruppen im Spannungsfeld der politischen Auseinandersetzungen in der Sowjetischen Besatzungszone und in der Deutschen Demokratischen Republik," in *Die geteilte Vergangenheit: Zum Umgang mit Nationalsozialismus und Widerstand in beiden deutschen Staaten,* ed. Jürgen Danyel (Berlin: Akademie, 1995), 18–22. The following summary also draws on Annette Leo, "Antifaschismus und Kalter Krieg," in *Mythos Antifaschismus: Ein Traditionskabinett wird kommentiert,* ed. Kulturamt Prenzlauer Berg and Aktives Museum Faschismus und Widerstand in Berlin (Berlin: Christoph Links, 1992), 143–53.

4. *Deutsche Volkszeitung,* 3 July 1945, quoted in Olaf Groehler, "Der Holocaust in der Geschichtsschreibung der DDR," in Ulrich Herbert and Olaf Groehler, *Zweierlei Bewältigung: Vier Beiträge über den Umgang mit der NS-Vergangenheit in den beiden deutschen Staaten* (Hamburg: Ergebnisse-Verlag, 1992), 42–43. People labeled *Arbeitsvertragssünder* by the Nazis were often committed to so-called *Arbeitserziehungslager* such as Lager 21 in Salzgitter (see chap. 1).

5. For examples of such a distinction in the Western zones, see Wolf-Dietrich Schmidt, "'Wir sind die Verfolgten geblieben': Zur Geschichte der Vereinigung der Verfolgten des Naziregimes (VVN) in Hamburg 1945–1951," in *Das andere Hamburg: Freiheitliche Bestrebungen in der Hansestadt seit dem Spätmittelalter,* ed. Jörg Berlin (Cologne: Pahl-Rugenstein, 1981), 333–34; Constantin Goschler, *Wiedergutmachung: Westdeutschland und die Verfolgten des Nationalsozialismus (1945–1954)* (Munich: R. Oldenbourg, 1992), 88–89.

6. Angelika Timm, "Der 9. November 1938 in der politischen Kultur der DDR," in Steininger, *Umgang mit dem Holocaust* (see n. 3), 248. The number of 160,000 refers to Berlin's Jewish population in 1933. Of those, about 90,000 emigrated, and about 55,000 were murdered. For the following, see ibid., 248–50.

7. Paul Merker, "Die Hintergründe der Reichskristallnacht," *Neues Deutschland,* 10 Nov. 1948, quoted in Timm, "Der 9. November 1938" (see n. 6), 250.

8. Merker's analysis was published in West Germany in the early 1970s: Paul Merker, *Das Dritte Reich und sein Ende* (Frankfurt am Main: Materialismus-Verlag, 1972); Paul Merker, *Von Weimar zu Hitler* (Frankfurt am Main: Materialismus-Verlag, 1973). At the same time, Merker's analysis was dismissed as dated in the GDR: Wolfgang Kießling, *Alemania Libre in Mexiko* (Berlin: Akademie, 1974), 235–36.

9. Herf, *Divided Memory* (see n. 3), 95.

10. Quoted in Eschwege, *Fremd unter meinesgleichen* (see n. 3), 63.

11. Quoted in Olaf Groehler, "SED, VVN und Juden in der sowjetischen Besatzungszone Deutschlands (1945–1949)," *Jahrbuch für Antisemitismusforschung* 3 (1994): 293.

12. Burgauer, *Zwischen Erinnerung und Verdrängung* (see n. 3), 172; see 173–75, for the following.

13. Muhlen quotes an article by Bodo Uhse in *Tägliche Rundschau* that refers to "passportless, rootless cosmopolites, the bearded and hook-nosed enemies of national sovereignty": Norbert Muhlen, *The Survivors: A Report on the Jews in Germany Today* (New York: Thomas Y. Cromwell, 1962), 200. Muhlen does not provide a reference, and I could not locate the newspaper article. His is the only evidence of *explicit* Nazi-style anti-Semitism in official GDR discourse. Other authors claiming such anti-Semitism draw on Muhlen: see Burgauer, *Zwischen Erinnerung und Verdrängung* (see n. 3), 177–78.

14. Ostow variously estimates that 500 or 550 of 3,000 East German Jews left the GDR: Ostow, *Jews in Contemporary East Germany* (see n. 3), 5; Robin Ostow, "Imperialist Agents, Anti-Fascist Monuments, Eastern Refugees, Property Claims: Jews as Incorporations of East German Social Trauma, 1945–94," in *Jews, Germans, Memory: Reconstructions of Jewish Life in Germany,* ed. Y. Michal Bodemann (Ann Arbor: University of Michigan Press, 1996), 231; According to a *New York Times* report from 21 January 1953, by 1953 a quarter of East Germany's Jewish population had fled the country: quoted in Herf, *Divided Memory* (see n. 3), 133; according to Inge Deutschkron, East Germany lost nearly half of its Jewish population: quoted in Burgauer, *Zwischen Erinnerung und Verdrängung* (see n. 3), 182. It is difficult to establish the number of Jews in the GDR because those officially labeled "citizens of Jewish origin" were not counted separately in official statistics; Jewish congregations counted only their members: Burgauer, *Zwischen Erinnerung und Verdrängung* (see n. 3), 153.

15. "Lehren aus dem Prozeß gegen das Verschwörerzentrum Slansky" (Beschluß des Zentralkomitees vom 20. Dezember 1952), in *Dokumente der Sozialistischen Einheitspartei Deutschlands: Beschlüsse und Erklärungen des Zentralkomitees sowie seines Politbüros und seines Sekretariats,* vol. 4 (Berlin: Dietz, 1954), 206.

16. Annette Leo, "Das kurze Leben der VVN: Von der Vereinigung der

Verfolgten des Nazi-Regimes zum Komitee der Antifaschistischen Widerstands-kämpfer in der DDR," in *Von der Erinnerung zum Monument: Die Entstehungs-geschichte der Nationalen Mahn- und Gedenkstätte Sachsenhausen,* ed. Günter Morsch (Berlin: Hentrich, 1996), 97–100; Elke Reuter and Detlef Hansel, *Das kurze Leben der VVN von 1947 bis 1953: Die Geschichte der Vereinigung der Ver-folgten des Naziregimes in der sowjetischen Besatzungszone und in der DDR* (Berlin: edition ost, 1997), 459–519.

17. See, also for the following, Timm, "Der 9. November 1938" (see n. 6), 251–55; Olaf Groehler, "Zur Gedenkstättenpolitik und zum Umgang mit der 'Reichskristallnacht' in der SBZ und DDR (1945–1988)," in Bergmann, Erb, and Lichtblau, *Schwieriges Erbe* (see n. 3), 295–98.

18. For the SED's campaigns against old Nazis in Bonn, see Michael Lemke, "Instrumentalisierter Antifaschismus und SED-Kampagnenpolitik im deutschen Sonderkonflikt 1960–1968," in Danyel, *Die geteilte Vergangenheit* (see n. 3), 61–86.

19. See Thomas Herz and Heiko Boumann, "Der 'Fall Globke': Entste-hung und Wandlung eines NS-Konfliktes," in Thomas Herz and Michael Schwab-Trapp, *Umkämpfte Vergangenheit: Diskurse über den Nationalsozialismus seit 1945* (Opladen: Westdeutscher Verlag, 1997), 57–107.

20. Ostow, *Jews in Contemporary East Germany* (see n. 3), 6.

21. Ostow, "Imperialist Agents" (see n. 14), 234.

22. Burgauer, *Zwischen Erinnerung und Verdrängung* (see n. 3), 223; for the following, see 221–47.

23. Quoted in Eschwege, *Fremd unter meinesgleichen* (see n. 3), 130.

24. In 1990, about 30,000 Jews lived in Germany. Within the next five years, some 40,000 Jews from the former Soviet Union migrated to Germany; by 1995, the German authorities had committed themselves to allow a total of 97,197 Jews to immigrate: Julius H. Schoeps, Willi Jasper, and Bernhard Vogt, "Einleitung," in *Russische Juden in Deutschland: Integration und Selbstbehauptung in einem fremden Land,* ed. Julius H. Schoeps, Willi Jasper, and Bernhard Vogt (Weinheim: Beltz Athenäum, 1996), 7–9. The overwhelming majority of these immigrants have joined Jewish congregations in Germany: Willi Jasper, Julius H. Schoeps, and Bernhard Vogt, "Jüdische Emigranten aus der ehemaligen Sowjetunion in Deutschland: Probleme der sozialen Integration und kulturell-religiösen Selbstbe-hauptung," in *Russische Juden in Deutschland,* 128–29.

25. Wolfgang Hasse, "Stätte der Pflege jüdischer Tradition ersteht als geistige Heimat neu," *Neue Zeit,* 11 Nov. 1988.

26. "Grundsteinlegung für Wiederaufbau der Neuen Synagoge Berlin," *National-Zeitung,* 11 Nov. 1988.

27. For the history of the New Synagogue, see Hermann Simon, "Die Neue Synagoge einst und jetzt," in *"Tuet auf die Pforten": Die Neue Synagoge 1966–1995,* ed. Hermann Simon and Jochen Boberg (Berlin: Stiftung Neue Syna-goge Berlin—Centrum Judaicum, 1995), 10–42; Heinz Knobloch, *Der beherzte Reviervorsteher: Ungewönliche Zivilcourage am Hackeschen Markt,* 2d ed. (Frank-furt am Main: Fischer Taschenbuch, 1996), 141–53.

28. Hans Hirschberg, "Die Orgelwerke der Neuen Synagoge," in Simon and Boberg, *Tuet auf die Pforten* (see n. 27), 57–62.

29. Ostow, *Jews in Contemporary East Germany* (see n. 3), 21, 41, 48–49.

30. See, for example, Jalda Rebling, "Yiddish Culture—a Soul Survivor of East Germany," in *Speaking Out: Jewish Voices from United Germany,* ed. Susan Stern (Chicago: edition q, 1995), 82–91.

31. For the latter, see Werner Bergmann, "Antisemitismus in öffentlichen Konflikten 1949–1994," in *Antisemitismus in Deutschland: Zur Aktualität eines Vorurteils,* ed. Wolfgang Benz (Munich: DTV, 1995), 76–79; Werner Bergmann, "Antisemitismus als politisches Ereignis: Die antisemitische Welle im Winter 1959/60," in *Antisemitismus in der politischen Kultur nach 1945,* ed. Werner Bergmann and Rainer Erb (Opladen: Westdeutscher Verlag, 1990), 253–75; Ulrich Brochhagen, *Nach Nürnberg: Vergangenheitsbewältigung und Westintegration in der Ära Adenauer* (Hamburg: Junius, 1994), 276–316.

32. The coordinating committee of the Societies for Christian-Jewish Cooperation registered 176 desecrations of Jewish cemeteries in West Germany between 1 January 1948 and 31 May 1957: Jasper, Schoeps, and Vogt, "Jüdische Emigranten" (see n. 24), 71.

33. See, for example: "80 Jewish Gravestones Upset," *New York Times,* 21 April 1957; "Desecration of Jews' Graves in Saxony [*sic*]," *The Times,* 22 April 1957; "Jewish Cemetery Desecrated," *Manchester Guardian,* 22 April 1957; "Desecration of Jewish Cemetery," *The Times,* 25 April 1957.

34. "Noch keine Spur der Grabschänder," *SZ,* 8 May 1957. Heinrich von Brentano (1904–1964) was parliamentary leader of the Christian Democrats in the federal parliament from 1949 to 1955 and from 1961 to 1964, and minister for foreign affairs from 1955 to 1961.

35. Apparently, the desecration of the Jammertal cemetery in Salzgitter was widely reported in East Germany. On 26 April 1957, the First Secretary of the IG Metall's Salzgitter branch rejected the "talking up" of the incident on East German radio: "Bekenntnis zur Freiheit an den Gräbern," *SK,* 27 April 1957.

36. "Eine Schande für uns alle," *SZ,* 24 April 1957.

37. "Rat verurteilt Grabschändung in Jammertal," *SK,* 25 April 1957.

38. Präsident des Niedersächsischen Verwaltungsbezirk Braunschweig, Abt. II Dez. J III PN, to Niedersächsischer Minister des Innern, 23 April 1957, NdsHSA, Nds. 100, Acc. 1/89, Nr. 114; Sonderkommission der Sicherungsgruppe des Bundeskriminalamts bei der Nachrichtenstelle Salzgitter, "Ermittlungsbericht" (22 May 1957), 9–23, NdsHSA, Nds. 100, Acc. 1/89, Nr. 114. The idea that East German agents provocateurs were responsible for anti-Semitic graffiti and desecrations of Jewish cemeteries in West Germany was also broached by the FRG chancellor, Konrad Adenauer, in 1959: Brochhagen, *Nach Nürnberg* (see n. 31), 280.

39. Sonderkommission, "Ermittlungsbericht" (see n. 38), 23–24.

40. Der Niedersächsische Minister des Innern, Landesamt für Verfassungsschutz, "Die Aufklärung der Friedhofsschändung 'Jammertal' und der Geheimbündelei 'Freikorps Großdeutschland,'" 24 August 1961, NdsHSA, Nds. 100, Acc. 1/89, Nr. 114.

41. Judgement, 3. Strafsenat des Bundesgerichtshofs, 1 StE 1/62, 30 March 1962, p. 46 (emphasis in the original), NdsHSA, Nds. 100, Acc. 1/89, Nr. 114.

42. Präsident des Niedersächsischen Verwaltungsbezirk Braunschweig,

Abt. II Dez. J III PN, to Niedersächsischer Minister des Innern, 23 April 1957, p. 7, NdsHSA, Nds. 100, Acc. 1/89, Nr. 114.

43. Archives Arbeitskreis Stadtgeschichte Salzgitter, Friedhof Jammertal, Gewerkschaftsarchivalien.

44. "Noch keine Spur der Grabschänder," *SZ,* 27 April 1957.

45. "Die Jugend ehrte die Toten," *Braunschweigische Presse,* 1 May 1957; "Flammender Protest der Jugend," *Die Welt der Arbeit,* 10 May 1957.

46. "Jugendleiter chrten die Toten," *Braunschweigische Presse,* 27 April 1957.

47. See Karin Schittenhelm, *Zeichen, die Anstoß erregen: Mobilisierungsformen zu Mahnmalen und zeitgenössischen Außenskulpturen* (Opladen: Westdeutscher Verlag, 1996), 99–119.

48. Quoted in "Rabin Ends Visit to 'New Germany' by Urging Fight against neo-Nazism," *Jerusalem Post,* 17 Sept. 1992.

49. For the following, see Wolfgang Titz, "Zur Geschichte der Baracken 38 und 39: Aufbau, Belegung und museale Nutzung," in *Die Baracken 38 und 39: Geschichte und Zukunft eines geschändeten Denkmals,* ed. Günter Morsch (Oranienburg: Stiftung Brandenburgische Gedenkstätten, 1995), 15–24. For Sachsenhausen's architecture, see also Ulrich Hartung, "Zur Baugeschichte des Konzentrationslagers Sachsenhausen," in Morsch, *Von der Erinnerung zum Monument* (see n. 16), 26–29; Eduard Führ, "Morphologie und Topographie eines Konzentrationslagers," in Morsch, *Von der Erinnerung zum Monument,* 42–50.

50. Mijndert Bertram, *Celle—Eine deutsche Stadt vom Kaiserreich zur Bundesrepublik,* vol. 1: *Das Zeitalter der Weltkriege* (Celle: Stadt Celle [1992]), 245.

51. Jürgen Rostock, "Zum Umgang mit der historischen Bausubstanz," in Morsch, *Von der Erinnerung zum Monument* (see n. 16), 232–43.

52. Walter Ulbricht, "In the German Democratic Republic the Legacy of the Anti-Fascists has been Fulfilled," trans. John Peet, in *Sachsenhausen,* ed. Komitee der antifaschistischen Widerstandskämpfer in der Deutschen Demokratischen Republik (Berlin: Kongress-Verlag [1962]), 51–55.

53. Susanne zur Nieden, "Das Museum des Widerstandskampfes und der Leiden des jüdischen Volkes," in Morsch, *Von der Erinnerung zum Monument* (see n. 16), 272–78.

54. "Stolpe warnt vor neuem Auschwitz," *Oranienburger Generalanzeiger,* 28 Sept. 1992; "Sachsenhausen: Anschlag auf die 'Jüdische Baracke,'" *Die Welt,* 28 Sept. 1992.

55. Malte Lehmig, "Sachsenhausen—'die fast logische Konsequenz,'" *Der Tagesspiegel,* 30 Sept. 1992.

56. "Kinkel: Deutschland ist nicht ausländerfeindlich," *Märkische Allgemeine Zeitung,* 30 Sept. 1992; "Kinkel warnt vor einem ausländerfeindlichen 'Steppenbrand,'" *FAZ,* 30 Sept. 1992.

57. See Rainer Erb and Hermann Kurthen, "Appendix: Selected Chronology of Antisemitic and Extreme Right-Wing Events in Germany during and after Unification, 1989–1994," in *Antisemitism and Xenophobia in Germany after Unification,* ed. Hermann Kurthen, Werner Bergmann, and Rainer Erb (New York: Oxford University Press, 1997), 263–85.

58. Sander L. Gilman, *Jews in Today's German Culture* (Bloomington: Indiana University Press, 1995), 27.

59. Wolfgang Pohrt, *Harte Zeiten: Neues vom Dauerzustand* (Berlin: Tiamat, 1993), 152.

60. The privileging of reports about German anxieties over those about anti-Semitism in Germany was most evident in the French print media: see, for example, "Kohl: 'Notre image est en jeu,'" *Le Figaro,* 28 Sept. 1992.

61. See, for example, "German Press Campaign against Nuclear Arms," *The Times,* 25 April 1957; "'From the Saar to the Memel,'" *Manchester Guardian,* 27 April 1957.

62. See, for example, "Bonn Tries to Patch Up V2 Damage," *Sydney Morning Herald,* 30 Sept. 1992; "The Rocket Goes Up" (editorial), *Guardian,* 30 Sept. 1992. In the *Jerusalem Post,* the arson attack was reported on 30 September on the front page ("German FM Visits Vandalized Jewish Memorial at Sachsenhausen"), and the planned V2 celebrations were the subject of an article of the same length on page 2 ("Anniversary of Hitler's V2 Rocket to Be Commemorated Despite Row"); it was, however, the V2 issue rather than the arson attack that was followed up in an editorial the next day ("Party Time at Peenemunde," *Jerusalem Post,* 1 Oct. 1992).

63. Rudolf Stiege, "Es gärt gefährlich," *Berliner Morgenpost,* 27 Sept. 1992.

64. These are the words of Thüringen's state premier, Bernhard Vogel: "Bernhard Vogel, Übergriff wie in Buchenwald eine Schande für unser Volk," *WT,* 30 July 1994. It would be instructive to repeat Jochimsen's survey of non-Sinti residents of Hildesheim; Rainer Erb reports that in December 1992 in a nationwide "poll measuring social distance of socially stigmatized groups like drug addicts, alcoholics, immigrants, left-wing radicals, Jews, and so on, right-wing extremists were rejected most frequently as neighbors by 77% of West Germans and 79% of East Germans": Rainer Erb, "Public Responses to Antisemitism and Right-Wing Extremism," in Kurthen, Bergmann, and Erb, *Antisemitism and Xenophobia* (see n. 57), 222–23 n. 23.

65. Ulbricht, "In the German Democratic Republic" (see n. 52), 53. Similar statements abounded in official East German discourse. In 1958, GDR prime minister Otto Grotewohl said at Buchenwald: "Today the world is confronted by two German states. One of these states has learned the lesson of the mistakes in German history. It has learned the right lessons, good lessons. That is the German Democratic Republic, a state of peace and socialism": Otto Grotewohl, "A Warning for All Time," trans. John Peet, in *Buchenwald,* ed. Komitee der Antifaschistischen Widerstandskämpfer in der Deutschen Demokratischen Republik (Berlin: Kongress-Verlag [1960]), 54.

66. Quoted in Claudia Seiring, "Ein trauriger Jahrestag," *Oranienburger Generalanzeiger,* 26 Sept. 1997.

Chapter 6

1. For the following, see Andreas Huyssen, "The Politics of Identification: 'Holocaust' and West German Drama," *New German Critique* 19 (1980): 122–23;

Alvin H. Rosenfeld, "Popularization and Memory: The Case of Anne Frank," in *Lessons and Legacies: The Meaning of the Holocaust in a Changing World,* ed. Peter Hayes (Evanston, Ill.: Northwestern University Press, 1991), 259–70; Ulrich Brochhagen, *Nach Nürnberg: Vergangenheitsbewältigung und Westintegration in der Ära Adenauer* (Hamburg: Junius, 1994), 434 n. 70.

2. For the Steglitz memorial, see Horst Seferens, *Ein deutscher Denkmalstreit: Die Kontroverse um die Spiegelwand in Berlin-Steglitz* (Berlin: Hentrich, 1995). The Hannover project also entailed a publication of the names listed on the memorial: Peter Schulze, *Namen und Schicksale der jüdischen Opfer des Nationalsozialismus aus Hannover* (Hannover: Verein zur Förderung des Wissens über jüdische Geschichte und Kultur e.V., 1995).

3. The names are listed in *Gedenkbuch Berlins der jüdischen Opfer des Nationalsozialismus: "Ihre Namen mögen nie vergessen werden!,"* ed. Freie Universität Berlin, Zentralinstitut für Sozialwissenschaftliche Forschung (Berlin: Hentrich, 1995).

4. A memorial book published in 1995, admittedly incomplete, lists the names of 8,877 murdered Jews who were either from or killed in Hamburg: Jürgen Sielemann and Paul Flamme, eds., *Hamburger jüdische Opfer des Nationalsozialismus: Gedenkbuch* (Hamburg: Staatsarchiv Hamburg, 1995).

5. Serge Klarsfeld, *French Children of the Holocaust: A Memorial,* ed. Susan Cohen, Howard M. Epstein, and Serge Klarsfeld, trans. Glorianne Depondt and Howard M. Epstein (New York: New York University Press, 1996).

6. For this and the following, see Günther Schwarberg, *Der SS-Arzt und die Kinder vom Bullenhuser Damm* (Göttingen: Steidl, 1997) (an earlier edition of this book was published in an English translation as *The Murders at Bullenhuser Damm* in 1983 by Indiana University Press); Günther Schwarberg, *Meine zwanzig Kinder* (Göttingen: Steidl, 1996).

7. K. Heißmeyer, "Grundsätzliches über Gegenwarts- und Zukunftsaufgaben der Lungenheilstätte," *Zeitschrift für Tuberkulose* 90, no. 1 (1943): 37

8. Ibid., 36.

9. Otto Prokop and Ehrenfried Stelzer, "Die Menschenexperimente des Dr. med. Heißmeyer (Medizinische und kriminalistische Erhebungen)," *Kriminalistik und forensische Wissenschaften* 3 (1970): 95–102.

10. Ibid., 75.

11. He died in a car accident in 1950 (ibid., 103).

12. Günther Schwarberg, *Die Mörderwaschmaschine* (Göttingen: Steidl, 1990), 81–88.

13. Paulina Trocki, "In den Lagern Auschwitz, Neugamme [*sic*], Bendorf als Ärztin, recorded by Dr Ball-Kaduri," 30 December 1956, Yad Vashem Archives, 01/166.

14. Hermann Kaienburg, *Das Konzentrationslager Neuengamme 1938–1945* (Bonn: J. H. W. Dietz Nachfolger, 1997), 251–52. There were few other children in Neuengamme; see Michael Grill, "Kinder und Jugendliche im KZ Neuengamme," in *Kinder und Jugendliche als Opfer des Holocaust,* ed. Edgar Bamberger and Annegret Ehmann (Heidelberg: Dokumentations- und Kulturzentrum Deutscher Sinti und Roma, 1995), 107–28.

15. Ulrike Jensen, "'Es war schön nicht zu frieren': Die 'Aktion Bernadotte' und das 'Skandinavierlager' des Konzentrationslagers Neuengamme," in *Kriegsende und Befreiung: Beiträge zur Geschichte der nationalsozialistischen Verfolgung in Norddeutschland,* ed. KZ-Gedenkstätte Neuengamme, vol. 2 (Bremen: Temmen, 1995), 24–34.

16. It is not entirely clear how many Red Army prisoners of war were murdered at Bullenhuser Damm, and how many managed to escape. Attempts to track down the survivors or relatives of those murdered have so far proven unsuccessful.

17. Emil Carlebach, *Tote auf Urlaub: Kommunist in Deutschland: Dachau und Buchenwald 1937–1945* (Bonn: Pahl-Rugenstein Nachfolger, 1995), 110.

18. Helge Grabitz, "Die Verfolgung von NS-Verbrechen in der Bundesrepublik Deutschland, der DDR und Österreich," in *Der Umgang mit dem Holocaust: Europa—USA—Israel,* ed. Rolf Steininger (Vienna: Böhlau, 1994), 207–8.

19. "Ihnen ist also über die Vernichtung ihres Lebens hinaus kein weiteres Übel zugefügt worden," Leitender Oberstaatsanwalt beim Landgericht Hamburg, Einstellungverfügung Ermittlungsverfahren Arnold Strippel of 30 June 1967, 147 Js 45/67, p. 21, courtesy of Günther Schwarberg.

20. D. Haller, Gespräch mit dem früheren Schulleiter Jonni Voigt, GS, vol. 13.

21. Fritz Bringmann and Hartmut Roder, *Neuengamme: Verdrängt— vergessen—bewältigt? Die "zweite" Geschichte des Konzentrationslagers Neuengamme 1945–1985* (Hamburg: KZ-Gedenkstätte Neuengamme, 1995), 86.

22. Landesschulrat Matthewes to Hans Schwarz, Arbeitsgemeinschaft Neuengamme, 11 May 1959, GS, vol. 13.

23. The plaque was replaced after the opening of the memorial exhibition and has since been stored in a room above the actual memorial museum that is used by the Association of the Children of Bullenhuser Damm as an office and meeting room.

24. Staatsarchiv Hamburg, Oberschulbehörde (361–2) VI Abl. 1986, 1:1, Unterakte Bullenhuser Damm, 9: Verschiedenes; Ernest Gaillard, "Cérémonie Commémorative à 24 Martyrs du camp de concentration de Neuengamme à Hamburg le 30 janvier 1963" (23 Feb. 1963), photocopied typescript, GS, vol. 11.

25. For this and the following, see Bringmann and Roder, *Neuengamme* (see n. 21), 10–13; Detlef Garbe, "Ein schwieriges Erbe: Hamburg und das ehemalige Konzentrationslager Neuengamme," in *Das Gedächtnis der Stadt: Hamburg im Umgang mit seiner nationalsozialistischen Vergangenheit,* ed. Peter Reichel (Hamburg: Dölling und Galitz, 1997), 113–16.

26. Quoted in Ute Wrocklage, "Neuengamme," in *Das Gedächtnis der Dinge: KZ-Relikte und KZ-Denkmäler 1945–1995,* ed. Detlef Hoffmann (Frankfurt am Main: Campus, 1998), 186.

27. C. Wallis, 5 Jan. 1948, quoted ibid., 186. This was of course the solution adopted in Bergen-Belsen.

28. See ibid., 178–83.

29. Max Brauer, letter of 23 June 1951, quoted in Garbe, "Ein schwieriges Erbe" (see n. 25), 117.

30. Buhl, letter of 14 June 1951, quoted ibid., 131–32 n. 20.

31. Wolf-Dietrich Schmidt, "'Wir sind die Verfolgten geblieben': Zur Geschichte der Vereinigung der Verfolgten des Naziregimes (VVN) in Hamburg 1945–1951," in *Das andere Hamburg: Freiheitliche Bestrebungen in der Hansestadt seit dem Spätmittelalter,* ed. Jörg Berlin (Cologne: Pahl-Rugenstein, 1981), 339.

32. For this and the following, see Volker Plagemann, *"Vaterstadt, Vaterland, schütz Dich Gott mit starker Hand": Denkmäler in Hamburg* (Hamburg: Hans Christians, 1986), 160–61; Peter Reichel, *Politik mit der Erinnerung: Gedächtnisorte im Streit um die nationalsozialistische Vergangenheit* (Munich: Carl Hanser, 1995), 95–96; Peter Reichel, "Das Gedächtnis der Stadt: Hamburg im Umgang mit seiner nationalsozialistischen Vergangenheit: Zur Einführung," in Reichel, *Das Gedächtnis der Stadt* (see n. 25), 14–16.

33. For the following, see Garbe, "Ein schwieriges Erbe" (see n. 25), 113–20.

34. It has not been established what happened to them. According to local legend, they were buried. They may have been sold to cover the cost of their removal. See Wrocklage, "Neuengamme" (see n. 26), 191.

35. Schmidt, "Wir sind die Verfolgten geblieben" (see n. 31), 348–50.

36. Albin Stobwasser, *Die den roten Winkel trugen: Zur Geschichte der VVN—Bund der Antifaschisten—Hamburg* (Hamburg: Landesvorstand der Vereinigung der Verfolgten des Naziregimes—Bund der Antifaschisten Landesverband Hamburg, 1983), 50; Carmen Lange, "Die Bedrohung der freiheitlich-demokratischen Grundordnung durch Hammer und Zirkel auf einer Kranzschleife: Zur Entstehungsgeschichte der Gedenkstätte Neuengamme," in *Von der Erinnerung zum Monument: Die Entstehungsgeschichte der Nationalen Mahn- und Gedenkstätte Sachsenhausen,* ed. Günter Morsch (Berlin: Hentrich, 1996), 115–16.

37. Lange, "Die Bedrohung" (see n. 36), 114–16. Since 1959, the flag of the German Democratic Republic showed a hammer and a pair of dividers on a black, red, and gold background. The press release was written in response to the UPI press agency's asking the police to detail what they were doing to identify whoever had cut off the ribbons (ibid., 114 n. 1). The incident led the Hamburg authorities to consider the case of East German barges that flew the GDR flag in the Hamburg port (ibid., 122 n. 54).

38. Günther Schwarberg with Daniel Haller, "Der SS-Arzt und die Kinder," *Stern,* 8 March 1979; Günther Schwarberg with Daniel Haller, "Der SS-Arzt und die Kinder [II]," *Stern,* 15 March 1979; Günther Schwarberg with Daniel Haller, "Der SS-Arzt und die Kinder: Bringt die Kinder um!" *Stern,* 22 March 1979; Günther Schwarberg with Daniel Haller, "Wohin mit den Leichen," *Stern,* 29 March 1979; Günther Schwarberg with Daniel Haller, "Die zwei Gesichter des Dr. Heißmeyer," *Stern,* 5 April 1979; Günther Schwarberg with Daniel Haller, "Arnold Strippel—eine KZ-Karriere," *Stern,* 11 April 1979.

39. Günther Schwarberg, *Der SS-Arzt und die Kinder: Bericht über den Mord vom Bullenhuser Damm* (Hamburg: Stern-Magazin im Verlag Gruner + Jahr, 1979).

40. Henry Meyer, "Redegørelse for 19 Maaneders: Ophold i tyske Fengsler og Koncentrationslejre i Danmark og Tyskland," in Gerhard Rundberg and

Henry Meyer, *Rapport fra Neuengamme* (Copenhagen: Martins Forlag, 1945), 108.

41. *Tragédie de la déportation 1940–1945: Témoignages de survivants des camps de concentration allemands,* ed. Olga Wormser and Henri Michel (Paris: Hachette, 1954), 457–60.

42. Lord Russell of Liverpool, *The Scourge of the Swastika: A Short History of Nazi War Crimes* (London: Cassell, 1954), 190–91.

43. Bringmann and Roder, *Neuengamme* (see n. 21), 14–32.

44. Interview with Fritz Bringmann, Aukrug, 16 April 1997. The article appeared in *Norddeutsches Echo,* 3–4 March 1956.

45. "Lieber Stern-Leser," *Stern,* 21 May 1959. Ironically, the editorial also heaps scorn on British newspapers that in 1955 bought the memoirs of Hitler's valet: "These memoirs were then also offered to *Stern.* It declined and wrote: 'For us, Hitler died in 1945.'" Some thirty years later, *Stern* decided to buy what it believed to be Hitler's diaries; the magazine never recovered from the loss of credibility that it suffered when it was discovered that the texts were crude forgeries.

46. Lagergemeinschaft Neuengamme, ed., *So ging es zu Ende . . . Neuengamme: Dokumente und Berichte* (Hamburg: Max Kristeller, 1960), 54–58.

47. Fritz Bringmann, *Kindermord am Bullenhuser Damm: SS-Verbrechen in Hamburg 1945: Menschenversuche an Kindern* (Frankfurt: Röderberg, 1978).

48. *Stern* published a book for teachers that suggested how the story of the children could be used in schools: Hermann Kaienburg, *Materialien und Unterrichtshilfen zu dem Stern-Buch Günther Schwarberg, "Der SS-Arzt und die Kinder"* (Hamburg: Stern-Bücher, 1979).

49. Andrei S. Markovits and Rebecca S. Hayden, "*Holocaust* before and after the Event: Reactions in West Germany and Austria," *New German Critique* 19 (1980): 58. On the reception of *Holocaust* in Germany, see Peter Märthesheimer and Ivo Frenzel, *Im Kreuzfeuer: Der Fernsehfilm "Holocaust": Eine Nation ist betroffen* (Frankfurt am Main: Fischer Taschenbuch, 1979); Yizhak Ahren, Christopher Melchers, Werner Seifert, and Werner Wagner, *Das Lehrstück "Holocaust": Zur Wirkungspsychologie eines Medienereignisses* (Opladen: Westdeutscher Verlag, 1982).

50. Elie Wiesel, "Trivializing of the Holocaust: Semi-Fact and Semi-Fiction," *New York Times,* 16 April 1978; Markovits and Hayden, "'Holocaust'" (see n. 49), 57.

51. The relevant chapter in Wormser and Michel, *Tragédie de la déportation* (see n. 41), for example, is based on Trzebinski's account. The account published by the Lagergemeinschaft in 1960 largely consists of transcripts of Frahm's and Trzebinski's statements in the 1946 Curio-Haus trials: Lagergemeinschaft Neuengamme, *So ging es zu Ende* (see n. 46), 55–58.

52. Schwarberg, *Der SS-Arzt und die Kinder* (see n. 6), 82.

53. In 1984, in the Düsseldorf Majdanek trial, Strippel was sentenced to three-and-a-half years in prison for crimes committed while in Majdanek; as he was deemed to be too frail to be kept in prison, he never had to serve this sentence.

54. Schwarberg, *Meine zwanzig Kinder* (see n. 6).

55. Herbert Enge and Hanne Stig, dirs., *Die Kinder vom Bullenhuser Damm:*

Versuch einer Annäherung, play by Thalia Treffpunkt premiered on 20 April 1990 at Thalia in der Kunsthalle, Hamburg; Herbert Enge, dir., *Die Kinder vom Bullenhuser Damm,* play by Thalia Treffpunkt premiered on 20 April 1995 at Thalia in der Kunsthalle, Hamburg; Paul Hengge, *Der Rosengarten* (Vienna: Zsolnay, 1989); Fons Rademakers, dir., *Der Rosengarten,* Germany/France (1989); Vereinigung "Kinder vom Bullenhuser Damm e.V.," ed., *Straßen der Erinnerung,* Hamburg (n.d.); Peter Schütt's poem, "Zum Gedenken an die Kinder vom Bullenhuser Damm" is quoted in Jörn Tiedemann, "Altonaer Schüler und die Kinder aus Neuengamme," in *Hamburg: Schule unterm Hakenkreuz: Beiträge der "Hamburger Lehrerzeitung" (Organ der GEW) und der Landesgeschichtekommission der VVN/Bund der Antifaschisten,* ed. Ursel Hochmuth and Hans-Peter de Lorenz (Hamburg: Hamburger Lehrerzeitung, 1985), 116–17.

56. In the second half of the 1990s, the building no longer housed a school but a training institution for unemployed young people. The memorial was freely accessible during normal office hours and on weekends. In 1999, the survival of the memorial was threatened when tenants moved out of the building and the state government contemplated selling it as a surplus asset. Intense lobbying by the Association of the Children of Bullenhuser Damm and a record attendance at the commemoration on 20 April 1999 not only dissuaded Hamburg's politicians from pursuing that option but convinced them to increase funding for the memorial. As *Shifting Memories* goes to press, a new exhibition, which was made possible by a government grant of DM 500,000, has just been opened at the former school.

57. The fact that the children were not the only ones murdered at the school has often been forgotten. A separate memorial next to the rose garden, funded by the government of the Soviet Union, commemorates the slain prisoners of war.

58. Huyssen, "The Politics of Identification" (see n. 1), 118.

59. "What I and many students after me learned about the Holocaust was some basic data and facts. But nobody taught us how to relate to the Shoah emotionally," Björn Krondorfer, an expatriate German of my age, observed: *Remembrance and Reconciliation: Encounters between Young Jews and Germans* (New Haven: Yale University Press, 1995), 33.

60. Klaus Theweleit, *Male Phantasies,* trans. Stephen Conway in collaboration with Erica Carter and Chris Turner, 2 vols. (Cambridge: Polity Press, 1987).

61. Recherche des enfants Witonski par leur mère (1945–1981), Yad Vashem Archives, 09, 268, pt. 2; Marc Grumelin, "Nazi Killer of 20 Jewish Children Still Free in Germany," *Voice of Radom,* March–April 1982, 6.

62. Henri Morgenstern to Günther Schwarberg, 22 Feb. 1979, GS, vol. 3.12.

63. Henri Morgenstern, "Begegnung mit dem Mörder meiner Familie" (1 July 1979), photocopied typescript, GS, vol. 3.12.

64. Jizhak Reichenbaum to Günther Schwarberg, 25 Jan. 1984, GS, vol. 3.13.

Chapter 7

1. Helge Grabitz, "Die Verfolgung von NS-Verbrechen in der Bundesrepublik Deutschland, der DDR und Österreich," in *Der Umgang mit dem Holocaust: Europa—USA—Israel,* ed. Rolf Steininger (Vienna: Böhlau, 1994), 209–15.

2. For Hammann's biography, see Bernd Heyl, "Ein 'Gerechter unter den Völkern'—Wilhelm Hammann," in *Verfolgung und Widerstand in Hessen 1933–1945,* ed. Renate Knigge-Tesche and Axel Ulrich (Frankfurt am Main: Eichborn, 1996), 236–47; Stefan Gabel, "Leben und Kampf des Kommunisten und Lehrers Wilhelm Hammann an der Seite der Genossen der KPD gegen Faschismus und Krieg für ein antifaschistisch-demokratisches Deutschland," qualifying thesis, Institut für Lehrerbildung "Walter Wolf," Weimar, 1979; Heinz Albertus, "'Dem Gerechten unter den Völkern' Wilhelm Hammann, ehemaliger Blockältester der Kinderbaracke 8 im KZ Buchenwald, zum 100. Geburtstag (10. 2. 1977)" (1977), Archives Gedenkstätte Buchenwald, 52-11-56/8; *Die neue Zeit und ihre Folgen: Alltag—Politik—Personen: Groß-Gerau 1869–1956: Katalog zur Ausstellung* (Groß-Gerau: Magistrat der Stadt Groß-Gerau, 1992), 68–76.

3. For this and the following, see Karin Hartewig and Lutz Niethammer, introduction to *Der "gesäuberte" Antifaschismus: Die SED und die roten Kapos von Buchenwald: Dokumente,* ed. Lutz Niethammer (Berlin: Akademie, 1994), 27–58.

4. Kurt Köhler, 13 April 1989, quoted in ibid., 35.

5. Heyl, "Gerechter unter den Völkern" (see n. 2), 240.

6. Much has been written about children in Buchenwald; see, for example, Rosmarie Hofmann, "Kinder und Jugendliche im Konzentrationslager Buchenwald," in *Nachbarn auf dem Ettersberg: Menschenverachtung und Erziehung zur Ehrfurcht,* ed. Thomas A. Seidel (Neudietendorf/Weimar: Evangelische Akademie Thüringen, Kuratorium Schloß Ettersburg e.V., 1995), 21–34; and Miriam Rouveyre, *Enfants de Buchenwald* (Paris: Julliard, 1995). For Block 8, see Bernhard Rosenkötter, "Die Schule von Block 8: Über geduldete und illegale Schulen im Konzentrationslager Buchenwald oder Anmerkungen zu einer pädagogischen Extremsituation," M.A. thesis, Erziehungswissenschaften, Fernuniversität Hagen, 1996.

7. Stanislaw Sattler, *Prisoner of 68 months. . . : Buchenwald and Auschwitz* (Melbourne: Kelly Books, 1980), 112–13.

8. Bruno Apitz, *Nackt unter Wölfen* (Halle: Mitteldeutscher Verlag, 1958).

9. See Dagmar C. G. Lorenz, *Verfolgung bis zum Massenmord: Holocaust-Diskurse in deutscher Sprache aus der Sicht der Verfolgten* (New York: Peter Lang, 1992), 169–71.

10. Klaus Drobisch and Martin Hackethal, "Lehrer Hammann: Ein Bericht über das Leben und den Kampf eines Antifaschisten," *Deutsche Lehrerzeitung,* 19 June 1959, 26 June 1959, 3 July 1959, 10 July 1959, 17 July 1959, and 24 July 1959. Drobisch continued to write about Hammann until 1988: Klaus Drobisch, "Wilhelm Hammann—Pläne für die Zukunft, Leben für die Kinder in Buchenwald (1938–1945)," *Buchenwaldheft* 32 (1988): 25–42.

11. Klaus Drobisch, "Wilhelm Hammann," in *Antifaschistische Lehrer im Widerstandskampf,* ed. Gerd Tunsch (Berlin: Volk und Wissen, 1967), 144. Further references to this article, abbreviated KD, appear parenthetically in the text.

12. "Wilhelm Hammann † ," *Die Tat,* 30 July 1955.

13. David A. Hackett, ed., *The Buchenwald Report,* trans. David A. Hackett (Boulder, Colo.: Westview Press, 1995); Eugen Kogon, *Der SS-Staat* (Stockholm: Bermann-Fischer, 1947).

14. "KP-Funktionär prallt gegen US-Panzer," *Abendpost Nachtausgabe* (Frankfurt am Main), 27 July 1955, facsimile in Autorenkollektiv, *Gerechter unter den Völkern: Wilhelm Hammann: Landrat, Lehrer, Kommunist, Widerstandskämpfer: Eine Dokumentation* (Rüsselsheim: Deutsche Kommunistische Partei, Kreisvorstand Groß-Gerau [1984]), 87.

15. Albert Lehmann, VVN Groß-Gerau, to Franz Skala, Kreisausschuß des Kreistages Groß-Gerau, 17 Feb. 1980, Yad Vashem, Department for the Righteous, Archives, file 2725 (Wilhelm Hammann); see also "Als Symbol jeden Widerstandes," *Frankfurter Rundschau,* 23 Feb. 1980.

16. Kreisausschuß des Kreises Groß-Gerau, ed., *150 Jahre Kreis Groß-Gerau: Sonderdruck des Amtsblattes zum 150jährigen Bestehen des Kreises Groß-Gerau* (Darmstadt: Darmstädter Echo, 1982), 7.

17. Zoltan S. Blau to Mordecai Paldiel, Dept for the Righteous, Yad Vashem, 23 June 1983, Hammann file (see n. 15).

18. See, for example, Aron Bulwa's testimony, in Rouveyre, *Enfants* (see n. 6), 119–20.

19. Emil Carlebach, Lagergemeinschaft Buchenwald-Dora, to [Deborah] Goldberger, 9 Feb. 1983, Hammann file (see n. 15).

20. Mordecai Paldiel, Department for the Righteous, Yad Vashem, to Emil Carlebach, 20 May 1984; Emil Carlebach to Mordecai Paldiel, 24 May 1984; statement of Emil Carlebach and thirty others, 17 June 1984, all in Hammann file (see n. 15).

21. See, for example, Emil Carlebach, Paul Grünewald, Hellmuth Röder, Willy Schmidt, and Walther Vielhauer, *Buchenwald: Ein Konzentrationslager* (Frankfurt am Main: Röderberg, 1986), 87–88. Survivors not committed to preserve the memory of the ILK, however, did not highlight Hammann's achievements, even after 1984. Jack Werber, a Polish Jew imprisoned in Buchenwald between 1939 and 1945, did not mention Hammann once in his 1996 memoirs, which deal extensively with the situation of the children: Jack Werber with William B. Helmreich, *Saving Children: Diary of a Buchenwald Survivor and Rescuer* (New Brunswick, N.J.: Transaction Publishers, 1996), 95–110.

22. Geert Platner and Schüler der Gerhart-Hauptmann-Schule in Kassel, eds., *Schule im Dritten Reich: Erziehung zum Tod? Eine Dokumentation* (Munich: DTV, 1983), 184–94.

23. Geert Platner and Schüler der Gerhart-Hauptmann-Schule in Kassel, eds., *Schule im Dritten Reich: Erziehung zum Tod: Eine Dokumentation,* rev. ed. (Cologne: Pahl-Rugenstein, 1988), 216.

24. Mörfelden-Walldorf is the result of the amalgamation of the small towns of Mörfelden and Walldorf. The Communist Party was traditionally strong in Mörfelden, which was also referred to as "Klein-Moskau" (Little Moscow).

25. Raymond L. Patten, Major, CMP, Political Activity Report, Landkreis Gross-Gerau, 16 Oct. 1945, quoted from microfilm copy, Hessisches Hauptstaatsarchiv Wiesbaden, Abt. 649, 8/11-3/6.

26. Friedrich Grünewald, "Naziherrschaft und Nachkriegszeit: Erinnerungen eines Groß-Gerauer Antifaschisten," in *Spuren der Groß-Gerauer Arbeiterbe-*

wegung: Bilder—Erinnerungen—Dokumente, ed. Fritz Grünewald et al. (Groß-Gerau: DGB Ortskartell Groß-Gerau, 1985), 55.

27. Autorenkollektiv, *Gerechter unter den Völkern* (see n. 14), 65–66.

28. Arnold Busch, *Wilhelm Hammann 1897–1955: Eine Dokumentation zu seinem Leben und politischen Wirken* (Groß-Gerau: Kreisausschuß des Kreises Groß-Gerau, 1986), 23.

29. Arnold Busch, *Widerstand im Kreis Groß-Gerau 1933–1945: Eine im Auftrag des Kreises Groß-Gerau erstellte Dokumentation* (Groß-Gerau: Kreisausschuß des Kreises Groß-Gerau—Kreisvolkshochschule, 1988). For a pertinent critique of Busch's book, see Horst Steffens, "Ein Buch als Denkmal? Anmerkungen zu Arnold Busch's *Widerstand im Kreis Groß-Gerau 1933–1945,*" in *"Widerstand im Kreis Groß-Gerau 1933–1945": Arbeitsbericht des 1. Seminars der Reihe: "Wir alle machen Geschichte. . . ,"* ed. B. Heyl and H. Wirthwein (Rüsselsheim: Volkshochschule der Stadt Rüsselsheim, Örtliche Arbeitsgemeinschaft Arbeit und Leben, 1990), 12–28.

30. During the commemorative ceremony for Hammann in Groß-Gerau, held soon after he had been posthumously honored at Yad Vashem, Gerardo del Rio Romero, one of the Kassel students, reminded the local authorities that the reputation of the town and district of Groß-Gerau was at stake by citing an article from the *Jerusalem Post* that referred to Groß-Gerau as Hammann's "largely conservative home town": Eva Basnietzky, "Overdue Tribute," *Jerusalem Post,* 6 Nov. 1984; "Gedenkfeier für Wilhelm Hammann am 21. 11. 1984 im Schloß Dornberg, Groß-Gerau" (transcript of audiotaped speeches), courtesy of Bernd Heyl, 6.

31. Interview with Mordecai Paldiel, Jerusalem, 20 May 1998.

32. Wolf Lindner and Manfred Krupp, dirs., *"Eher werde ich sterben . . .": Wilhelm Hammann: Lehrer, Kommunist, Widerstandskämpfer,* television documentary, Hessischer Rundfunk, first broadcast in 1985.

33. The authors of the DKP-published booklet provided a very detailed account of Hammann's achievements as a teacher: Autorenkollektiv, *Gerechter unter den Völkern* (see n. 14), 8–21.

34. Hansard, Hessian State Parliament, 11 June 1929, quoted ibid., 25.

35. Kollektiv der Polytechnischen Oberschule 55 "Wilhelm Hammann" to Nationale Mahn- und Gedenkstätte Buchenwald, 11 April 1989, Archives Gedenkstätte Buchenwald, 52-11-56.

36. Monika Zorn, ed., *Hitlers zweimal getötete Opfer: Westdeutsche Endlösung des Antifaschismus auf dem Gebiet der DDR* (Freiburg: AHRIMAN, 1994), 223–28.

37. Rudi Hechler to Yad Vashem Martyrs' and Heroes' Remembrance Authority, 1 Dec. 1992, courtesy of Rudi Hechler. The letter was published in part as "In Erfurt wurde Name W. Hammann getilgt" in *Neues Deutschland,* 9 Dec. 1992.

38. Benjamin Armon to Manfred Ruge, Oberbürgermeister der Stadt Erfurt, 6 Jan. 1993, courtesy of Rudi Hechler.

39. Peter Neigefindt, Dezernent für Bildung und Jugend, to Alle Schulleiter der Stadt Erfurt, 25 June 1993, quoted in Kurt Faller and Bernd Wittich, eds., *Abschied vom Antifaschismus* (Frankfurt an der Oder: Frankfurt Oder Editionen, 1997), 406.

40. See Kornelia Schrenk-Eckert, "Unbewältigte Vergangenheit: Der Fall Wilhelm Hammann: 'Gerechter unter den Völkern' (Teil I)," *Heimatzeitung Groß-Gerau,* 25 Feb. 1994; Kornelia Schrenk-Eckert, "Hammann—Konsequenz des politischen Wegs: 'Gerechter unter den Völkern' (Teil II)," *Heimatzeitung Groß-Gerau,* 3 March 1994; Kornelia Schrenk-Eckert, "Hammann—Opfer von Nachkriegsintrigen: 'Gerechter unter den Völkern' (Teil III)," *Heimatzeitung Groß-Gerau,* 5 March 1994; Kornelia Schrenk-Eckert, "'Mit diesem Mut wird Hammann zum Vorbild': 'Gerechter unter den Völkern' (Teil IV)," *Heimatzeitung Groß-Gerau,* 11 March 1994; Hanns Mattes, "40 Jahre nach seinem Tod noch ein Politikum," *FAZ,* 22 Sept. 1995.

41. Press release, Christlich-Demokratische Union, CDU-Fraktion im Kreistag Groß-Gerau, 4 July 1996, courtesy of Rudi Hechler.

42. Annette Leo, *Briefe zwischen Kommen und Gehen* (Berlin: BasisDruck, 1991), 35.

43. Ibid., 11.

44. [Grade 9 students of Regelschule 2 "Wilhelm Hammann," Erfurt], "Wilhelm Hammann: Menschlichkeit und Widerstand: ein Vorbild—einst und heute?" submitted for 1997 essay competition, Förderverein Jüdische Geschichte und Kultur im Kreis Groß-Gerau, courtesy of Walter Ullrich.

45. To give but one other example: in 1992, Hamburg's state premier recommended that Fritz Bringmann (see chap. 6) be awarded the Order of the Federal Republic of Germany. Bringmann had been imprisoned in Sachsenhausen and Neuengamme and had there refused to obey an SS order to kill Red Army POWs by lethal injection. The federal government rejected the Hamburg proposal—apparently for no other reason than Bringmann's postwar commitment to the Communist Party. For a multifaceted and "personal" portrait of Bringmann, see *"Trotz aller Widrigkeiten immer Mensch bleiben": Fritz Bringmann zum 80. Geburtstag,* ed. Detlef Garbe and Ulrike Jensen (Hamburg: Mitarbeiterinnen und Mitarbeiter der KZ-Gedenkstätte Neuengamme, 1998).

46. For the following, see Heinz Knobloch, *Der beherzte Reviervorsteher: Ungewöhnliche Zivilcourage am Hackeschen Markt,* 2d ed. (Frankfurt am Main: Fischer Taschenbuch, 1996), 7, 73–95, 154–58; Heinz Knobloch, Der Polizei-Oberleutnant Wilhelm Krützfeld, in *"Tuet auf die Pforten": Die Neue Synagoge 1966–1995,* ed. Hermann Simon and Jochen Boberg (Berlin: Stiftung Neue Synagoge Berlin—Centrum Judaicum, 1995), 245–55.

47. Quoted in "Gedenkfeier für Wilhelm Hammann" (see n. 30), 2. Carlebach's patriotism has been informed by the view that German fascism was the responsibility of the ruling class: see Emil Carlebach, "Die Grenze verläuft nicht zwischen Juden und Nichtjuden. . . ," in *Fremd im eigenen Land: Juden in der Bundesrepublik,* ed. Henryk M. Broder and Michael R. Lang (Frankfurt am Main: Fischer Taschenbuch, 1979), 106.

Chapter 8

For an earlier and slightly more detailed version of this chapter, see Klaus Neumann, "Goethe, Buchenwald, and the New Germany," *German Politics and*

Society 17, no. 1 (1999): 56–84. Permission to reprint parts of this article here is gratefully acknowledged.

1. For the selection of a site near Weimar, see Jens Schley, "Die Stadt Weimar und das Konzentrationslager Buchenwald (1937–1945): Aspekte einer Nachbarschaft," M.A. thesis, Philosophische Fakultät I, Humboldt-Universität Berlin (1997), 61–70.

2. Eicke to Himmler, 24 July 1937, re "Bezeichnung des K.L. Ettersberg," facsimile in Nationale Mahn- und Gedenkstätte Buchenwald, ed., *Konzentrationslager Buchenwald, Post Weimar/Thür.: Katalog zu der Ausstellung aus der Deutschen Demokratischen Republik im Martin-Gropius-Bau, Berlin (West), April–Juni 1990* (Weimar: Nationale Mahn- und Gedenkstätte Buchenwald, 1990), 18.

3. "Der Hochwald," first published in 1842, is one of Stifter's best-known stories: Adalbert Stifter, *Werke und Briefe: Historisch-kritische Gesamtausgabe,* ed. Alfred Doppler and Wolfgang Frühwald, vol. 1.4: *Studien: Buchfassungen Erster Band,* ed. Helmut Bergner and Ulrich Dittmann (Stuttgart: W. Kohlhammer, 1980), 209–318.

4. Simon Schama, *Landscape and Memory* (New York: Alfred Knopf, 1995), 118.

5. Johann Peter Eckermann, *Gespräche mit Goethe in den letzten Jahren seines Lebens,* ed. Fritz Bergemann (Frankfurt: Insel, 1955), 600–601.

6. Robert H. Abzug, *Inside the Vicious Heart: Americans and the Liberation of Nazi Concentration Camps* (New York: Oxford University Press, 1985), 46.

7. These included a photograph, and a drawing made in July 1944: Léon Delarbre, *Dora, Auschwitz, Buchenwald, Bergen-Belsen: Croquis clandestins* (Paris: Éditions Michel de Romilly, 1945), n.p.

8. Georges Angeli, explanatory notes regarding photograph of "Le Chêne de Goethe," 1997, Archives Gedenkstätte Buchenwald. On Goethe's oak, see also "Goethe-Eiche: Symbol zwischen Kultur und Barbarei," *Mitteldeutsche Allgemeine,* 2 Jan. 1993; Claus Jacobi, "Goethe-Eiche von Buchenwald: Im Herzen Thüringens—Stätten der Dichter und Henker," *Die Welt,* 19 Oct. 1994; Sabine Stein and Harry Stein, *Buchenwald: Ein Rundgang durch die Gedenkstätte* (Weimar-Buchenwald: Gedenkstätte Buchenwald, 1993), 33.

9. For the "abduction" and "rescue" of Goethe's and Schiller's coffins, see Volker Wahl, *Die Rettung der Dichtersärge: Das Schicksal der Sarkophage Goethes und Schillers bei Kriegsende 1945* (Weimar: Stadtmuseum Weimar, 1991); and Walter Steiner, Renate Ragwitz, Frank Funke, and Anke Bickel, *Weimar 1945: Ein historisches Protokoll* (Weimar: Stadtmuseum Weimar, 1997), 31–36.

10. Steiner et al., *Weimar 1945* (see n. 9).

11. Eckermann, *Gespräche* (see n. 5), 602.

12. For this and the following, see Schley, "Die Stadt Weimar" (see n. 1), 75, 139–61, 182–84, and appendix III/1–IV/2. The manifold contacts between a concentration camp and the town closest to it have been documented elsewhere: see, for example, Sybille Steinbacher, *Dachau—Die Stadt und das Konzentrationslager in der NS-Zeit: Die Untersuchung einer Nachbarschaft* (Frankfurt am Main: Peter Lang, 1993); Hermann Kaienburg, "'. . . sie nächtelang nicht ruhig schlafen ließ': Das KZ Neuengamme und seine Nachbarn," *Dachauer Hefte* 12

(1996): 34–57; and Gordon J. Horwitz, *In the Shadow of Death: Living Outside the Gates of Mauthausen* (New York: Free Press, 1990).

13. Erich Kloos, "Erinnerungen an die Besetzung Weimars durch die Amerikaner im April 1945: Eine verwaltungsgeschichtliche Studie," quoted from Peter Krahulec, Roland Schopf, and Siegfried Wolf, *Buchenwald—Weimar: April 1945: Wann lernt der Mensch? Ein Grundlagenbuch für Gruppenarbeit und Selbststudium* (Münster: LIT, 1994), 59.

14. Ibid., 60–61.

15. Krahulec et al., *Buchenwald* (see n. 13), 65–67; see also the eyewitness reports in Steiner et al., *Weimar 1945* (see n. 9), 91–228.

16. Buchenwald was the first large concentration camp liberated by the Western Allies and therefore attracted an enormous amount of attention. For the American media's reaction to Buchenwald, see Norbert Frei, "'Wir waren blind, ungläubig und langsam': Buchenwald, Dachau und die amerikanischen Medien im Frühjahr 1945," *Vierteljahreshefte für Zeitgeschichte* 35, no. 3 (1987): 385–401.

17. Quoted in Krahulec et al., *Buchenwald* (see n. 13), 78.

18. George S. Patton, *War as I Knew It* (Boston: Houghton Mifflin, 1947), 299.

19. Manfred Overesch, "Ernst Thapes Buchenwalder Tagebuch von 1945," *Vierteljahreshefte für Zeitgeschichte* 29, no. 4 (1981): 656–57; emphasis added. See also Imre Kertész, "Der KZ-Mythos," *Die Woche,* 7 April 1995, quoted in Jens Schley, "Weimar und Buchenwald: Beziehungen zwischen der Stadt und dem Lager," *Dachauer Hefte* 12 (1996): 207.

20. Gitta Günther, *Weimar-Chronik IV: Stadtgeschichte in Daten: Vierte Folge: April 1945 bis Dezember 1960* (Weimar: Rat der Stadt Weimar, 1984). Günther's chronicles were republished in 1996: Gitta-Maria Günther, *Weimar: Eine Chronik* (Leipzig: Gustav Kiepenheuer, 1996). Günther was a long-serving director of the Weimar municipal archives.

21. See Rudi Jahn, ed., *Das war Buchenwald! Ein Tatsachenbericht* (Leipzig: Verlag für Wissenschaft und Literatur [c. 1945]); Karl Brauer and Kurt Beyer, *Hölle Buchenwald* (Halle: Provinzialverwaltung Sachsen, 1945).

22. For this and the following, see Alan Nothnagle, "From Buchenwald to Bismarck: Historical Myth-Building in the German Democratic Republic, 1945–1989," *Central European History* 26, no. 1 (1993): 91–113; Volkhard Knigge, "Vom provisorischen Grabdenkmal zum Nationaldenkmal," *Bauwelt* 86, no. 39 (1995): 2258–66; Volkhard Knigge, "Opfer, Tat, Aufstieg: Vom Konzentrationslager Buchenwald zur Nationalen Mahn- und Gedenkstätte der DDR," in Volkhard Knigge, Jürgen Maria Pietsch, and Thomas A. Seidel, *Das Buchenwalder Mahnmal von 1958,* 2 vols. (Spröda: Edition Schwarz Weiss, 1997), 1:5–94.

23. Elie Wiesel, *All Rivers Run to the Sea: Memoirs* (New York: Schocken, 1995), 96.

24. Quoted in Judith Tydor Baumel, *Kibbutz Buchenwald: Survivors and Pioneers* (New Brunswick, N.J.: Rutgers University Press, 1997), 8.

25. Arnold Zweig, preface, trans. John Peet, in *Buchenwald,* ed. Komitee der Antifaschistischen Widerstandskämpfer in der Deutschen Demokratischen Republik (Berlin: Kongress-Verlag [1960]), 50–52.

26. Ulrich Teschner, dir., *O Buchenwald,* German Democratic Republic (1984).

27. Nationale Mahn- und Gedenkstätte Buchenwald, *Konzentrationslager* (see n. 2), 135. The same photograph is reproduced in another text published by the *Gedenkstätte* three years later—this time in order to draw attention to the tree: Stein and Stein, *Buchenwald* (see n. 8), 32.

28. Steinbacher, *Dachau* (see n. 12), 15–20; and Harold Marcuse, "Das ehemalige Konzentrationslager Dachau: Der mühevolle Weg zur Gedenkstätte 1945–1968," *Dachauer Hefte* 6 (1990): 182–205. Similar observations have been made about Mauthausen in Austria: see Horwitz, *Shadow of Death* (see n. 12), 164–88.

29. Günther Kühn and Wolfgang Weber, *Stärker als die Wölfe: Ein Bericht über die illegale militärische Organisation im ehemaligen Konzentrationslager Buchenwald und den bewaffneten Aufstand,* 3d ed. (Berlin: Militärverlag der Deutschen Demokratischen Republik, 1984), 284. The title of this book ("Stronger than the wolves") indicates an interesting shift from an interpretation emphasizing the brutality and power of the SS (as in "Naked among wolves," the title of Apitz's novel) to one emphasizing the superior strength of the prisoners.

30. Mark Raphael Baker, *The Fiftieth Gate: A Journey through Memory* (Sydney: HarperCollins, 1997), 298.

31. The incommensurability of the experiences of Jewish prisoners in the small camp with those of political prisoners in the main camp has been explored in a dialogue between Elie Wiesel and Jorge Semprun: Jorge Semprun and Elie Wiesel, *Schweigen ist unmöglich,* trans. Wolfram Bayer (Frankfurt am Main: Suhrkamp, 1997).

32. Robert Zeiler, "Eingesperrt von meinen Befreiern," in *Recht oder Rache? Buchenwald 1945–1950: Betroffene erinnern sich,* ed. Hanno Müller (Frankfurt am Main: dipa, 1991), 17–28.

33. Bodo Ritscher, *Spezlager Nr. 2 Buchenwald: Zur Geschichte des Lagers Buchenwald 1945 bis 1950* (Weimar-Buchenwald: Gedenkstätte Buchenwald, 1993), 61.

34. See, in particular, Lutz Niethammer, ed., *Der "gesäuberte" Antifaschismus: Die SED und die roten Kapos von Buchenwald: Dokumente* (Berlin: Akademie, 1994).

35. After 1989, many former *Speziallager* prisoners wrote about their camp experiences; see, for example, Werner Rathsfeld and Ursula Rathsfeld, *Die Graupenstraße: Erlebtes und Erlittenes* (Bad Lauterberg: C. Kohlmann, 1993).

36. Gedenkstätte Buchenwald, ed., *Zur Neuorientierung der Gedenkstätte Buchenwald: Die Empfehlungen der vom Minister für Wissenschaft und Kunst des Landes Thüringen berufenen Historikerkommission* (Weimar-Buchenwald: Gedenkstätte Buchenwald, 1992). For the changes to the Buchenwald memorial, see Peter Monteath, "Buchenwald Revisited: Rewriting the History of a Concentration Camp," *International History Review* 16, no. 2 (1994): 267–83; Sarah Farmer, "Symbols That Face Two Ways: Commemorating the Victims of Nazism and Stalinism at Buchenwald and Sachsenhausen," *Representations* 49 (1995): 97–119; Rikola-Gunnar Lüttgenau, "Eine schwebende Gedenkstätte? Die

Gedenkstätte Buchenwald im Wandel," in *Reaktionäre Modernität und Völkermord: Probleme des Umgangs mit der NS-Zeit in Museen, Ausstellungen und Gedenkstätten: Dokumentation einer Tagung des Forschungsinstituts für Arbeiterbildung und der Hans-Böckler-Stiftung*, ed. Bernd Faulenbach and Franz-Josef Jelich (Essen: Klartext, 1994), 113–29; Claudia Koonz, "Germany's Buchenwald: Whose Shrine? Whose Memory?" in *The Art of Memory: Holocaust Memorials in History*, ed. James E. Young (New York: Jewish Museum, 1994), 110–19; Rikola-Gunnar Lüttgenau, "Nach Buchenwald," in *KulturStadtRaum: Eine architektonische Wanderung durch Weimar Kulturstadt Europas 1999*, ed. Gerd Zimmermann and Jörg Brauns (Weimar: Universitätsverlag, 1997), 168–73. For a comparatively early and polemical account of changes at Buchenwald, see Ian Buruma, "Buchenwald," *Granta* 42 (1992): 65–75.

37. For the Jewish memorial, see Christiane Weber, "Überfälliges Zeichen," *Thüringische Landeszeitung*, 11 Nov. 1993; and Horst Seferens, "Eine gelungene künstlerische Annäherung an das Unvorstellbare," *Allgemeine Jüdische Wochenzeitung*, 18 Nov. 1993. For the Sinti and Roma memorial, see Stiftung Gedenkstätten Buchenwald und Dora-Mittelbau, ed., *50. Jahrestag der Befreiung der Konzentrationslager Buchenwald und Mittelbau-Dora* (Weimar-Buchenwald: Stiftung Gedenkstätten Buchenwald und Mittelbau-Dora, 1995), 5–18; and Edgar Bamberger, "Versinkende Stelen," *Weimar Kultur Journal* 4, no. 4 (1995): 13.

38. Lüttgenau, "Nach Buchenwald" (see n. 36), 171–73. Horst Hoheisel, "Aschrottbrunnen—Denk-Stein-Sammlung—Brandenburger Tor—Buchenwald: Vier Erinnerungsversuche," in *Shoah: Formen der Erinnerung: Geschichte, Philosophie, Literatur, Kunst*, ed. Nicolas Berg, Jess Jochimsen, and Bernd Stiegler (Munich: Wilhelm Fink, 1996), 263–65.

39. Karina Loos, "Das 'Gauforum' in Weimar: Vom bewußtlosen Umgang mit nationalsozialistischer Geschichte," in *Nationalsozialismus in Thüringen*, ed. Detlev Heiden and Gunther Mai (Weimar: Böhlau, 1995), 333–48; Korina Loos, "Das Weimarer Gauforum — ein Symbol der nationalsozialistischen Geschichte Weimars: Versuch einer Wertung," in *Vergegenständlichte Erinnerung: Perspektiven einer janusköpfigen Stadt*, ed. Reiner Bensch (Weimar: Bauhaus-Universität Weimar, 1996), 15–23; Norbert Korrek, "Das ehemalige Gauforum Weimar: Chronologie," in *Vergegenständlichte Erinnerung*, 24–51; Christiane Wolf, "Das Gauforum als typische Bauaufgabe nationalsozialistischer Architektur: Überlegungen zu früheren Planungen," in *Vergegenständlichte Erinnerung*, 53–71.

40. Justus H. Ulbricht, "Wider den 'extremsten Expressionismus,'" *Weimar Kultur Journal* 6, no. 4 (1997): 16–17.

41. Steiner et al., *Weimar 1945* (see n. 9), 23, 57–58 n. 39.

42. Thomas Bickelhaupt, "Die langen Schatten des Ettersberges werden kaum wahrgenommen," *Neue Zeit*, 30 March 1994.

43. Verena Lehmann-Spalleck, "Kulturstadt Europas: Eine Untersuchung über die Entstehungsgeschichte und Funktion einer Kulturinstitution der Europäischen Union," qualifying thesis, Kulturpädagogik, Universität Hildesheim, 1995, 31–52.

44. Stadtkulturdirektion Weimar, ed., *Weimar: "Spuren in die Zukunft*

legen": Weimar—Kulturstadt Europas 1999 (Weimar: Stadtkulturdirektion Weimar [1993]), 3 (English text).

45. Ibid., 5 (English text).

46. For a lucid critique of this alleged ambivalence, see Schley, "Weimar and Buchenwald" (see n. 19), 210–14. The most vocal, and probably most interesting, representative of the school of thought that sees Weimar and Buchenwald as a dichotomous pair is the director of the authority in charge of the City of Culture events, Bernd Kauffmann. A discussion of his views would be beyond the scope of this chapter: Bernd Kauffmann, "Weimar und Buchenwald," *Weimar Kultur Journal* 4, no. 4 (1995): 18–21; Bernd Kauffmann, "Weimars deutsches Gesicht," in *Nachbarn auf dem Ettersberg: Menschenverachtung und Erziehung zur Ehrfurcht,* ed. Thomas A. Seidel (Neudietendorf/Weimar: Evangelische Akademie Thüringen, 1995), 15–20.

47. Walther Grunwald, "Die 'Zeitschneise,'" *Weimar Kultur Journal* 6, no. 8 (1997): 13–15. For other projects related to Buchenwald, see Weimar 1999—Kulturstadt Europas GmbH, ed., *Weimar 1999: Bausteine für ein Kulturstadt-Programm* (Weimar: Weimar 1999—Kulturstadt Europas GmbH, 1996), 26–28.

48. Jorge Semprun, *Quel beau dimanche!* (Paris: Bernard Grasset, 1980), 280–89. Such entanglements are also stressed in Volkhard Knigge, "Im Schatten des Etterberges [sic]: Von den Schwierigkeiten der Vernunft—Unbefragte Traditionen und Geschichtsbilder," *WerkstattGeschichte* 14 (1996): 71–86.

49. Compare Manfred Overesch, *Machtergreifung von links: Thüringen 1945/46* (Hildesheim: Georg Olms, 1993), 63.

50. See Eike Geisel, *Triumph des guten Willens: Gute Nazis und selbsternannte Opfer: Die Nationalisierung der Erinnerung,* ed. Klaus Bittermann (Berlin: Tiamat, 1998), 55–60; compare Mathias Wedel, "Das Land, in dem die Opfer wohnen," in *Identität und Wahn: Über einen nationalen Minderwertigkeitskomplex,* ed. Klaus Bittermann (Berlin: Tiamat, 1994), 159.

51. Daniel Jonah Goldhagen, *Hitler's Willing Executioners: Ordinary Germans and the Holocaust* (London: Little, Brown and Company, 1996); Hamburger Institut für Sozialforschung (ed.), *Vernichtungskrieg: Verbrechen der Wehrmacht 1941 bis 1944* (Hamburg: Hamburger Edition, 1996).

52. Compare Richard Chaim Schneider, *Fetisch Holocaust: Die Judenvernichtung—verdrängt und vermarktet* (Munich: Kindler, 1997); Eike Geisel, *Die Banalität der Guten: Deutsche Seelenwanderungen* (Berlin: Tiamat, 1992), 57–66.

53. Dominik Graf, dir., *Reise nach Weimar* (1996), television film first broadcast on 3 Oct. 1996 by ARD television.

54. Renato Barneschi, *Frau von Weber: Vita e morte di Mafalda di Savoia a Buchenwald* (Milan: Rusconi, 1982).

55. Compare Schley, "Die Stadt Weimar" (see n. 1), 189.

56. See Rolf Bothe, "Offenlegen statt zudecken," *Weimar Kultur Journal* 4, no. 4 (1995): 24–26.

57. In April 1997, Weimar's Department of Cultural Affairs asked Weimar residents to propose a new name for the former Karl-Marx-Platz. The majority of submissions favored the name Museumsplatz, which refers to a building adjoining the square that predates the Gauforum.

Chapter 9

1. See Sibylle Steinbacher, *Dachau—Die Stadt und das Konzentrationslager in der NS-Zeit: Die Untersuchung einer Nachbarschaft* (Frankfurt am Main: Peter Lang, 1993), 93–100.

2. For overviews of the history of Ravensbrück Concentration Camp, see Monika Herzog and Bernhard Strebel, "Das Frauenkonzentrationslager Ravensbrück," in *Frauen in Konzentrationslagern: Bergen-Belsen, Ravensbrück,* ed. Claus Füllberg-Stolberg et al. (Bremen: Temmen, 1994), 13–26; Jutta von Freyberg and Ursula Krause-Schmitt, *Moringen—Lichtenburg—Ravensbrück: Frauen im Konzentrationslager 1933–1945: Lesebuch zur Ausstellung* (Frankfurt am Main: VAS, 1997), 75–78; Ino Arndt, "Das Frauenkonzentrationslager Ravensbrück," *Dachauer Hefte* 3 (1993): 125–57; Sigrid Jacobeit, "Ravensbrück: Zur Geschichte des Frauen-KZ und der Gedenkstätte," *Dachauer Hefte* 11 (1995): 145–49.

3. Anise Postel-Vinay, "Gaskammern und die Ermordung durch Gas im Konzentrationslager Ravensbrück," trans. Giselind Rinn, in *Forschungsschwerpunkt Ravensbrück: Beiträge zur Geschichte des Frauen-Konzentrationslagers,* ed. Sigrid Jacobeit and Grit Philipp (Berlin: Hentrich, 1997), 35–46.

4. For a history of the Ravensbrück memorial, see Jacobeit, "Ravensbrück" (see n. 2), 149–59; Sigrid Jacobeit, "Zur Neukonzeption der Mahn- und Gedenkstätte Ravensbrück/Stiftung Brandenburgische Gedenkstätten," in *Reaktionäre Modernität und Völkermord: Probleme des Umgangs mit der NS-Zeit in Museen, Ausstellungen und Gedenkstätten: Dokumentation einer Tagung des Forschungsinstituts für Arbeiterbildung und der Hans-Böckler-Stiftung,* ed. Bernd Faulenbach and Franz-Josef Jelich (Essen: Klartext, 1994), 99–111; Insa Eschebach, "Frauen—Frieden—Mütter: Zur Entstehungsgeschichte der Nationalen Mahn- und Gedenkstätte Ravensbrück," *Gedenkstätten-Rundbrief* 82 (1998): 3–13.

5. Dunya Breur, *Ich lebe, weil du dich erinnerst: Frauen und Kinder in Ravensbrück,* trans. Rüdie Leikies and Diete Oudesluijs (Berlin: Nicolai, 1997), 116.

6. For a history of the so-called supermarket affair, see Lagergemeinschaft Ravensbrück, ed., *Dokumentation zur Auseinandersetzung um die privatwirtschaftliche Zweckentfremdung des Geländes der Mahn- und Gedenkstätte Ravensbrück* (Stuttgart: Lagergemeinschaft Ravensbrück, 1991); see also Klaus Jarmatz, ed., *Ravensbrücker Ballade oder Faschismusbewältigung in der DDR* (Berlin: Aufbau Taschenbuch, 1992), 112–21.

7. Incidentally, at that stage, the council, which had made the political decision in favor of the supermarket, was formally no longer involved in granting the necessary approvals for the supermarket to open. Responsibility for the supervision of the supermarket's construction lay with the district of Gransee, to which Fürstenberg belonged—a fact that seemed to matter little in the controversy.

8. "Werbeschilder vor dem Krematorium," *Nord-Kurier,* 3 July 1991.

9. Ulrike Helwerth, "Sonderangebote neben der KZ-Gedenkstätte," *Die Tageszeitung,* 6 July 1997.

10. In December 1990, Erdmann was in Israel. He later wrote that his con-

tribution had been deliberately misunderstood as a "heroic feat" (Kirchenchronik Stadtkirche Fürstenberg, 238; quoted from photocopy courtesy of Eberhard Erdmann).

11. These words were used by Georgia Peet-Taneva in an interview ("Laut geworden: Eine Betroffene über Ravensbrück," *Bremer Kirchenzeitung,* 11 Aug. 1991); West German commentators frequently used similar terms (see, for example, Arnd Bäucker, "Nichts heilig," *Stuttgarter Nachrichten,* 18 July 1991; Herbert Wessels, "Der Fall Ravensbrück," *Hamburger Abendblatt,* 19 July 1991).

12. *Wetzlarer Neue Zeitung,* as quoted in *FAZ,* 20 July 1991.

13. Christa Wagner, *Geboren am See der Tränen* (Berlin: Militärverlag der Deutschen Demokratischen Republik, 1987), 11.

14. See, for example, an interview with Stolpe: "Ganz Deutschland wird an Ravensbrück gemessen," *Märkische Allgemeine Zeitung,* 24 July 1991.

15. See, for example, three editorials in liberal West German newspapers: "Ein Lehrstück," *Frankfurter Rundschau,* 19 July 1991; "Das Streiflicht," *Süddeutsche Zeitung,* 19 July 1991; "Zum Thema: KZ Ravensbrück: Verdrängung," *Badische Zeitung,* 18 July 1991.

16. See the editorial in *Neue Osnabrücker Zeitung,* quoted in *FAZ,* 22 July 1991.

17. Siegfried Wolf, quoted in *Abschied vom Antifaschismus,* ed. Kurt Faller and Bernd Wittich (Frankfurt an der Oder: Frankfurt Oder Editionen, 1997), 248.

18. Hetty Voute, quoted in *Erinnerung und Begegnung: Gedenken im Land Brandenburg zum 50. Jahrestag der Befreiung,* ed. Ministerium für Wissenschaft und Kultur des Landes Brandenburg (Potsdam: Verlag für Berlin-Brandenburg, 1996), 133.

19. Freyberg and Krause-Schmitt, *Moringen—Lichtenburg—Ravensbrück* (see n. 2), 153–54; Thomas Lutz and Hermann Müller, *Die kalte Schulter des Hauses Siemens: Materialien zur Musterklage einer Zwangsarbeiterin auf Entschädigung für geleistete Zwangsarbeit* (Berlin: Aktion Sühnezeichen Friedensdienste e.V., n.d.).

20. See Insa Eschebach, "Das Aufseherinnenhaus: Überlegungen zu einer Ausstellung über SS-Aufseherinnen in der Gedenkstätte Ravensbrück," *Gedenkstätten-Rundbrief* 75 (1997): 1–12.

21. The emphasis on political prisoners was particularly pronounced in Erika Buchmann, *Die Frauen von Ravensbrück,* ed. Komitee der Antifaschistischen Widerstandskämpfer in der Deutschen Demokratischen Republik (Berlin: Kongress-Verlag, 1961).

22. The three best-known books about Ravensbrück that were published in the FRG before 1990 include Isa Vermehren, *Reise durch den letzten Akt: Ravensbrück, Buchenwald, Dachau: Eine Frau berichtet* (Hamburg: Christian Wegner, 1946); Corrie ten Boom, *Die Zuflucht,* trans. Hansjürgen Wille and Barbara Klau (Wuppertal: Brockhaus, 1975); and Anja Lundholm, *Das Höllentor: Bericht einer Überlebenden* (Reinbek: Rowohlt, 1988).

23. Germaine Tillion, *Ravensbrück,* trans. Gerald Satterwhite (Garden City, N.Y.: Anchor Press, 1975). Tillion later revised her book to incorporate new research: *Ravensbrück* (Paris: Éditions du Seuil, 1988); for the German edition see

Frauenkonzentrationslager Ravensbrück, trans. Barbara Glassmann (Lüneburg: Klampen, 1998).

24. These include, for example, texts by a committed Christian, a Roma woman, a German Jew, a French non-Communist former political prisoner, and a German Communist; respectively, Theodolinde Katzenmaier, *Vom KZ ins Kloster: Ein Stück Lebensgeschichte* (St. Ottilien: Eos, 1996); Ceija Stojka, *Reisende auf dieser Welt: Aus dem Leben einer Rom-Zigeunerin* (Vienna: Picus, 1992); Jutta Pelz-Bergt, *Die ersten Jahre nach dem Holocaust: Odyssee einer Gezeichneten* (Berlin: Hentrich, 1997); Odette Fabius, *Sonnenaufgang über der Hölle: Von Paris in das KZ Ravensbrück: Erinnerungen,* trans. Ira Joswiakowski and Gerd Joswiakowski (Berlin: Neues Lebens, 1997); Rita Sprengel, *Der Rote Faden: Lebenserinnerungen: Ostpreußen, Weimarer Republik, DDR, Die Wende* (Berlin: Hentrich, 1994).

25. This is reflected in the content and title of one of the last GDR publications about Ravensbrück, a study of the life histories of seventeen of its antifascist woman prisoners: Sigrid Jacobeit and Lieselotte Thoms-Heinrich, *Kreuzweg Ravensbrück: Lebensbilder antifaschistischer Widerstandskämpferinnen* (Leipzig: Verlag für die Frau, 1987). *Kreuzweg* means "way of the cross."

26. Wagner, *Geboren am See der Tränen* (see n. 13), 109.

27. Quoted in *Erinnerung und Begegnung* (see n. 18), 69.

28. For Brandenburg (Sachsenhausen and Ravensbrück concentration camp memorials), see Ministerium für Wissenschaft, Forschung und Kultur des Landes Brandenburg, ed., *Brandenburgische Gedenkstätten für die Verfolgten des NS-Regimes: Perspektiven, Kontroversen und internationale Vergleiche* (Berlin: Hentrich, 1992).

29. Sigrid Jacobeit with Elisabeth Brümann-Güdter, eds., *Ravensbrückerinnen* (Berlin: Hentrich, 1995).

30. See "Erinnerungen an Drögen," ed. Annette Leo, in Florian von Buttlar, Stefanie Endlich, and Annette Leo, *Fürstenberg-Drögen: Schichten eines verlassenen Ortes* (Berlin: Hentrich, 1994), 188–211.

31. For such attempts, see the interviews done in 1995 with Fürstenberg residents about Ravensbrück and about the arrival of the Red Army: Christa Schulz, "Zusammenbruch—Befreiung—Besatzung: Fürstenbergerinnen und Fürstenberger erinnern sich," in *"Ich grüße Euch als freier Mensch": Quellenedition zur Befreiung des Frauen-Konzentrationslagers Ravensbrück im April 1945,* ed. Sigrid Jacobeit with Simone Erpel (Berlin: Hentrich, 1995), 209–30.

32. See Stefanie Endlich, "Der verlassene Ort: Ein Überblick," in Buttlar, Endlich, and Leo, *Fürstenberg-Drögen* (see n. 30), 26–57.

33. For the following, see Volker Koop, *Deckname "Vergeltung": Die Stasi und der Toder der Brüder Baer* (Bonn: Bouvier, 1997).

34. So did some of the women liberated by the Russians; see Micheline Maurel, *Ravensbrück,* trans. Margaret S. Summers (London: Anthony Blond, 1959), 121–23; and Pelz-Bergt, *Die ersten Jahre* (see n. 24), 29–30. For obvious reasons, this aspect of Ravensbrück's history has rarely been publicly mentioned.

35. About Milena Jesenská's time in Ravensbrück, see Margarete Buber-Neumann, *Milena,* trans. Ralph Manheim (New York: Seaver Books, 1988).

36. James E. Young, *The Texture of Memory: Holocaust Memorials and Meaning* (New Haven: Yale University Press, 1993), 69. In the mid-1990s, Dachau's political leaders, who in the past were notorious for their oppositional stance toward the memorial, adopted a new approach. The brochures that were still available at the *Gedenkstätte* in 1997 could have been a relic of bygone days.

Chapter 10

1. For an overview, see Lothar Bembenek and Axel Ulrich, *Widerstand und Verfolgung in Wiesbaden 1933–1945: Eine Dokumentation* (Gießen: Anabas, 1990); and Ursula Krause-Schmitt and Jutta von Freyberg, *Heimatgeschichtlicher Wegweiser zu Stätten des Widerstandes und der Verfolgung 1933–1945*, vol. 1.1: *Hessen I: Regierungsbezirk Darmstadt* (Frankfurt am Main: VAS, 1995), 338–62.

2. Axel Ulrich, *Gedenkstätten, Mahnmale, Gedenktafeln und andere Formen der Erinnerung an die Opfer der nationalsozialistischen Gewaltherrschaft in Wiesbaden: Ein Überblick* (Wiesbaden: Stadtarchiv Wiesbaden, 1995), 21–27; see also Rolf Faber and Axel Ulrich, "Im Kampf gegen Diktatur und Rechtlosigkeit— für Menschlichkeit und Gerechtigkeit: Ein Klarenthaler Straßen-ABC des Widerstandes und der Verfolgung in 21 Lebensbildern," in *Wiesbaden und der 20. Juli 1944*, ed. Peter Joachim Riedle (Wiesbaden: Magistrat der Landeshauptstadt Wiesbaden, Kulturamt, 1996), 135–238. For a survey of relevant memorials in Wiesbaden, see <http://stadt.wiesbaden.de/Gedenkstaetten/>, a website that is maintained by Wiesbaden's Department for Cultural Affairs.

3. Lothar Bembenek and Fritz Schumacher, *Nicht alle sind tot, die begraben sind: Widerstand und Verfolgung in Wiesbaden 1933–1945* (Frankfurt am Main: Röderberg, 1980).

4. For a history of the Unter den Eichen camp, see Bärbel Maul and Axel Ulrich, *Das KZ-Außenkommando "Unter den Eichen,"* 4th ed. (Wiesbaden: Magistrat der Landeshauptstadt Wiesbaden—Stadtarchiv, 1995); Bärbel Maul, "Das Außenkommando Wiesbaden des SS-Sonderlagers Hinzert," in *Verfolgung und Widerstand in Hessen 1933–1945*, ed. Renate Knigge-Tesche and Axel Ulrich (Frankfurt am Main: Eichborn, 1996), 484–97.

5. Aloyse Raths, "KZ-Gedenkstätte in Wiesbaden," *Rappel: Revue de la L.P.P.D.* 47, no. 2 (1992): 279–323; "Gedenkstätte erinnert an KZ-Außenlager der SS," *WK,* 5 Nov. 1991; Margit Fehlinger, "Erinnerung an ein düsteres Kapitel der Stadtgeschichte," *Frankfurter Rundschau,* 9 Nov. 1991; "Erinnern und mahnen," *FAZ,* 10 Nov. 1991; "'Wir verzeihen, aber vergessen nicht,'" *WT,* 11 Nov. 1991; Uwe Niemeier, "Gedenkstätte als Erinnerung und Mahnung," *WK,* 11 Nov. 1991.

6. Lothar Bembenek, "Der November 1938," *Begegnungen* 1 (1988), 92–110.

7. Telephone interview with Egon Altdorf, 25 May 1998; Garten- und Friedhofsamt Wiesbaden, Magistratsvorlage betr. Ausgestaltung des Synagogengeländes am Michelsberg, 17 March 1953, StAWi; minutes of Sitzung der Stadtverordnetenversammlung, 23 April 1953, StAWi.

8. "Der Synagogenstein soll mahnen: Der Welt Gewissen ist die Liebe," *WK,* 22 Aug. 1953.

9. Mechthild Herzer and Werner Kennig, *Wiesbadener Sommer '89* (Essen: Klartext, 1991), 26–33.

10. Heinrich O. Lessing, "Städtebauliche Neuordnung der Straßen und Platzräume im Bereich der Schwalbacher Straße in Wiesbaden, sowie Rückbau und Umnutzung der Brücke," qualifying thesis, Fachhochschule Mainz, 1994.

11. Compare Hans Dickel, "Installationen als ephemere Form von Kunst," in *Mo(nu)mente: Formen und Funktionen ephemerer Denkmäler,* ed. Michael Diers (Berlin: Akademie, 1993), 223–39.

12. "Opfer-Namen auf 1200 Klingelschildern," *WK,* 24 Oct. 1996.

13. "Öffentliche Sitzung der Stadtverordnetenversammlung am 19.09.1985; Nr. 243: Antrag der CDU-Stadtv.-Fraktion vom 13.05.1985" (courtesy of Günter Retzlaff).

14. Hans Maus, SPD-Stadtverordnetenfraktion, to Stadtverordneten-vorsteher Günter Retzlaff, 1 Oct. 1985 (courtesy of Günter Retzlaff).

15. Interview with Günther Retzlaff, Wiesbaden, 5 June 1987, tape recording.

16. "Öffentliche Sitzung der Stadtverordnetenversammlung am 19.06.1986; Nr. 887: Mahnmal für die Opfer der nationalsozialistischen Gewaltherrschaft" (courtesy of Günter Retzlaff).

17. Also in 1986, the city council of Oldenburg (Lower Saxony) decided to fund a central memorial for "all victims of National Socialism in Oldenburg." In 1989, five artists were invited to submit proposals. The jury chose that of Udo Reimann; it was realized in 1990: see *Mahnmal für alle Opfer des Nationalsozialismus in Oldenburg: 9. November 1990: Eine Dokumentation,* ed. Stadt Oldenburg, Kulturdezernat (Oldenburg: Holzberg, 1991).

18. Marianne Peter, "Widerstand und Verfolgung der Sozialistischen Arbeiterjugend (SAJ)," in Knigge-Tesche and Ulrich, *Verfolgung und Widerstand in Hessen* (see n. 4), 158–59, 161.

19. For Georg Buch's political life, see Erik Emig, *Georg Buch: Leben und Wirken eines Sozialdemokraten* (Bonn: Courier, 1983); and Axel Ulrich, "Georg Buch: Ein Wiesbadener Sozialdemokrat zwischen Widerstand und Wiederaufbau," in *Georg Buch: 24. September 1903–5. August 1995: Zum Gedächtnis* (Wiesbaden: Magistrat der Landeshauptstadt Wiesbaden—Stadtarchiv, 1995), 7–40. According to the local Christian Democrats, Buch's credentials were rather problematic: when Buch stood for the office of deputy mayor in 1952, the CDU voted against him because Buch was a professed atheist (Emig, *Georg Buch,* 87–88).

20. Interview with Margarethe Goldmann, Wiesbaden, 5 June 1997.

21. Hans Walden, "Das Schweigen der Denkmäler: Wie sich Hamburg des Kriegs entsinnt," in *Das Gedächtnis der Stadt: Hamburg im Umgang mit seiner nationalsozialistischen Vergangenheit,* ed. Peter Reichel (Hamburg: Dölling und Galitz, 1997), 29–46; Hans Walden, "Der Streit um das Hamburger Kriegs-denkmal von 1936," in *Denkmäler: Ein Reader für Unterricht und Studium,* ed. Eberhard Grillparzer, Günther Ludwig, and Peter Schubert (Hannover: Bund Deutscher Kunsterzieher, 1994), 14–25; Dietrich Schubert, "Alfred Hrdlickas antifaschistisches Mahnmal in Hamburg oder: die Verantwortung der Kunst," in *Denkmal—Zeichen—Monument: Skulptur und öffentlicher Raum heute,* ed. Ekke-

hard Mai and Gisela Schmirber (Munich: Prestel, 1989), 134–43. This and the following examples were only the most prominent artistic attempts to memorialize the Nazi past in Germany and Austria between 1985 and 1991. For overviews of German and Austrian discussions about *Mahnmale* since the mid-1980s, see Hubertus Adam, "Bestimmtheit, Unbestimmtheit, Unsichtbarkeit: Wirkungen und Wirkungsweisen neuester NS-Mahnmäler," in Grillparzer, Ludig, and Schubert, *Denkmäler,* 26–39; James E. Young, *The Texture of Memory: Holocaust Memorials and Meaning* (New Haven: Yale University Press, 1993), 27–48; Christoph Heinrich, "Denkmal als Soziale Plastik," in *Gedächtnisbilder: Vergessen und Erinnern in der Gegenwartskunst,* ed. Kai-Uwe Hemken (Leipzig: Reclam, 1996), 344–54; Matthias Winzen, "The Need for Public Representation and the Burden of the German Past," *Art Journal* 48, no. 4 (1989): 309–14.

22. Jochen Gerz and Esther Shalev-Gerz, *Das Harburger Mahnmal gegen Faschismus / The Harburg Monument against Fascism* (Ostfildern: Hatje, 1994); see also Stephan Schmidt-Wulffen, "The Monument Vanishes: A Conversation with Esther and Jochen Gerz," in *The Art of Memory: Holocaust Memorials in History,* ed. James E. Young (New York: Jewish Museum, 1994), 69–75.

23. Stefan Goebel, "Stein des Anstosses: Black Form (Dedicated to the Missing Jews)," in *Denkmäler in Münster: Auf Entdeckungsreise in die Vergangenheit,* ed. Heinrich Avenwedde and Heinz-Ulrich Eggert (Münster: Eigenverlag Schriftproben, 1996), 315–88.

24. Hans Haacke, "Und ihr habt doch gesiegt, 1988," in Young, *The Art of Memory* (see n. 22), 76–81.

25. Young, *The Texture of Memory* (see n. 21), 104–12; John Czaplicka, "Stones Set Upright in the Winds of Controversy: An Austrian Monument against War and Fascism," in *A User's Guide to German Cultural Studies,* ed. Scott Denham, Irene Kacandes, and Jonathan Petropoulos (Ann Arbor: University of Michigan Press, 1997), 257–86.

26. Hans Dickel, "Das fehlende Haus: Christian Boltanski in Berlin," *Ästhetik und Kommunikation* 78 (1992): 42–48; Cordula Meier, "Anselm Kiefer. Christian Boltanski. On Kawara. Rebecca Horn. Zur künstlerischen Konstruktion von Erinnerung," in *Shoah: Formen der Erinnerung: Geschichte, Philosophie, Literatur, Kunst,* ed. Nicolas Berg, Jess Jochimsen, and Bernd Stiegler (Munich: Wilhelm Fink, 1996), 270–74; John Czaplicka, "History, Aesthetics, and Contemporary Commemorative Practice in Berlin," *New German Critique* 65 (1995): 155–87.

27. "Protokoll zur Mahnmaldiskussion am 25. November 1991," 2 (courtesy of Günther Retzlaff).

28. "Protokoll zur 3. Sitzung 'Mahnmal' für die Opfer der nationalsozialistischen Gewaltherrschaft," 5 (courtesy of Günther Retzlaff).

29. Magistratsbeschluß, 4 February 1963, Nr. 220; Magistratsbeschluß, 13 May 1963, Nr. 966; Magistratsbeschluß, 23 April 1968, Nr. 713. I thank Axel Ulrich for these references.

30. Michael Meinert, "Parlament respektiert die Perspektive der Opfer," *Frankfurter Rundschau,* 23 May 1992; "Ein Mahnmal nur für alle NS-Verfolgten," *WT,* 7 April 1992.

31. Heinz Loewenthal, Ines Henn, and Friedrich Weber, Gesellschaft für

Christlich-Jüdische Zusammenarbeit in Wiesbaden, to Stadtverordnetenvorsteher Günter Retzlaff, Oberbürgermeister Achim Exner and Stadträtin Margarethe Goldmann, 27 May 1992 (StAWi, Dienstakten "Sinti und Roma I, Mahnmal").

32. Jenny Holzer, "Project Proposal" [1994] (courtesy of Kulturamt der Stadt Wiesbaden). In 1994, Holzer realized elements of the project she had proposed for Wiesbaden, in Nordhorn, a small town in the northeast of Lower Saxony; the Nordhorn memorial is titled *Black Garden.*

33. For the following, see Stefan Lange, "Etappen eines Diskussionsverlaufs," in *Im Irrgarten Deutscher Geschichte: Die Neue Wache 1818 bis 1993,* ed. Daniela Büchten and Anja Frey (Berlin: Aktives Museum Faschismus und Widerstand in Berlin e.V., 1994), 45–50; Klaus Kühnel, "Die Ideologiekathedrale: Berlins Neue Wache in Geschichte und Gegenwart," in *Nationaler Totenkult: Die Neue Wache: Eine Streitschrift zur zentralen deutschen Gedenkstätte,* ed. Robert Halbach (Berlin: Karin Kramer, 1995), 27–40; Jürgen Tietz, "Schinkels Neue Wache Unter den Linden: Baugeschichte 1816–1993," in *Die Neue Wache Unter den Linden: Ein deutsches Denkmal im Wandel der Geschichte,* ed. Christoph Stölzl (Berlin: Koehler und Amelang, 1993), 9–93; Bernhard Schulz, "Kein Konsens im Land der Menschenketten: Zur Vorgeschichte einer 'Zentralen Gedenkstätte der Bundesrepublik Deutschland,'" in *Die Neue Wache Unter den Linden,* 172–82; Eberhard Roters, "Die Skulptur—Der Raum—Das Problem," in *Streit um die Neue Wache: Zur Gestaltung einer zentralen Gedenkstätte,* ed. Jürgen Feßmann (Berlin: Akademie der Künste, 1993), 7–18; Wallis Miller, "Schinkel and the Politics of German Memory: The Life of the Neue Wache in Berlin," in Denham, Kacandes, and Petropoulos, *User's Guide* (see n. 25), 227–56.

34. Förderkreis Aktives Museum Deutsch-Jüdischer Geschichte in Wiesbaden, "'Gedenken der Opfer des Naziregimes': Plädoyer für drei Gedenktage in Wiesbaden," discussion paper, 1997, 4.

35. For this and the following, see Hans Hattenhauer, *Geschichte der deutschen Nationalsymbole: Zeichen und Bedeutung,* 2d ed. (Munich: Olzog, 1990), 136–77; and Dietmar Schiller, "Politische Gedenktage in Deutschland: Zum Verhältnis von öffentlicher Erinnerung und politischer Kultur," *Aus Politik und Zeitgeschichte* B25/93 (18 June 1993): 32–39.

36. For the annual commemorations on 11 August in Celle, see Mijndert Bertram, *Celle—Eine deutsche Stadt vom Kaiserreich zur Bundesrepublik,* vol. 1: *Das Zeitalter der Weltkriege* (Celle: Stadt Celle [1992]), 126–31.

37. Quoted in Hattenhauer, *Geschichte der deutschen Nationalsymbole* (see n. 35), 175.

38. Interview with Günther Retzlaff, Wiesbaden, 5 June 1997, tape recording. Ironically, Schorsch Buch, who would have been one of those to be honored by the memorial, argued that he did not trust artists to be able to create meaningful statements about "Auschwitz" when he recommended in 1991 that the 1986 council decision not be implemented (Georg Buch to Stadtverwaltung Wiesbaden, 17 March 1991, StAWi, Dienstakten "Mahnmal-Diskussion").

39. Interview with Heike Notz and Björn Toelstede, Breitenkamp, 15 June 1997, tape recording.

40. Interview with Peter Joachim Riedle, Wiesbaden, 7 May 1997, tape recording.

41. In Wiesbaden, all members of the executive *(Magistrat)* except for the mayor are elected by the council for six-year terms, and all major parties are represented in the *Magistrat*. The members of the council *(Stadtverordnetenversammlung)* are elected every four years in local government elections.

42. Jochen Gerz, *Gegenwart der Kunst: Interviews (1970–1995)* (Regensburg: Lindinger + Schmid, 1995), 157.

43. She did not, of course, intend this to be taken literally; rather, she was hoping that her memorial would prompt the people of Wiesbaden to remember (interview with Jenny Holzer, Canberra, 14 March 1998).

44. See Axel Ulrich, *Authentische Orte der Verfolgung und des Widerstandes 1933–1945 in Wiesbaden* (Wiesbaden: Magistrat der Landeshauptstadt Wiesbaden, Kulturamt, 1998). Detlef Hoffmann has drawn attention to the absurdity of calling such sites "authentic": "Das Gedächtnis der Dinge," in *Das Gedächtnis der Dinge: KZ-Relikte und KZ-Denkmäler 1945–1995,* ed. Detlef Hoffmann (Frankfurt am Main: Campus, 1998), 10.

Chapter 11

1. For this and the following, see Jan Patjens and Dirk Panten, "Die Kinder vom Bullenhuser Damm: Wie ein Hamburger Neubaugebiet an die Naziverbrechen erinnert," essay, Schülerwettbewerb Deutsche Geschichte um den Preis des Bundespräsidenten (1993), Archiv der Körber-Stiftung, Nr. 930271, 65–71. Hamburg is divided into seven boroughs *(Bezirke),* each of which is administered by a *Bezirksamt.* A *Bezirk* may have several wards. Each ward is administered by an *Ortsamt.* The *Ortsausschuß* is a body of elected members that deals with matters relating to the administration of the ward.

2. VVN Bund der Antifaschisten, Ortsvereinigung Niendorf/Schnelsen, to Jens-Peter Petersen, Vorsitzender des Ortsausschusses Lokstedt, 21 Sept. 1981, facsimile in Patjens and Panten, "Die Kinder" (see n. 1), 161–62.

3. Familie Zylberberg to Jens-Peter Petersen, Vorsitzender des Ortsausschusses Lokstedt, 28 Sept. 1981, facsimile ibid., 163–64.

4. Letter received by Ortsamt Lokstedt on 16 April 1992, facsimile ibid., 175.

5. This and the following quotes of Burgwedel residents are from audiotaped interviews done by Jan Patjens and me between July 1997 and July 1998. With one exception, the interviews took place upon prior arrangement and at the interviewees' homes. All interviewees are referred to by fictive first names.

6. Quoted in Barbara Straka, "Große Gesten, hohle Worte, leere Formen: Eine Absage an die Gigantonamie des Gedenkens und ein Aufruf," in *Der Wettbewerb für das "Denkmal für die ermordeten Juden Europas": Eine Streitschrift,* ed. Leonie Baumann et al. (Berlin: Verlag der Kunst, 1995), 148.

7. James E. Young, *The Texture of Memory: Holocaust Memorials and Meaning* (New Haven: Yale University Press, 1993), 18, 20. Compare Y. Michal

Bodemann, *Gedächntistheater: Die jüdische Gemeinschaft und ihre deutsche Erfindung* (Hamburg: Rotbuch, 1996), 80–81.

8. Ehrhard Bahr, "'My Metaphors Are My Wounds': Nelly Sachs and the Limits of Poetic Metaphor," in *Jewish Writers, German Literature: The Uneasy Examples of Nelly Sachs and Walter Benjamin*, ed. Timothy Bahti and Marilyn Sibley Fries (Ann Arbor: University of Michigan Press, 1995), 48.

9. See, for example, Bettina Durrer, "Eine Verfolgte als Täterin? Zur Geschichte der Blockältesten Carmen Maria Mory," in *Forschungsschwerpunkt Ravensbrück: Beiträge zur Geschichte des Frauen-Konzentrationslagers,* ed. Sigrid Jacobeit and Grit Philipp (Berlin: Hentrich, 1997), 86–93; Irmtraud Heike, "'. . . da es sich ja lediglich um die Bewachung der Häftlinge handelt . . .': Lagerverwaltung und Bewachungspersonal," in *Frauen in Konzentrationslagern: Bergen-Belsen, Ravensbrück,* ed. Claus Füllberg-Stolberg et al. (Bremen: Temmen, 1994), 221–39; Insa Eschebach, "SS-Aufseherinnen des Frauenkonzentrationslagers Ravensbrück: Erinnerungen ehemaliger Häftlinge," *WerkstattGeschichte* 13 (1996): 39–59; Ute Gebhardt, dir., *Mythos Ilse Koch? Auf den Spuren einer Täterin,* television documentary, MDR, Landesfunkhaus Thüringen, first broadcast on MDR television on 14 April 1997.

10. *Hamburger Adreßbuch: Anschriften- und Nachschlagewerk der Hansestadt Hamburg mit Handels-, Industrie- und Gewerbe-Adreßbuch* 156 (1943): 1904.

11. "Listening is a form of ethical responsiveness that recognizes a duty to the story of the other." John Frow, "A Politics of Stolen Time," *Meanjin* 57, no. 2 (1998): 364.

Select Bibliography

Note on Sources

Shifting Memories draws on research in municipal archives in Salzgitter, Hildesheim, Celle, and Wiesbaden, in the Hessen, Hamburg, and Lower Saxony state archives, in the archives and libraries of the memorial museums at Buchenwald, Ravensbrück, Sachsenhausen, and Neuengamme, at the Centrum Judaicum in Berlin, and at the Yad Vashem Memorial Authority in Jerusalem. Associations committed to promoting the remembrance of Nazi crimes such as Arbeitskreis Stadtgeschichte Salzgitter, Aktives Museum Faschismus und Widerstand (Berlin), and Förderkreis Aktives Museum Deutsch-Jüdischer Geschichte in Wiesbaden generously opened their files and gave me access to invaluable collections of press cuttings. Eva Freudenstein, Christoph Großmann, Bernd Heyl, Rudi Hechler, R. W. L. E. Möller, Georgia Peet-Taneva, Günther Schwarberg, and many others let me peruse, copy from, or borrow their private archives.

The writing of this book is also informed by numerous interviews with people in Germany, ranging from local high school students to the mayors of towns featured in the texts. Interviewees included survivors of Buchenwald, Drütte, Neuengamme, Ravensbrück, and Sachsenhausen concentration camps, staff working for German memorial museums and local councils, local historians and journalists, and private individuals demanding or opposing the establishment of memorials.

Complementary Readings

A comprehensive listing of all sources cited in and referred to this book would needlessly duplicate much of the notes. The following bibliographical references are intended to draw the reader's attention to writings that pursue issues raised in *Shifting Memories* and could be usefully read as companion pieces to chapters of this book. The list is deliberately selective and includes also texts not listed in the notes. I was aiming for shorter, English-language articles and chapters that would be particularly appropriate in the context of the classroom, and I otherwise let the selection be governed by my idiosyncratic tastes.

Introduction
Musil, Robert. *Posthumous Papers of a Living Author,* Translated by Peter Worts-
mann. Hygiene: Eridanos Press, 1987. 61–64.
Young, James E. *The Texture of Memory: Holocaust Memorials and Meaning.*
New Haven: Yale University Press, 1993. 27–48.
Koonz, Claudia. "Between Memory and Oblivion: Concentration Camps in Ger-
man Memory." In *Commemorations: The Politics of National Identity,* edited
by John R. Gillis, 258–80. Princeton: Princeton University Press, 1994.
Huyssen, Andreas. *Twilight Memories: Marking Time in a Culture of Amnesia.*
New York: Routledge, 1995. 67–84.

Chapter 1
Lüdtke, Alf. " 'Coming to Terms with the Past': Illusions of Remembering, Ways
of Forgetting Nazism in West Germany." *Journal of Modern History* 65
(1993): 542–72.

Chapter 2
Arendt, Hannah. "The Aftermath of Nazi Rule: Report from Germany." *Com-
mentary* 10, no. 4 (1950): 342–53. Reprinted in Hannah Arendt, *Essays in
Understanding 1930–1954,* edited by Jerome Kohn (New York: Harcourt
Brace, 1994), 248–69.

Chapter 3
Koshar, Rudy. *Germany's Transient Pasts: Preservation and National Memory in
the Twentieth Century.* Chapel Hill: University of North Carolina Press, 1998.
289–328.
Geyer, Michael, and Miriam Hansen. "German-Jewish Memory and National
Consciousness." In *Holocaust Remembrance: The Shapes of Memory,* edited
by Geoffrey H. Hartman, 175–90. Oxford: Blackwell, 1994.
Benz, Wolfgang. "The Persecution and Extermination of the Jews in the German
Consciousness." Translated by Joe O'Donnell and John Milfull. In *Why Ger-
many? National Socialist Anti-Semitism and the European Context,* edited by
John Milfull, 91–104. Providence: Berg, 1993.

Chapter 4
Bartov, Omer. " 'Seit die Juden weg sind . . .': Germany, History, and Representa-
tions of Absence." In *A User's Guide to German Cultural Studies,* edited by
Scott Denham, Irene Kacandes, and Jonathan Petropoulos, 209–26. Ann
Arbor: University of Michigan Press, 1997.
Bergerson, Andrew Stuart. "In the Shadow of the Towers: An Ethnography of a
German-Israeli Exchange Program." *New German Critique* 71 (1997): 141–76.

Chapter 5
Bodemann, Michal Y. "Reconstructions of History: From Jewish Memory to
Nationalized Commemoration of Kristallnacht in Germany." In *Jews, Ger-
mans, Memory: Reconstructions of Jewish Life in Germany,* edited by Y.
Michal Bodemann, 179–223. Ann Arbor: University of Michigan Press, 1996.

Erb, Rainer. "Public Responses to Antisemitism and Right-Wing Extremism." In *Antisemitism and Xenophobia in Germany after Unification,* edited by Hermann Kurthen, Werner Bergmann, and Rainer Erb, 211–23. New York: Oxford University Press, 1997.

Ostow, Robin. "Imperialist Agents, Anti-Fascist Monuments, Eastern Refugees, Property Claims: Jews as Incorporations of East German Social Trauma, 1945–94." In *Jews, Germans, Memory: Reconstructions of Jewish Life in Germany,* edited by Y. Michal Bodemann, 227–41. Ann Arbor: University of Michigan Press, 1996.

Chapter 6
Huyssen, Andreas. "The Politics of Identification: *Holocaust* and West German Drama." *New German Critique* 19 (1980): 117–36.

Chapter 7
Diner, Dan. "On the Ideology of Antifascism." Translated by Christian Gundermann. *New German Critique* 67 (1996): 123–32.

Chapter 8
Bender, Benjamin. *Glimpses through Holocaust and Liberation.* Berkeley: North Atlantic Books, 1995. 116–71.

Koonz, Claudia. "Germany's Buchenwald: Whose Shrine? Whose Memory?" In *The Art of Memory: Holocaust Memorials in History,* edited by James E. Young, 110–19. New York: Jewish Museum, 1994.

Monteath, Peter. "Buchenwald Revisited: Rewriting the History of a Concentration Camp." *International History Review* 16, no. 2 (1994): 267–83.

Chapter 9
Farmer, Sarah. "Symbols That Face Two Ways: Commemorating the Victims of Nazism and Stalinism at Buchenwald and Sachsenhausen." *Representations* 49 (1995): 97–119.

Chapter 10
Kramer, Jane. *The Politics of Memory: Looking for Germany in the New Germany.* New York: Random House, 1996. 255–93.

Chapter 11
Gedi, Noa, and Yigal Elam. "Collective Memory–What Is It?" *History and Memory* 8, no. 1 (1996): 30–50.

Index

Note: Italic numbers refer to illustrations.

325

Social History, Popular Culture, and Politics in Germany
Geoff Eley, Series Editor

(continued from pg. ii)